CARTOON ANIMATION

by Preston Blair

WALTER FOSTER PUBLISHING, INC.

Laguna Hills, California

CARTOON ANIMATION

Published by Walter Foster Publishing, Inc.,
23062 La Cadena Drive, Laguna Hills, CA 92653.
Copyright © 1994 Preston Blair.
All rights reserved.
Designed and produced by Joshua Morris Publishing, Inc.,
355 Riverside Avenue, Westport, CT 06880.
Printed in Hong Kong.

ISBN: 1-56010-084-2
10 9 8 7 6 5 4

About the Author

Preston Blair was a native Californian from Redlands. He attended Pomona College, then studied art at the Otis Art Institute and illustration under Pruett Carter at Chouinard. He exhibited widely as a member of the California Watercolor Society and the American Watercolor Society in New York.

Preston was one of the fine artists of animation. With the Disney Studio, he designed and animated the hippos in "The Dance of the Hours" and animated Mickey Mouse in the "Sorcerer's Apprentice" (both in *Fantasia*), parts of *Pinocchio*, and the segment in *Bambi* when the owl tells about love in "twitterpatted" speech.

At MGM, Preston directed *Barney Bear* shorts, and is well known as the animator and designer of *Red Hot Riding Hood* in the Tex Avery epic shorts. Later, Preston moved to Connecticut and produced television commercials, educational films, and half-hour cartoon episodes (including *The Flintstones*) for West Coast producers. More recently, he was an inventor of interactive TV systems using animation methods to teach reading or to provide full-figure game action that simulates reality— for example, playing tennis with an animated opponent.

Preston died in April 1995 at the age of 85.

CONTENTS

INTRODUCTION

This book is dedicated to Hope and Ian, my wife and my son.
 –Preston Blair

An American art form, animation is the process of drawing and photographing a character—a person, an animal, or an inanimate object—in successive positions to create lifelike movement. Animation is both art and craft; it is a process in which the cartoonist, illustrator, fine artist, screenwriter, musician, camera operator, and motion picture director combine their skills to create a new breed of artist—the animator.

The art of animators is unique. Animators bring life to their drawings, creating an illusion of spirit and vigor. They caricature the gestures and expressions in the drawings, give them a fantastic array of character and personality, and make us believe that the drawings actually think and have feelings.

This book was written by an animator to help you learn how to animate—how to make a series of drawings that create a sensation of movement when viewed in sequence. The pioneers of the art of animation learned many lessons, most through trial and error, and it is this body of knowledge that has established the fundamentals of animation. This book will teach you these fundamentals.

Animators must first know how to draw; good drawing is the cornerstone of their success.

They must be able to dramatize and caricature life while they time and stage their characters' actions and reactions. The value of animators' work is determined by the ability of their characters to sway the emotions of the audience—in other words, the characters' "acting" skills. Animators must know how to entertain an audience: how to present gag comedy and how to portray an interesting or unusual happening of life. To do this, they study the great film comedians and read recognized texts on acting. This knowledge helps them to grip their viewers with suspense or make them smile and laugh with humor in the theater of animation.

The animation process, however, involves much more than just good drawing. Animators must have knowledge of the elements of screen writing: plot-setting, premise, character, conflict, crisis, climax, exposition, dialogue, and action. These factors determine the types of personalities, expressions, and actions they will need to create. Moreover, if the animation includes a character moving her mouth in speech or song, animators need a knowledge of phonetics; if it features a character responding to a musical soundtrack, they must have a knowledge of music and rhythm. Animators must also know how an animation camera

works and how to time the character actions to fit the speed of the film. The list goes on and on; the animators' job is immeasurable.

Animation is a vast and virtually unexplored art form. It is, perhaps, more popular today than ever before, and new techniques and methods of animating—including computer animation—are being developed all the time. There are many characters, styles, and background designs, however, that remain to be discovered—so pick up your pencil and get started!

The curtains part as you turn the pages. The journey will be an exciting and adventurous one.

Best wishes!

Preston Blair

CHARACTER DEVELOPMENT

It can be an exciting experience to create and develop an original cartoon character. Constructing and developing a character is not merely a matter of drawing the figure; each character also has its own shape, personality, features, and mannerisms. The animator has to take these qualities into consideration to make the characters seem lifelike and believable. For example, there are various personality types such as "goofy," "cute," and "screwball." Think about the type of character you wish to design; then use the diagrams and guides shown in this chapter to begin your drawing. When creating a character, you should begin by drawing rough "idea" sketches. These will give you a direction for the type and nature of the character you wish to create. Develop the basic shape of the figure; then add the features and other details. This procedure should be followed whether the character you are developing is a human, an animal, or an inanimate object you wish to bring to life (for example, drawing a face on a computer and making it dance).

After you have developed the character and the proportions are to your liking, develop the movement expressions of the body, head, and hands. Hands can tell a complete story with just a simple pose. Study and practice drawing the hands shown on page 29; then create some hand positions of your own. Also, the "line of action" section is a big help in creating attitudes in posture and movement. This chapter is the starting point to a world of exciting cartoon animation.

CARTOON CONSTRUCTION

PROPORTION IS ONE OF THE MOST IMPORTANT FACTORS TO CONSIDER WHEN CONSTRUCTING A CARTOON CHARACTER. THE ANIMATOR MUST KEEP IN MIND THE RELATIVE SIZES OF THE BODY PARTS, BECAUSE SPECIFIC PROPORTIONS ARE USED TO CREATE CHARACTER TYPES. FOR EXAMPLE, THE HEAVY, PUGNACIOUS CHARACTER HAS A SMALL HEAD, LARGE CHEST OR BODY AREA, HEAVY ARMS AND LEGS, AND THE JAW AND CHIN NORMALLY PROTRUDE; THE CUTE CHARACTER IS BASED ON THE PROPORTIONS OF A BABY WITH A LARGE HEAD IN PROPORTION TO THE OVAL BODY, A HIGH FOREHEAD, AND A SMALL MOUTH/EYE/CHIN AREA; "SCREWBALL" TYPES HAVE EXAGGERATED PARTS AND FEATURES (DETAILED INFORMATION ON CHARACTER TYPES BEGINS ON PAGE 32).

CARTOON STUDIOS OFTEN USE HEAD SIZE TO MEASURE THE HEIGHT OF A CHARACTER—FOR INSTANCE, A CUTE BEAR MAY BE THREE HEADS HIGH, AND A PUGNACIOUS BEAR MIGHT BE FIVE OR SIX HEADS HIGH. THIS INFORMATION HELPS THE ANIMATOR TO KEEP THE PROPORTIONS AND HEIGHT OF A CHARACTER CONSISTENT. STUDY THE CHARACTERS ON THIS PAGE, AND MEASURE EACH ONE IN "HEADS."

WHEN ANIMATING, YOU'LL ALSO FIND IT HELPFUL TO MAKE A REFERENCE DRAWING OF THE CHARACTER ON A SEPARATE PIECE OF PAPER. THIS WAY, THE ANIMATOR CAN REFER TO THE PROPORTION GUIDELINES WHEN DRAWING THE CHARACTER IN DIFFERENT POSES AND ACTIONS.

THE PROPER USE OF CARTOON PROPORTIONS MAKES A CHARACTER, SO ANALYZE THE PROPORTIONS OF YOUR ANIMATED ACTOR BEFORE HE OR SHE GOES ON STAGE—UP ON THE SCREEN.

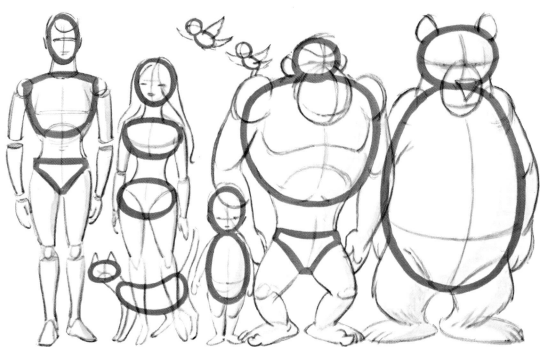

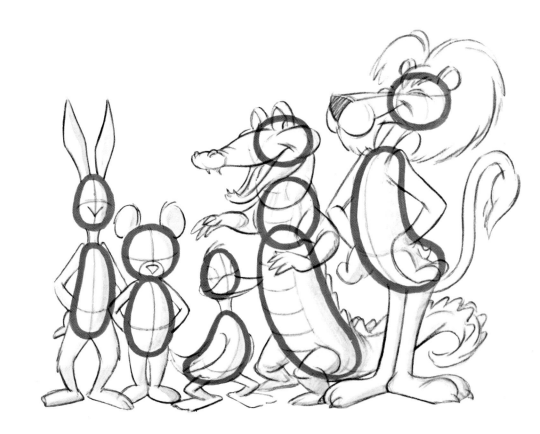

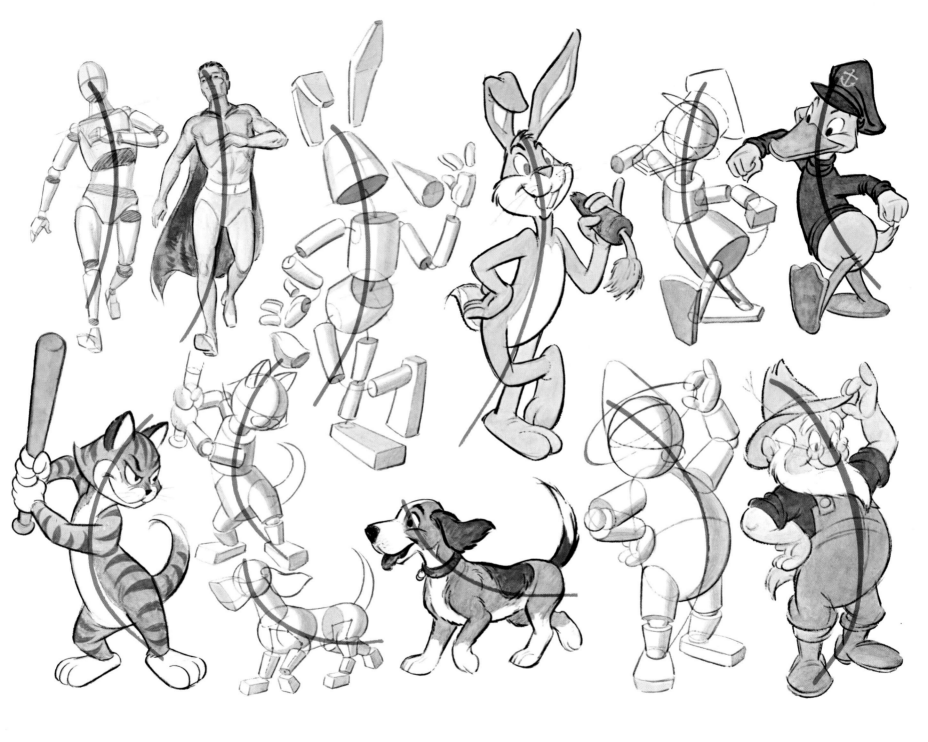

STANCE (SOLID MASSES)–DRAW A "LINE OF ACTION" THROUGH THE THREE-DIMENSIONAL PARTS TO ORGANIZE AND SET THE ATTITUDE OR ACTION. CONSTRUCT YOUR DRAWING AS IF YOU WERE FITTING TOGETHER THE PARTS OF A PUPPET AT THE JOINTS ACCORDING TO A CHARACTER FORMULA. THUS YOUR CHARACTER BECOMES BELIEVABLE, AND WHEN HE ACTS, THE AUDIENCE EMOTIONALLY RESPONDS.

11

BODY BUILT FROM CIRCULAR AND ROUNDED FORMS

THE ANIMATED CARTOON CHARACTER IS BASED ON THE CIRCULAR, ROUNDED FORM. IN A CARTOON STUDIO SEVERAL PEOPLE MAY WORK ON THE SAME DRAWING AND THE ROUNDED FORM IS USED BECAUSE OF ITS SIMPLICITY—IT MAKES ANIMATION EASIER. ALSO, CIRCULAR FORMS "FOLLOW THROUGH" BETTER ON THE SCREEN.

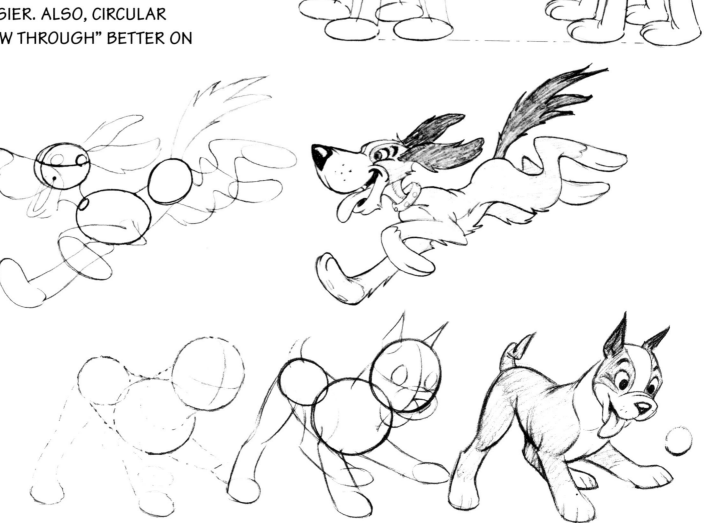

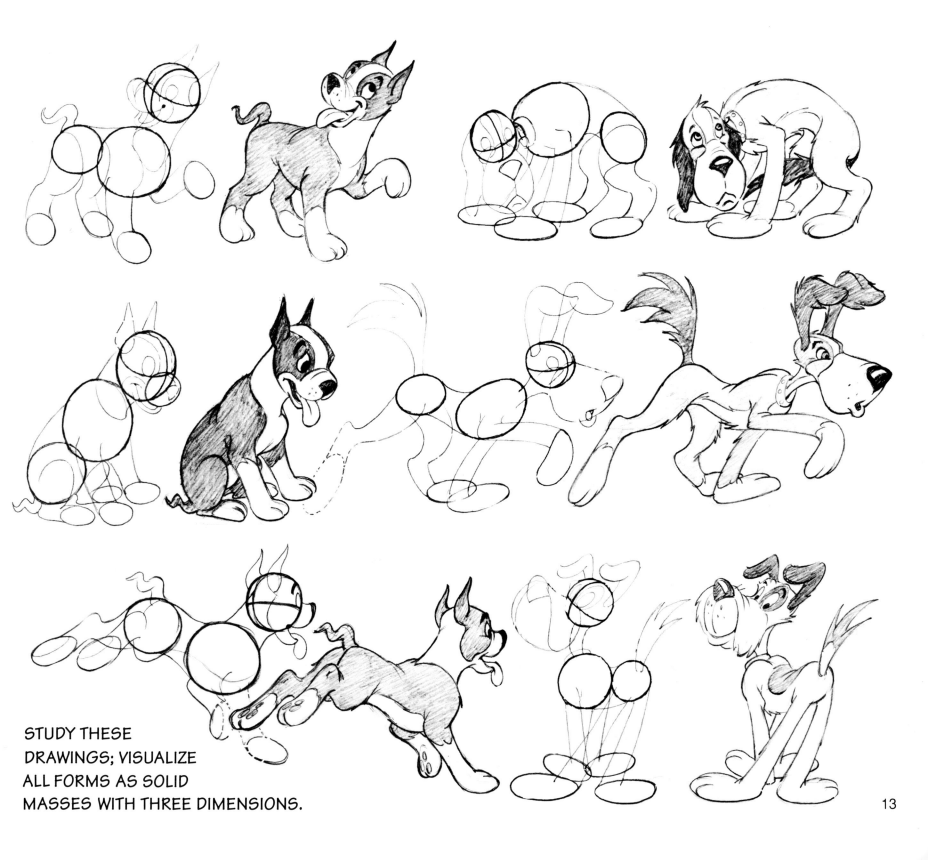

STUDY THESE
DRAWINGS; VISUALIZE
ALL FORMS AS SOLID
MASSES WITH THREE DIMENSIONS.

13

MORE CIRCULAR AND ROUNDED FORMS

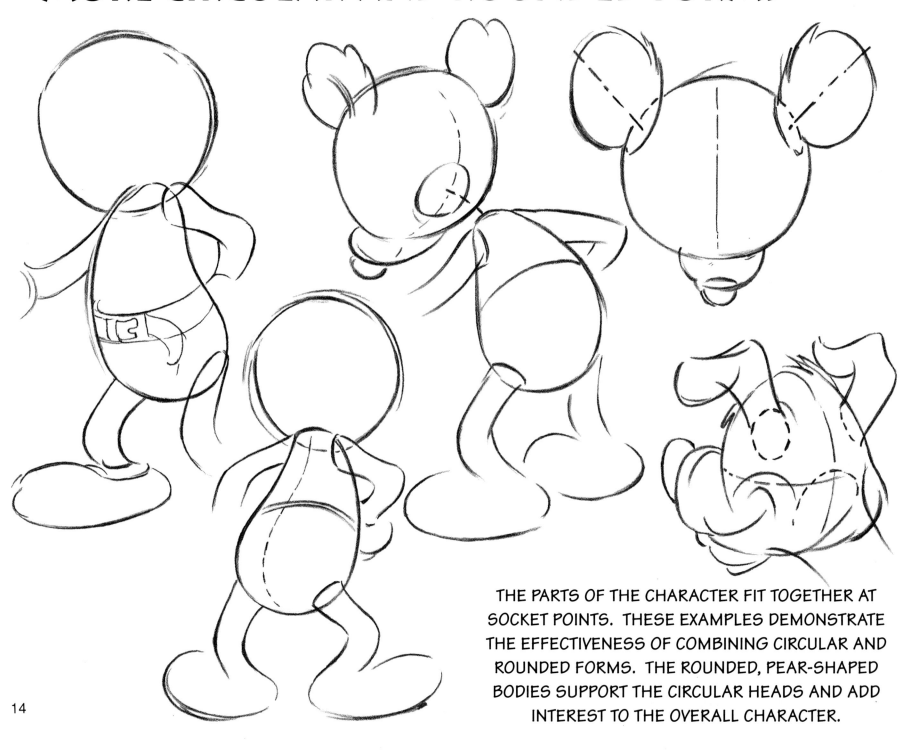

THE PARTS OF THE CHARACTER FIT TOGETHER AT SOCKET POINTS. THESE EXAMPLES DEMONSTRATE THE EFFECTIVENESS OF COMBINING CIRCULAR AND ROUNDED FORMS. THE ROUNDED, PEAR-SHAPED BODIES SUPPORT THE CIRCULAR HEADS AND ADD INTEREST TO THE OVERALL CHARACTER.

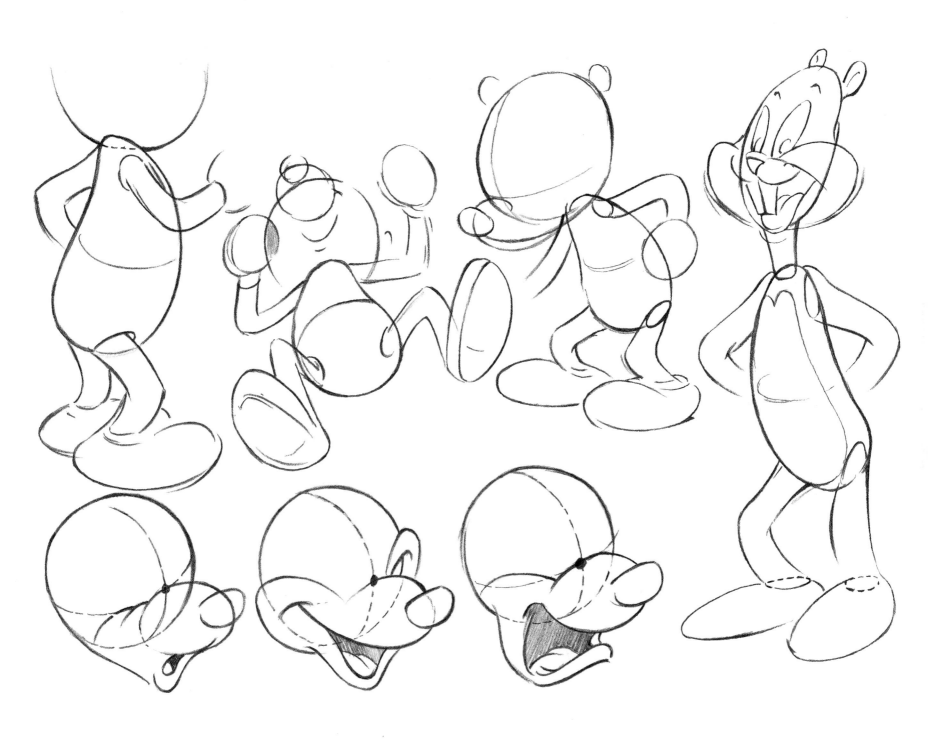

LOCATE SOCKETS ACCORDING TO PERSPECTIVE GUIDELINES.

THE SKELETON FOUNDATION

BUILD THE CARTOON FROM A ROUGH SKELETON, BUT DON'T EXPECT TO ALWAYS GET THE SKELETON RIGHT ON THE FIRST TRY—NOBODY CAN DO THAT! EXPERIMENT ... DISCARD ... MAKE SEVERAL DRAWINGS; THEN PICK THE BEST ONE. BE SURE TO WORK LOOSELY WHEN CONSTRUCTING THE CHARACTER.

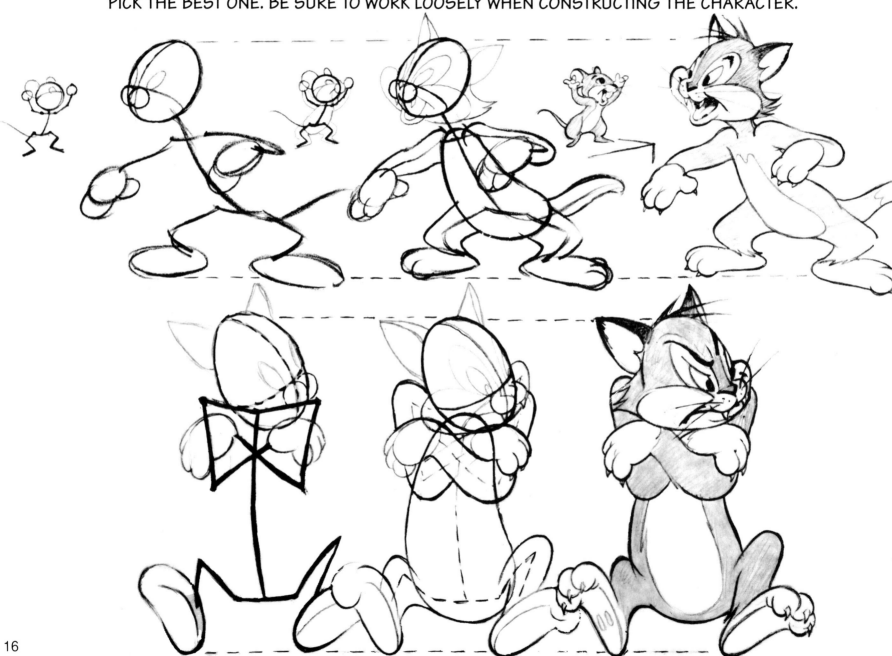

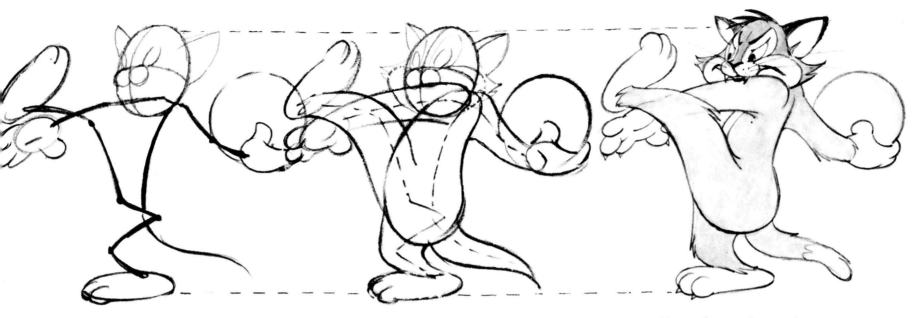

WORK OUT A SKELETON, CONSTRUCT BODY MASSES AROUND IT, AND THEN BUILD DETAILS OVER THE MASSES.

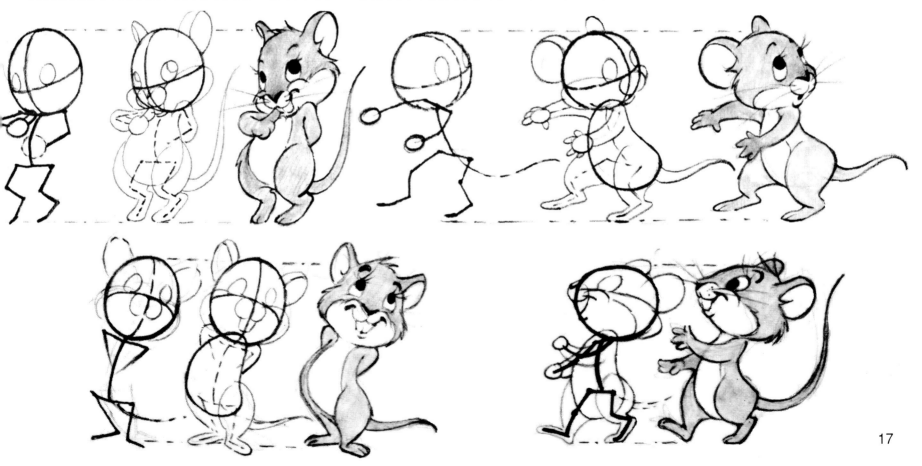

CONSTRUCTION OF THE HEAD

THINK OF THE HEAD AS A ROUNDED MASS: IT IS EITHER BALL-SHAPED, PEAR-SHAPED, OR EGG-SHAPED. IN ANIMATION THE HEAD SHAPE MAY CHANGE PERSPECTIVE AND FORM MANY TIMES DURING A SCENE. TO SIMPLIFY MATTERS, A FRAMEWORK IN PROPER PERSPECTIVE MUST BE DRAWN FIRST; THEN THE DETAILS ARE CONSTRUCTED OVER THIS FORM.

THIS CHARACTER STARTS WITH A BALL SHAPE.

DRAW AN ELLIPTICAL GUIDELINE AROUND THE FIRST SHAPE THAT WILL DIVIDE THE FACE IN THE MIDDLE LENGTHWISE. THIS DETERMINES THE TILT OF THE HEAD.

DRAW THE EYE GUIDELINE AT RIGHT ANGLES TO THE SECOND CIRCLE. THIS SETS THE FACE UP OR DOWN.

THE BASE OF THE EYES AND THE TOP OF THE NOSE TIE INTO THE EYE LINE. THE PERSPECTIVE MAKES THE LEFT EYE BIGGER THAN THE RIGHT EYE.

NOW THE DETAILS ARE DRAWN OVER THE FRAMEWORK.

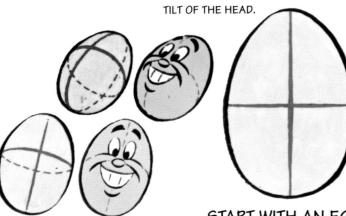 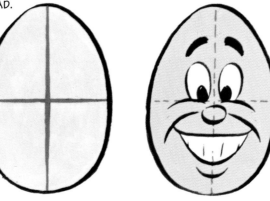 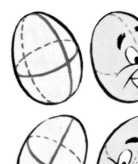 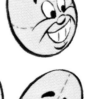 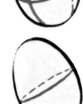 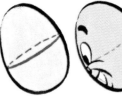

START WITH AN EGG SHAPE, DRAW GUIDELINES AROUND IT, AND THEN DRAW THE FACE. TURN THE EGG IN VARIOUS POSITIONS AND DRAW THE SAME FACE. ANIMATION PRESENTS THE SAME CHALLENGE!

ADD A FEW DETAILS AND DRAW THESE HEADS IN EVERY POSITION USING THE EGG AS A GUIDE. CARTOON STUDIOS OFTEN MAKE SMALL CLAY MODELS TO HELP THE ANIMATOR DRAW DIFFICULT CHARACTERS FROM DIFFERENT ANGLES.

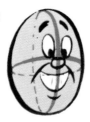

EGGHEAD MODEL METHOD

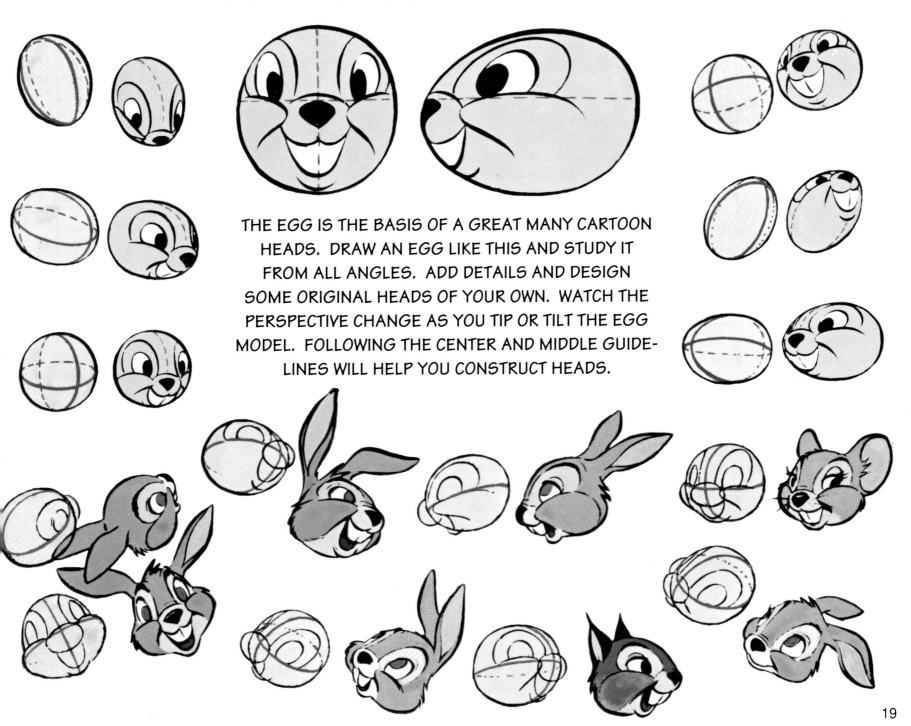

THE EGG IS THE BASIS OF A GREAT MANY CARTOON HEADS. DRAW AN EGG LIKE THIS AND STUDY IT FROM ALL ANGLES. ADD DETAILS AND DESIGN SOME ORIGINAL HEADS OF YOUR OWN. WATCH THE PERSPECTIVE CHANGE AS YOU TIP OR TILT THE EGG MODEL. FOLLOWING THE CENTER AND MIDDLE GUIDE-LINES WILL HELP YOU CONSTRUCT HEADS.

MORE HEAD CONSTRUCTION

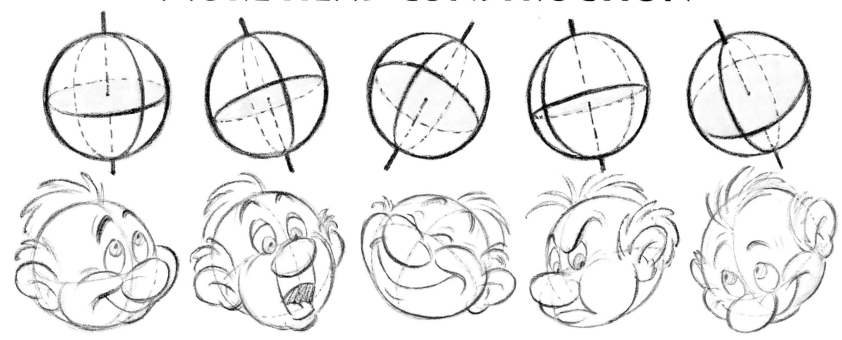

HEAD CONSTRUCTION—THE CRANIUM MASS CAN BE BALL-, OVAL-, OR PEAR-SHAPED, DEPENDING ON THE CHARACTER. THE HORIZONTAL GUIDELINE CAN CIRCLE THE CENTER, UPPER, OR LOWER PART OF THIS MASS. THE EYES FIT ABOVE THE LINE; THE NOSE AREA FITS BELOW. THESE FEATURES REMAIN FIXED TO THE HEAD AS PART OF THE CRANIUM MASS.

TILT—DRAW THE VERTICAL AND HORIZONTAL GUIDELINES AROUND THE HEAD MASS. THESE LINES SET THE PERSPECTIVE TILT OF THE HEAD, WHICH IS THE BASIS OF MANY EXPRESSIONS. THE TILT CHANGES CONSTANTLY, ESPECIALLY IN IMPORTANT DIALOGUE SCENES. ANCHOR THE EYES, THE NOSE, AND THE EARS TO THESE GUIDELINES.

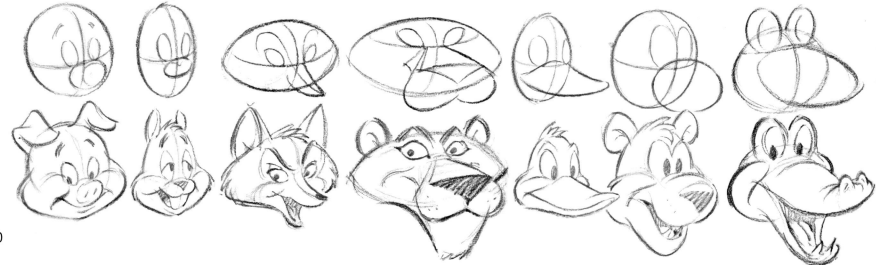

FLEXIBLE FEATURES—THE MOUTH AND CHEEK MASSES ARE VERY FLEXIBLE, AND, AS THE JAW MOVES, THEY TAKE ON MANY DIFFERENT SHAPES, CREATING VARIOUS EXPRESSIONS AND MOUTH POSITIONS IN SPEECH. THE EYEBROWS AND THE EARS ARE ALSO FLEXIBLE, BUT THE BASE OF THE EARS AND THE NOSE REMAIN FIXED TO THE HEAD. THE EYES ARE FLEXIBLE WITHIN FIXED SOCKETS.

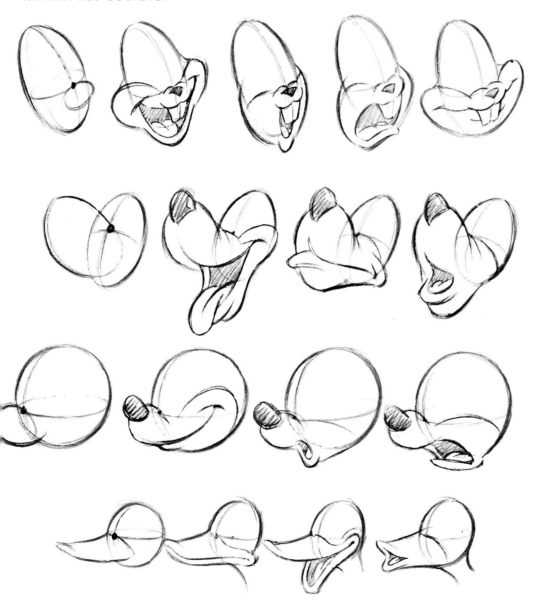
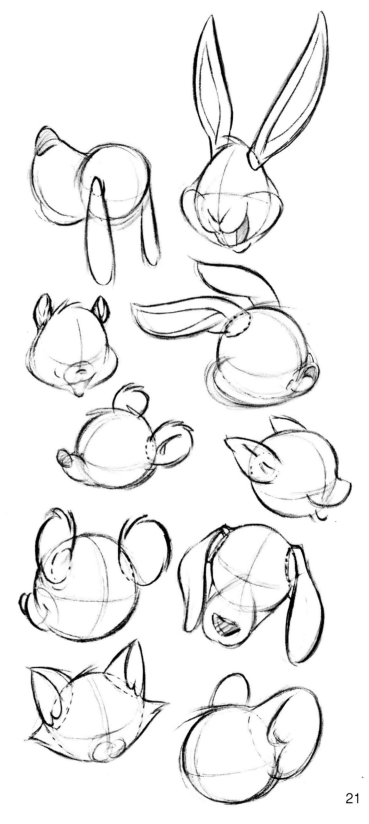

MORE HEAD CONSTRUCTION

ALL ANIMATED CARTOON CHARACTERS CAN BE REDUCED TO A BASIC FORMULA. THIS FORMULA MAKES THEM EASIER TO MASTER AND ENSURES UNIFORMITY THROUGHOUT A FILM, EVEN IF SEVERAL DIFFERENT ARTISTS WORK ON THE SAME CHARACTER.

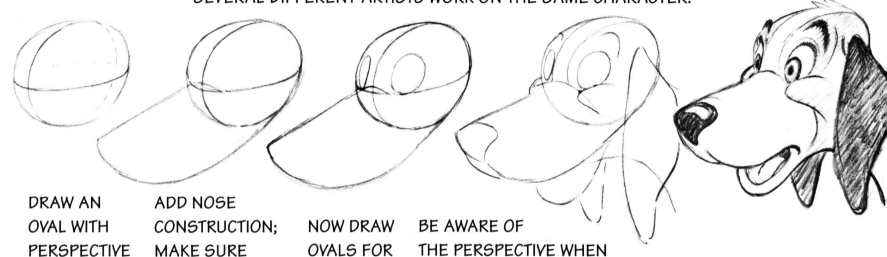

DRAW AN OVAL WITH PERSPECTIVE GUIDELINES.

ADD NOSE CONSTRUCTION; MAKE SURE IT FITS SOLIDLY.

NOW DRAW OVALS FOR THE EYES.

BE AWARE OF THE PERSPECTIVE WHEN CONSTRUCTING THE REMAINING DETAILS.

STUDY THIS BASIC FORMULA; THEN DRAW THE DOG IN DIFFERENT POSITIONS.

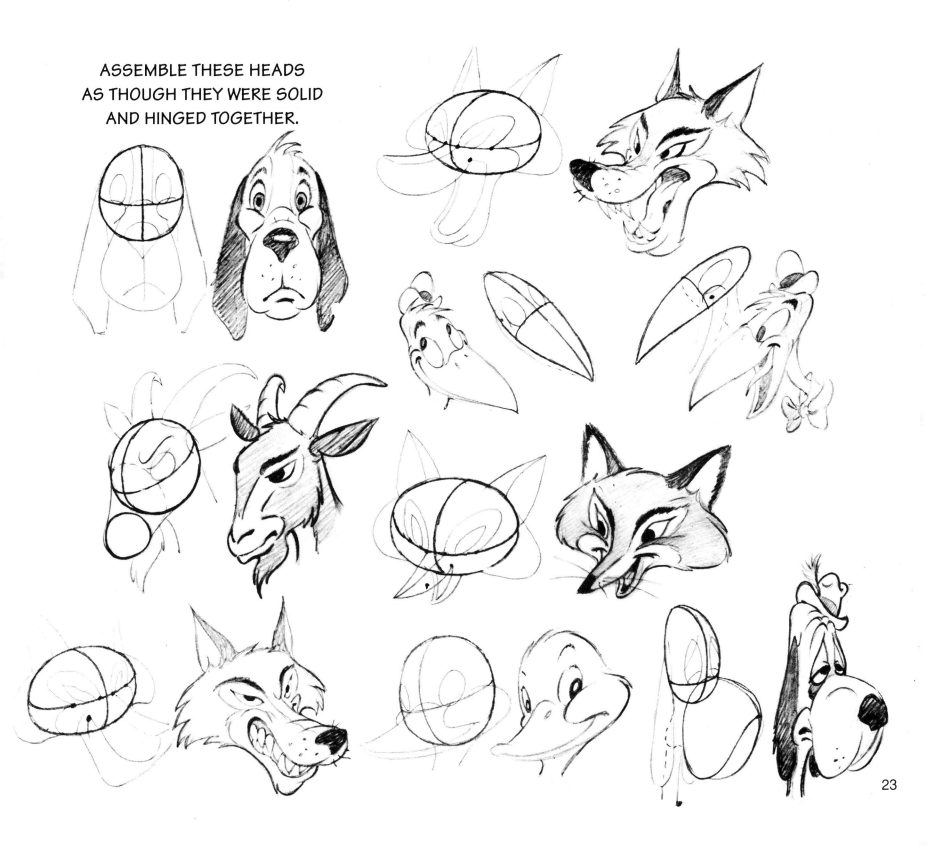

ASSEMBLE THESE HEADS
AS THOUGH THEY WERE SOLID
AND HINGED TOGETHER.

23

FACIAL EXPRESSIONS

THE JOB OF AN ANIMATOR IS THE SAME AS THE JOB OF AN ACTOR IN LIVE ACTION PICTURES. BOTH SHOULD BE MASTERS OF PORTRAYING EMOTIONS. STUDYING YOUR OWN GRIMACES IN A MIRROR IS A MUST. PICK A CHARACTER YOU KNOW AND GO THROUGH THE EXPRESSIONS WITH HIM, AS I HAVE HERE WITH THIS LITTLE PUP.

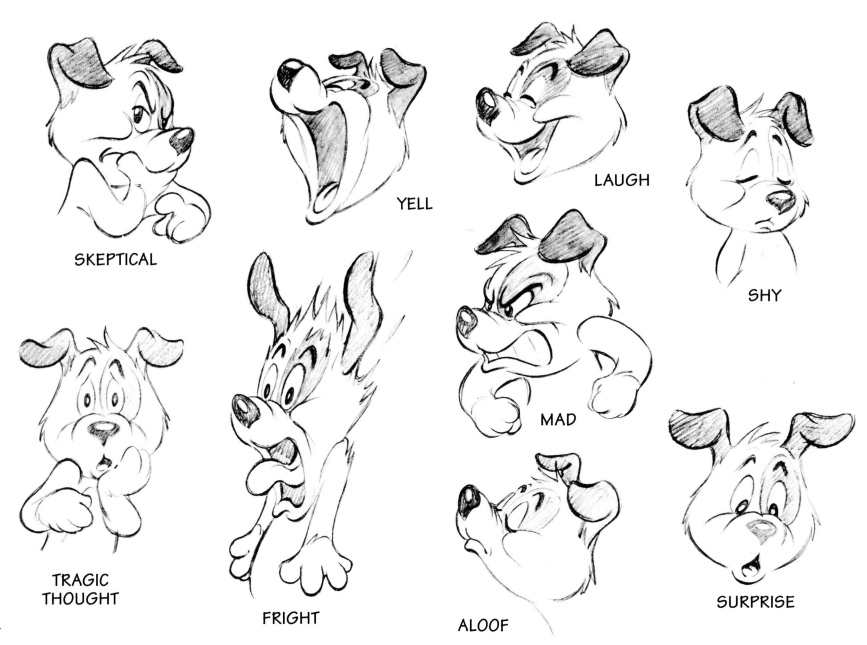

SKEPTICAL

YELL

LAUGH

SHY

TRAGIC
THOUGHT

FRIGHT

MAD

ALOOF

SURPRISE

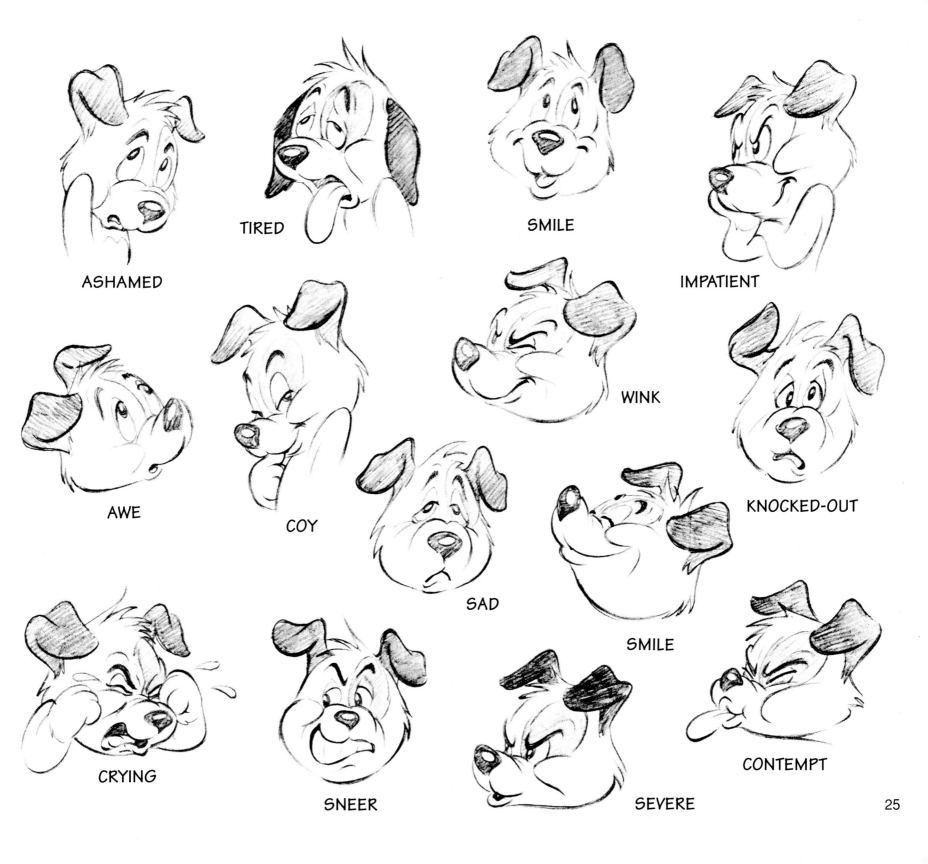

ASHAMED

TIRED

SMILE

IMPATIENT

AWE

COY

WINK

KNOCKED-OUT

SAD

SMILE

CRYING

SNEER

SEVERE

CONTEMPT

25

STRETCH AND SQUASH ON HEADS

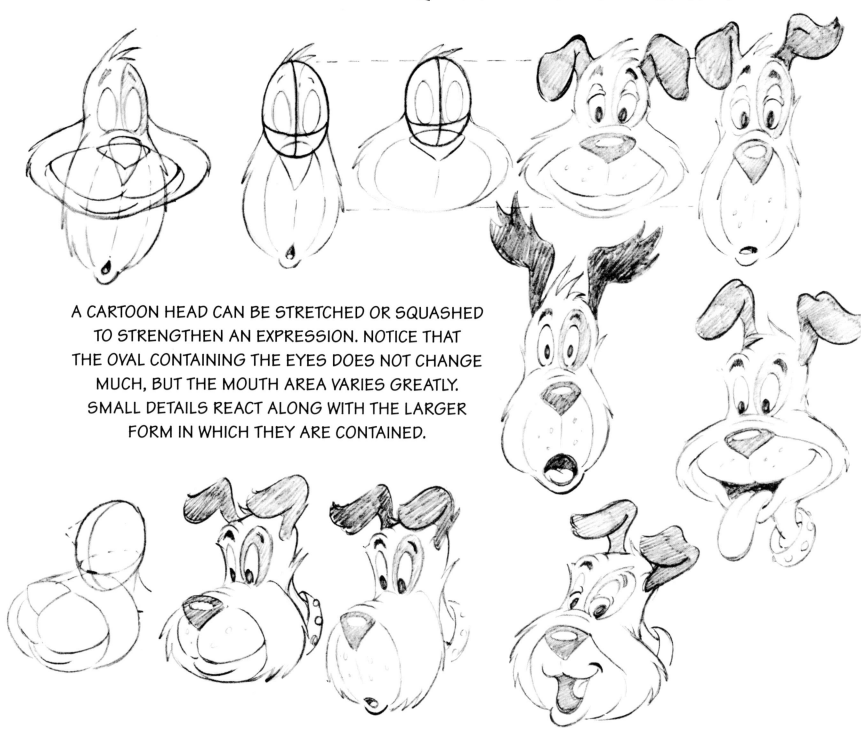

A CARTOON HEAD CAN BE STRETCHED OR SQUASHED
TO STRENGTHEN AN EXPRESSION. NOTICE THAT
THE OVAL CONTAINING THE EYES DOES NOT CHANGE
MUCH, BUT THE MOUTH AREA VARIES GREATLY.
SMALL DETAILS REACT ALONG WITH THE LARGER
FORM IN WHICH THEY ARE CONTAINED.

THE WIDE VARIETY OF EXPRESSIONS SHOWN HERE
IS THE RESULT OF STRETCHING AND SQUASHING
SELECTED AREAS OF THE FACE. NOTICE THAT THE
EYES REFLECT THE EXPRESSION OF EACH
STRETCH AND SQUASH.

SHOCKED

LIGHTHEARTED

PLEASED

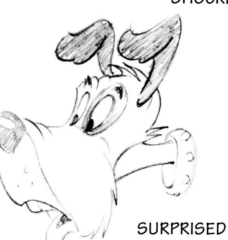

SURPRISED

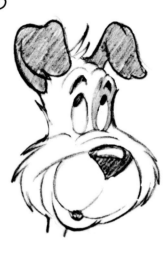

CONTEMPLATIVE

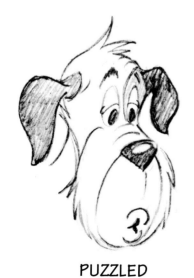

PUZZLED

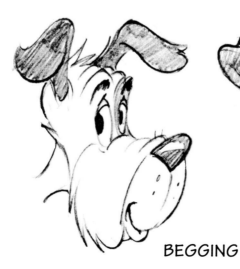

BEGGING

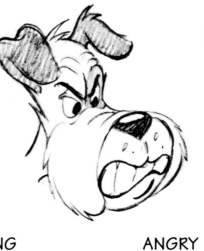

ANGRY

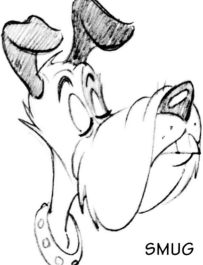

SMUG

HANDS

CARTOON HANDS ARE TRICKY TO DRAW. STUDY THE HANDS SHOWN BELOW AND AT THE RIGHT.
THE FINGERS SHOULD BE PLACED UNEVENLY TO PREVENT A MONOTONOUS QUALITY.

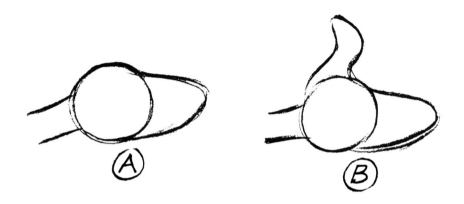

TO DRAW THE HAND, BEGIN AS IF IT WERE A MITTEN (A AND B);
THEN ADD THE TWO MIDDLE FINGERS BY FOLLOWING THIS SHAPE (C).

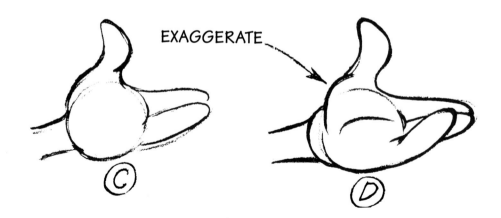

EXAGGERATE

NOW PUT IN THE LITTLE FINGER, VARYING ITS POSITION TO PREVENT MONOTONY (D).
IT IS ALSO A GOOD IDEA TO EXAGGERATE THE BASE OF THE THUMB.

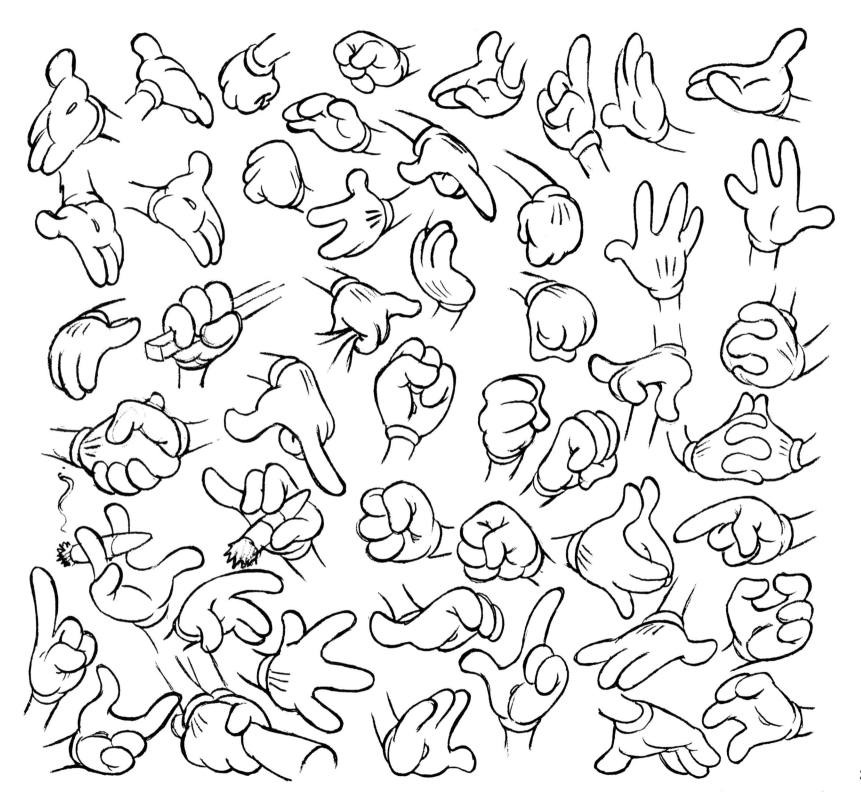

MORE HANDS

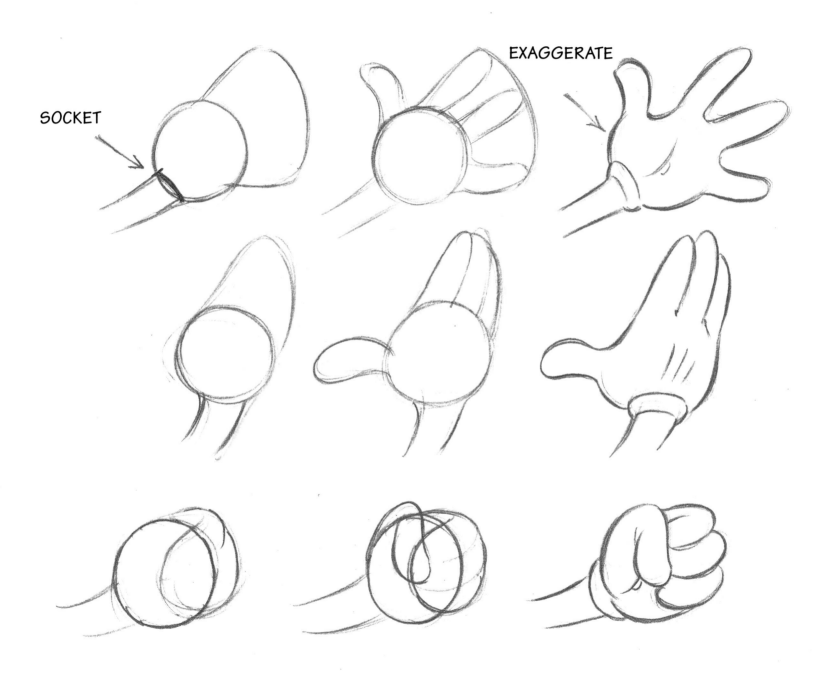

SOCKET

EXAGGERATE

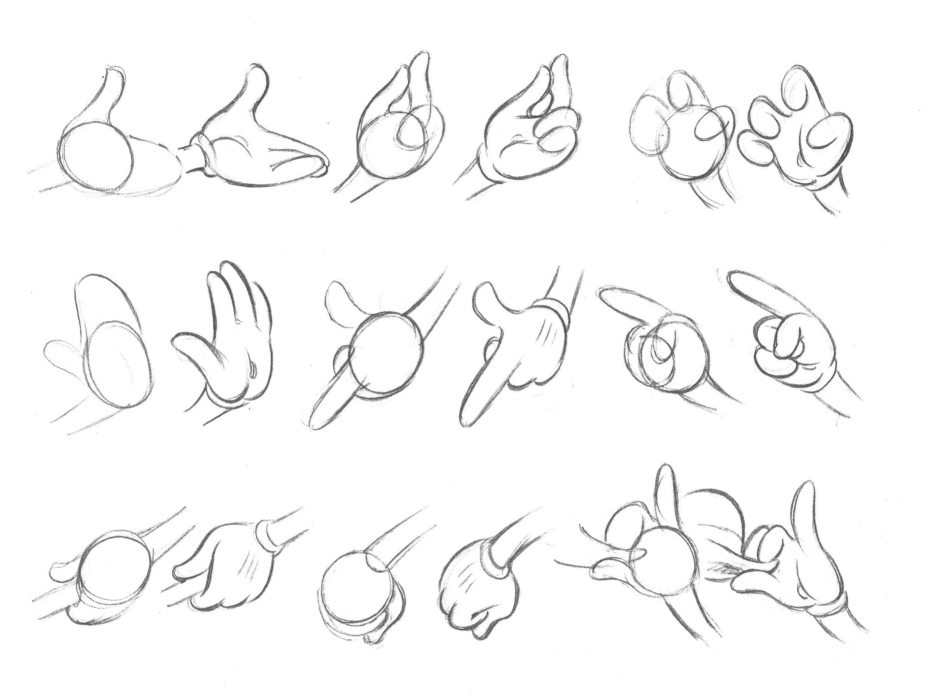

DRAW YOUR OWN HANDS (SIMPLIFIED) FROM A MIRROR.
THIS WAY THEY APPEAR AS THEY DO IN A DRAWING.

THE CUTE CHARACTER

"CUTENESS" IS BASED ON THE BASIC PROPORTIONS OF A BABY AND THE EXPRESSIONS OF SHYNESS OR COYNESS.

THE EARS ARE SMALL IN RELATION TO ADULT SIZE.

THERE IS NO NECK; THE HEAD ATTACHES DIRECTLY TO THE BODY.

THE BODY IS PEAR-SHAPED AND ELONGATED.

THE BACK IS SWAYED; THE LINE CONTINUES UP THE BACK OF THE HEAD AND DOWN INTO THE FANNY.

THE FANNY PROTRUDES; IT NEVER BULGES, BUT FITS INTO THE LEG LINES AND BASE OF THE BODY.

THE HEAD IS LARGE IN RELATION TO THE BODY.

A HIGH FOREHEAD IS VERY IMPORTANT.

THE EYES ARE SPACED LOW ON THE HEAD; THEY ARE USUALLY LARGE AND WIDE-SET.

THE NOSE AND THE MOUTH ARE ALWAYS SMALL.

THE ARMS ARE SHORT—NEVER SKINNY—AND TAPER DOWN TO THE HAND AND TINY FINGERS.

THE TUMMY BULGES; THE CHARACTER SHOULD LOOK WELL-FED.

THE LEGS ARE SHORT AND FAT, AND THEY TAPER DOWN INTO SMALL FEET FOR THE TYPE.

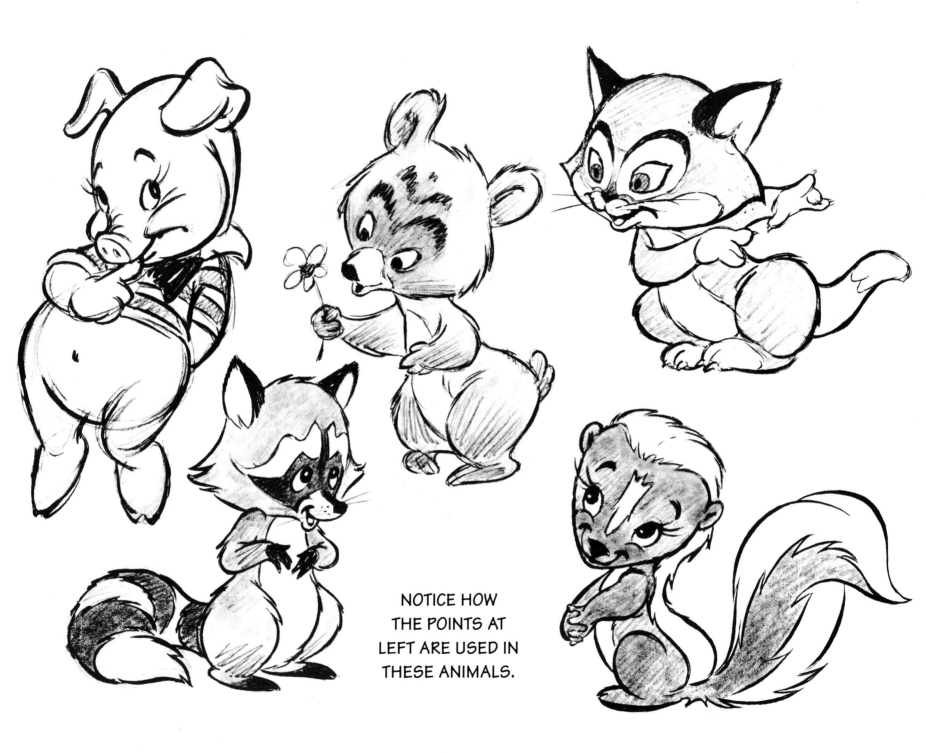

NOTICE HOW
THE POINTS AT
LEFT ARE USED IN
THESE ANIMALS.

CUTE KITTEN

1. DEVELOP THE KITTEN'S BODY WITH A CIRCLE AND AN OVAL.
2. ADD PERSPECTIVE GUIDELINES.
3. PLACE THE EYES AND THE NOSE.
4. BUILD THE EARS AND THE LEGS.
5. ADD THE DETAILS TO COMPLETE THE KITTEN.

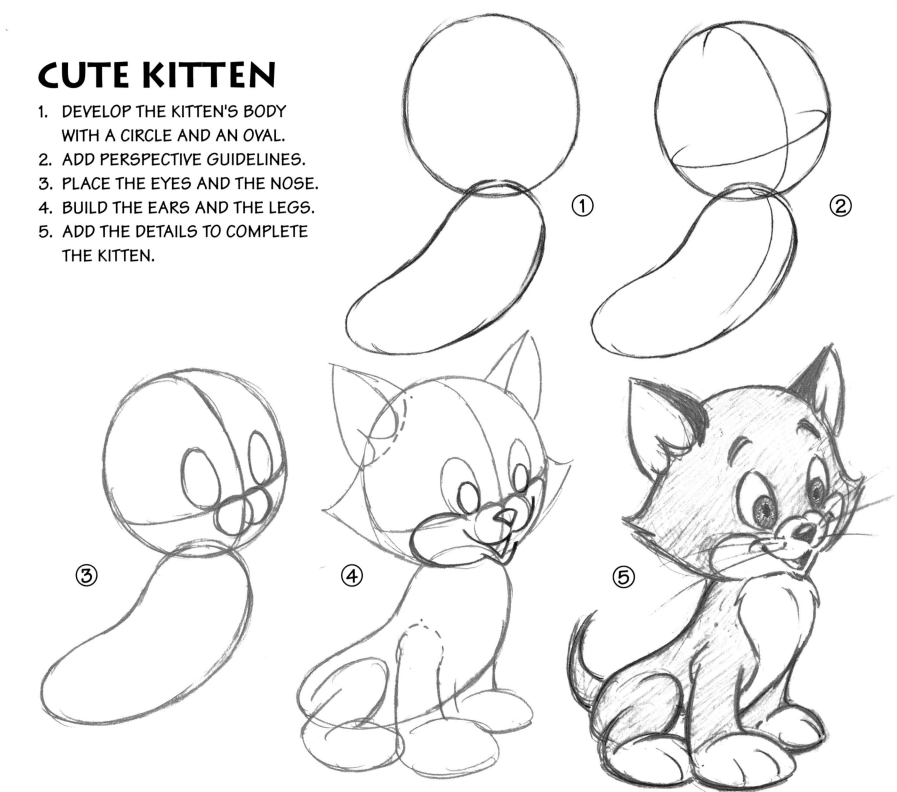

NOTICE THE LARGE PAWS THAT ADD TO THE CUTE LOOK.

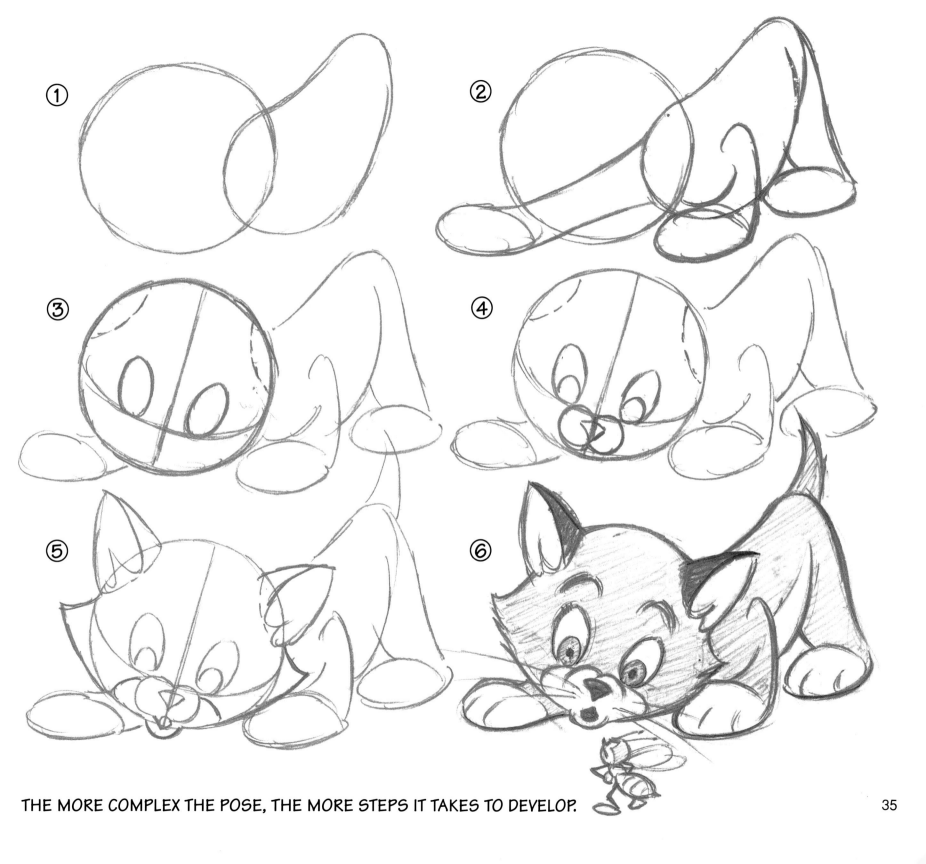

THE MORE COMPLEX THE POSE, THE MORE STEPS IT TAKES TO DEVELOP.

CUTE PUP
BEGIN WITH A BASIC CONSTRUCTION OF CIRCLES AND OVALS.
THEN DRAW PERSPECTIVE GUIDELINES TO PLACE THE FEATURES.

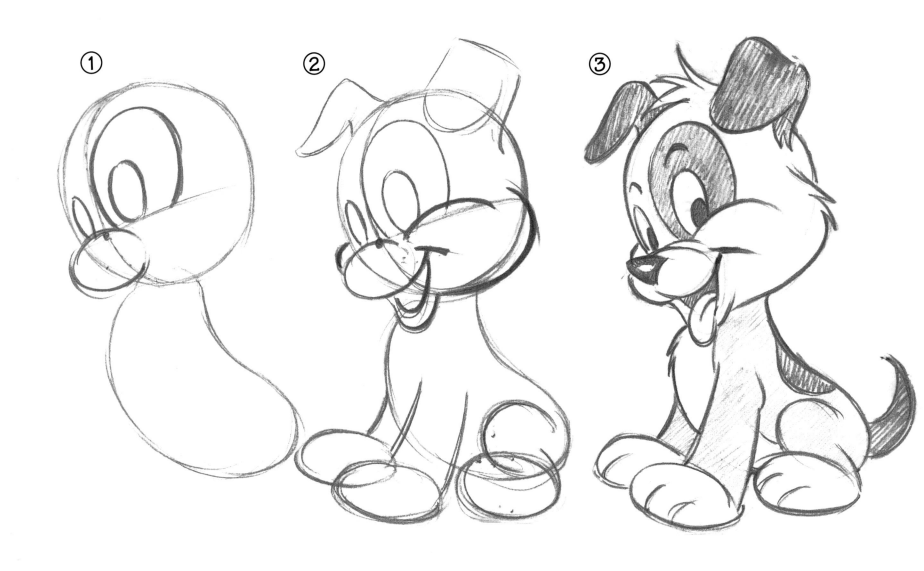

NOTICE THAT THE TONGUE ACCENTUATES THE HAPPY EXPRESSION OF THE MOUTH,
AND THE CHEEKS OVERLAP THE EYES, ACCENTING THE EXPRESSION.
A SIDEWAYS GLANCE LIKE THIS IS A "CUTE" EXPRESSION.

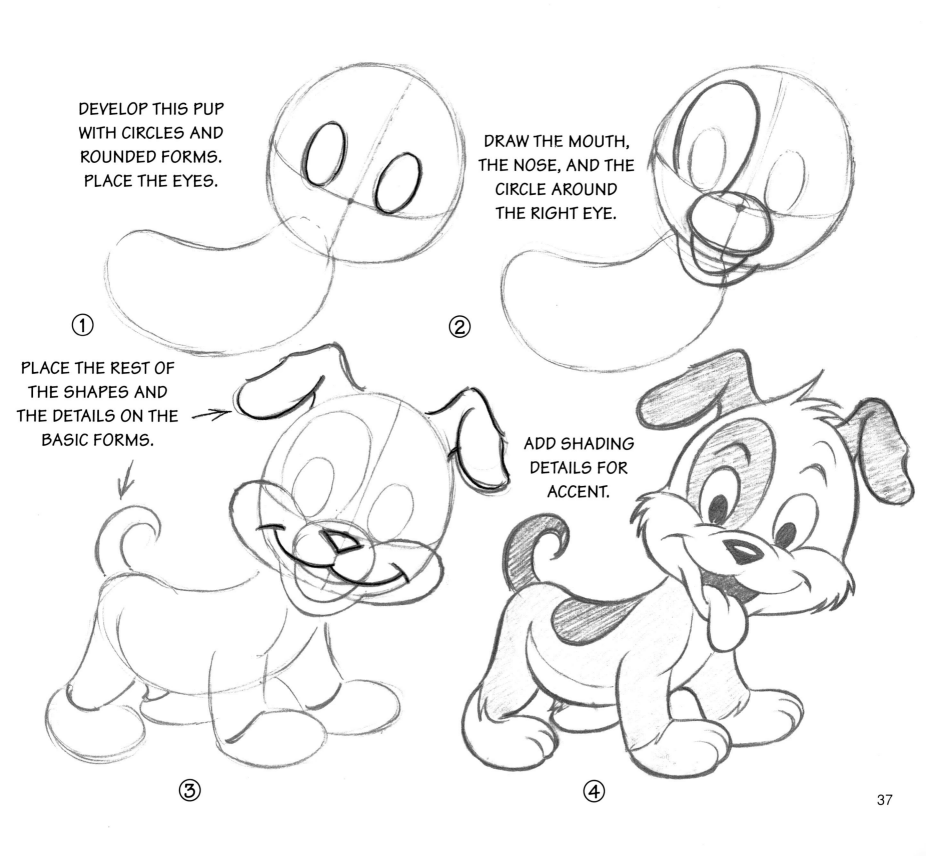

DEVELOP THIS PUP WITH CIRCLES AND ROUNDED FORMS. PLACE THE EYES.

①

DRAW THE MOUTH, THE NOSE, AND THE CIRCLE AROUND THE RIGHT EYE.

②

PLACE THE REST OF THE SHAPES AND THE DETAILS ON THE BASIC FORMS.

③

ADD SHADING DETAILS FOR ACCENT.

④

37

GOOSE GANDER

THESE ARE THE PROGRESSIVE STEPS THAT ARE TAKEN BY AN ANIMATOR ...

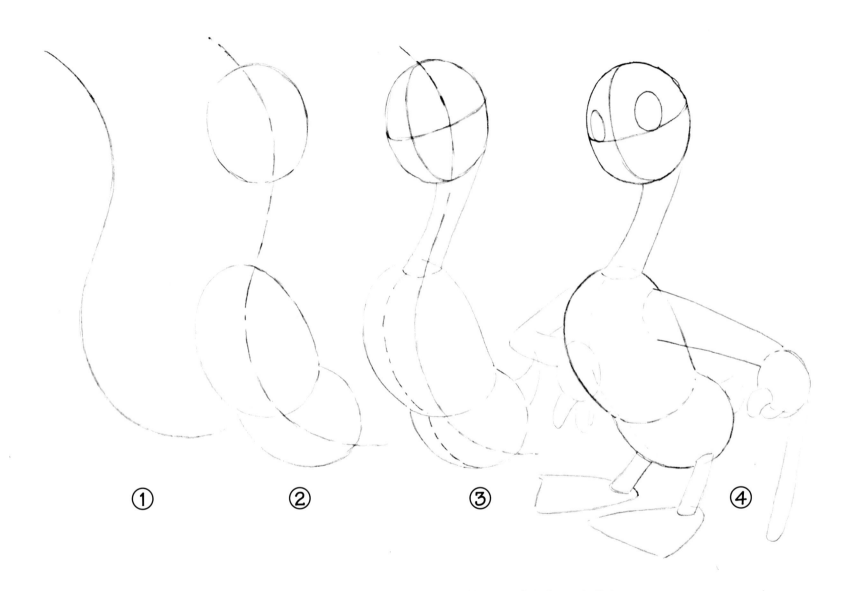

① ② ③ ④

1. DRAW A "LINE OF ACTION" TO ESTABLISH THE GENERAL STANCE OF THE FIGURE.
2. ADD ROUNDED MASSES FOR THE HEAD AND THE BODY.
3. DRAW PERSPECTIVE LINES AROUND THESE MASSES TO ESTABLISH THE FRONT, SIDE, AND TILT OF THE BODY AND HEAD.

... TO CONSTRUCT AND DRAW A CARTOON CHARACTER.

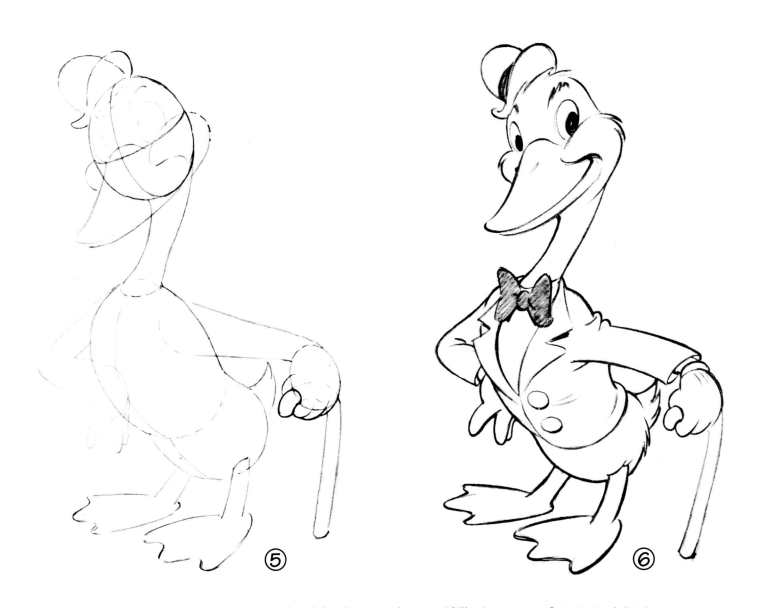

⑤

⑥

4. CONSTRUCT THE ARMS, LEGS, AND EYES ON (OR "ANCHORED TO") THEIR PROPER PLACES
 ON THE PERSPECTIVE LINES.
5. FIT OR "HINGE" THE DETAILS INTO THEIR POSITIONS.
6. CLEAN UP THE CHARACTER AROUND THE CONSTRUCTION LINES.

ROWDY RABBIT

WHEN CONSTRUCTING AN ANIMATED CHARACTER,
VISUALIZE IT AS A THREE-DIMENSIONAL PUPPET THAT
YOU ARE JOINING TOGETHER WITH SOLID MASSES.

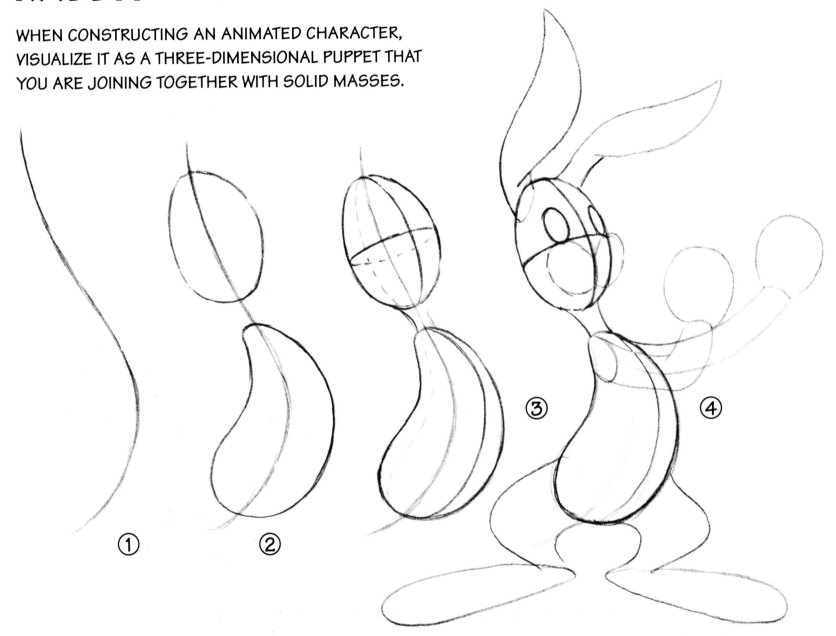

① ② ③ ④

EACH PART HAS A DEFINITE PLACE ACCORDING TO THE FORMULA.

... USE PERSPECTIVE GUIDELINES TO ASSEMBLE THE SOLID PARTS.

BUILD "PUPPET PARTS"
WHEN CONSTRUCTING A
CHARACTER FOR
ANIMATION.

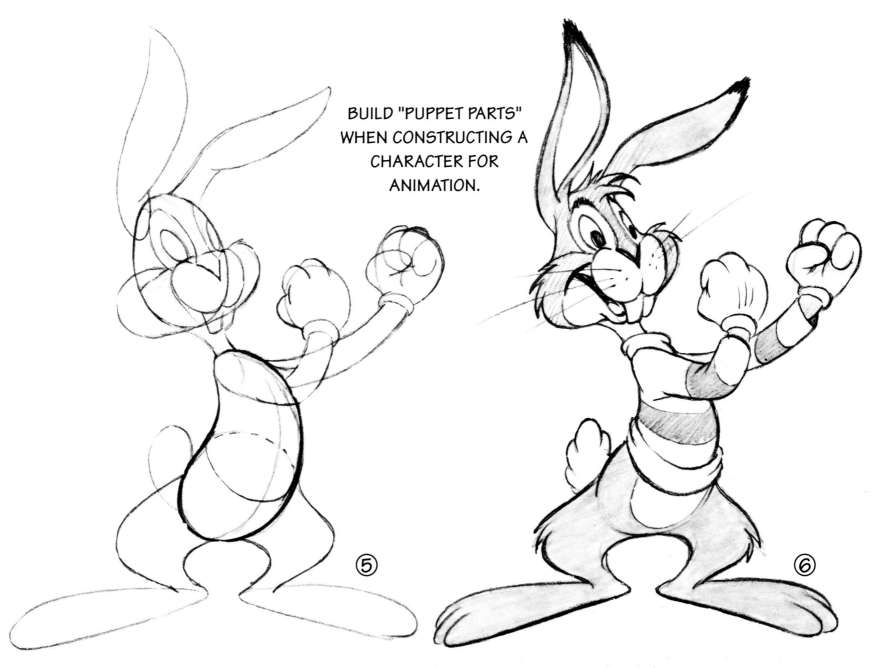

⑤

⑥

THE PARTS JOIN ACCORDING TO A FORMULA PLAN.

LITTLE WOLF-HUNTER PIG

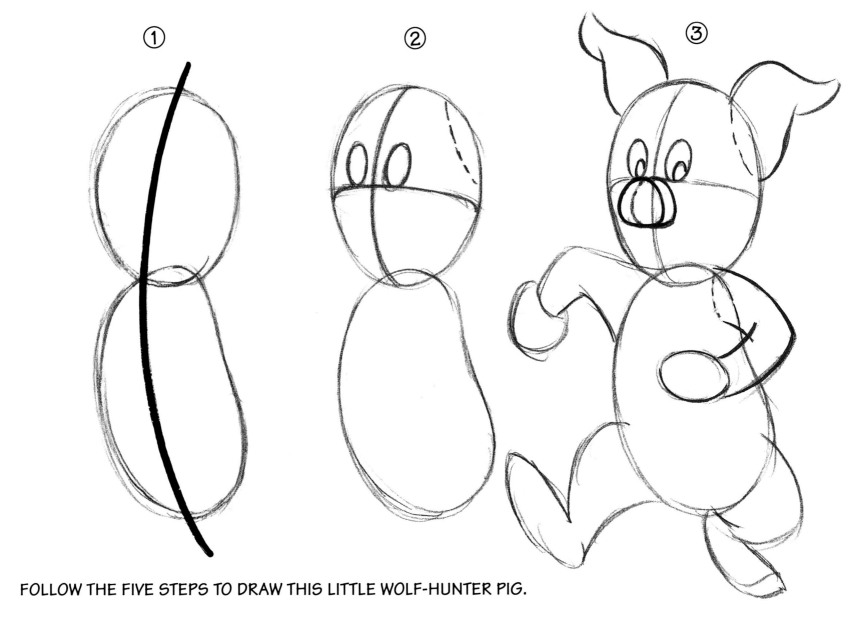

FOLLOW THE FIVE STEPS TO DRAW THIS LITTLE WOLF-HUNTER PIG.

1. DRAW A LINE OF ACTION, AND THEN BUILD THE OVAL BODY AND THE ROUND HEAD OVER IT.
2. ADD PERSPECTIVE GUIDELINES AND PLACE THE EYES.
3. SET THE SHOULDER, ARM, HAND, AND EAR SOCKETS. DRAW THE NOSE.

42

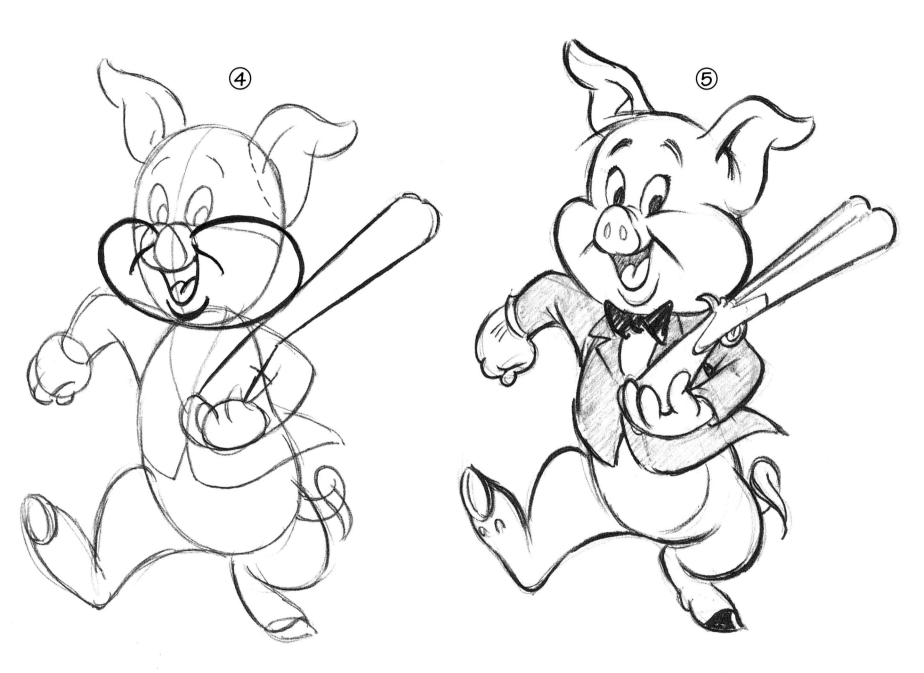

4. NOW BUILD THE FEATURES—EARS, CHEEKS, MOUTH, ETC. FIT ON THE COAT AND THE GUN.
5. USE AN ANIMATION BOARD TO MAKE A "CLEANUP" DRAWING BY PLACING A CLEAN PIECE OF PAPER OVER STEP 4 AND TRACING.

CUTE RABBIT

ANIMATORS USUALLY DRAW WITH A
SCRIPTO PENCIL WITH A NO. 2 LEAD.
THEN A KNEADED ERASER IS LIGHTLY ...

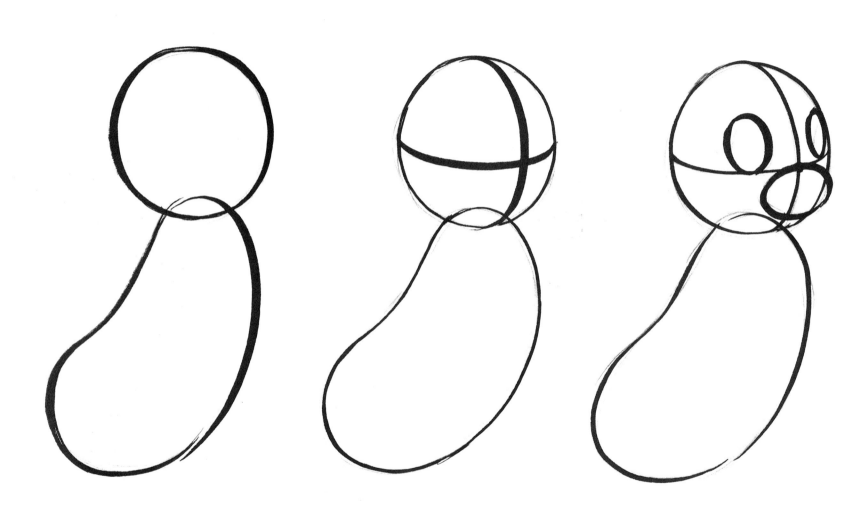

①

DRAW A CIRCLE
FOR THE HEAD AND
A PEAR SHAPE
FOR THE BODY.

②

ADD PERSPECTIVE
GUIDELINES
AROUND
THE HEAD.

③

THE EYES ARE PLACED ABOVE
THE HORIZONTAL GUIDELINE.
THE NOSE STARTS WHERE
THE GUIDELINES CROSS.

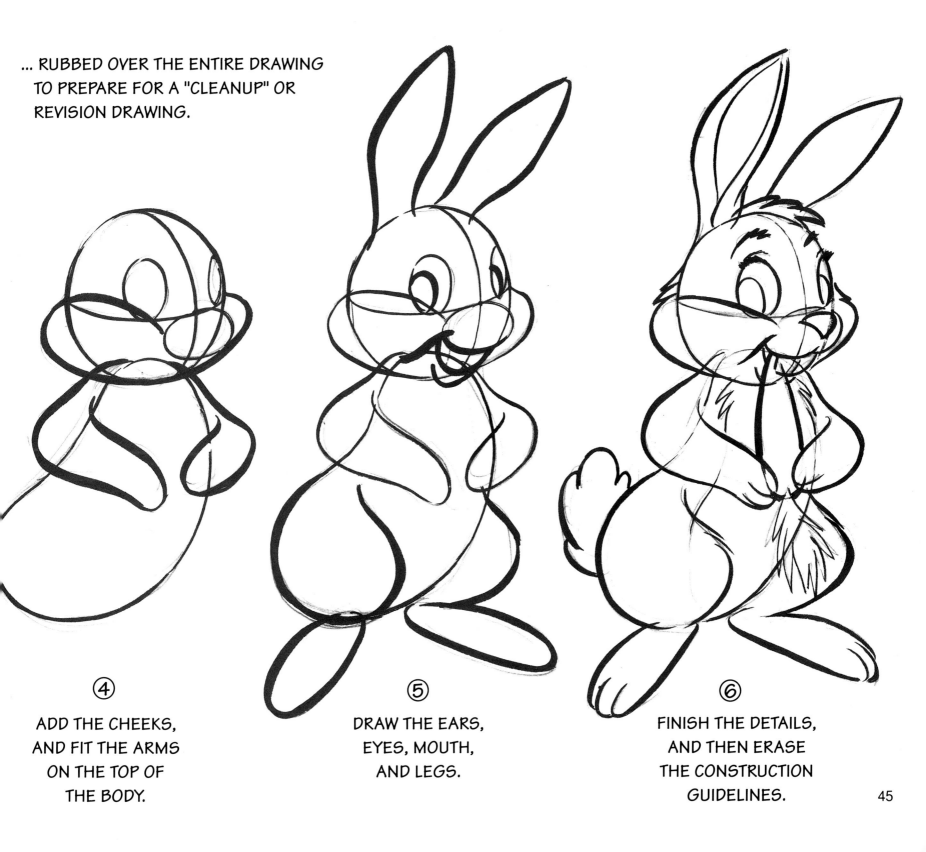

... RUBBED OVER THE ENTIRE DRAWING
TO PREPARE FOR A "CLEANUP" OR
REVISION DRAWING.

④

ADD THE CHEEKS,
AND FIT THE ARMS
ON THE TOP OF
THE BODY.

⑤

DRAW THE EARS,
EYES, MOUTH,
AND LEGS.

⑥

FINISH THE DETAILS,
AND THEN ERASE
THE CONSTRUCTION
GUIDELINES.

45

SQUIRRELS

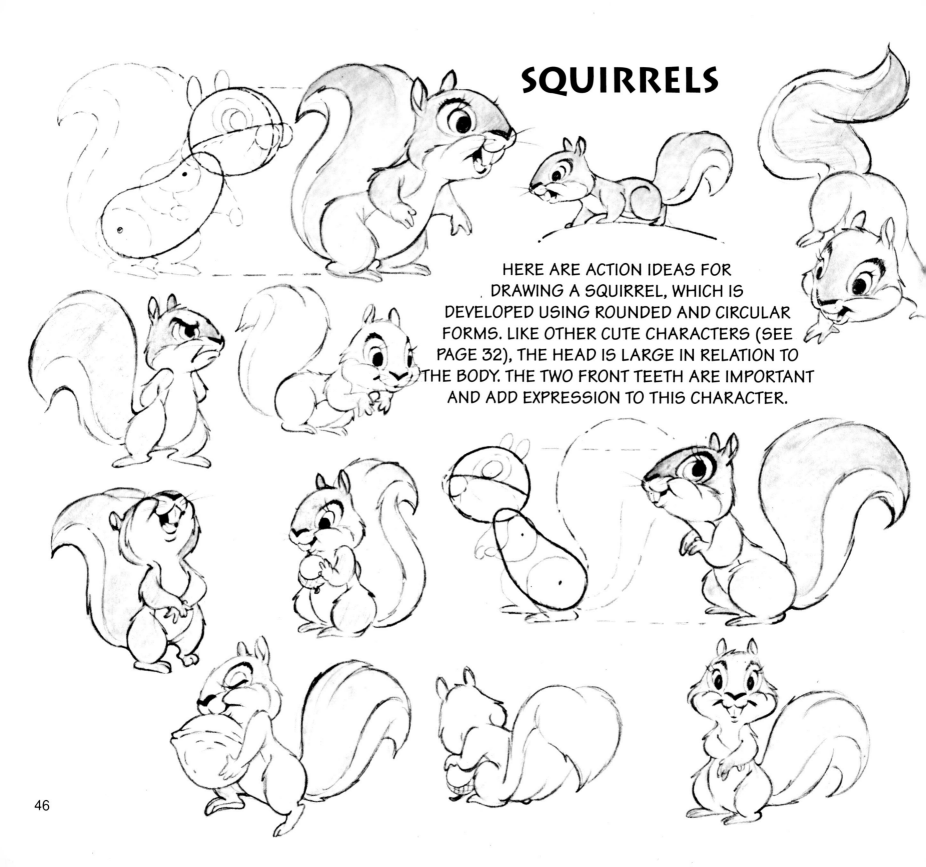

HERE ARE ACTION IDEAS FOR DRAWING A SQUIRREL, WHICH IS DEVELOPED USING ROUNDED AND CIRCULAR FORMS. LIKE OTHER CUTE CHARACTERS (SEE PAGE 32), THE HEAD IS LARGE IN RELATION TO THE BODY. THE TWO FRONT TEETH ARE IMPORTANT AND ADD EXPRESSION TO THIS CHARACTER.

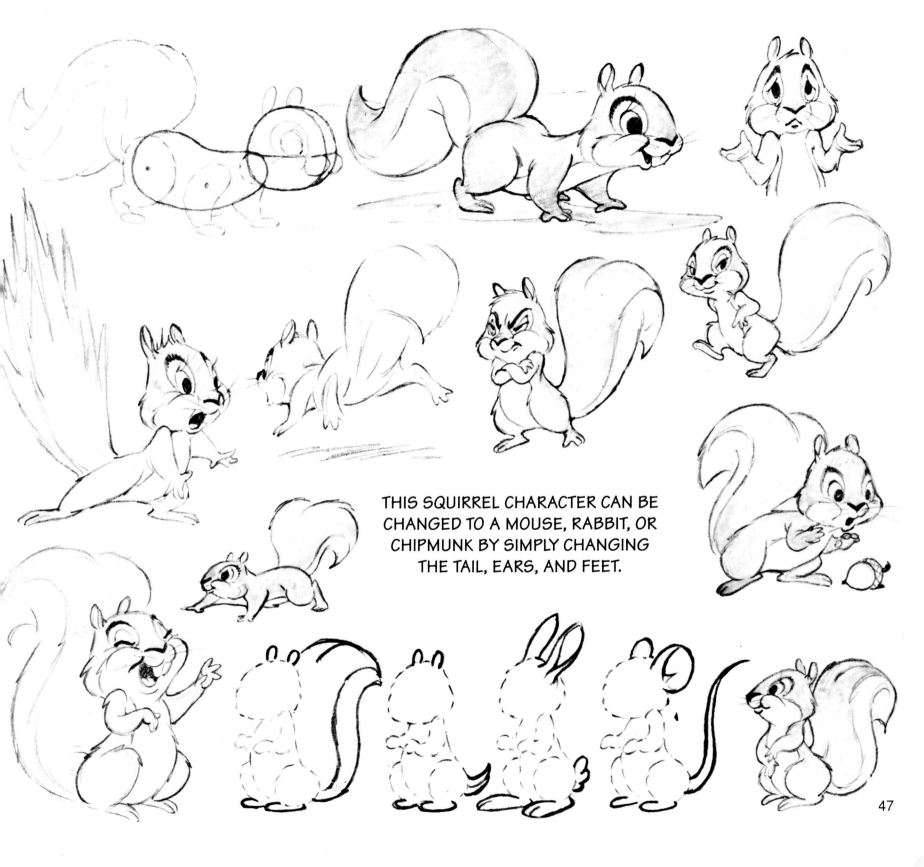

THIS SQUIRREL CHARACTER CAN BE CHANGED TO A MOUSE, RABBIT, OR CHIPMUNK BY SIMPLY CHANGING THE TAIL, EARS, AND FEET.

47

MORE
CUTE
CHARACTERS

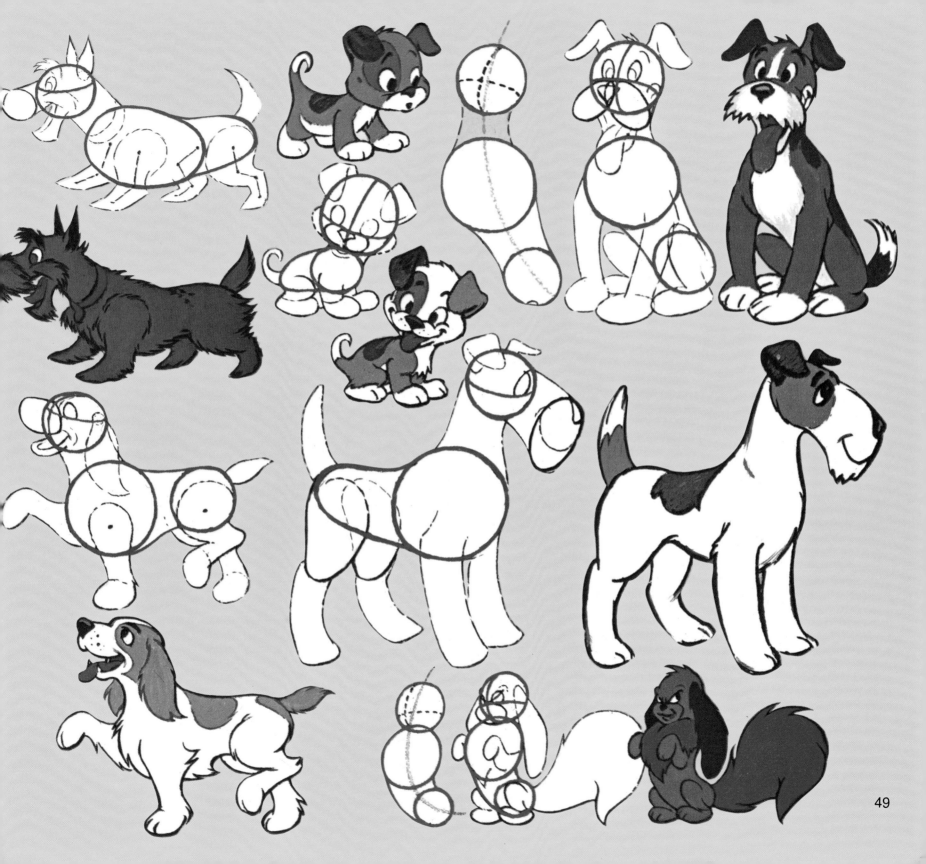

49

THE SCREWBALL TYPE

IN THIS FORMULA YOU WILL RECOGNIZE SOME FEATURES THAT ALL THESE COCKY WISE GUYS HAVE IN COMMON.

ELONGATED HEAD (NOT TOO BIG)

SKINNY NECK

EXAGGERATED FEATURES

PEAR-SHAPED BODY

LOW FOREHEAD

BIG FEET

LITTLE OR SKINNY LEGS

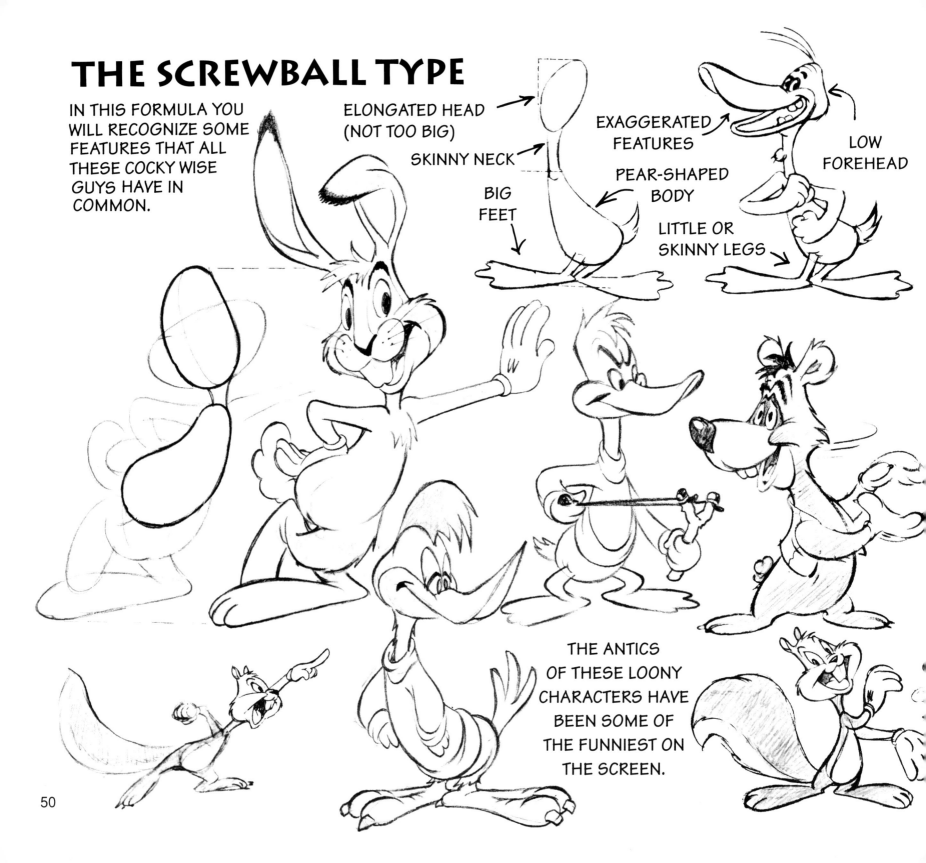

THE ANTICS OF THESE LOONY CHARACTERS HAVE BEEN SOME OF THE FUNNIEST ON THE SCREEN.

GOOFY CHARACTERS

HERE IS THE BASIC FORMULA FOR GOOFY TYPES
THAT ACT LIKE A "SIMPLE SIMON" CLODHOPPER:

LONG, SKINNY NECK

HUMPBACKED AND STOOP-SHOULDERED

LONG, DROOPY ARMS WITH BIG HANDS

OVERHANGING FANNY

PANTS LOW, LOOSE, AND BAGGY

ENORMOUS,
CLUMSY FEET

SMALL HEAD HELD FORWARD

HAIR HANGS OVER EYES

DROOPY, HALF-AWAKE EYES

BIG BEAK OR NOSE

BUCKED TEETH

ABSOLUTELY NO CHIN
(THIS IS IMPORTANT!)

BOBBING ADAM'S APPLE

BIG STOMACH PROTRUDES

LOW CROTCH IN PANTS

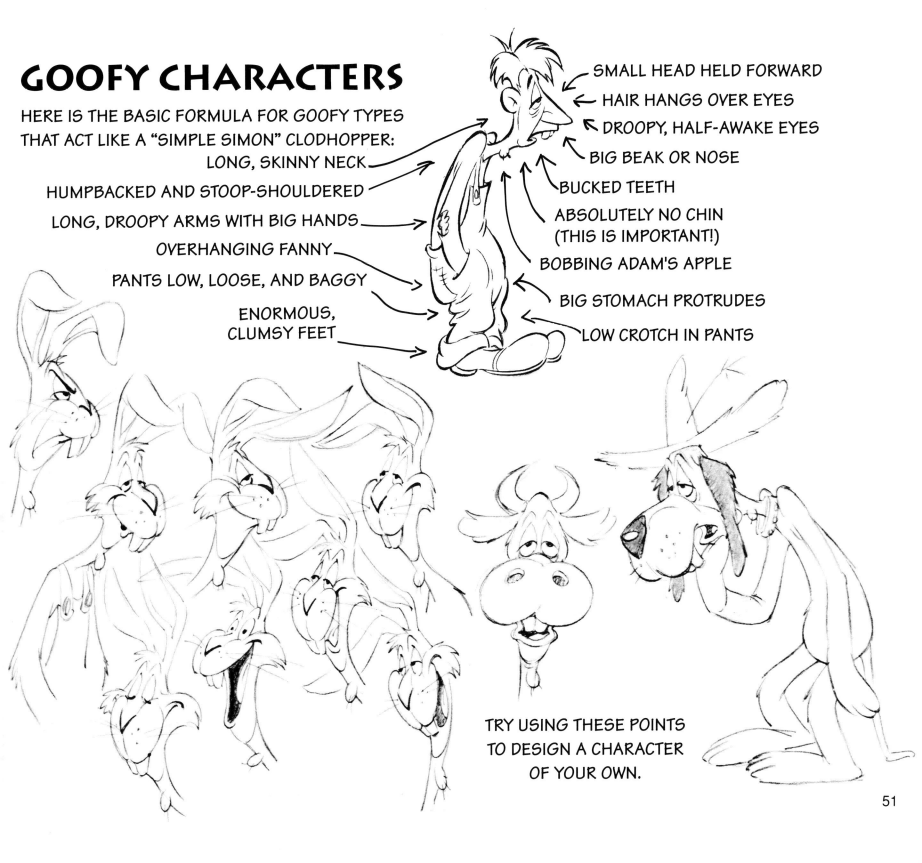

TRY USING THESE POINTS
TO DESIGN A CHARACTER
OF YOUR OWN.

THE HEAVY, PUGNACIOUS CHARACTER

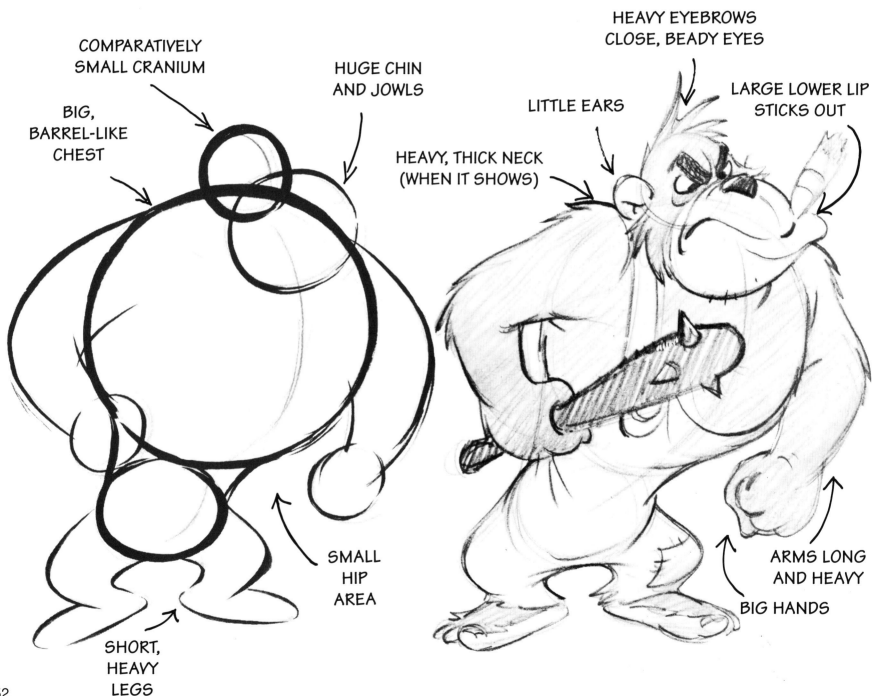

COMPARATIVELY
SMALL CRANIUM

BIG,
BARREL-LIKE
CHEST

HUGE CHIN
AND JOWLS

HEAVY, THICK NECK
(WHEN IT SHOWS)

SMALL
HIP
AREA

SHORT,
HEAVY
LEGS

HEAVY EYEBROWS
CLOSE, BEADY EYES

LITTLE EARS

LARGE LOWER LIP
STICKS OUT

ARMS LONG
AND HEAVY

BIG HANDS

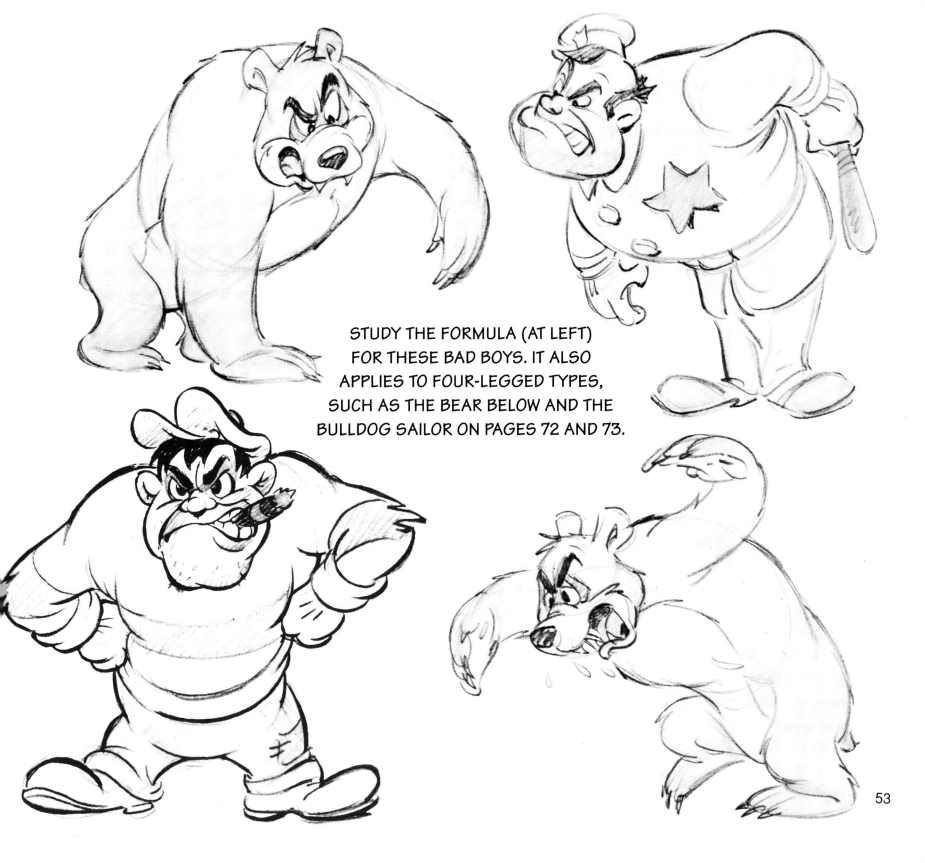

STUDY THE FORMULA (AT LEFT)
FOR THESE BAD BOYS. IT ALSO
APPLIES TO FOUR-LEGGED TYPES,
SUCH AS THE BEAR BELOW AND THE
BULLDOG SAILOR ON PAGES 72 AND 73.

MORE ANIMAL CHARACTERS

THE NEXT FOUR PAGES CONTAIN A VARIETY OF ANIMAL CHARACTERS WITH DIFFERENT EXPRESSIONS. THE CONSTRUCTION METHODS INCLUDE THE USE OF SKELETAL FORMS IN COMBINATION WITH ROUNDED AND CIRCULAR FORMS.

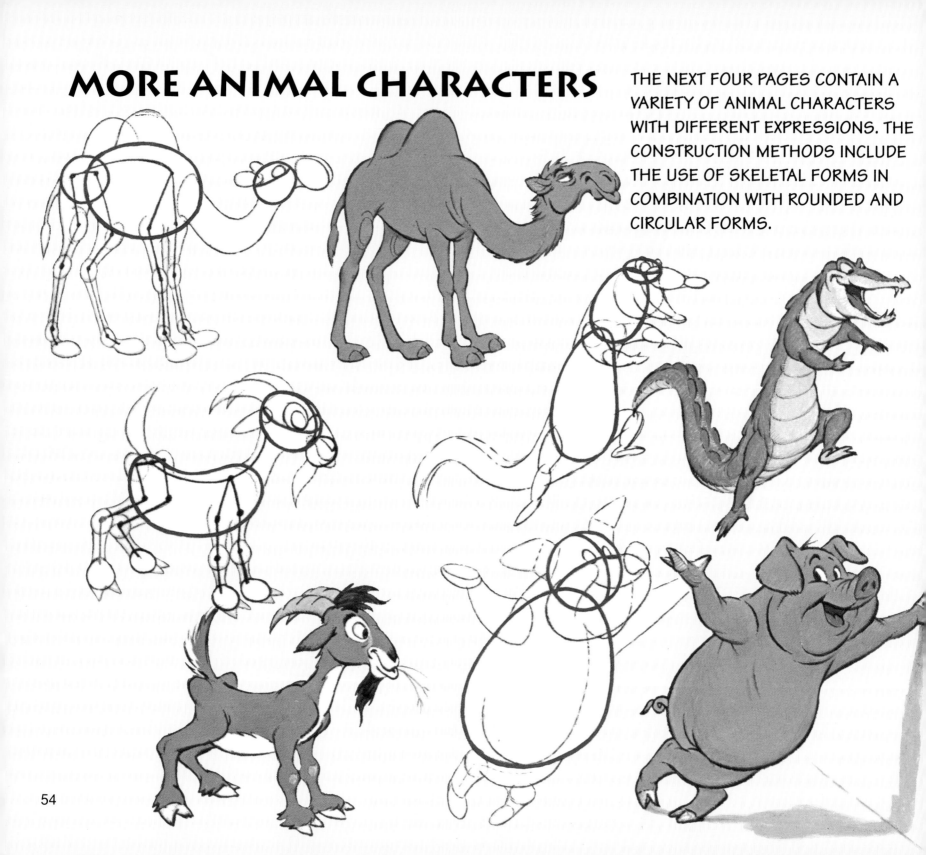

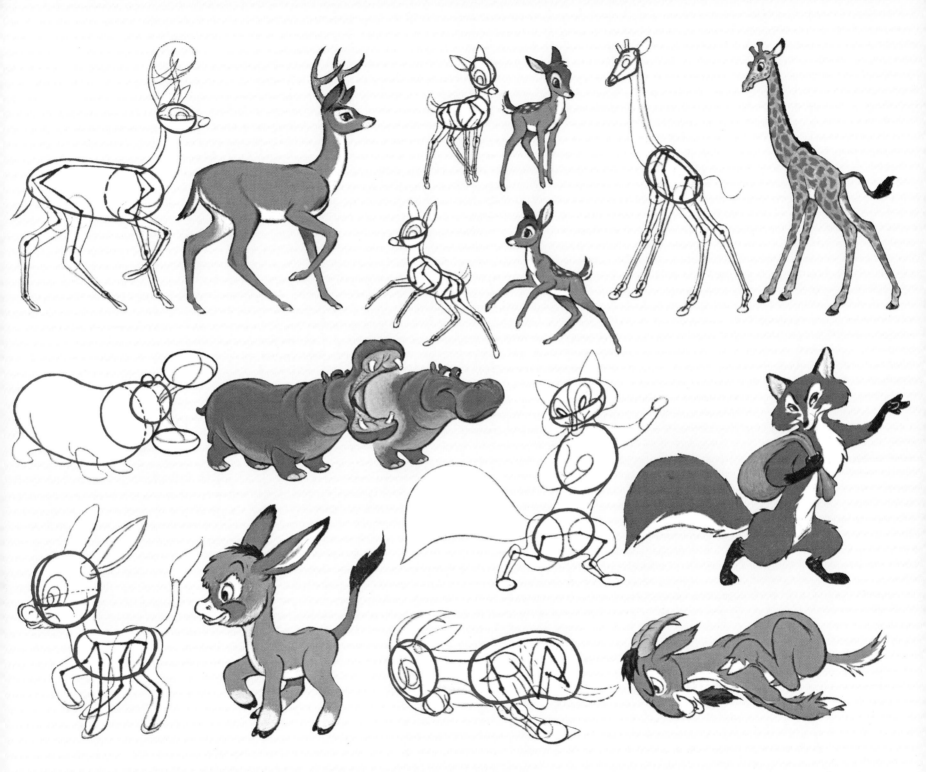

THE FACIAL EXPRESSIONS AND BODY ATTITUDES MUST COMPLEMENT ONE ANOTHER.

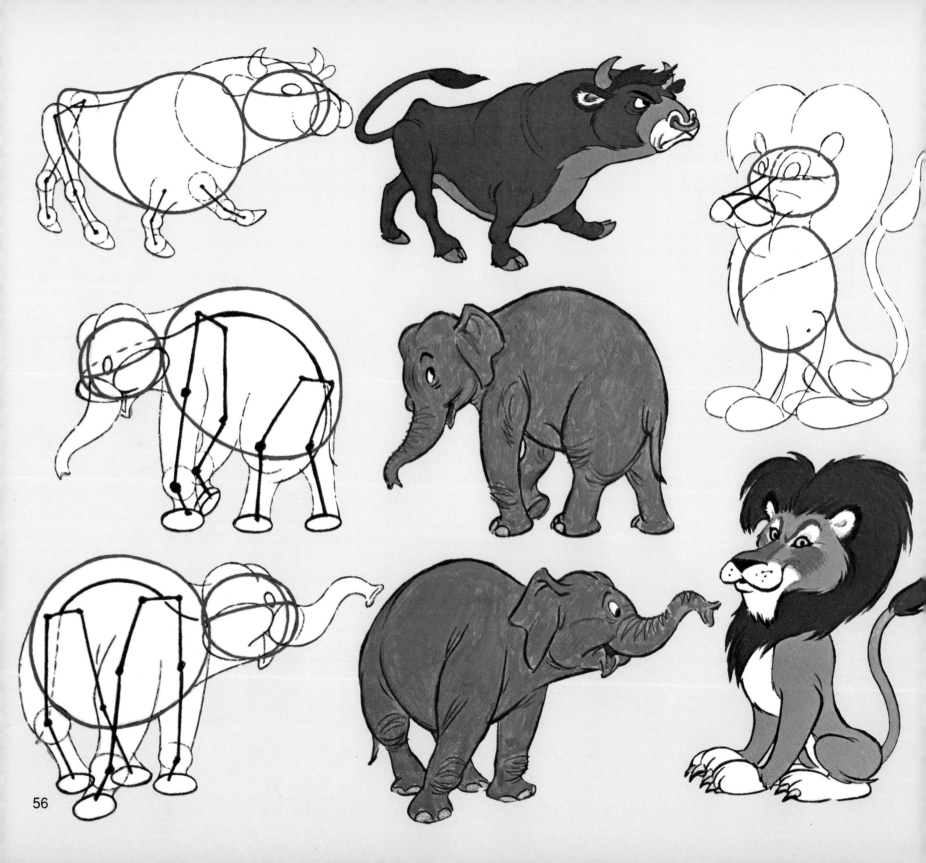

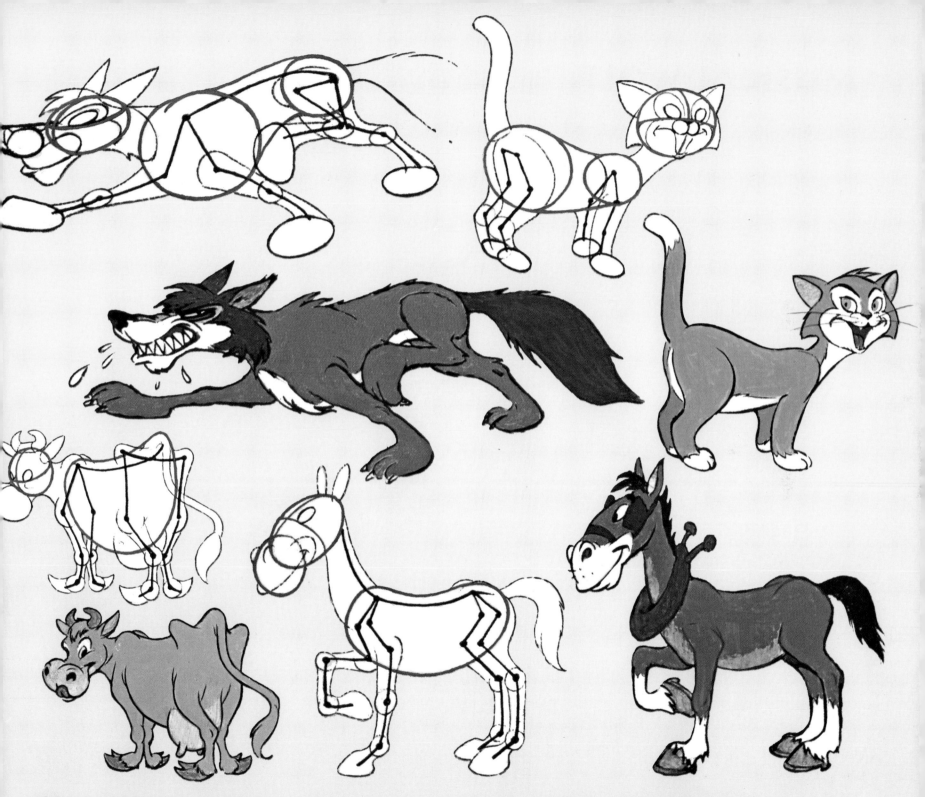

NOTICE THAT SOME OF THESE FORMS ARE SQUASHED WHILE OTHERS ARE STRETCHED TO DEVELOP THE PERSONALITY. 57

MUSICAL WOLF

LIFE IS JUST ONE WILD CARTOON "TAKE" (SEE PAGE 148) OR VIOLENT REACTION AFTER ANOTHER FOR THIS MUSICIAN.

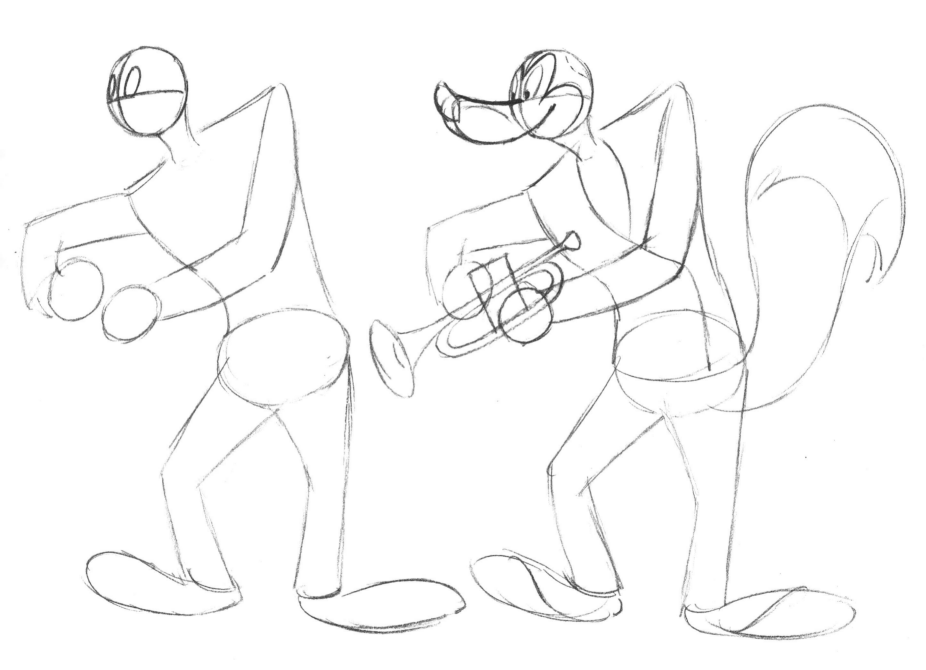

ROUGH IN THE BASIC CONSTRUCTION.

FIT ON THE DETAILS CAREFULLY.

ANYTHING CAN HAPPEN WHEN WOLFY SEES A PRETTY GIRL ...

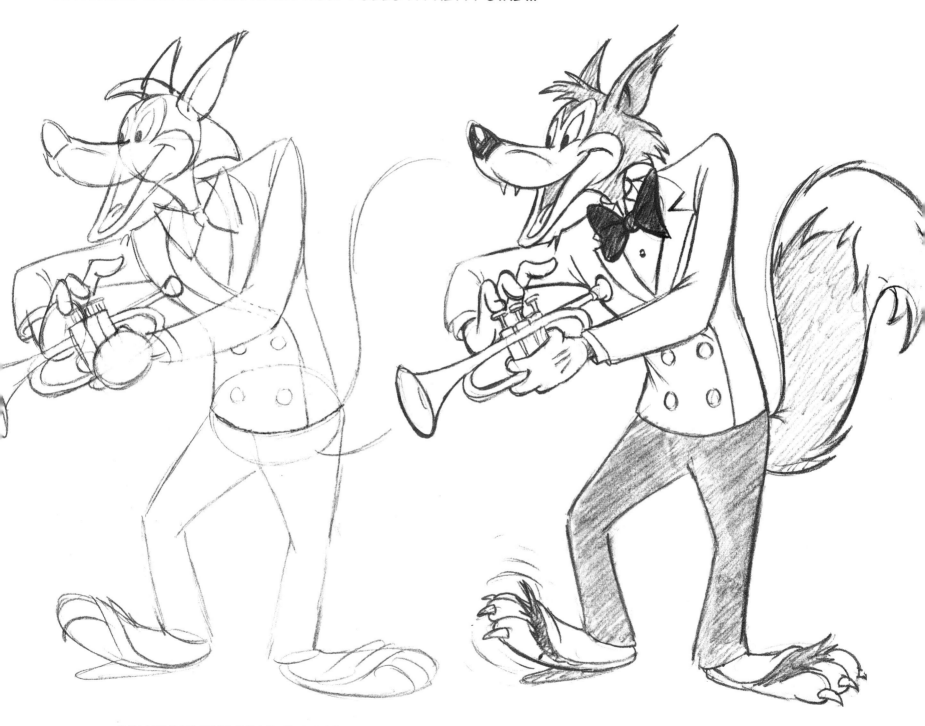

CONTINUE BUILDING THE WOLF.

CLEAN UP FROM CONSTRUCTION.

WOLF HEADS

PRACTICE DRAWING THESE WOLF HEADS; THEY WILL HELP YOU TO DRAW MANY OTHER TYPES OF HEADS WITH VARIOUS EXPRESSIONS.

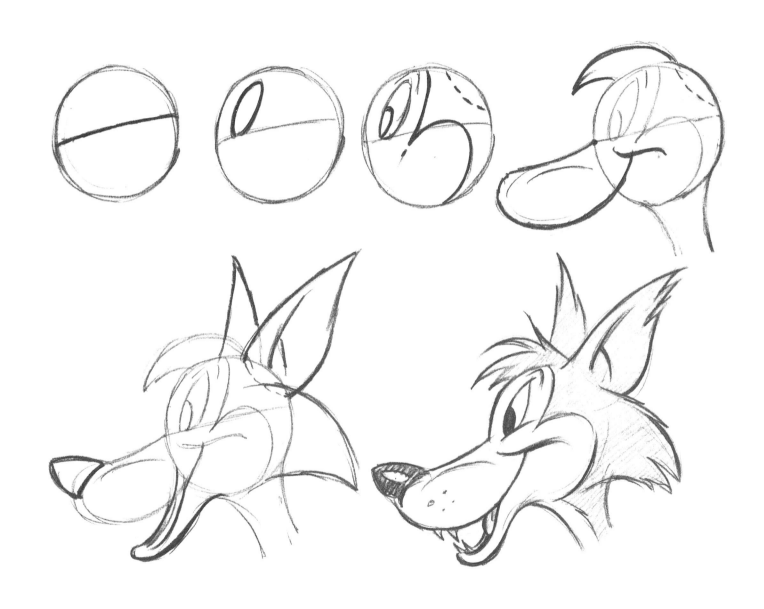

AN ANIMATOR MUST BE ABLE TO DRAW FROM ALL ANGLES.

LOOK AT YOUR OWN FACIAL EXPRESSIONS
IN A MIRROR FOR A GUIDE ...

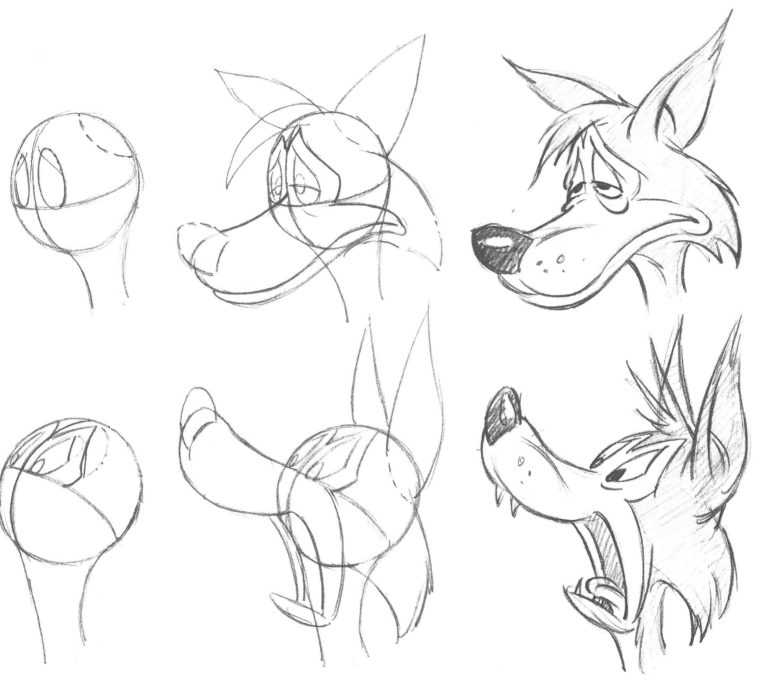

... OR STUDY OTHER EXPRESSIONS IN THIS BOOK.

LIONS AND TIGERS

HERE ARE
SUGGESTIONS
FOR FUNNY
LION AND TIGER
CHARACTERS.

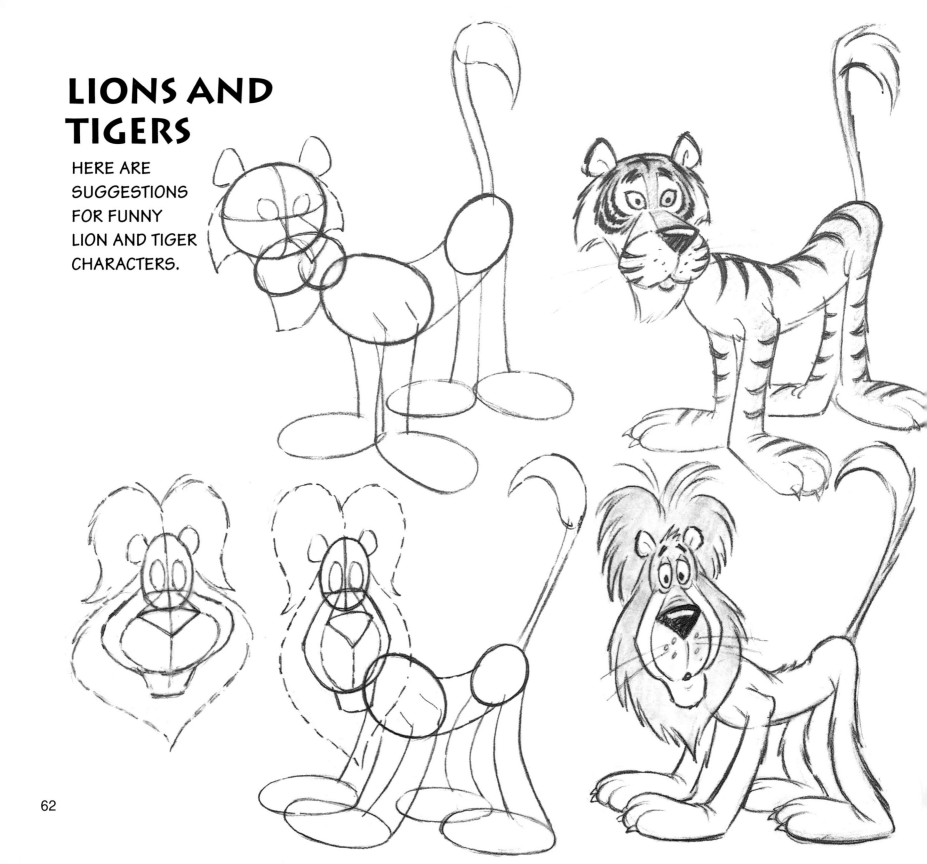

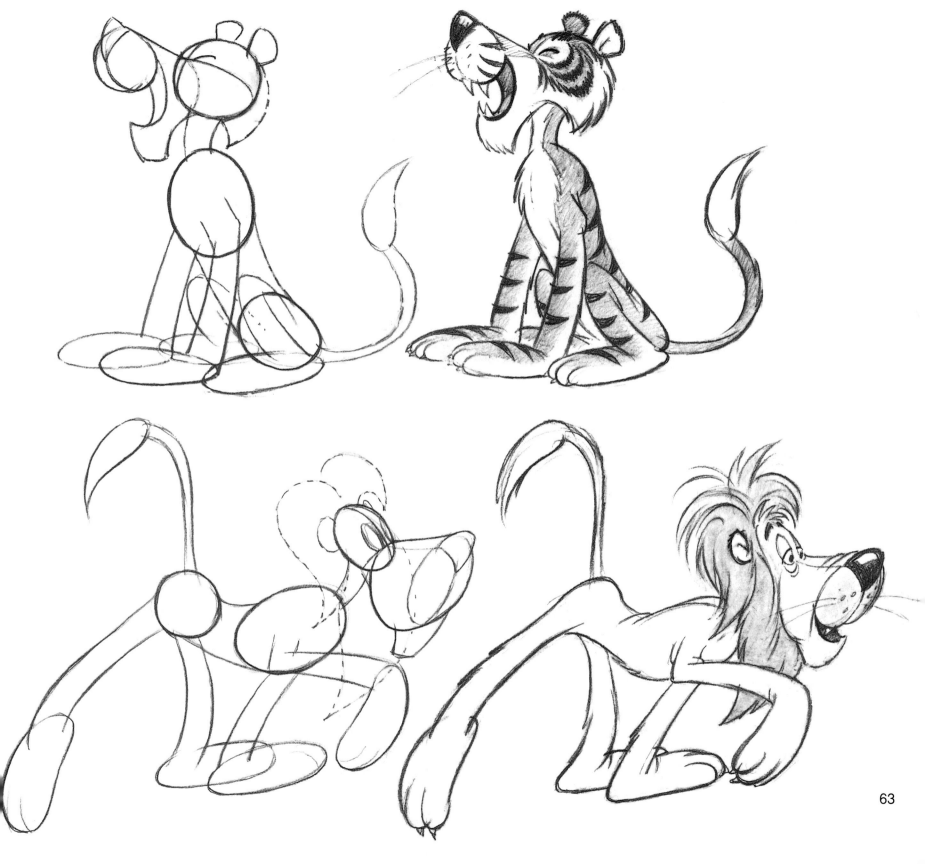

BIRDS

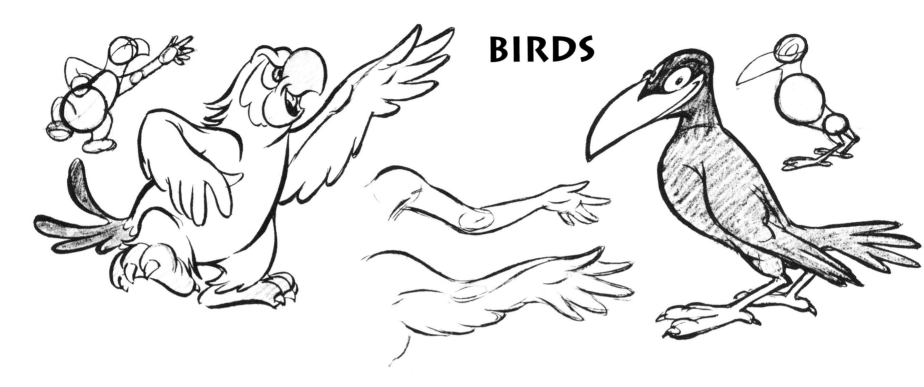

THE NATURAL SHAPE OF A BIRD'S WING CAN BE CHANGED TO
A MODIFIED (OR SUGGESTED) ARM AND HAND FOR CERTAIN
ACTIONS, THEN CHANGED BACK TO THE NATURAL SHAPE.

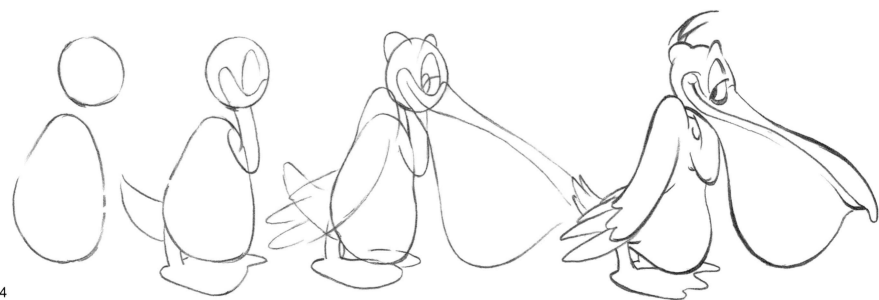

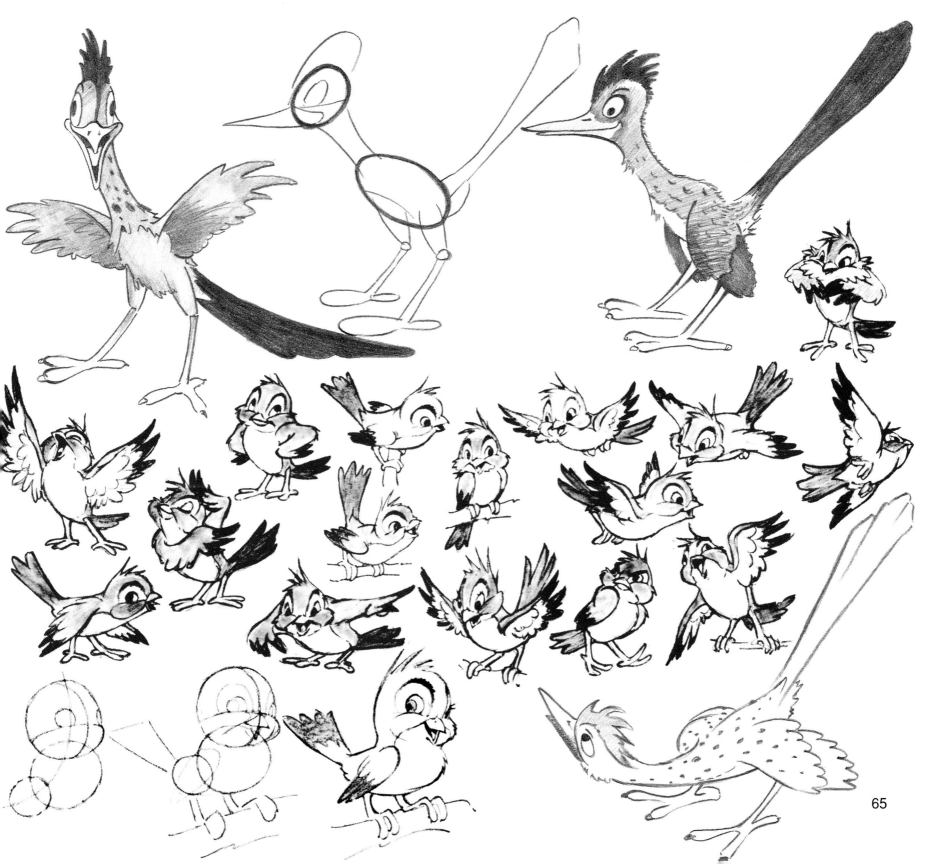

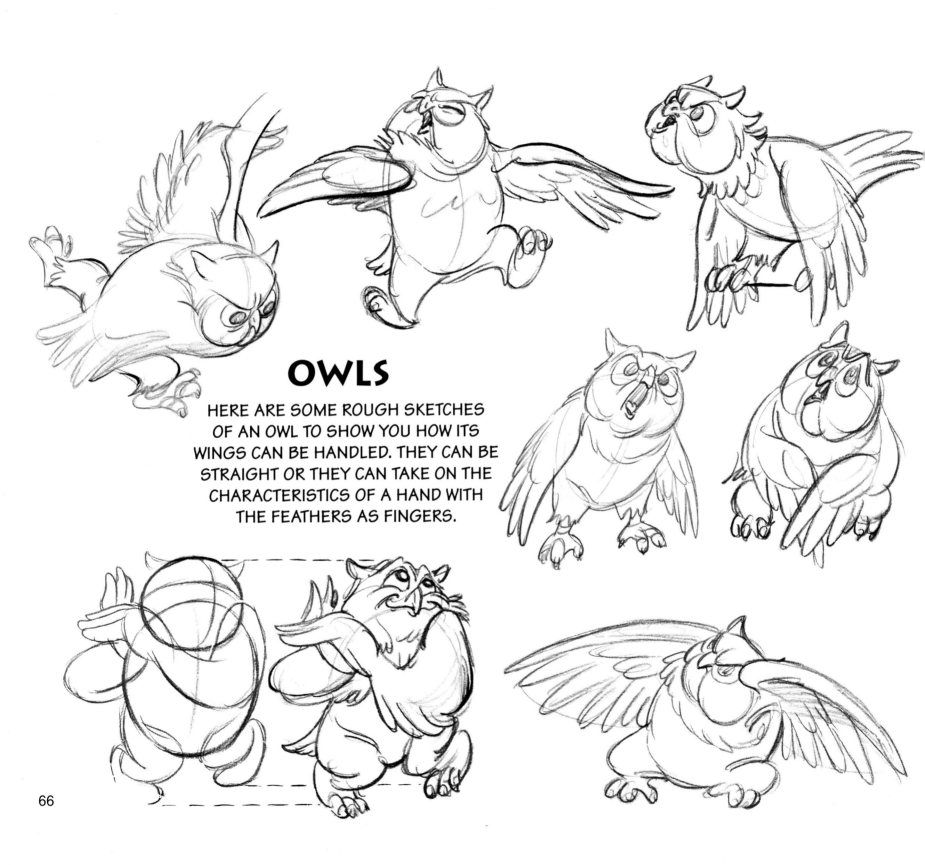

OWLS

HERE ARE SOME ROUGH SKETCHES OF AN OWL TO SHOW YOU HOW ITS WINGS CAN BE HANDLED. THEY CAN BE STRAIGHT OR THEY CAN TAKE ON THE CHARACTERISTICS OF A HAND WITH THE FEATHERS AS FINGERS.

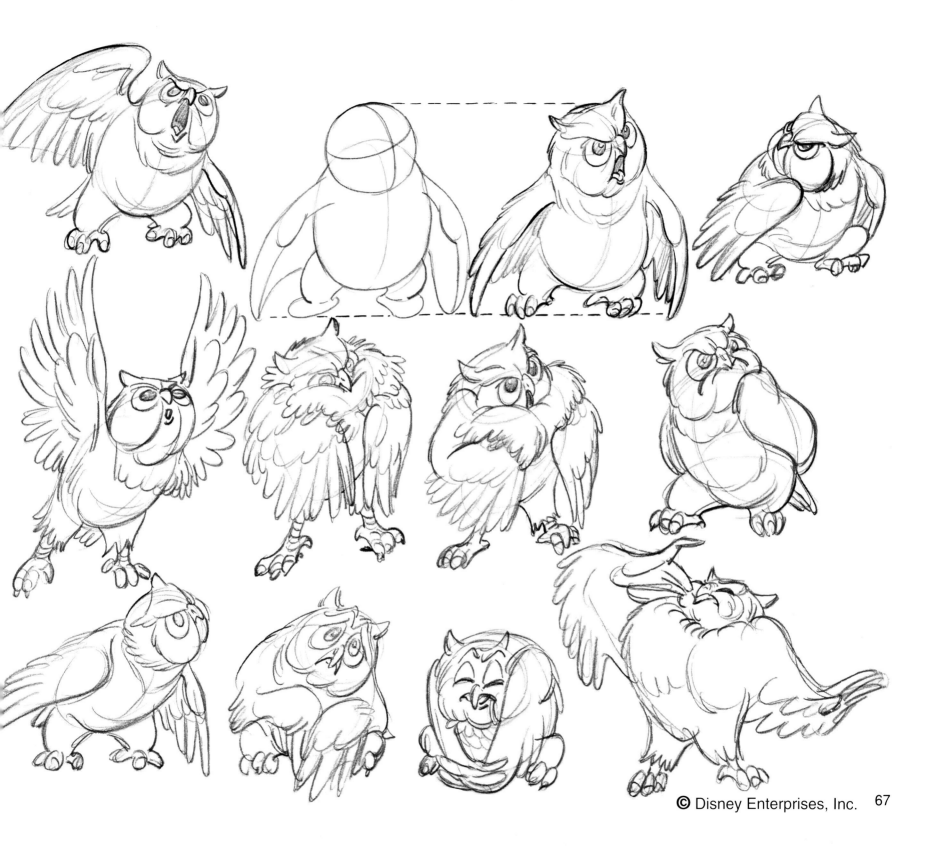

67

MORE BIRDS

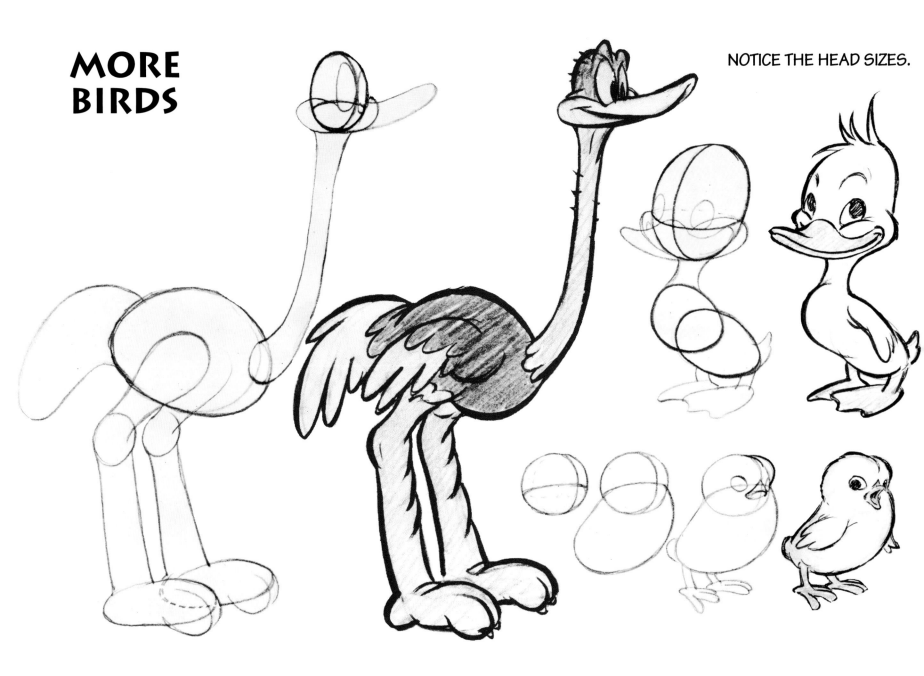

THESE CHARACTERS DIFFER GREATLY IN PERSONALITY AND SHAPE DUE TO THEIR PROPORTIONS. NOTICE THE DIFFERENCES IN BEAKS, LEGS, NECKS, AND WING SIZES. FOR EXAMPLE, THE BABY CHICK HAS NO NECK (THE HEAD SHAPE OVERLAPS THE BODY SHAPE), WHILE THE OSTRICH'S NECK IS EXAGGERATED. ALL OF THE CHARACTERS ON THESE TWO PAGES HAVE BEEN DEVELOPED USING THE CIRCLE AND ROUNDED FORM METHOD.

DIFFERENT SHAPES CAN SUGGEST DIFFERENT
PERSONALITIES: CUTE, GOOFY, PUGNACIOUS, ETC.

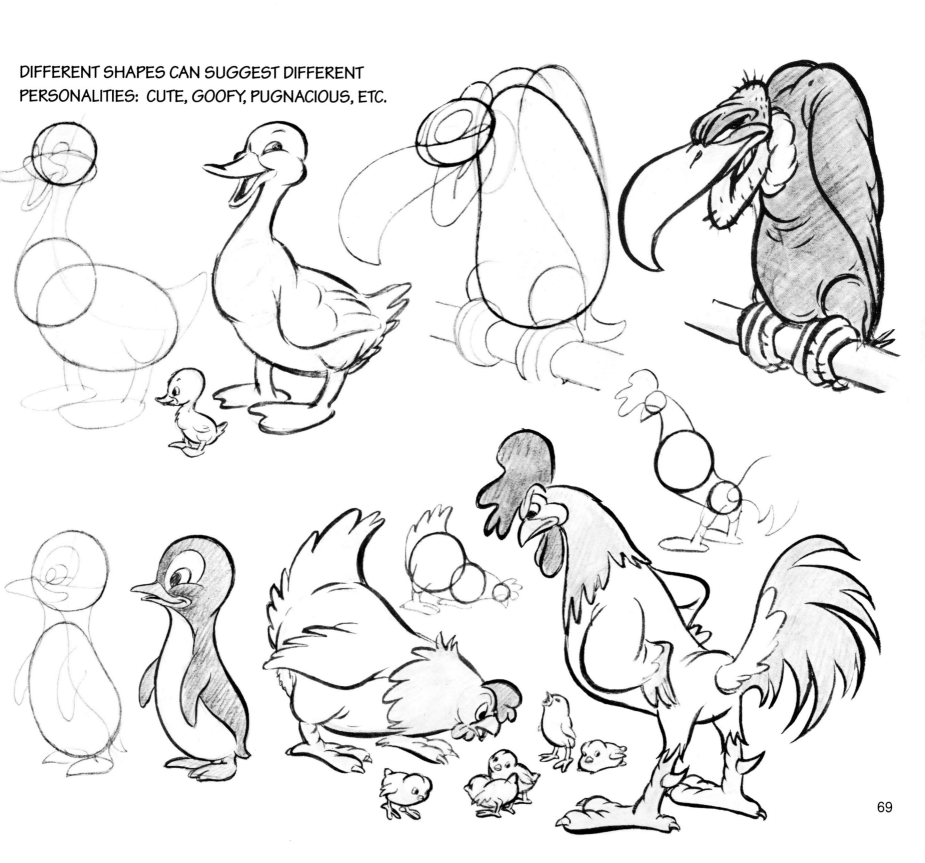

THE BELLIGERENT BULLDOG

SPIKE THE BULLDOG HAS A BARREL-LIKE CHEST,
SMALL BOTTOM, HEAVY ARMS AND LEGS, NO
NECK, PIGEON FRONT TOES, AND BOWED LEGS.

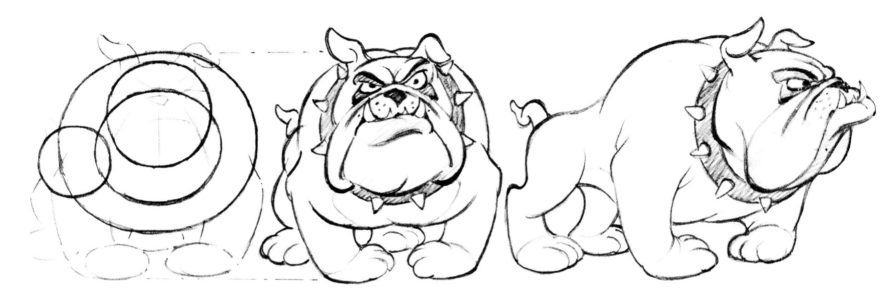

USE CONSTRUCTION GUIDELINES TO HELP YOU DRAW THIS
BULLDOG IN SEVERAL DIFFERENT POSES AND ACTION VIEWS.

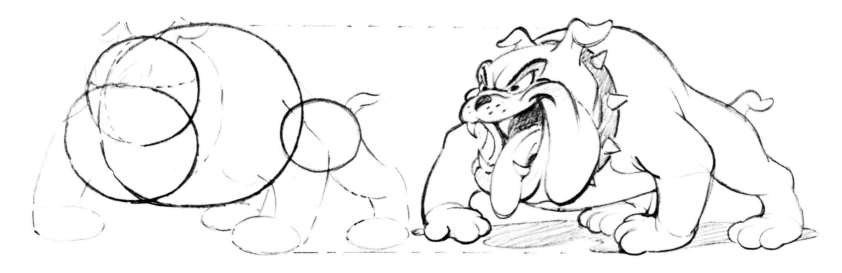

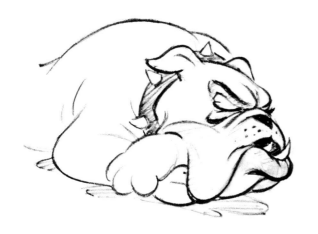

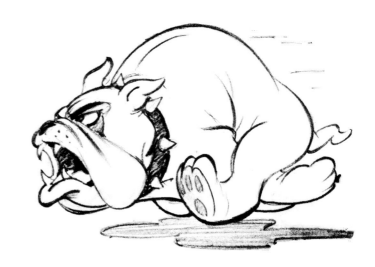

MAKE A REPEAT CYCLE OF BULLDOG RUNNING USING THE DRAWING AT RIGHT FOR POSITION ONE. SEE "GALLOP" IN "MOVEMENTS OF THE FOUR-LEGGED FIGURE" ON PAGE 102 FOR A GUIDE.

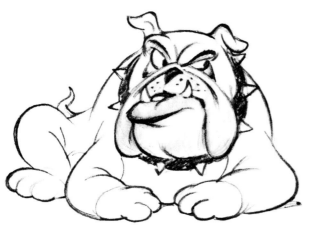

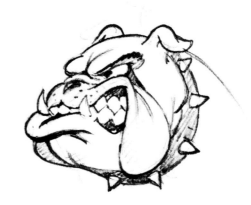

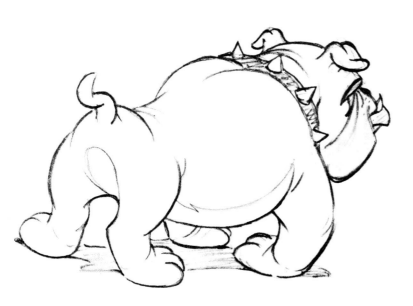

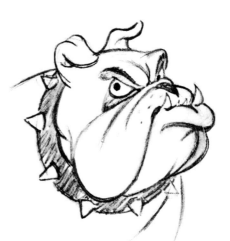

71

BULLDOG SAILOR

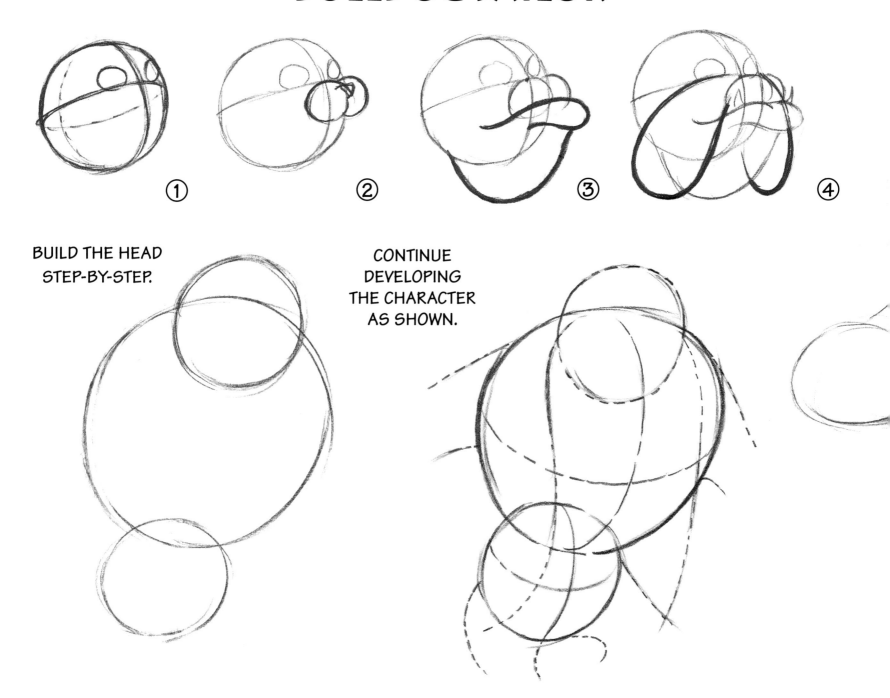

① ② ③ ④

BUILD THE HEAD
STEP-BY-STEP.

CONTINUE
DEVELOPING
THE CHARACTER
AS SHOWN.

ANIMATION FORMULA

IN ANIMATION THE BULLDOG JOWLS FLOP AROUND LIKE COATTAILS IN AN OVERLAPPING SECONDARY ACTION (SEE CHAPTER 3). THAT IS A VALUABLE TECHNIQUE FOR KEEPING POSES ALIVE.

THE BULLDOG HAS A DOUBLE JAW WITH JOWLS. DRAW THE CIRCULAR FORMS FIRST, AND THEN DETERMINE THE PERSPECTIVE LINES TO BUILD THE HEAD AND ASSEMBLE THE BODY.

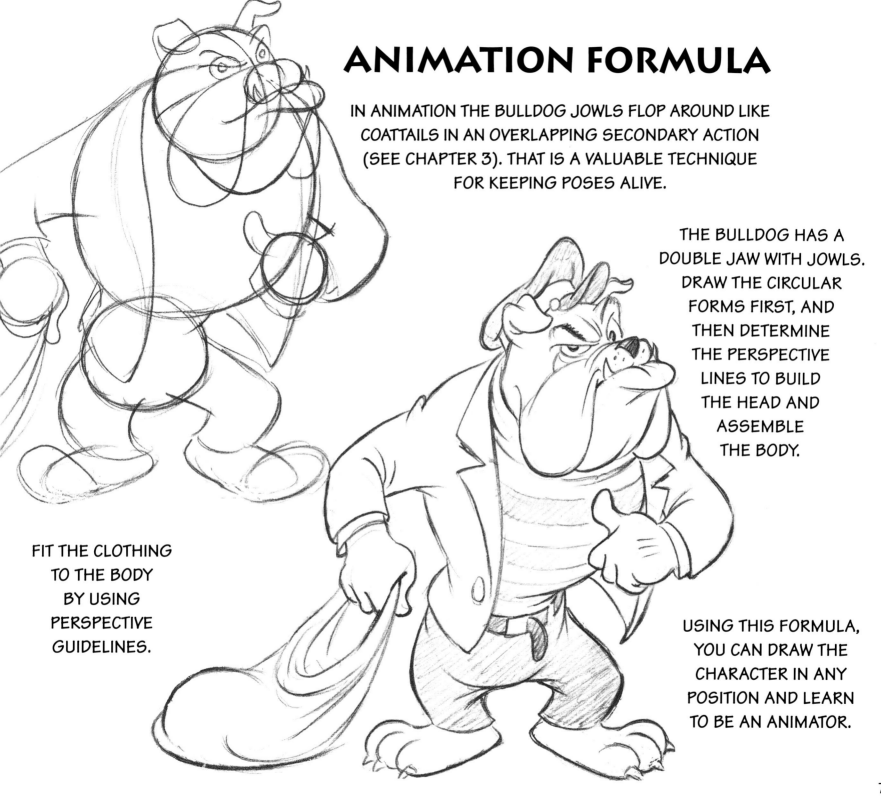

FIT THE CLOTHING TO THE BODY BY USING PERSPECTIVE GUIDELINES.

USING THIS FORMULA, YOU CAN DRAW THE CHARACTER IN ANY POSITION AND LEARN TO BE AN ANIMATOR.

73

FORESHORTENING—PERSPECTIVE

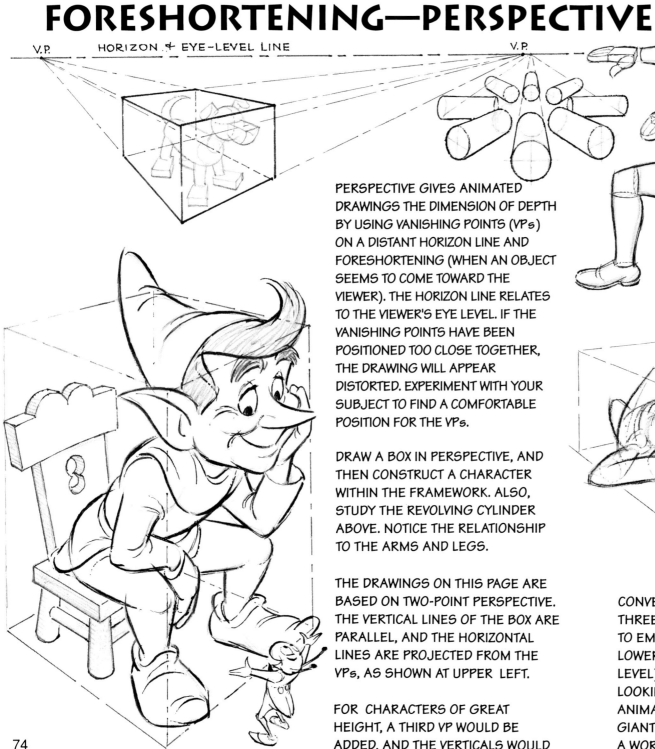

V.P. HORIZON + EYE-LEVEL LINE V.P.

PERSPECTIVE GIVES ANIMATED DRAWINGS THE DIMENSION OF DEPTH BY USING VANISHING POINTS (VPs) ON A DISTANT HORIZON LINE AND FORESHORTENING (WHEN AN OBJECT SEEMS TO COME TOWARD THE VIEWER). THE HORIZON LINE RELATES TO THE VIEWER'S EYE LEVEL. IF THE VANISHING POINTS HAVE BEEN POSITIONED TOO CLOSE TOGETHER, THE DRAWING WILL APPEAR DISTORTED. EXPERIMENT WITH YOUR SUBJECT TO FIND A COMFORTABLE POSITION FOR THE VPs.

DRAW A BOX IN PERSPECTIVE, AND THEN CONSTRUCT A CHARACTER WITHIN THE FRAMEWORK. ALSO, STUDY THE REVOLVING CYLINDER ABOVE. NOTICE THE RELATIONSHIP TO THE ARMS AND LEGS.

THE DRAWINGS ON THIS PAGE ARE BASED ON TWO-POINT PERSPECTIVE. THE VERTICAL LINES OF THE BOX ARE PARALLEL, AND THE HORIZONTAL LINES ARE PROJECTED FROM THE VPs, AS SHOWN AT UPPER LEFT.

FOR CHARACTERS OF GREAT HEIGHT, A THIRD VP WOULD BE ADDED, AND THE VERTICALS WOULD CONVERGE AT THE THIRD VP. THIS THREE-POINT PERSPECTIVE IS USED TO EMPHASIZE HEIGHT BY LOWERING THE HORIZON LINE (EYE LEVEL), AS IF THE VIEWER IS LOOKING UP. THUS, THE DRAMA OF ANIMATION IS HEIGHTENED. A GIANT IS MORE FRIGHTENING FROM A WORM'S-EYE VIEW.

...IN SINGLE DRAWINGS AND GROUPS

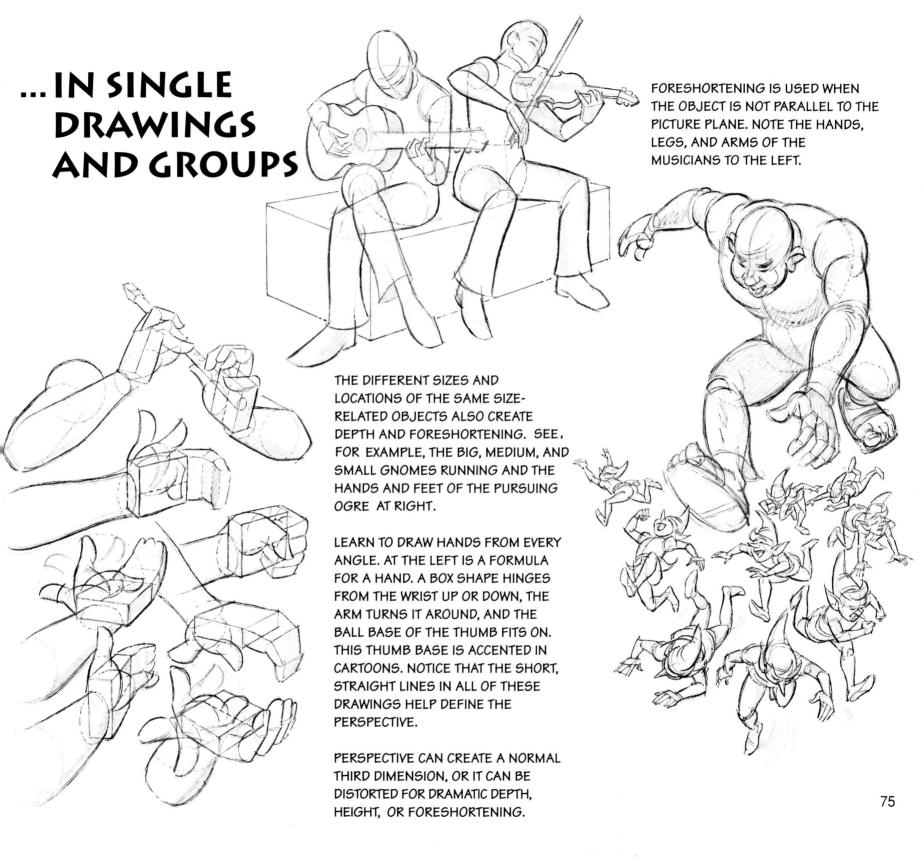

FORESHORTENING IS USED WHEN THE OBJECT IS NOT PARALLEL TO THE PICTURE PLANE. NOTE THE HANDS, LEGS, AND ARMS OF THE MUSICIANS TO THE LEFT.

THE DIFFERENT SIZES AND LOCATIONS OF THE SAME SIZE-RELATED OBJECTS ALSO CREATE DEPTH AND FORESHORTENING. SEE, FOR EXAMPLE, THE BIG, MEDIUM, AND SMALL GNOMES RUNNING AND THE HANDS AND FEET OF THE PURSUING OGRE AT RIGHT.

LEARN TO DRAW HANDS FROM EVERY ANGLE. AT THE LEFT IS A FORMULA FOR A HAND. A BOX SHAPE HINGES FROM THE WRIST UP OR DOWN, THE ARM TURNS IT AROUND, AND THE BALL BASE OF THE THUMB FITS ON. THIS THUMB BASE IS ACCENTED IN CARTOONS. NOTICE THAT THE SHORT, STRAIGHT LINES IN ALL OF THESE DRAWINGS HELP DEFINE THE PERSPECTIVE.

PERSPECTIVE CAN CREATE A NORMAL THIRD DIMENSION, OR IT CAN BE DISTORTED FOR DRAMATIC DEPTH, HEIGHT, OR FORESHORTENING.

75

GNOMES

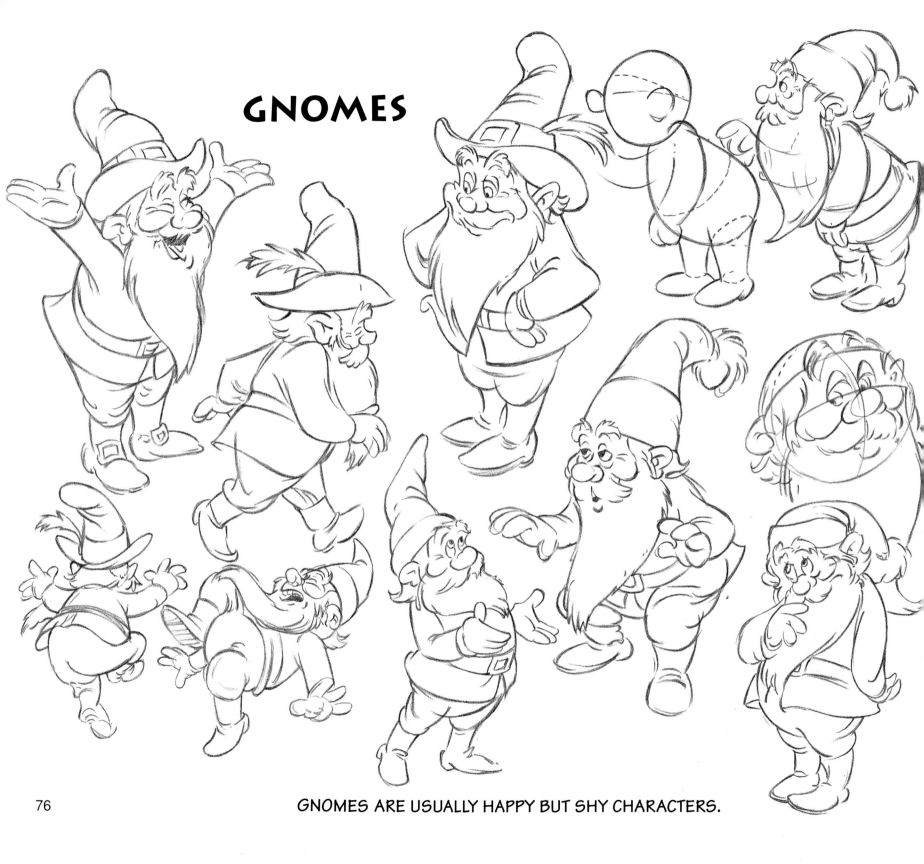

GNOMES ARE USUALLY HAPPY BUT SHY CHARACTERS.

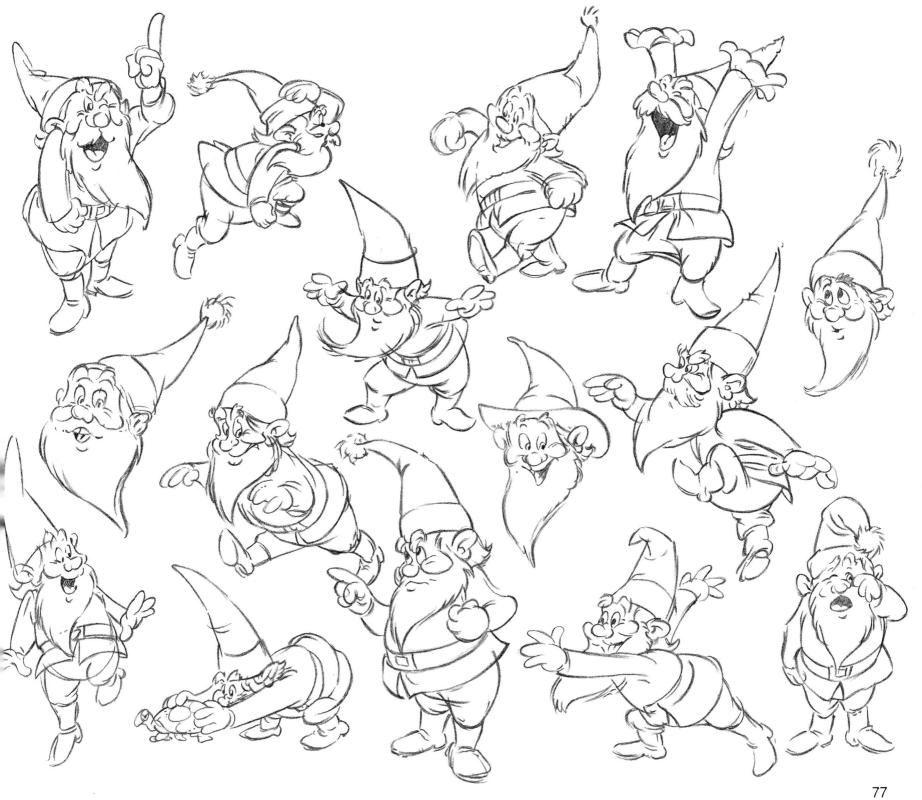

IT IS BEST TO DEVELOP THESE LITTLE FELLOWS WITH ROUNDED FORMS.

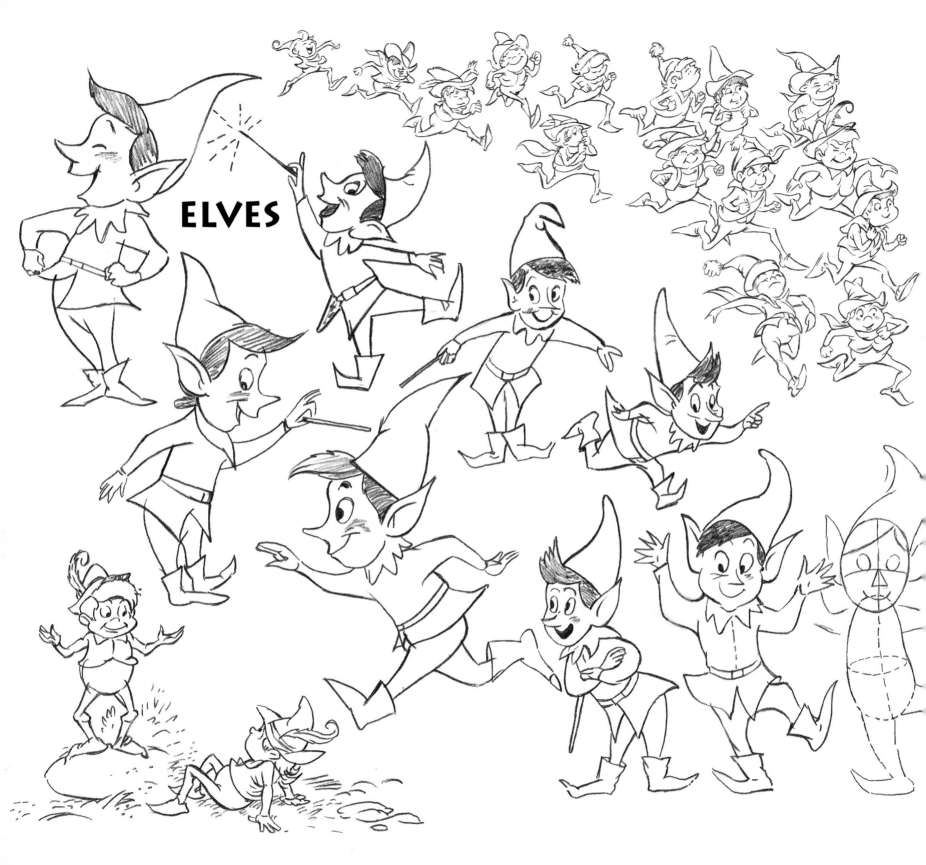

ELVES

DWARFS

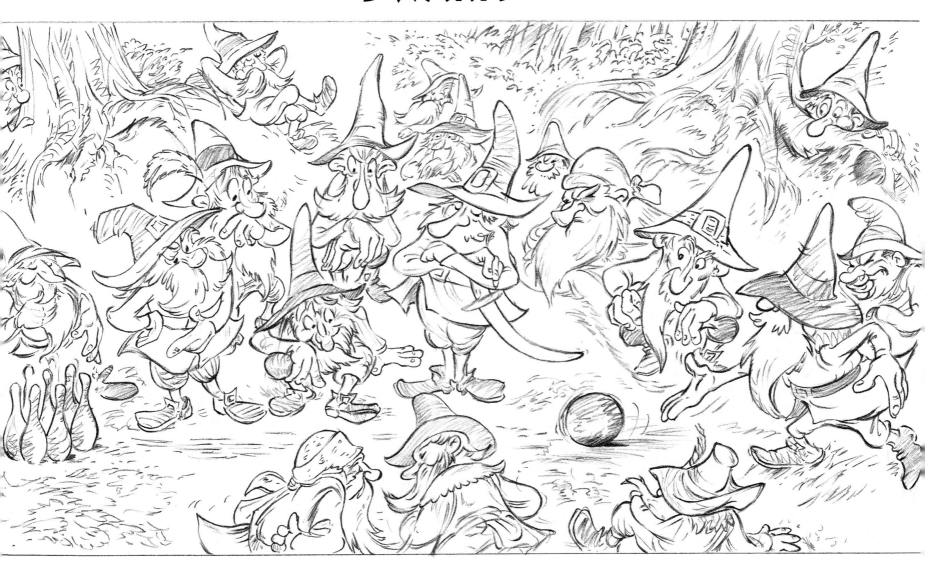

A MOTLEY CREW OF LITTLE MEN ASSEMBLES TO PLAY NINEPINS
ON AN ANIMATION LAYOUT DRAWING (IN PENCIL).

WICKED WITCH

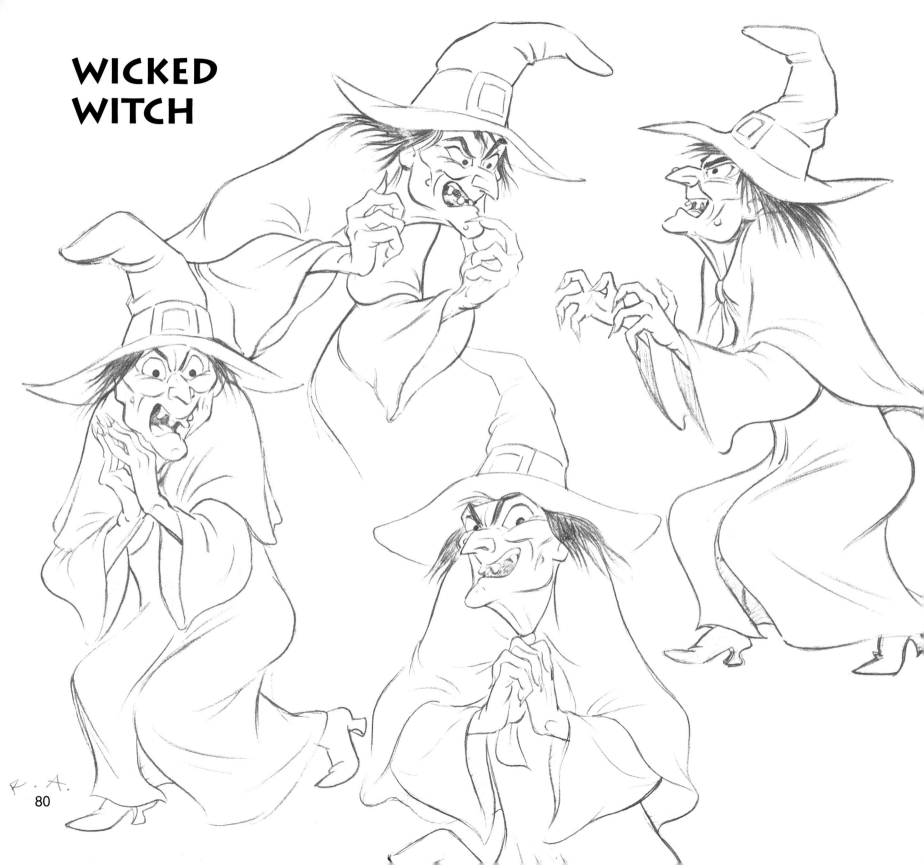

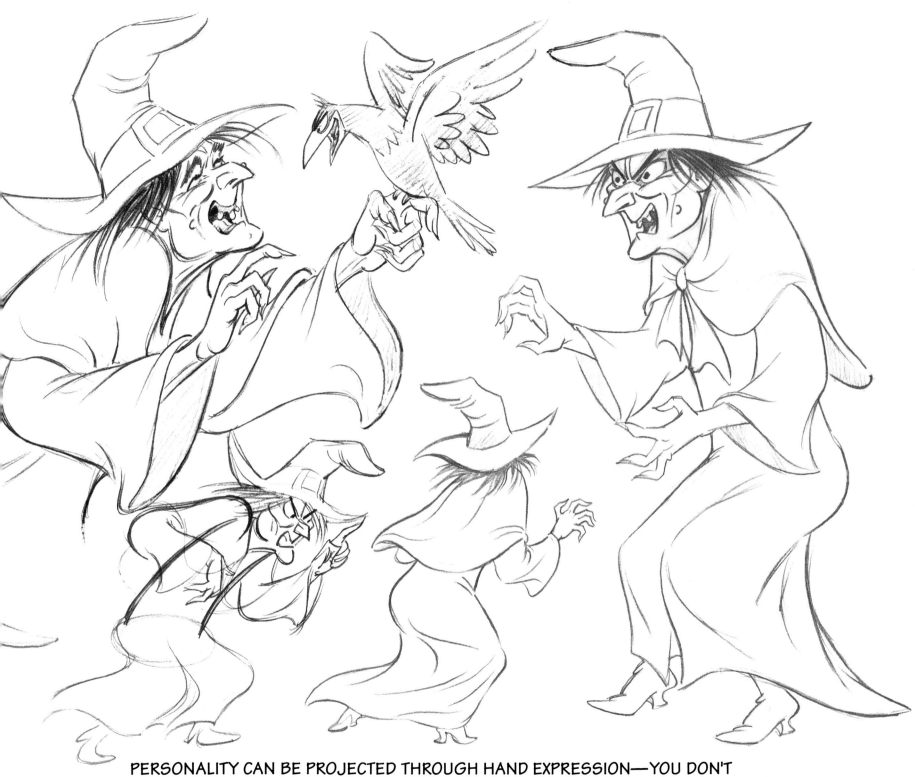

PERSONALITY CAN BE PROJECTED THROUGH HAND EXPRESSION—YOU DON'T
NEED TO SEE THE WITCH'S FACE TO KNOW THAT SHE IS "WICKED."

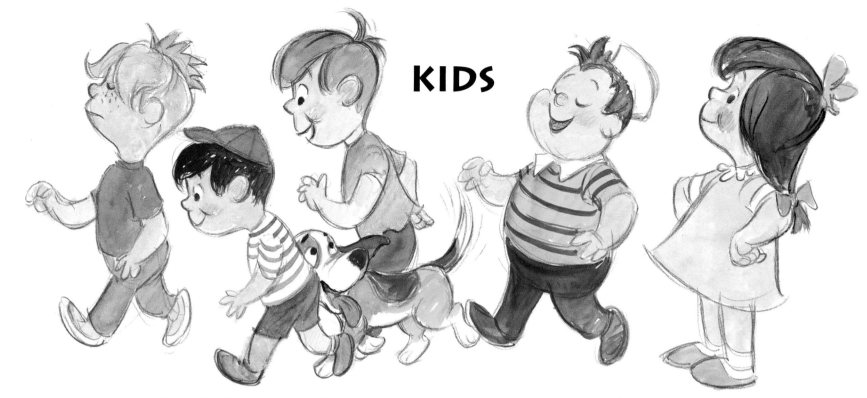

KIDS

KIDS COME IN ALL SHAPES AND SIZES. YOUNG CHILDREN HAVE LARGE HEADS AND SHORT LEGS, AND THEIR BODIES ARE SLIGHTLY PEAR-SHAPED WITH A PROTRUDING TUMMY (LIKE "THE CUTE CHARACTER"; SEE PAGE 32).

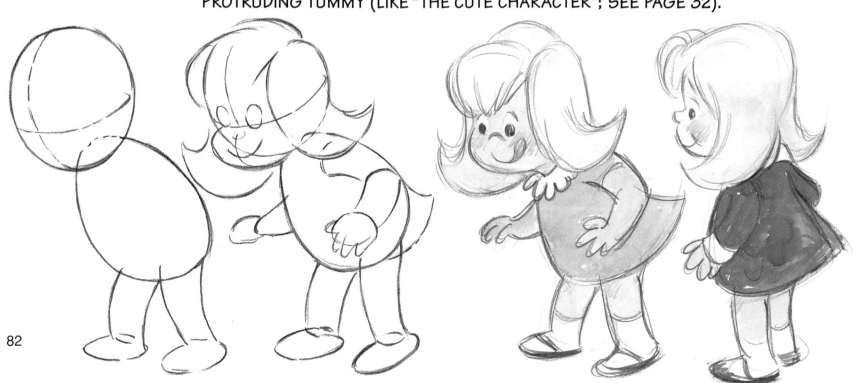

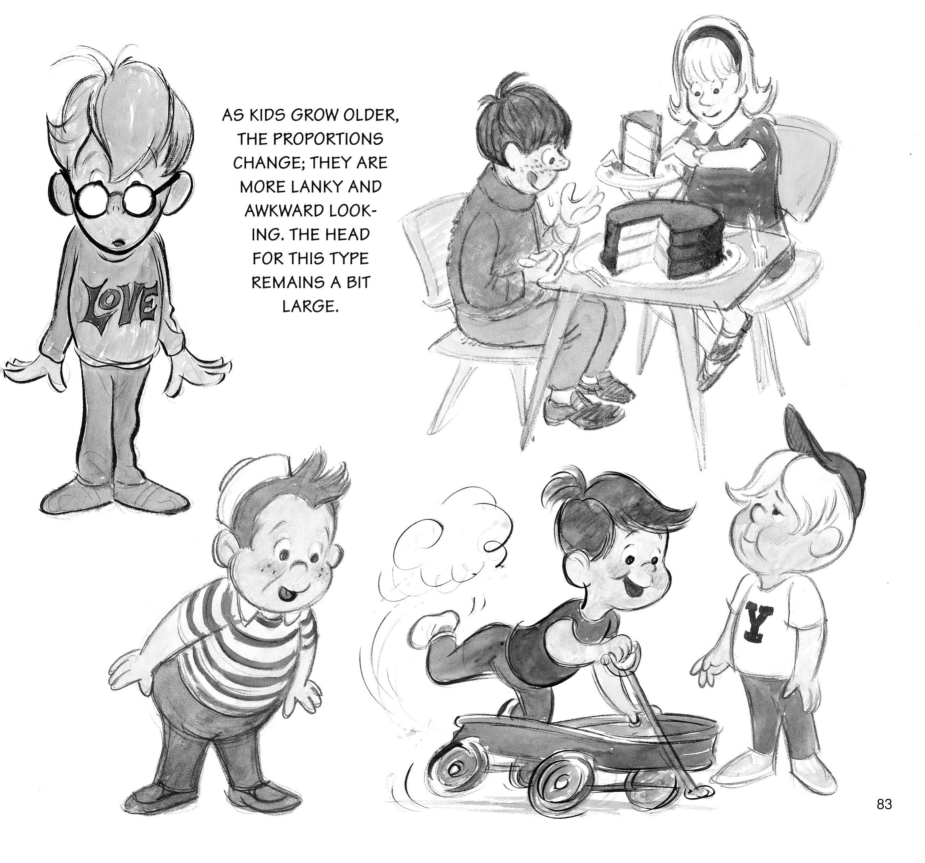

AS KIDS GROW OLDER, THE PROPORTIONS CHANGE; THEY ARE MORE LANKY AND AWKWARD LOOK-ING. THE HEAD FOR THIS TYPE REMAINS A BIT LARGE.

YOUNG HEROINE

THE PROPORTIONS OF THIS CHARACTER ARE DIFFERENT THAN THOSE OF THE CHILDREN ON THE PREVIOUS PAGES. USE THE CHART BELOW AS A GUIDE TO DRAW THIS YOUNG GIRL. THE CHART SHOWS THE FULL-FIGURE PROPORTIONS BASED ON A HEIGHT OF FIVE HEAD LENGTHS. THE LEGS ARE HALF OF THE HEIGHT (2-1/2 HEADS), THE WAIST IS TWO HEADS FROM THE TOP, AND THE ARMS AND HANDS ARE A LITTLE OVER TWO HEADS LONG. USE THIS SCALE TO DRAW THE YOUNG GIRL ACCURATELY IN ANY POSITION.

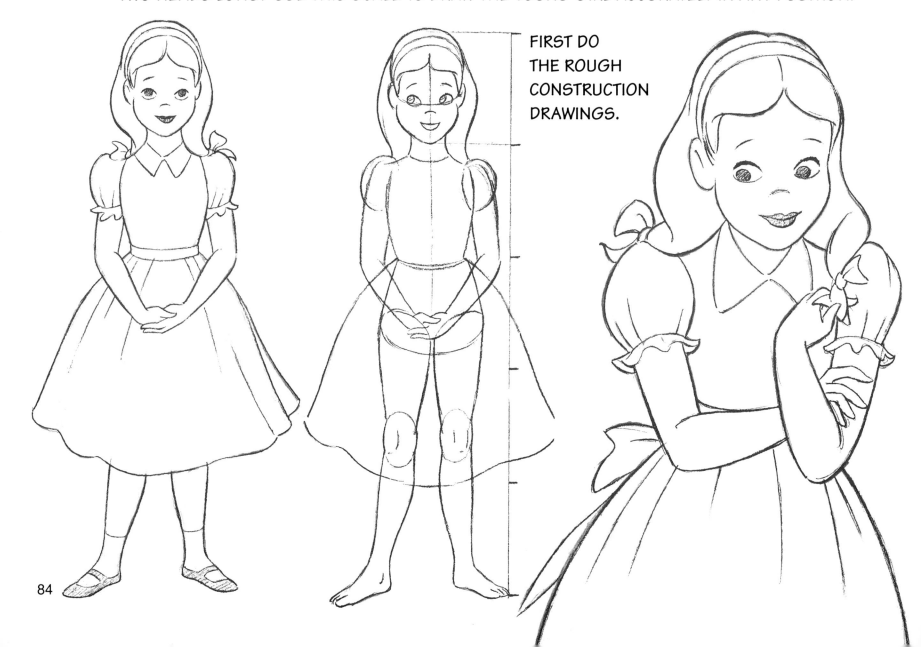

FIRST DO THE ROUGH CONSTRUCTION DRAWINGS.

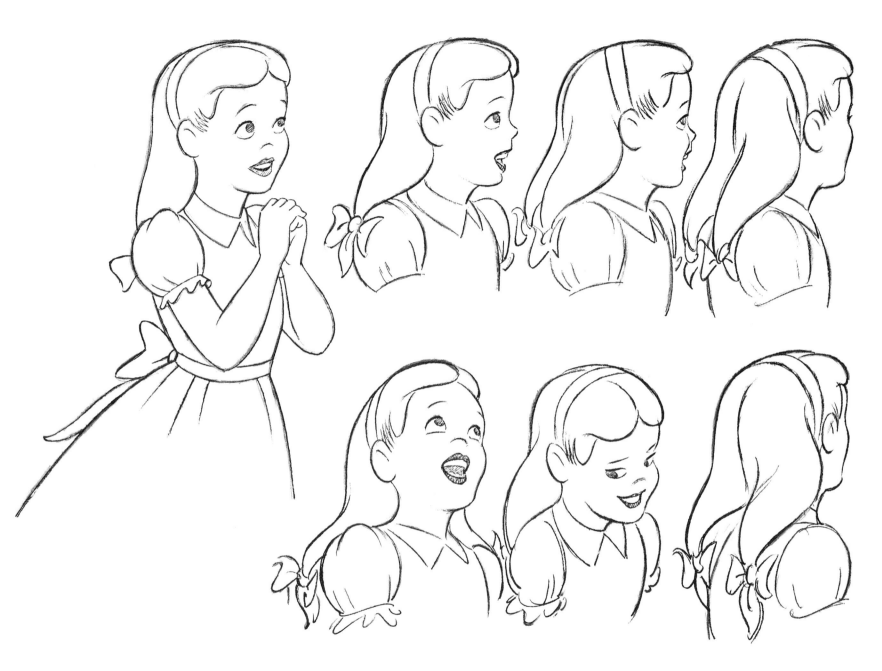

FACIAL FEATURES MOVE WITH THE HEAD: UP AND DOWN AND SIDEWAYS. THE POSITION AND ANGLE OF THE EYES CHANGE WITH THE HEAD MOVEMENT; THEY MUST BE DRAWN TO LOOK IN THE DIRECTION SPECIFIED BY THE HEAD POSITION. HERE THE CHANGE IS FROM A 3/4 FRONT VIEW TO A 3/4 BACK VIEW WHERE THE EYES ARE NOT SEEN AT ALL. USE THE RULES OF PERSPECTIVE AND FORESHORTENING TO ACCOMPLISH THESE TRANSITIONS ACCURATELY (SEE PAGES 74 AND 75).

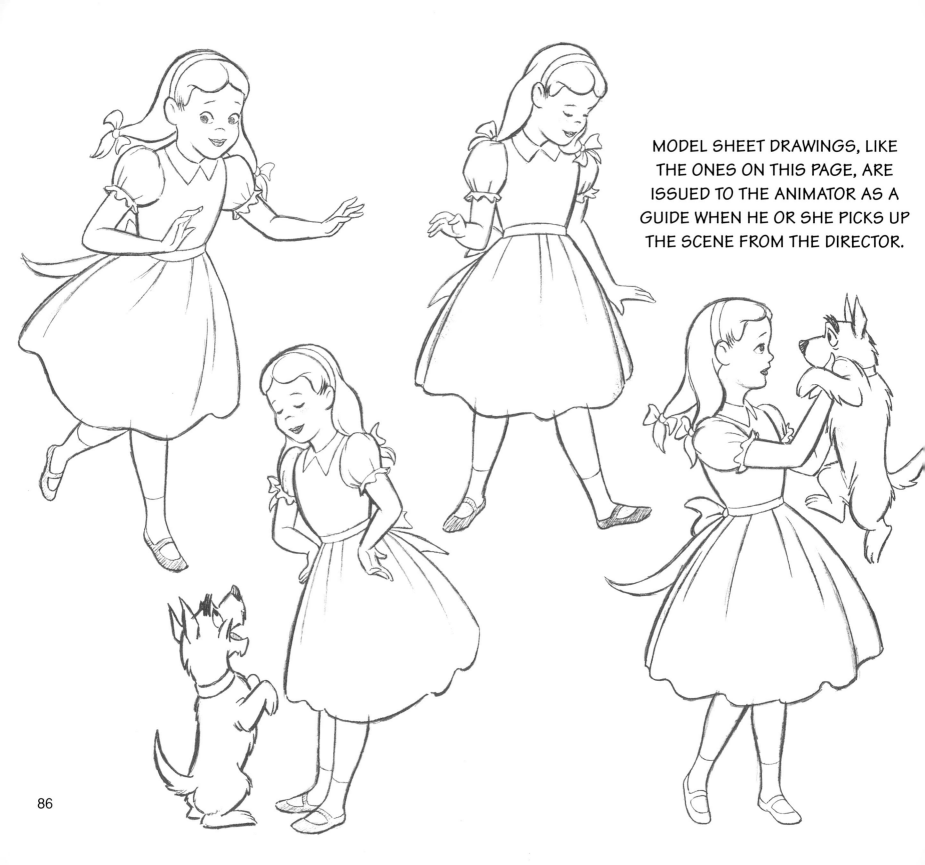

MODEL SHEET DRAWINGS, LIKE
THE ONES ON THIS PAGE, ARE
ISSUED TO THE ANIMATOR AS A
GUIDE WHEN HE OR SHE PICKS UP
THE SCENE FROM THE DIRECTOR.

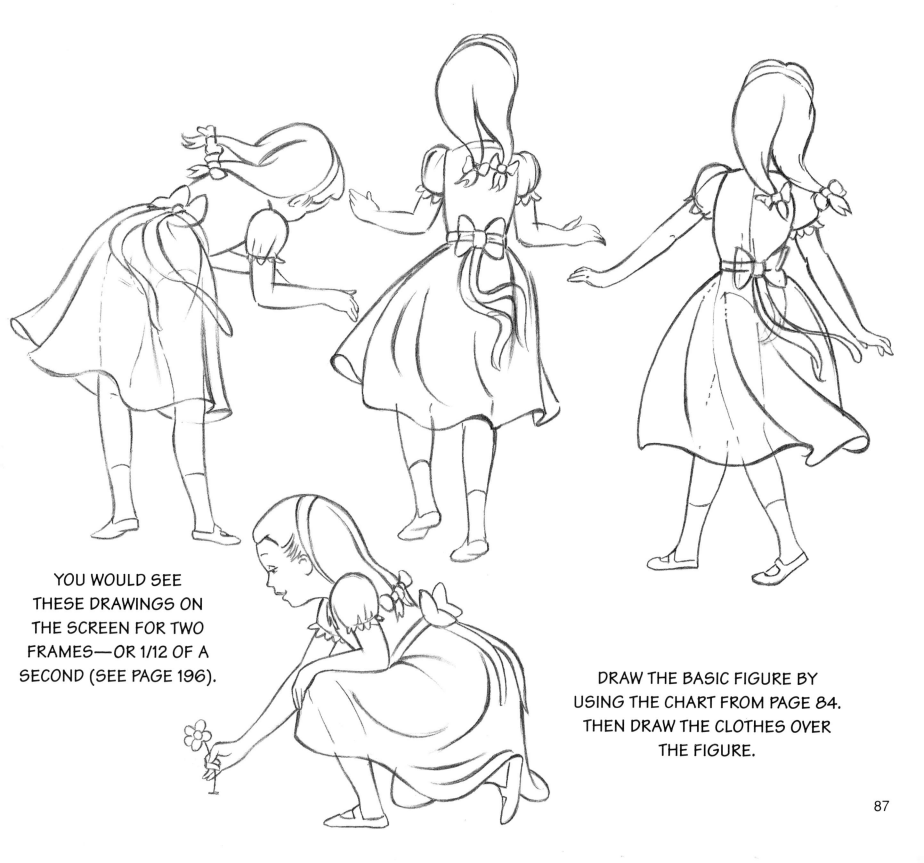

YOU WOULD SEE
THESE DRAWINGS ON
THE SCREEN FOR TWO
FRAMES—OR 1/12 OF A
SECOND (SEE PAGE 196).

DRAW THE BASIC FIGURE BY
USING THE CHART FROM PAGE 84.
THEN DRAW THE CLOTHES OVER
THE FIGURE.

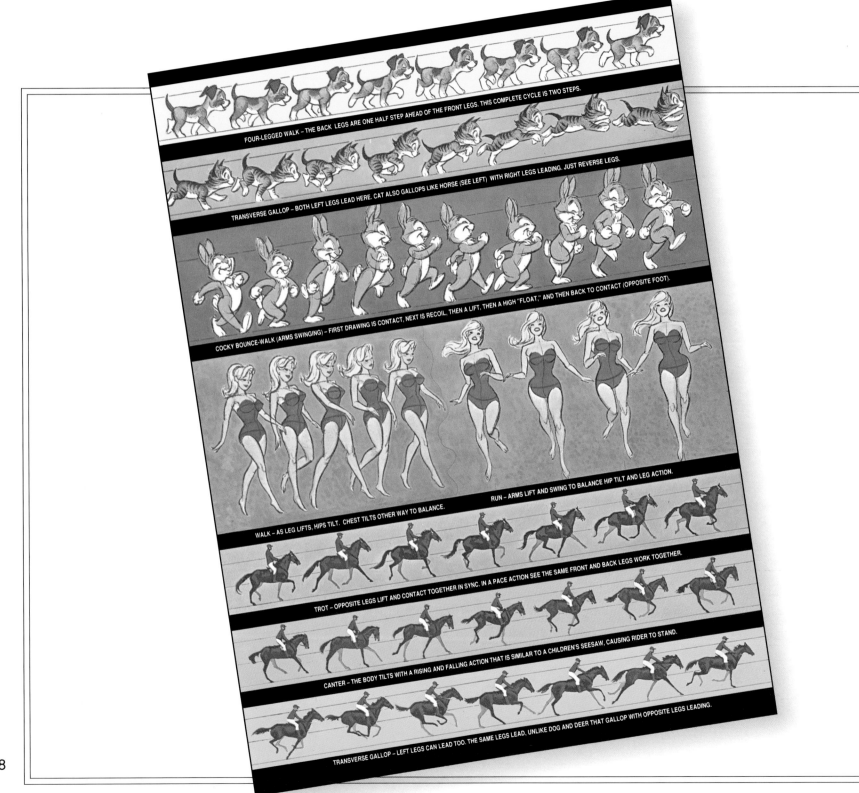

FOUR-LEGGED WALK – THE BACK LEGS ARE ONE HALF STEP AHEAD OF THE FRONT LEGS. THIS COMPLETE CYCLE IS TWO STEPS.

TRANSVERSE GALLOP – BOTH LEFT LEGS LEAD HERE. CAT ALSO GALLOPS LIKE HORSE (SEE LEFT) WITH RIGHT LEGS LEADING. JUST REVERSE LEGS.

COCKY BOUNCE-WALK (ARMS SWINGING) – FIRST DRAWING IS CONTACT, NEXT IS RECOIL, THEN A LIFT, THEN A HIGH "FLOAT," AND THEN BACK TO CONTACT (OPPOSITE FOOT).

WALK – AS LEG LIFTS, HIPS TILT. CHEST TILTS OTHER WAY TO BALANCE.

RUN – ARMS LIFT AND SWING TO BALANCE HIP TILT AND LEG ACTION.

TROT – OPPOSITE LEGS LIFT AND CONTACT TOGETHER IN SYNC. IN A PACE ACTION SEE THE SAME FRONT AND BACK LEGS WORK TOGETHER.

CANTER – THE BODY TILTS WITH A RISING AND FALLING ACTION THAT IS SIMILAR TO A CHILDREN'S SEESAW, CAUSING RIDER TO STAND.

TRANSVERSE GALLOP – LEFT LEGS CAN LEAD TOO. THE SAME LEGS LEAD, UNLIKE DOG AND DEER THAT GALLOP WITH OPPOSITE LEGS LEADING.

CHARACTER MOVEMENT

Once the character has been developed, the animator must consider the types of actions that are appropriate for it. A character's basic design should contain a sense of movement to convey a message to the viewer about the character's actions and intended actions. One way to accomplish this is to use the "line of action" that is the basis for rhythm, simplicity, and directness.

This chapter includes rhythm charts for creating movements of both humans and animals. These charts demonstrate that not only must the head, legs, arms, and hands move in proper relation to one another, but also the body mass must follow. The exercises on pages 100-101 that demonstrate the movements of a man diving into a pool and of a bouncing ball are excellent examples of accurate follow-through. Movements within the figure such as "squashing," "twisting," and "stretching" are only a few of the movements studied in this chapter. An animation cycle is a series of drawings that take a character through a complete movement (for instance, a walking step). Complete cycles for continuous animated movement and the differences in body attitudes for such movements as running, walking, dancing, posing, and much more are also included. Another subject introduced in this chapter is adapting a character to a background. This subject is covered in detail in the "Technical" chapter starting on page 195, but this introduction is an excellent stepping-stone to the more complex instructions.

By following the instructions in this chapter, you can make any character—person, animal, or inanimate object—come to life through animated movement. It is exciting and great fun to do.

LINE OF ACTION

AN IMAGINARY LINE EXTENDING THROUGH THE MAIN ACTION OF THE FIGURE IS THE "LINE OF ACTION." PLAN YOUR FIGURE AND ITS DETAILS TO ACCENTUATE THIS LINE. BY DOING SO, YOU WILL STRENGTHEN THE DRAMATIC EFFECT. THE FIRST THING TO DRAW WHEN CONSTRUCTING A FIGURE IS THE LINE OF ACTION.

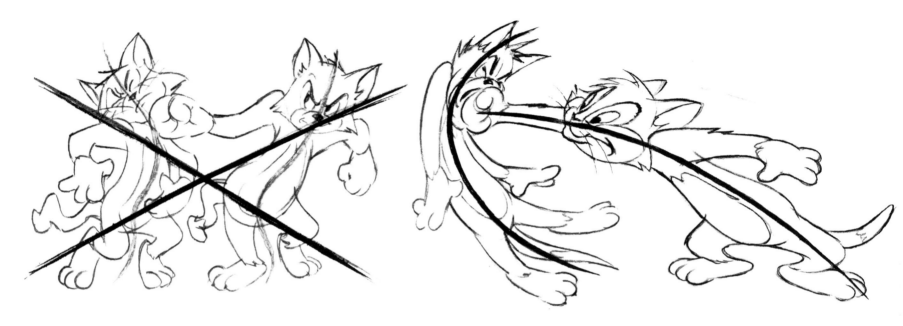

WRONG! THE LINES OF ACTION DO NOT FIT. CORRECT! THE LINES OF ACTION FIT AND ARE ACCENTUATED.

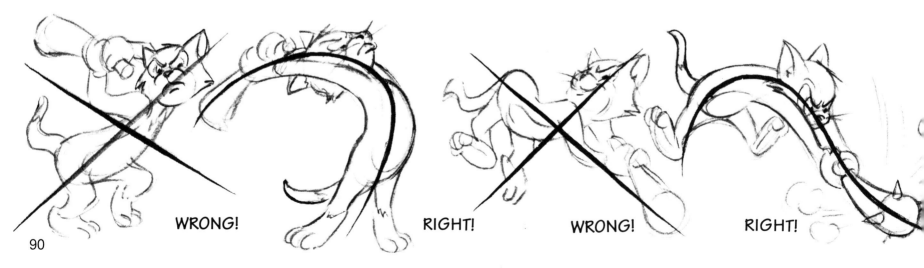

WRONG! RIGHT! WRONG! RIGHT!

STUDY THESE DRAWINGS IN WHICH I'VE INDICATED THE LINE OF ACTION.

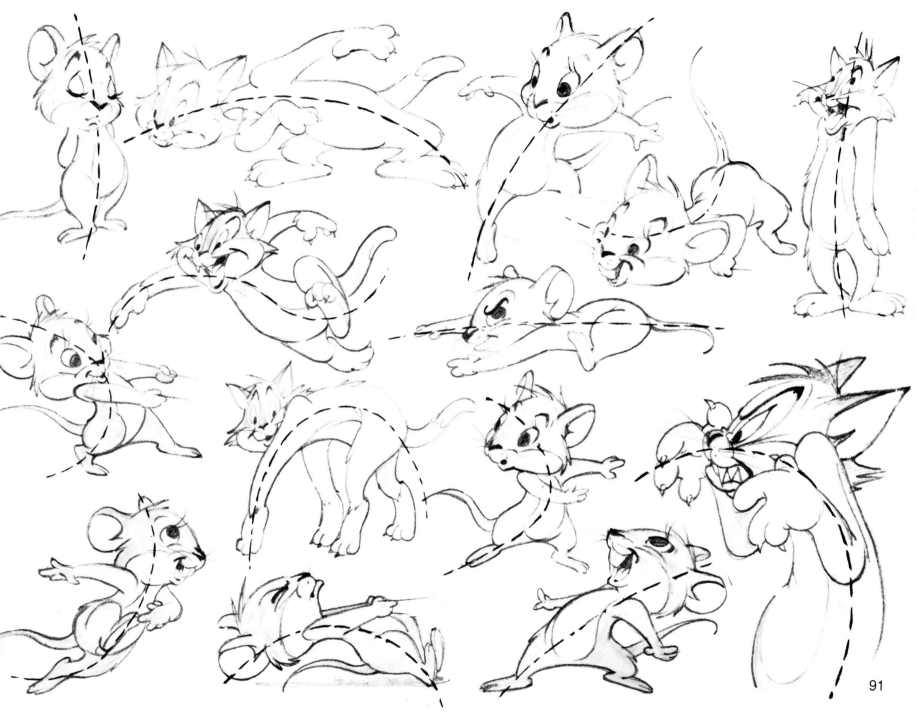

LINE OF ACTION IN ANIMATION

THE LINE OF ACTION IS THE BASIS FOR RHYTHM, SIMPLICITY, AND DIRECTNESS IN ANIMATION. START YOUR ANIMATION WITH A LINE OF ACTION. THEN DRAW THE SKELETON AND THE DETAILS.

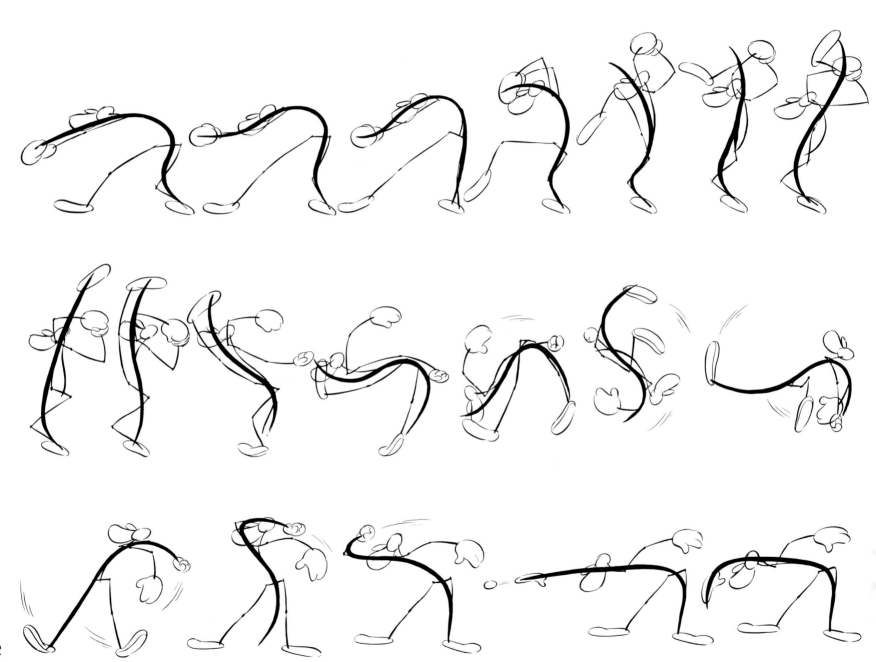

FINALLY ... ANIMATE ALL THE DETAILS.

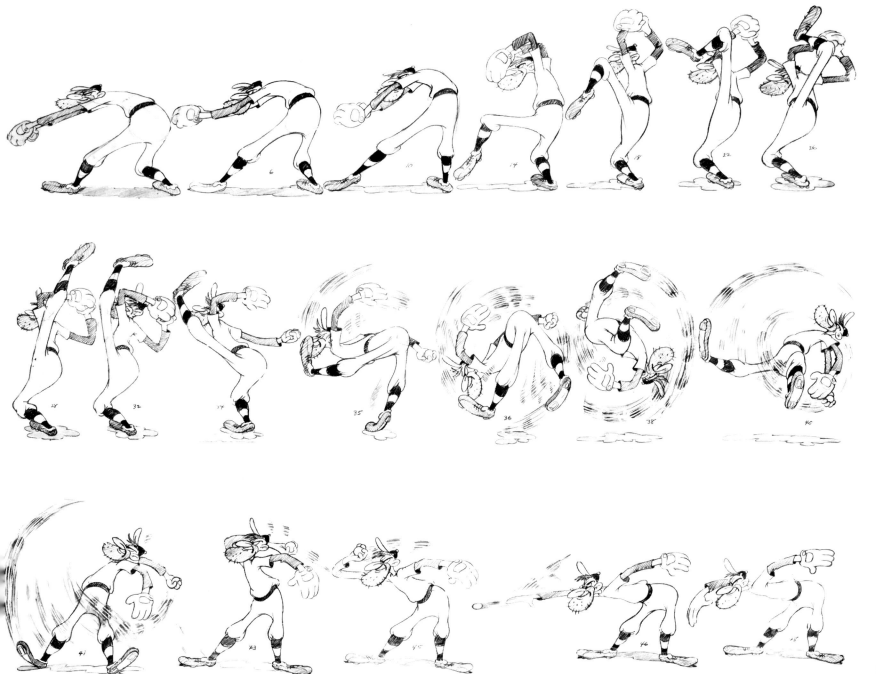

RHYTHM AND DESIGN IN CARTOON ART

RHYTHM AND DESIGN ARE THE SECRET FORMULAS BEHIND THE APPEAL AND CHARM OF GREAT CARTOON ART. ARTISTS HAVE INSTINCTS THAT TELL THEM THESE THINGS. THE FOLLOWING ABSTRACT DESIGN BASIS SHOULD HELP YOU.

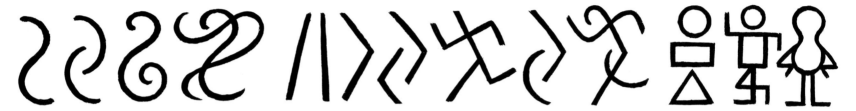

THE "LINE OF BEAUTY" CURVE AND VARIATIONS THE STRAIGHT LINE BECOMES ANGULAR DESIGNS GEOMETRIC SHAPES ARE THE BASIS OF MANY CARTOONS

THE BASIC "S" CURVE OF RHYTHM AND THE OPPOSING ARCS (SECOND FROM LEFT) HAVE GREAT VALUE FOR YOUR DRAWINGS. LEARN THEIR VALUES, SUCH AS THE "VALUE OF A STRAIGHT LINE." MANY DRAWINGS FAIL WITHOUT IT.

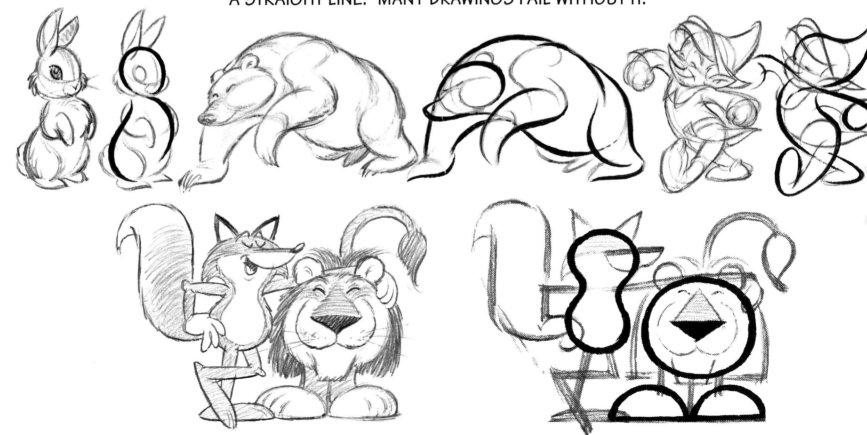

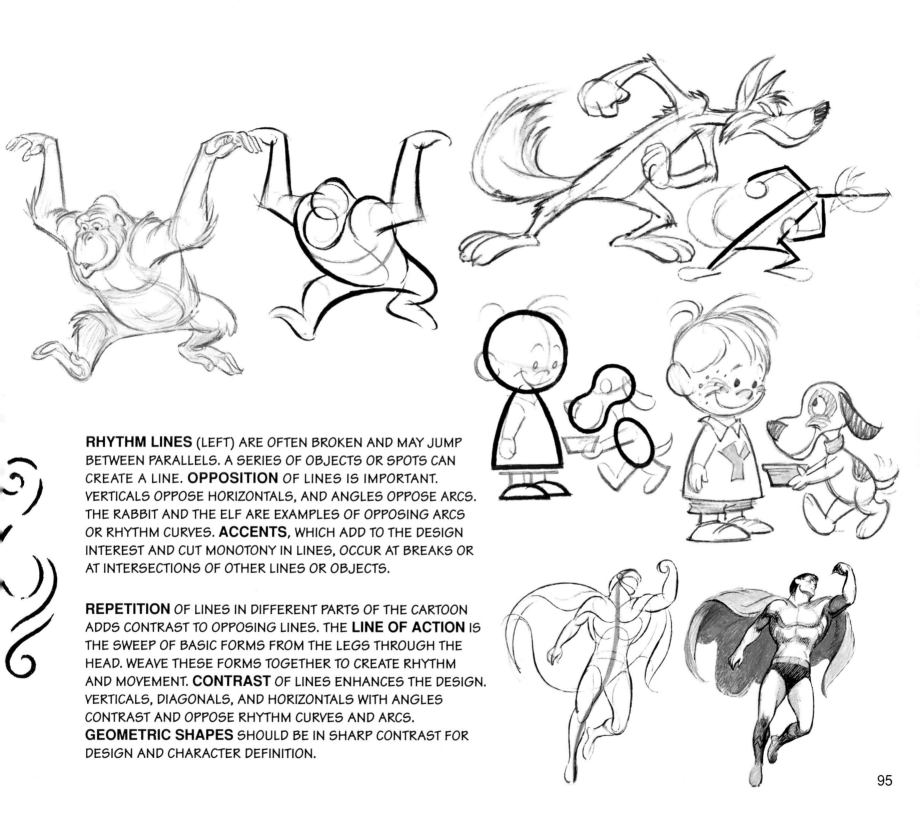

RHYTHM LINES (LEFT) ARE OFTEN BROKEN AND MAY JUMP BETWEEN PARALLELS. A SERIES OF OBJECTS OR SPOTS CAN CREATE A LINE. **OPPOSITION** OF LINES IS IMPORTANT. VERTICALS OPPOSE HORIZONTALS, AND ANGLES OPPOSE ARCS. THE RABBIT AND THE ELF ARE EXAMPLES OF OPPOSING ARCS OR RHYTHM CURVES. **ACCENTS**, WHICH ADD TO THE DESIGN INTEREST AND CUT MONOTONY IN LINES, OCCUR AT BREAKS OR AT INTERSECTIONS OF OTHER LINES OR OBJECTS.

REPETITION OF LINES IN DIFFERENT PARTS OF THE CARTOON ADDS CONTRAST TO OPPOSING LINES. THE **LINE OF ACTION** IS THE SWEEP OF BASIC FORMS FROM THE LEGS THROUGH THE HEAD. WEAVE THESE FORMS TOGETHER TO CREATE RHYTHM AND MOVEMENT. **CONTRAST** OF LINES ENHANCES THE DESIGN. VERTICALS, DIAGONALS, AND HORIZONTALS WITH ANGLES CONTRAST AND OPPOSE RHYTHM CURVES AND ARCS. **GEOMETRIC SHAPES** SHOULD BE IN SHARP CONTRAST FOR DESIGN AND CHARACTER DEFINITION.

MOVEMENT OF BODY MASSES

HERE ARE SOME SIMPLIFIED FIGURES IN ACTION TO SHOW YOU THE TWIST AND TURN AND THE VARIATION OF PERSPECTIVE IN THE MAIN BODY MASSES. BUILDING THE FIGURE IN SOLIDS MAKES ANIMATION EASIER TO "FEEL OUT."

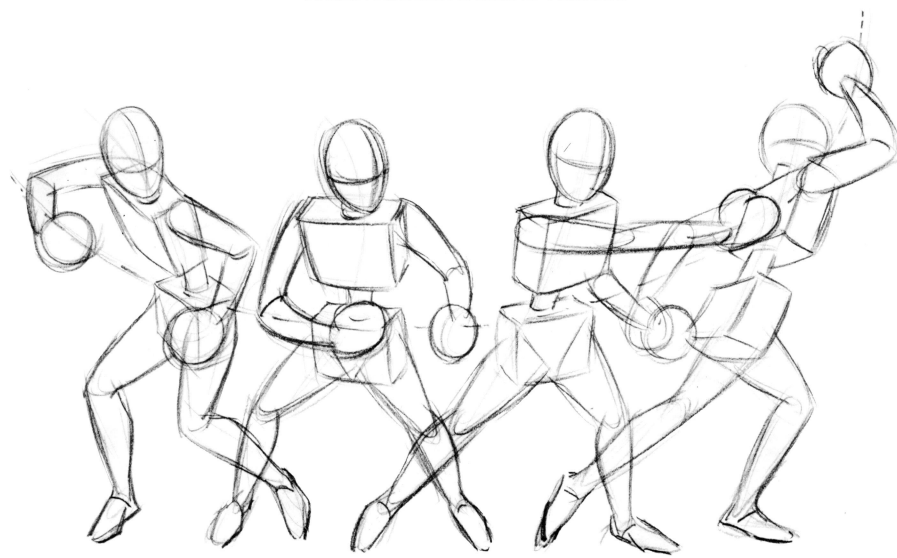

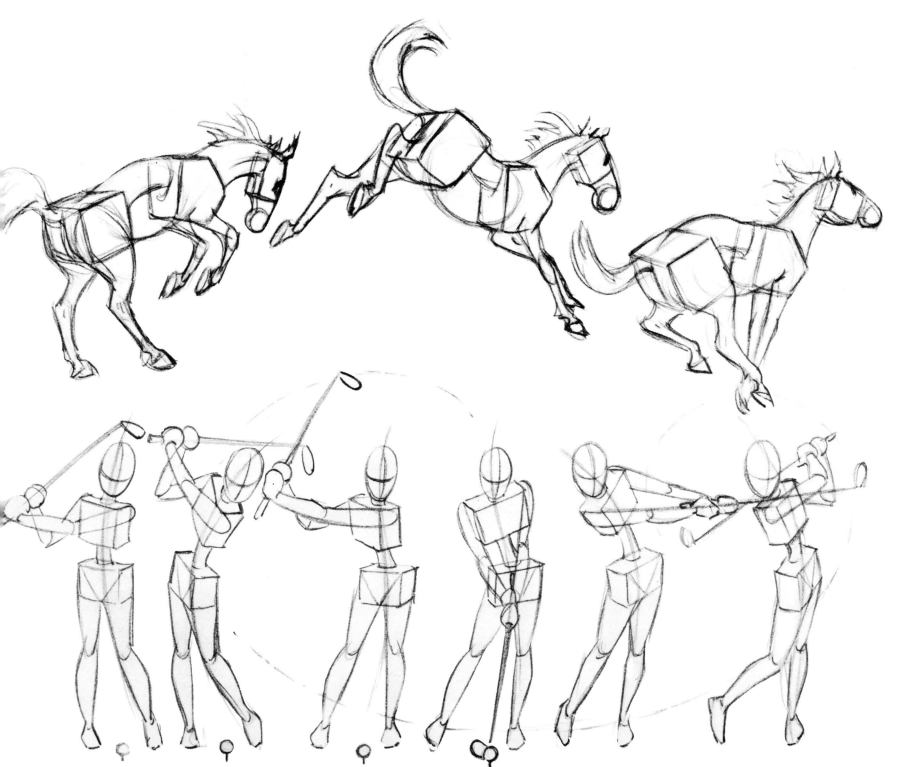

MOVEMENTS OF THE TWO-LEGGED FIGURE

A COMPLETE CYCLE FOR A TWO-LEGGED WALK IS TWO STEPS. DRAWINGS ARE MADE OF THE KEY POSITIONS OF THE STEPPING ACTION UNTIL THE NEXT DRAWING WOULD BE A REPEAT OF THE FIRST. THE DRAWINGS CAN BE USED OVER AND OVER AGAIN TO MAKE THE CHARACTER WALK AS FAR OR AS LONG AS DESIRED.

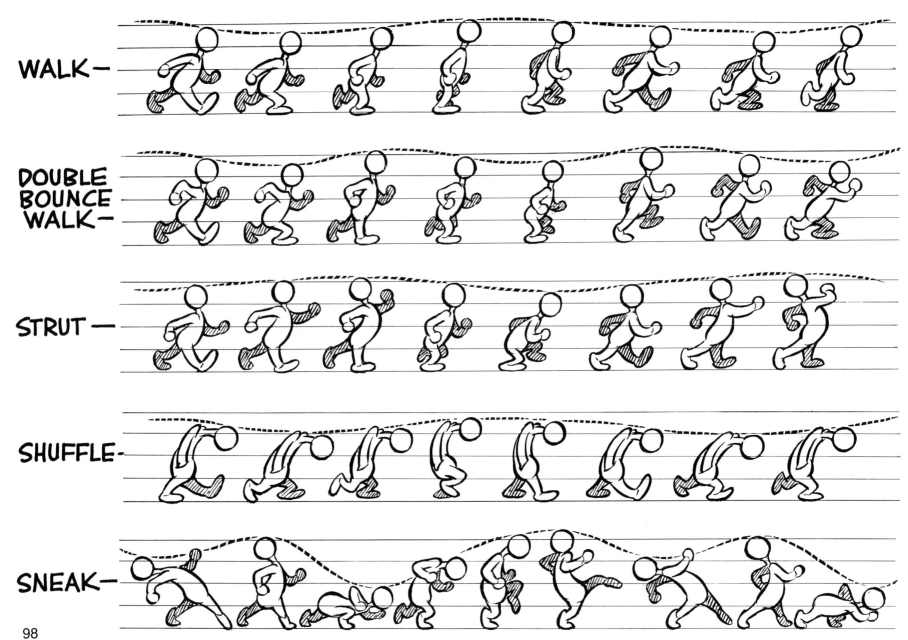

WALK—

DOUBLE BOUNCE WALK—

STRUT—

SHUFFLE-

SNEAK—

FOR A HALF-CYCLE, HALF OF THE ACTION (ONE STEP) CAN BE DRAWN, AND THEN THE HANDS, ARMS, LEGS, AND FEET CAN BE SWITCHED FROM SIDE TO SIDE, ESSENTIALLY CREATING A COMPLETE ACTION WITHOUT REDRAWING ALL OF THE BODY AND HEAD POSITIONS.

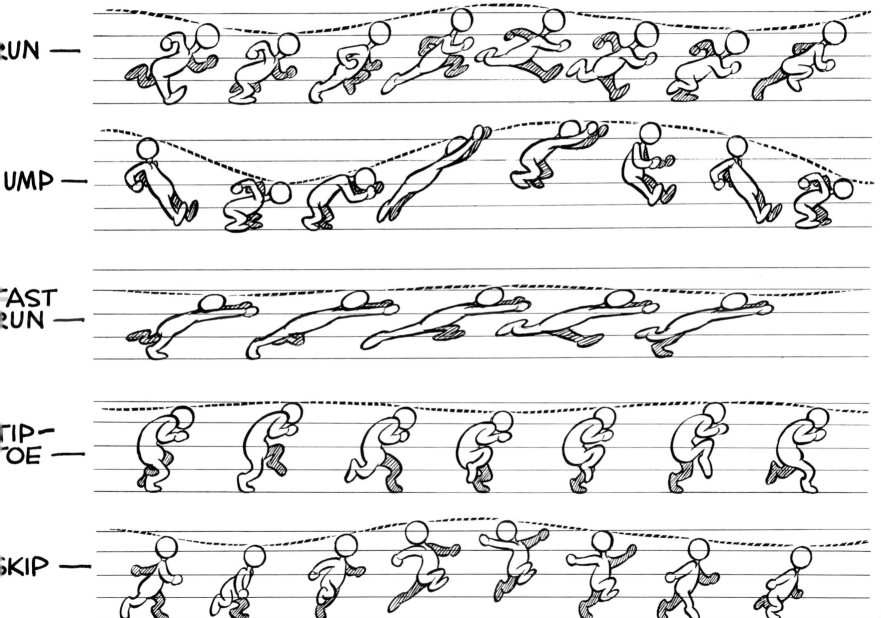

RUN —

UMP —

AST
RUN —

TIP-
OE —

SKIP —

THE BASIC BOUNCING BALL ACTION

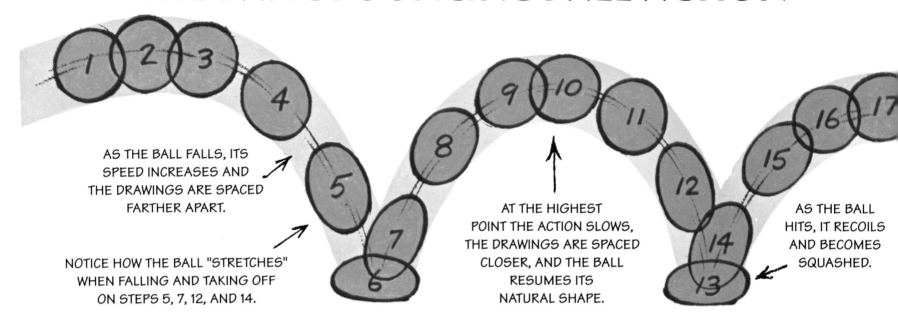

AS THE BALL FALLS, ITS SPEED INCREASES AND THE DRAWINGS ARE SPACED FARTHER APART.

NOTICE HOW THE BALL "STRETCHES" WHEN FALLING AND TAKING OFF ON STEPS 5, 7, 12, AND 14.

AT THE HIGHEST POINT THE ACTION SLOWS, THE DRAWINGS ARE SPACED CLOSER, AND THE BALL RESUMES ITS NATURAL SHAPE.

AS THE BALL HITS, IT RECOILS AND BECOMES SQUASHED.

THE BALL FOLLOWS A DEFINITE PATH OF ACTION. STUDY THE SPACING OF THE BALL ALONG THIS PATH. NOTICE THE SIMILARITY OF THE BALL ACTION TO THE HOP AND JUMP BELOW.

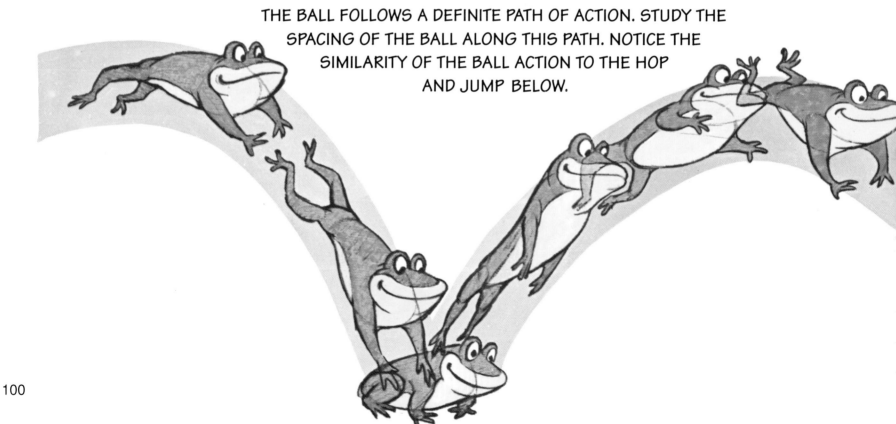

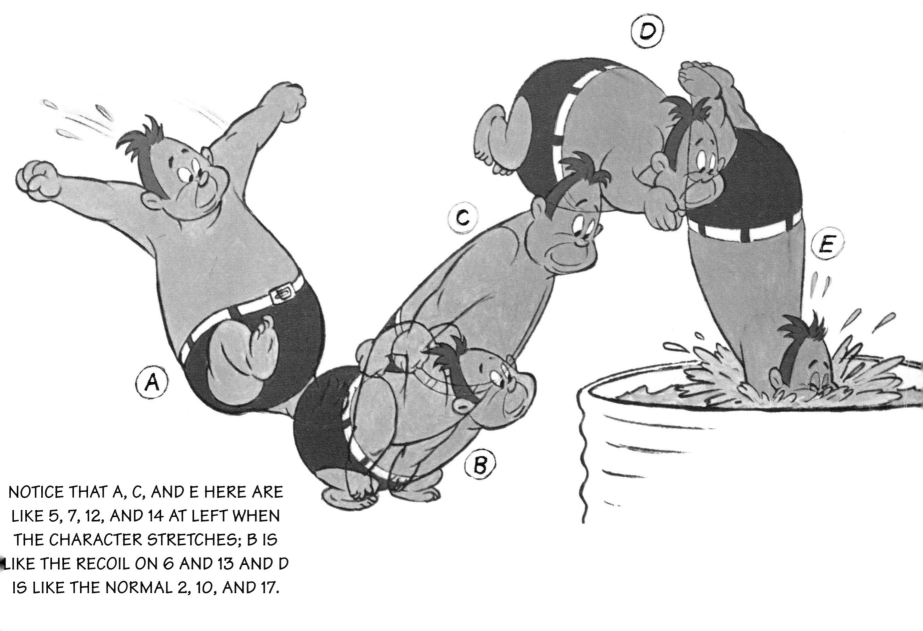

NOTICE THAT A, C, AND E HERE ARE LIKE 5, 7, 12, AND 14 AT LEFT WHEN THE CHARACTER STRETCHES; B IS LIKE THE RECOIL ON 6 AND 13 AND D IS LIKE THE NORMAL 2, 10, AND 17.

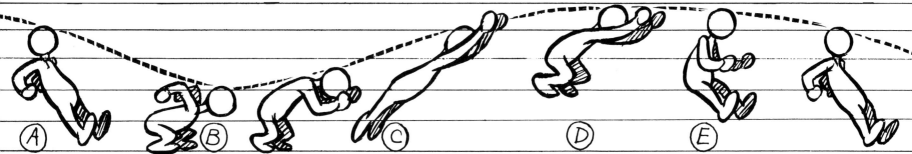

HERE THE ARMS ARE FLUNG UP SUDDENLY TO CREATE MOMENTUM HELPING THE JUMP.

MOVEMENTS OF THE FOUR-LEGGED FIGURE

HERE IS A COMPARISON OF THE MAIN CYCLES OF FOUR-LEGGED MOVEMENT. SOME OF THEM ARE COMPLETE—OTHERS ARE HALF-CYCLES (YOU CAN DRAW THEM ON THE OPPOSITE FEET FOR THE REST OF THE CYCLE). STUDY THE DIFFERENCES IN THE EXAMPLES. THE WALK, TROT, SNEAK, STRUT, AND TIPTOE ARE HALF-CYCLES. THE GALLOP, CANTER, AND SNIFF ARE COMPLETE CYCLES.

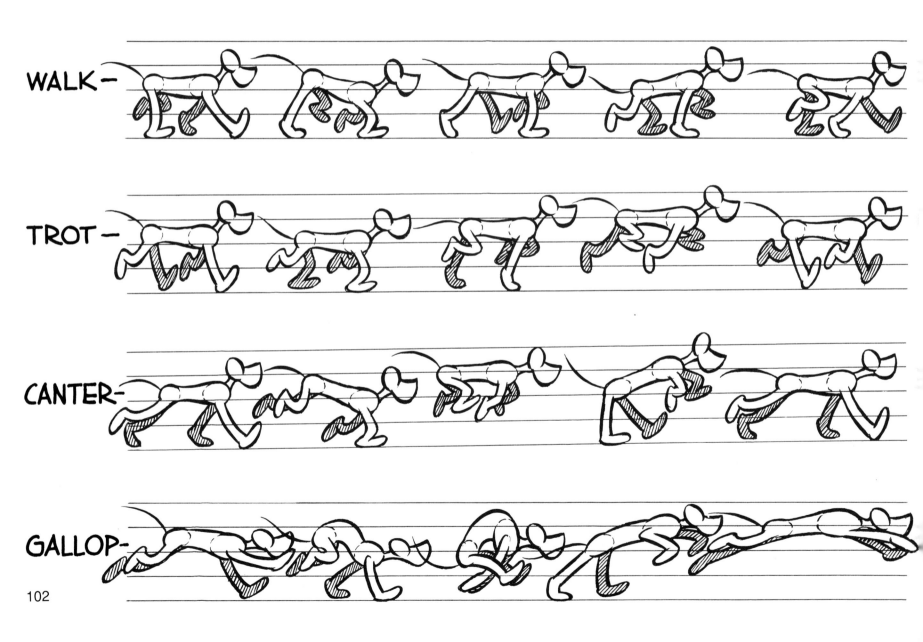

WALK-

TROT-

CANTER-

GALLOP-

102

IN-BETWEEN DRAWINGS ARE MADE BETWEEN THE KEY DRAWINGS AS TRANSITIONS TO CREATE A SMOOTH MOVEMENT OF THE FIGURE. YOU MUST DRAW ENOUGH IN-BETWEENS TO MAKE THE ACTION SMOOTH FOR THE SPECIFIC SPEED OF THE ACTION AND THE TIMING IN FILMING.

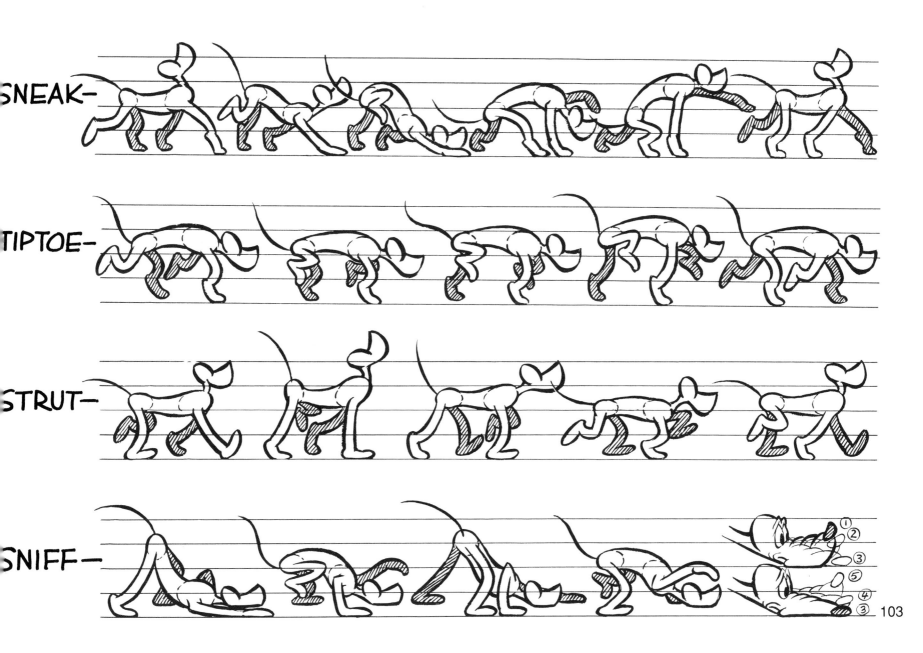

SNEAK—

TIPTOE—

STRUT—

SNIFF—

FRONT AND REAR VIEWS OF FIGURE MOVEMENTS

ALL ACTIONS TAKE ON DIFFERENT CHARACTERISTICS. HERE IS A WALK AND RUN FROM THE FRONT AND REAR VIEWS. ANIMATING FROM THESE ANGLES IS LIKE WATCHING A FOOTBALL

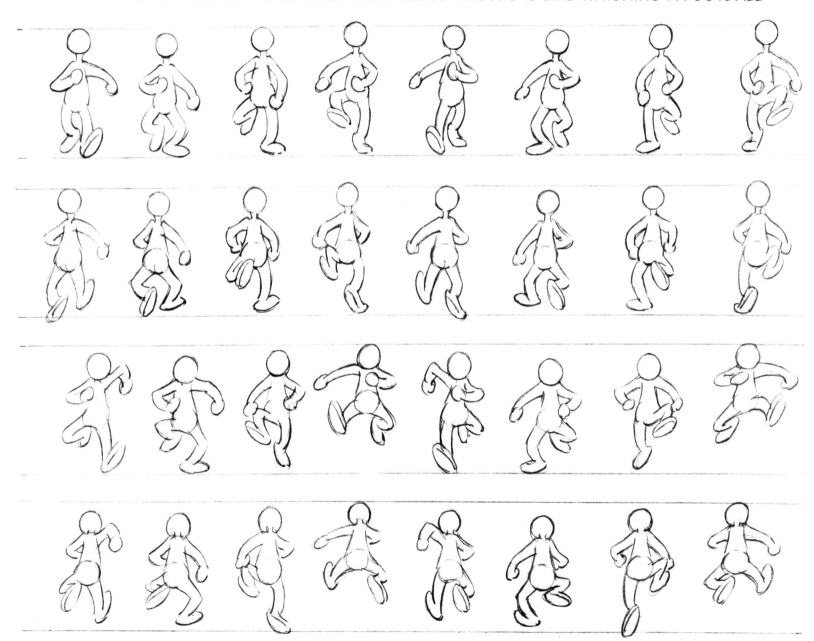

GAME FROM THE END ZONE. STUDY THE ACTIONS BELOW; THEN USE THEM AS A GUIDE
TO ANIMATE SOME OF THE CHARACTERS SHOWN IN THE FIRST CHAPTER.

THE DIFFERENCE BETWEEN WALK AND RUN

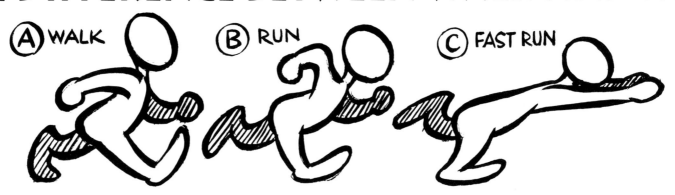

(A) WALK (B) RUN (C) FAST RUN

ABOVE ARE THE CONTACT DRAWINGS FROM (A) THE WALK, (B) THE RUN, AND (C) THE FAST RUN. THE CONTACT DRAWING IS THE DRAWING IN WHICH THE FOOT, AFTER BEING LIFTED, STRIKES THE GROUND. IN THE LAYOUT OF A RUN OR A WALK FOR ANIMATION, IT IS USUALLY THESE CONTACT DRAWINGS THAT ARE DETERMINED FIRST. THEY SET THE SPEED AND THE SIZE OF THE CHARACTER. THE REST OF THE ACTION IS THEN BUILT AROUND THEM.

MORE THAN ANY OTHER SINGLE FACTOR, THE POSITION OF THE BACK FOOT ON THE CONTACT DRAWING DETERMINES THE SPEED. NOTICE THAT ON STEP A THE BACK FOOT IS STILL TOUCHING THE GROUND. ON STEP B THE BACK FOOT HAS LEFT THE GROUND. ON STEP C THE POSITION OF THE BACK FOOT IS EVEN HIGHER.

ON THE WALK, THE FRONT FOOT IS STRETCHED OUT AND THE BODY

IS UPRIGHT, DENOTING SLOW SPEED. ON THE RUN, THE BODY LEANS FORWARD AND THE FRONT FOOT IS FARTHER BACK. ON THE FAST RUN, THE BODY LEANS FAR FORWARD, DENOTING SPEED, AND THE FRONT FOOT IS BACK UNDER THE BODY.

THE ARMS SWING CONVERSELY WITH THE LEGS. THE LEFT ARM SWINGS WITH THE RIGHT LEG AND VICE VERSA. THE ARMS SWING MORE VIOLENTLY IN THE RUN, BUT IN THE FAST RUN THE SWING OF THE ARMS WOULD BE TOO VIOLENT; THEY ARE MORE EFFECTIVE WHEN HELD STRAIGHT OUT IN A REACHING POSITION.

COMPARE THE ACTION OF THE WALK WITH THE RUN. IN THE WALK THE ARMS AND LEGS ARE STRETCHED OUT THE FARTHEST IN THE CONTACT DRAWING; HOWEVER, IN THE RUN THE STRETCH COMES WHEN THE FIGURE IS IN MIDAIR AT THE HIGH POINT OF THE ACTION.

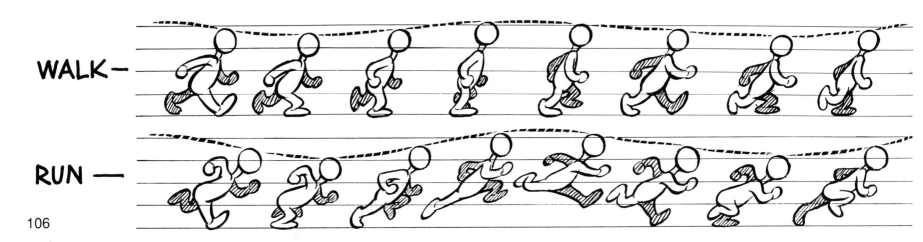

WALK —

RUN —

THE WALK

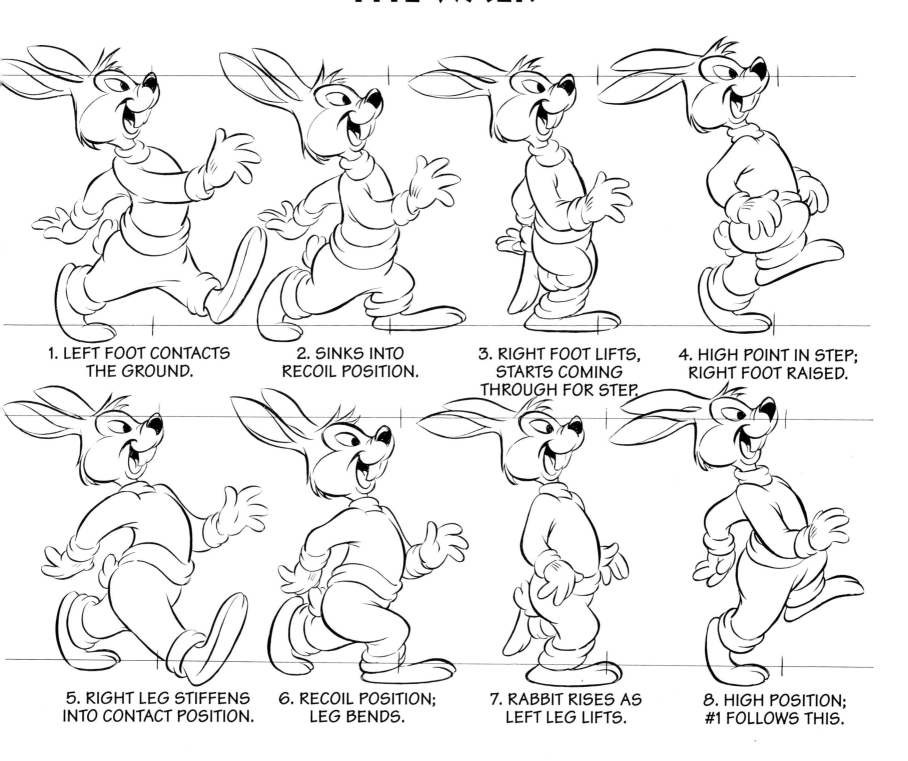

1. LEFT FOOT CONTACTS THE GROUND.

2. SINKS INTO RECOIL POSITION.

3. RIGHT FOOT LIFTS, STARTS COMING THROUGH FOR STEP.

4. HIGH POINT IN STEP; RIGHT FOOT RAISED.

5. RIGHT LEG STIFFENS INTO CONTACT POSITION.

6. RECOIL POSITION; LEG BENDS.

7. RABBIT RISES AS LEFT LEG LIFTS.

8. HIGH POSITION; #1 FOLLOWS THIS.

THE RUN

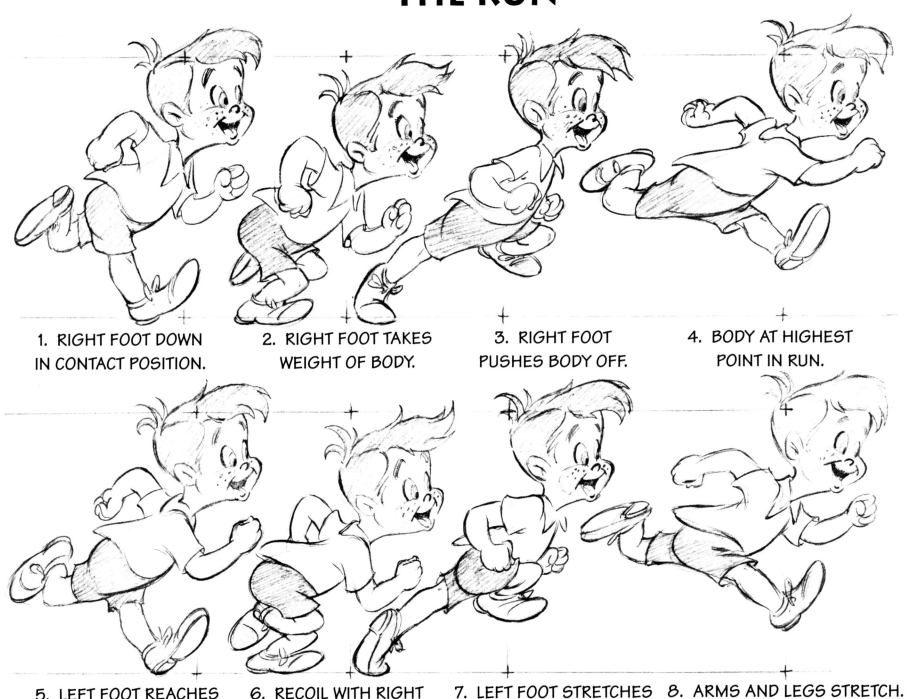

1. RIGHT FOOT DOWN IN CONTACT POSITION.

2. RIGHT FOOT TAKES WEIGHT OF BODY.

3. RIGHT FOOT PUSHES BODY OFF.

4. BODY AT HIGHEST POINT IN RUN.

5. LEFT FOOT REACHES FOR GROUND.

6. RECOIL WITH RIGHT FOOT COMING THROUGH.

7. LEFT FOOT STRETCHES FOR RECOIL.

8. ARMS AND LEGS STRETCH. #1 FOLLOWS THIS.

THE FAST RUN

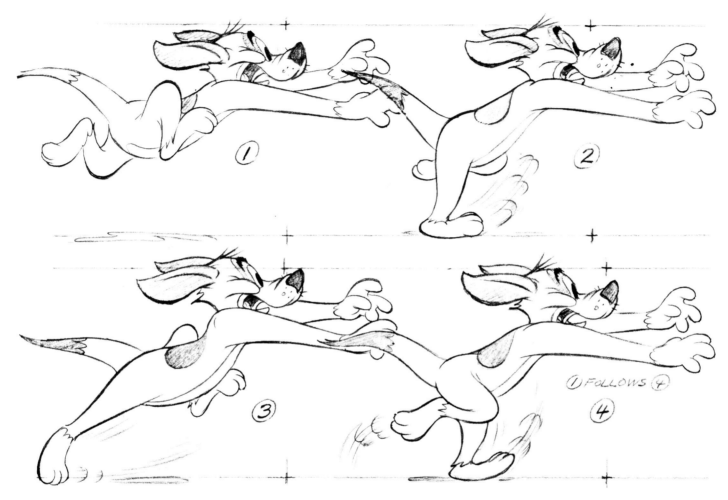

WHEN ANIMATING THE FAST RUN, TRY NOT TO HAVE TWO ACTION DRAWINGS IN THE SAME SILHOUETTE POSITION WITHIN ONE OR TWO FRAMES (EXPOSURES). THIS WOULD MAKE THE ACTION APPEAR MONOTONOUS AND MIGHT EVEN CREATE A FALSE ILLUSION AND A DIFFERENT EFFECT THAN THE ONE YOU ARE TRYING TO ACHIEVE (FOR EXAMPLE, THE WAGON WHEELS IN OLD WESTERN MOVIES THAT APPEAR TO BE GOING BACKWARDS). IN THE WALK AND THE RUN THERE ARE ENOUGH DRAWINGS BETWEEN SIMILAR SILHOUETTE POSITIONS—STEPS 1 AND 5 AT LEFT—SO THERE IS NO PROBLEM. BUT THAT IS NOT THE CASE WITH THIS FOUR-DRAWING CYCLE OF A FAST RUN. NOTICE THAT ALL

FOOT ACTION DRAWINGS ARE VARIED: STEP 3 IS DIFFERENT THAN STEP 1 AND STEP 2 IS DIFFERENT THAN STEP 4. THERE IS A SINGLE CIRCULAR ACTION ON THE HEAD AND BODY INSTEAD OF A DOUBLE CIRCULAR ACTION AS IN THE WALK AND RUN. NOTICE HOW THE SPEED LINES AROUND THE FEET HELP ILLUSTRATE THE FAST ACTION.

THE CROSSES ABOVE AND BELOW THE DRAWINGS REPRESENT A FIXED POINT ON THE SCREEN. THEY ENSURE THE PROPER POSITIONING OF THE FIGURE. IF YOU TRACE THESE REPEATS, BE SURE THE CROSSES COINCIDE.

THE SNEAK

THESE ARE THE KEY DRAWINGS IN A 64-DRAWING SNEAK CYCLE. THE MISSING NUMBERS ARE IN-BETWEENS. DRAWING 1 FOLLOWS DRAWING 64. WHEN TRACING, BE SURE THE CROSSES ABOVE AND BELOW THE CHARACTER COINCIDE.

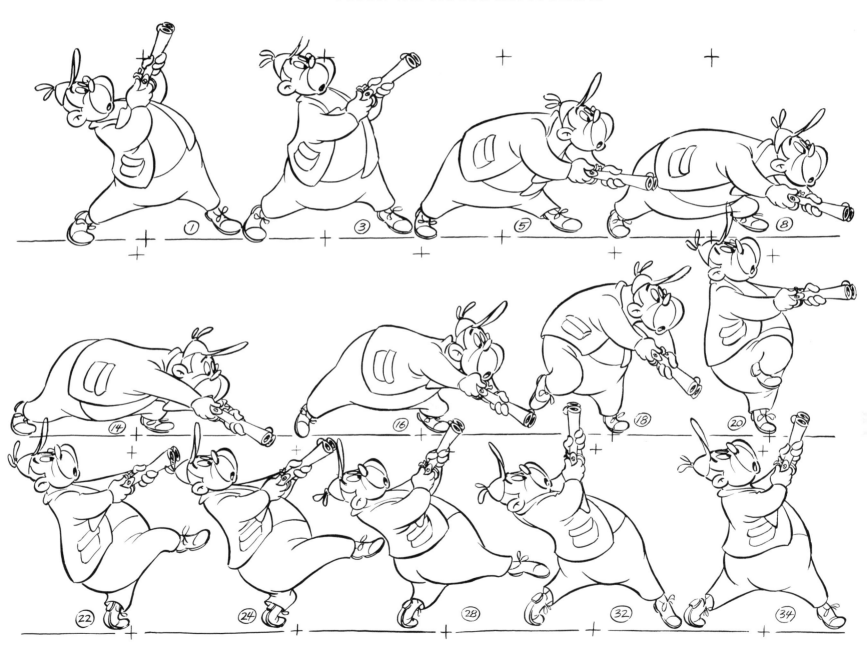

THE SNEAK IS A WALK IN WHICH THE RECOIL (AFTER THE FOOT CONTACTS THE GROUND) IS EXAGGERATED AND THE SPEED OF THE FOOT COMING DOWN INTO THE CONTACT POSITION IS SLOWED. THIS CREATES THE ILLUSION OF STEALTH—THAT THE FEET ARE CAREFULLY PLACED TO PREVENT NOISE AND EVADE DETECTION.

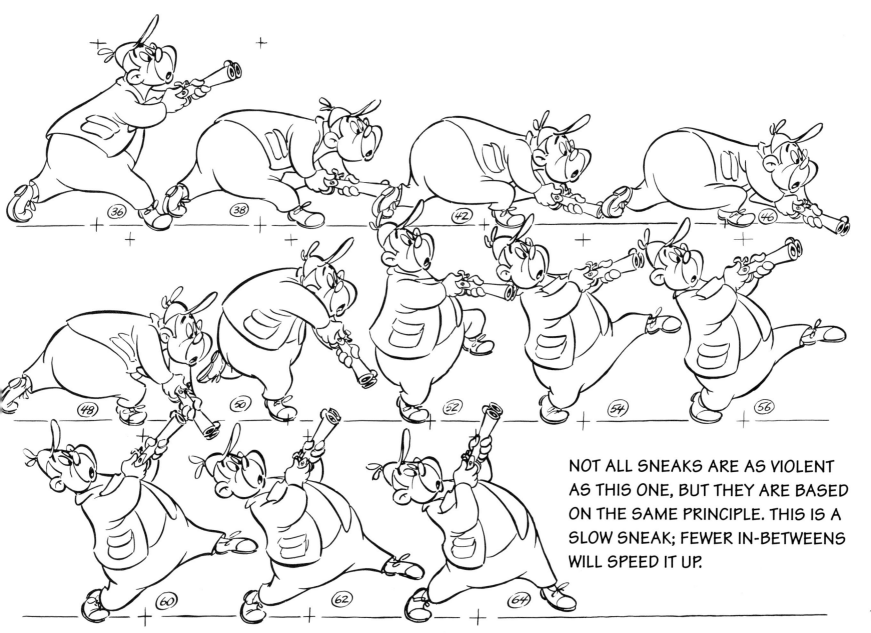

NOT ALL SNEAKS ARE AS VIOLENT AS THIS ONE, BUT THEY ARE BASED ON THE SAME PRINCIPLE. THIS IS A SLOW SNEAK; FEWER IN-BETWEENS WILL SPEED IT UP.

THE SKIP

HERE ARE THE EXTREMES OF A 24-DRAWING SKIP CYCLE. THE MISSING DRAWINGS ARE IN-BETWEENS (DRAWINGS SPACED EVENLY BETWEEN THE EXTREMES). THE EXCEPTIONS ARE STEPS 12 AND 24. NOTICE THE CHARTS (CALLOUTS AND NUMBERS) EXPLAINING THE UNEVEN SPACING ON THESE DRAWINGS. INSTEAD OF BEING SPACED EVENLY BETWEEN STEPS 11 AND 13, 12 IS 1/3 OF THE WAY (CLOSER TO 11). THE SAME THING HAPPENS WITH 24, WHICH IS 1/3 OF THE WAY BETWEEN STEPS 23 AND 1. DRAWING 24 COMPLETES THE CYCLE.

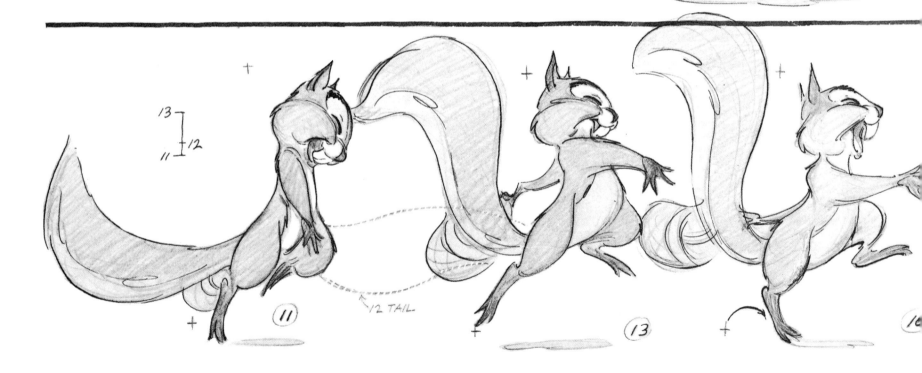

THE BODY AND THE HANDS IN THE SKIP ARE THE SAME AS IN THE RUN. THE DIFFERENCE IS IN THE ACTION OF THE FOOT THAT PUSHES THE BODY OFF THE GROUND AND THEN RAISES IN AN ARC AND CONTACTS THE GROUND FIRST.

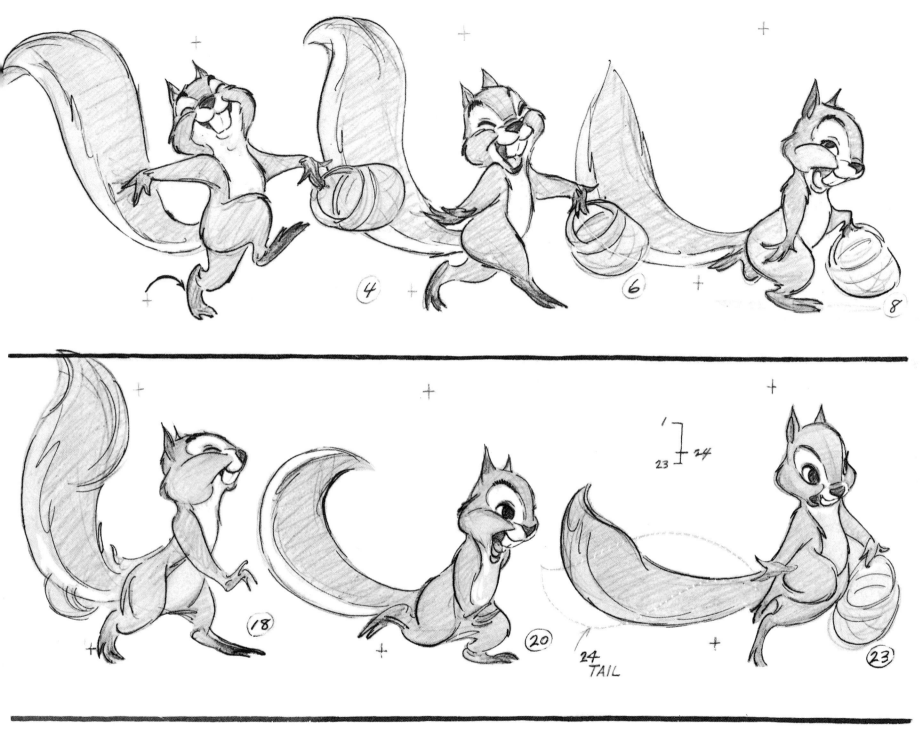

THE CROSS MARKS ABOVE AND BELOW EACH DRAWING ARE REGISTRATION MARKS. TRACE
EACH DRAWING ON A SEPARATE SHEET OF PAPER—MAKING SURE THE CROSSES OVERLAP—AND THEN
FLIP THE DRAWINGS AND STUDY THE ACTION.

THE STRUT

BEGINNING WITH A POSE ON STEP 1, THE STRUT STEP STARTS ON 8, AND ENDS ON 36. THEN THE CHARACTER GOES INTO ANOTHER POSE ON 42. THE ACTION IS COMPLETE AS IS AND CANNOT BE HOOKED UP INTO A CYCLE. THE WALK IS SIMILAR TO THE STRUT, EXCEPT IN THE STRUT THE HIGH POINT IN THE ACTION IS WHEN THE FOOT CONTACTS THE GROUND, AND THE LOWEST POINT IS WHEN THE FOOT IS LIFTED. (IN THE WALK THIS IS REVERSED.) MISSING NUMBERS IN THIS ACTION ARE IN-BETWEENS; SOME ARE UNEVENLY SPACED. WHEN AN IN-BETWEEN IS UNEVENLY SPACED, A CHART IS MADE NEXT TO THE EXTREME SHOWING THE IN-BETWEEN'S POSITION. ALL OF THESE DRAWINGS ARE EXTREMES. BELOW ARE THE IN-BETWEEN CHARTS THAT WERE PUT ON THEM.

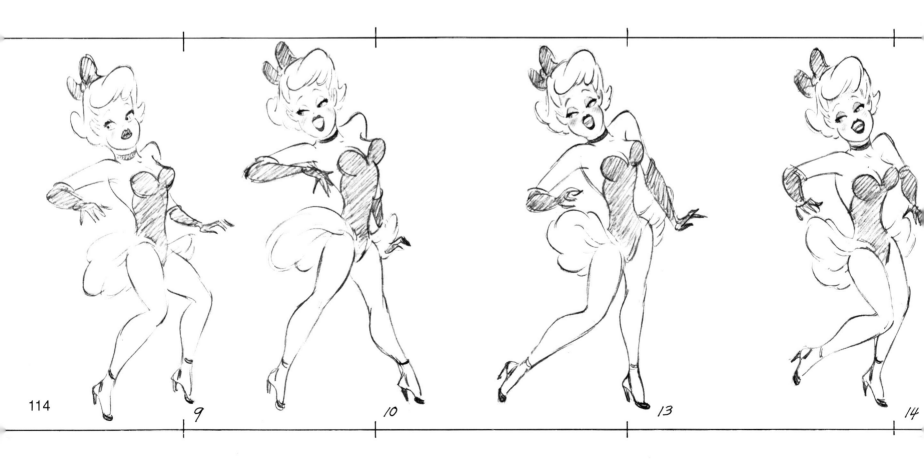

114 9 10 13 14

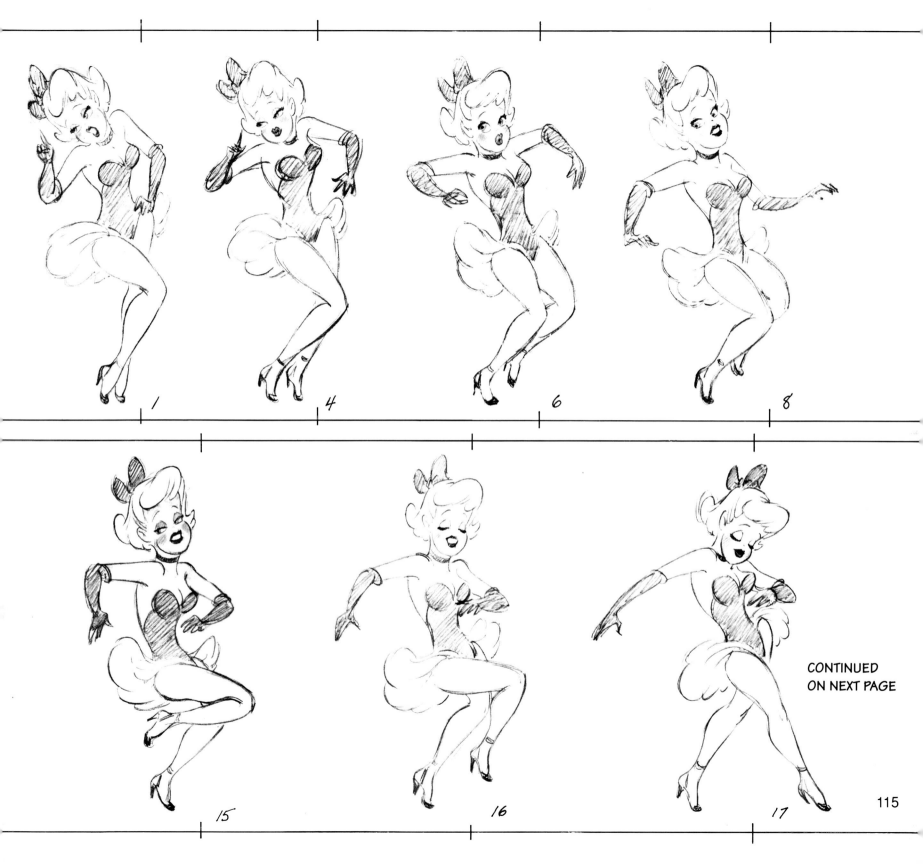

1

4

6

8

15

16

17

CONTINUED
ON NEXT PAGE

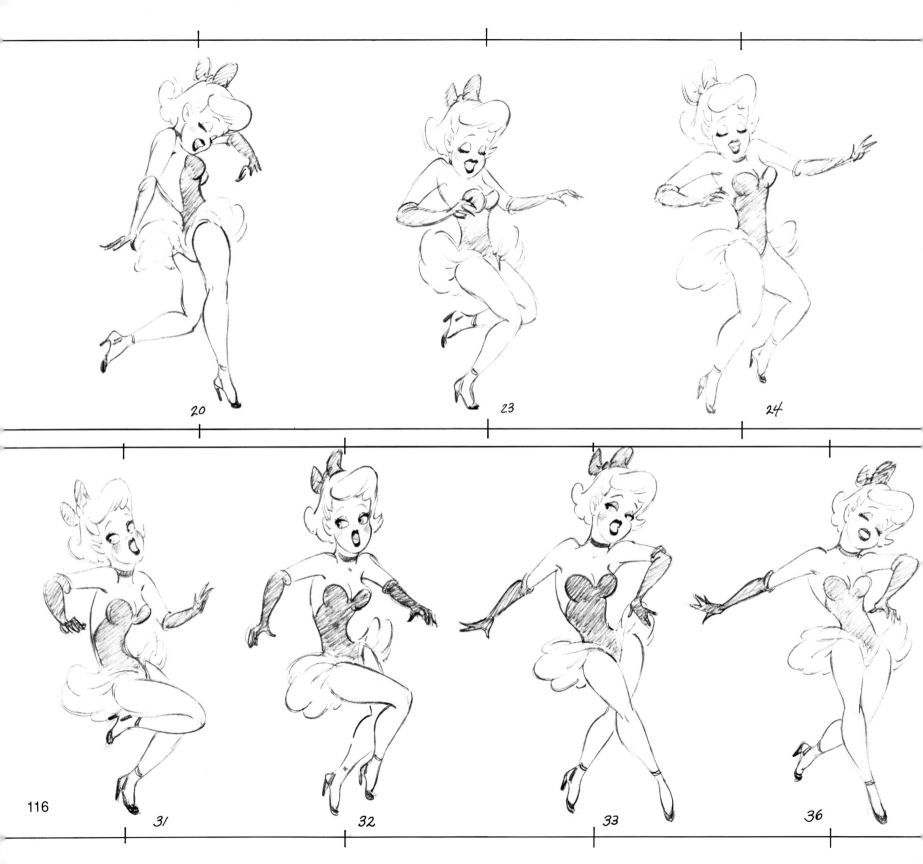

20

23

24

116

31

32

33

36

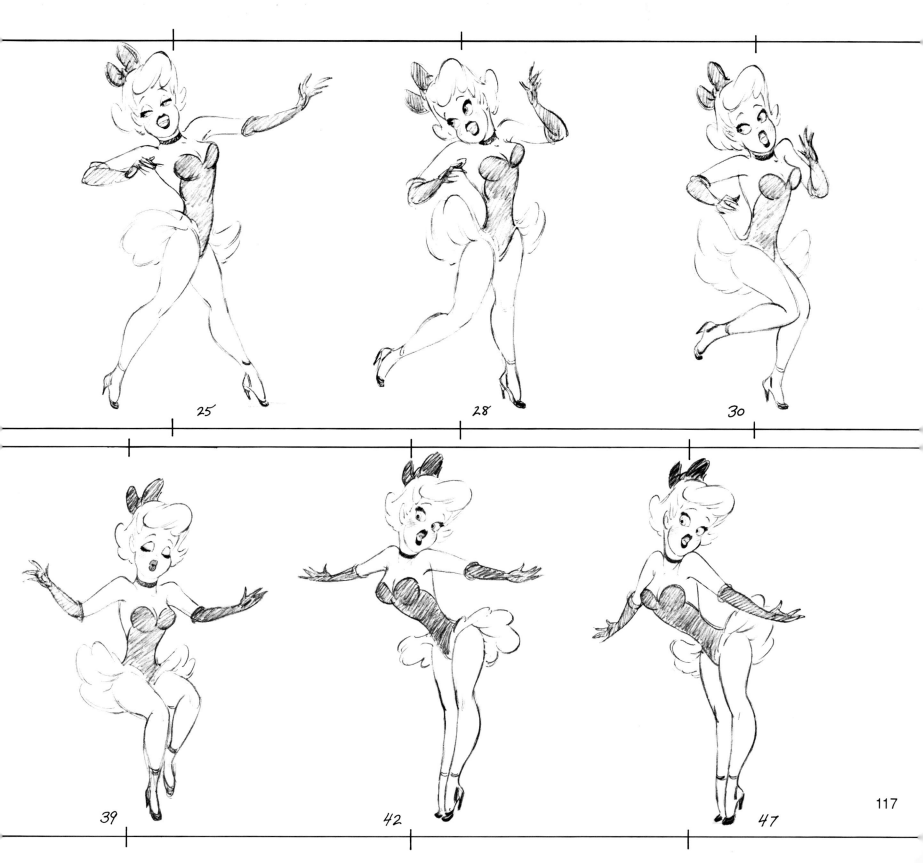

25

28

30

39

42

47

117

FOUR-LEGGED ANIMALS

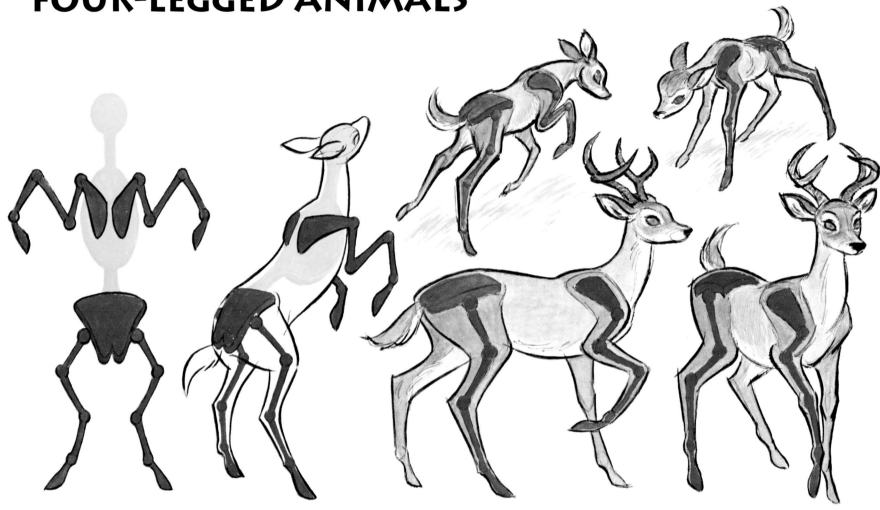

THIS SIMPLIFIED SKELETON DIVIDES THE ANIMAL'S BODY INTO THREE SECTIONS: THE FOREQUARTERS, THE BELLY, AND THE REAR QUARTERS. NOTICE THAT THE JOINTS OF THE SHOULDER BLADES AND THE HIP FORMS NEED TO BE DEFINED OR AT LEAST SUGGESTED IN YOUR DRAWINGS. AFTER LOCATING THESE PIVOT POINTS, PROCEED WITH YOUR DRAWING. MAKE THE LEGS IRREGULAR—NOT TOO PARALLEL.

AFTER ESTABLISHING THE BODY SHAPE AND SWEEP, SET A CENTERLINE OR BACKBONE, THEN MARK OFF THE THREE POINTS AS SHOWN ON THE HORSE ON THE OPPOSITE PAGE. FIT OR WEAVE THE PARTS TOGETHER WITH THE BODY RHYTHMS.

THE LEGS FOLD UP OR STRETCH OUT WITH THE BODY BASED ON THE ACTION OF THE PIVOT POINTS IN THEIR PATHS OF ACTION. CHARACTERS WITH THESE ANATOMICAL ELEMENTS SEEM MORE REALISTIC.

DOGS AND DEER RUN WITH A ROTARY GALLOP IN WHICH THE OPPOSITE FRONT AND BACK LEGS LEAD; CATS, HORSES, AND MOST OTHER ANIMALS RUN WITH A TRANSVERSE GALLOP IN WHICH THE SAME FRONT AND BACK LEGS LEAD. IN ANY RUN EITHER THE LEFT OR THE RIGHT FRONT LEG CAN LEAD, SO THERE ARE TWO VERSIONS OF EVERY ANIMAL RUN IN THIS BOOK— SIMPLY REVERSE THE LEAD LEG.

CONSTRUCTION AND MOVEMENT

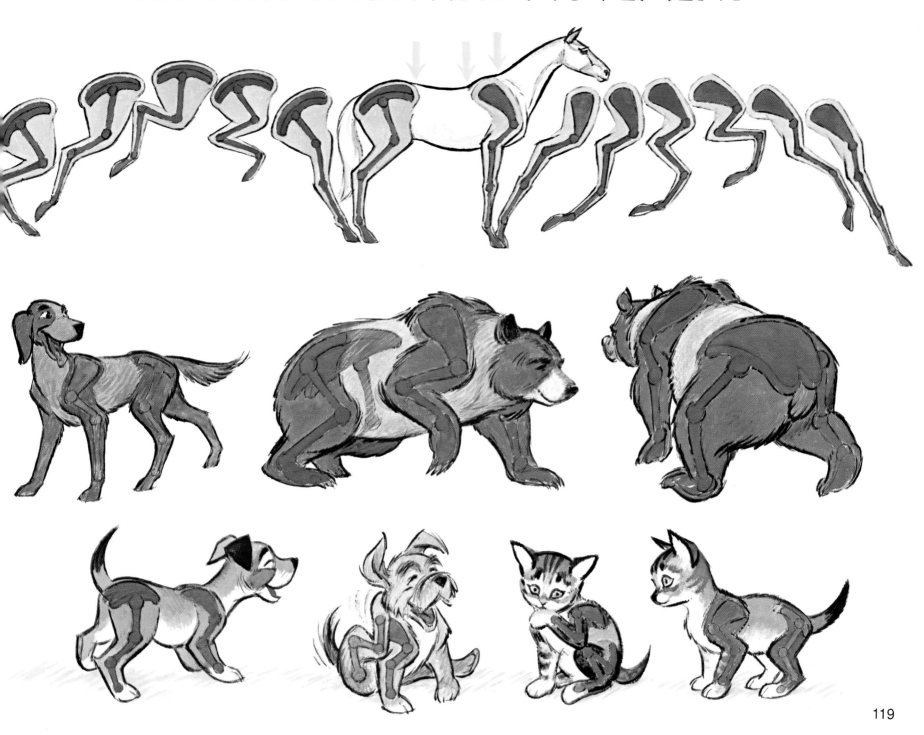

MORE FOUR-LEGGED ANIMALS

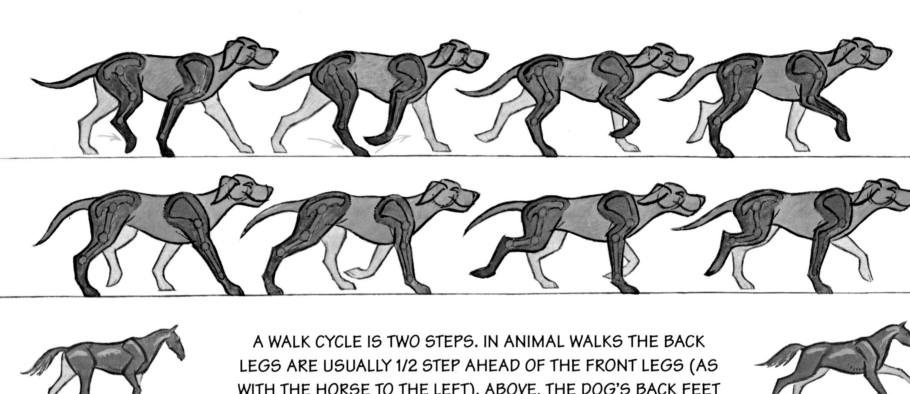

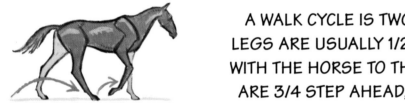 A WALK CYCLE IS TWO STEPS. IN ANIMAL WALKS THE BACK LEGS ARE USUALLY 1/2 STEP AHEAD OF THE FRONT LEGS (AS WITH THE HORSE TO THE LEFT). ABOVE, THE DOG'S BACK FEET ARE 3/4 STEP AHEAD, BUT THEY COULD BE 1/2 STEP AHEAD.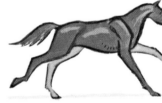

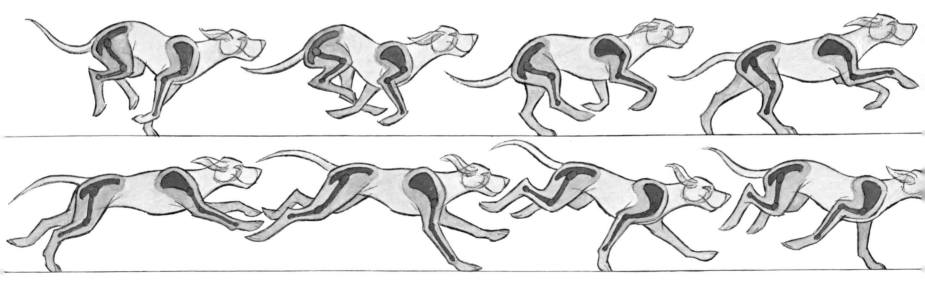

WALK AND RUN CYCLES

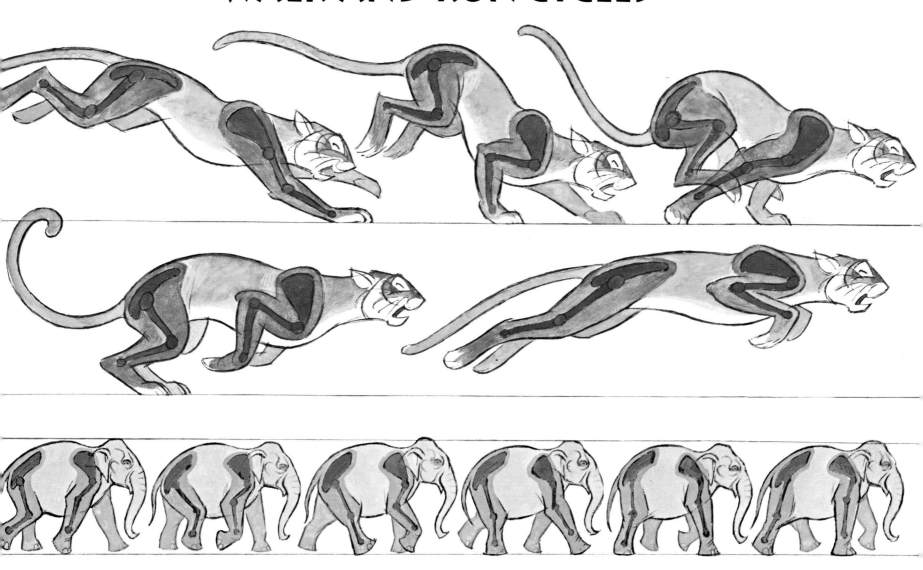

THE ELEPHANT'S BACK FEET (ABOVE) ARE 1/3 STEP AHEAD IN THE WALK AND 1/2 STEP AHEAD IN THE AMBLE-WALK, WHICH IS THEIR FASTEST PACE (ELEPHANTS CAN'T RUN). WHEN ANIMATING A WALK, THINK OF THE BACK FOOT COMING FORWARD AND RELEASING THE FRONT FOOT ON THE SAME SIDE TO RISE. THE BACK FOOT NEVER RELEASES THE OPPOSITE FRONT FOOT TO RISE, WHICH IS A COMMON MISTAKE WITH ANIMATORS AND ILLUSTRATORS. WHEN THE ANIMAL BACKS UP, IT IS THE SAME, EXCEPT IN REVERSE. 121

THE FLIGHT OF BIRDS

HERE IS A CYCLE OF A BIRD FLYING FROM BOTH THE FRONT AND THE SIDE VIEWS. DRAWING 8 IS FOLLOWED BY DRAWING 1. DRAWING 1 HERE IS THE SAME WING POSITION AS DRAWING 1 ON PAGE 123. NOTICE HOW THE WINGS FOLD UP AS THEY RISE IN DRAWINGS 2, 3, AND 4. THIS PART OF THE ACTION IS SLOWER SO THERE ARE MORE DRAWINGS TO IT. CONSEQUENTLY, YOU WILL SEE IT LONGER. IN DRAWINGS 5, 6, AND 7, THE WINGS ENLARGE TO CATCH MORE AIR. THEN IN DRAWING 8 THEY QUICKLY COME DOWN WIDE OPEN (ONE DRAWING) TO GIVE THE BIRD THE PUSH THAT CARRIES IT THROUGH THE AIR.

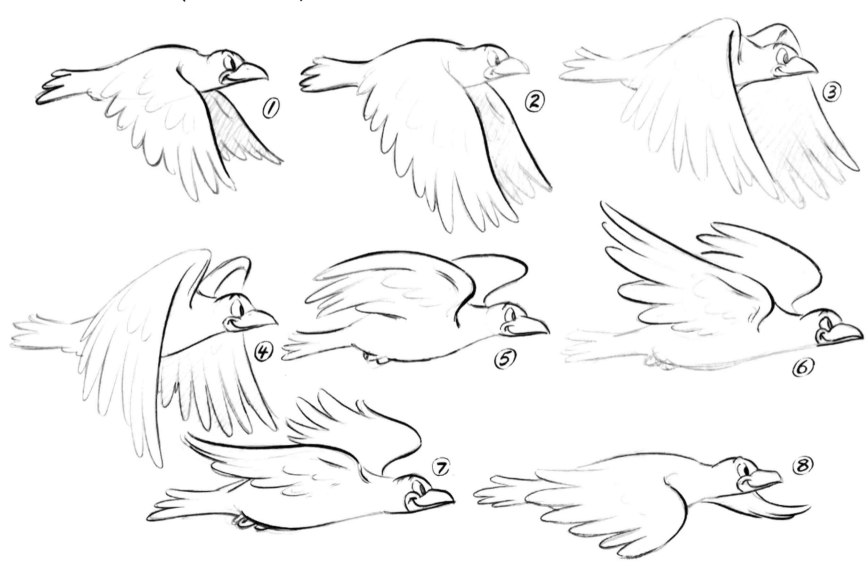

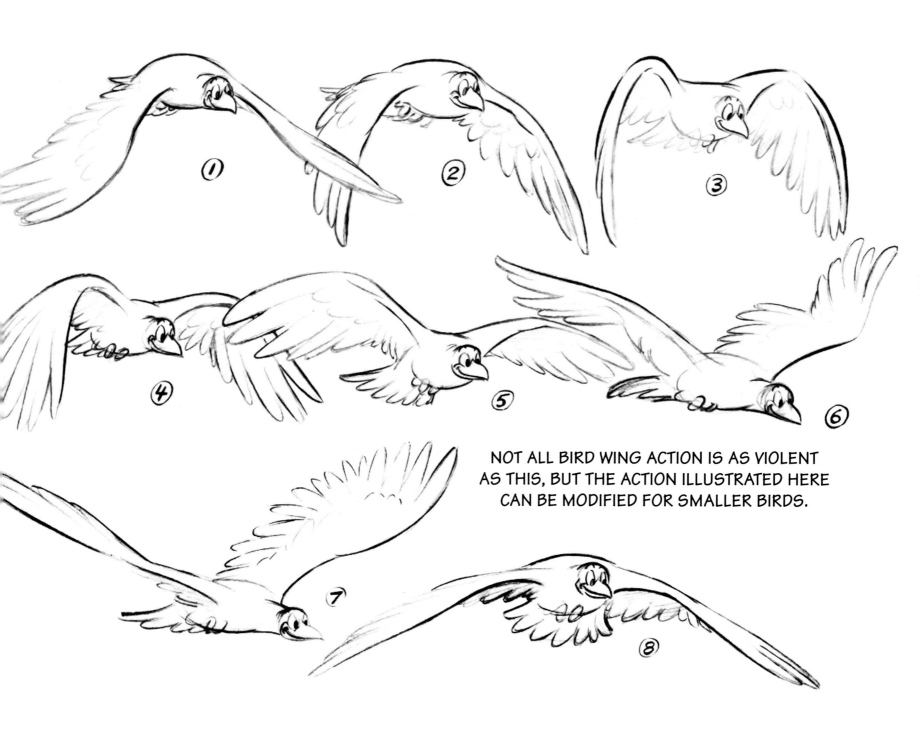

NOT ALL BIRD WING ACTION IS AS VIOLENT
AS THIS, BUT THE ACTION ILLUSTRATED HERE
CAN BE MODIFIED FOR SMALLER BIRDS.

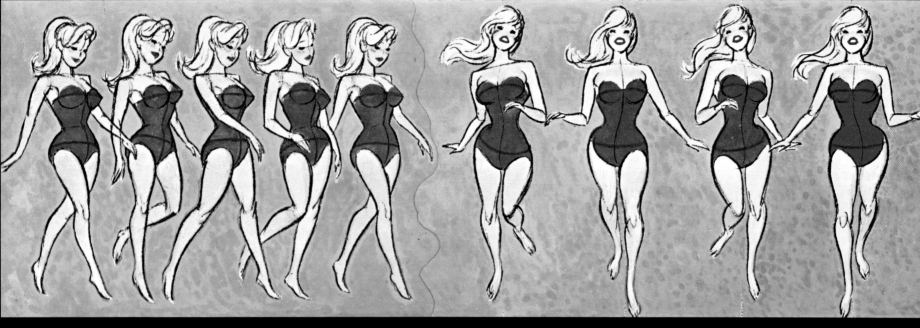

WALK – AS LEG LIFTS, HIPS TILT. CHEST TILTS OTHER WAY TO BALANCE.

RUN – ARMS LIFT AND SWING TO BALANCE HIP TILT AND LEG ACTION.

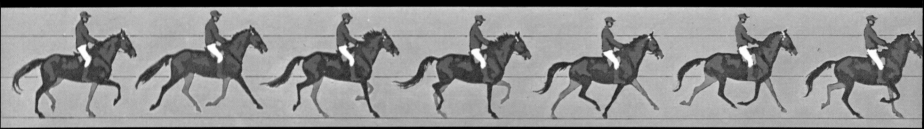

TROT – OPPOSITE LEGS LIFT AND CONTACT TOGETHER IN SYNC. IN A PACE ACTION SEE THE SAME FRONT AND BACK LEGS WORK TOGETHER.

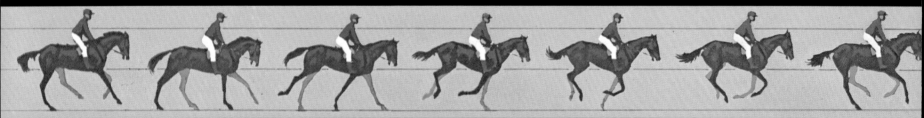

CANTER – THE BODY TILTS WITH A RISING AND FALLING ACTION THAT IS SIMILAR TO A CHILDREN'S SEESAW, CAUSING RIDER TO STAND.

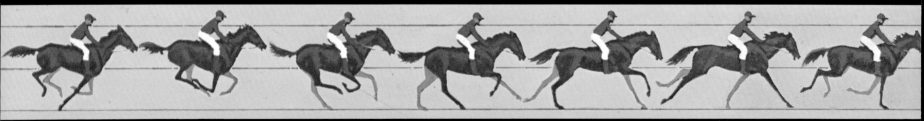

TRANSVERSE GALLOP – LEFT LEGS CAN LEAD TOO. THE SAME LEGS LEAD, UNLIKE DOG AND DEER THAT GALLOP WITH OPPOSITE LEGS LEADING.

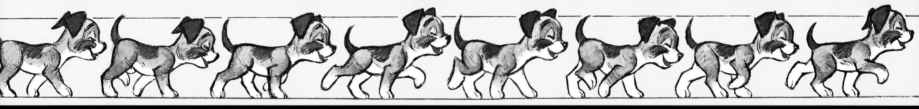

FOUR-LEGGED WALK – THE BACK LEGS ARE ONE HALF STEP AHEAD OF THE FRONT LEGS. THIS COMPLETE CYCLE IS TWO STEPS.

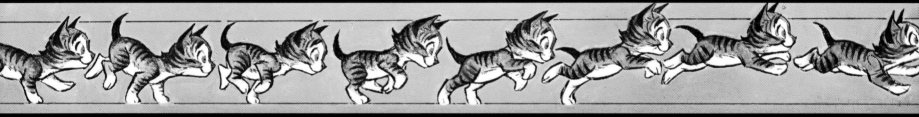

TRANSVERSE GALLOP – BOTH LEFT LEGS LEAD HERE. CAT ALSO GALLOPS LIKE HORSE (SEE LEFT) WITH RIGHT LEGS LEADING. JUST REVERSE LEGS.

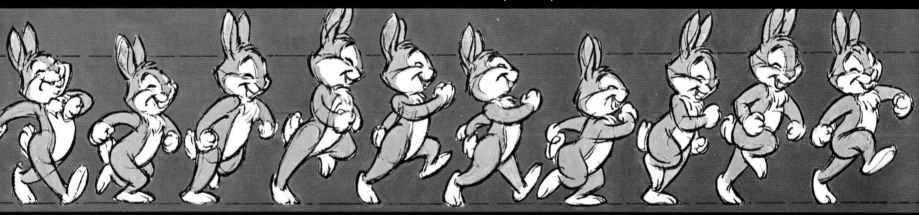

COCKY BOUNCE-WALK (ARMS SWINGING) – FIRST DRAWING IS CONTACT, NEXT IS RECOIL, THEN A LIFT, THEN A HIGH "FLOAT," AND THEN BACK TO CONTACT (OPPOSITE FOOT).

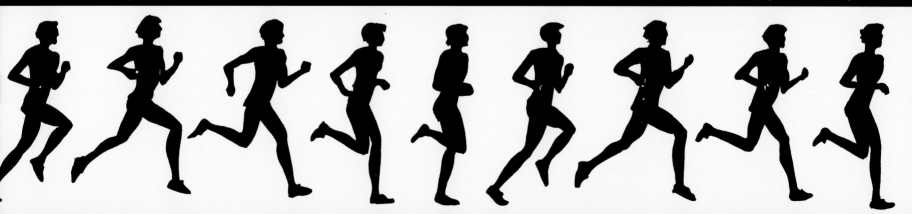

RUN – SILHOUETTE OF RUNNER FROM LIVE ACTION FILM REVEALS CONCAVE ARC KICK ON FOOT BEFORE CONTACT.

ANIMATION

An animator must consider a number of things when planning and creating animated movement. First, he or she must devise a plan for the action the character is supposed to perform. Once the plan is set, the actual movements of the character can be designed and rough sketches of the movements drawn. (At this stage, the animator should be well acquainted with the character so the movements will appear natural.) Next, key (or "extreme") character poses are drawn; then the key poses are used as guides to draw the in-between movements.

This chapter includes excellent practice exercises to help develop an understanding of timing in the animated sequences. The poses and extremes shown on pages 138-139 are simple, but excellent, examples.

Overlapping actions, holding poses, and other movements, as shown in the exercises involving the sheriff, the dancing girls, the hippo, and the alligator, are valuable examples of the highest-quality professional animation.

Other actions included in this chapter are the "take" (a surprise expression), straight-ahead and rhythm animation, balance and tilt in movement, and arcs, curves, and paths of action. The movement of legs, arms, and hands, and the anticipated movement or actions are covered in the section entitled "The Wave Principle." These are excellent methods for "waving" the animated movement in the proper directions. The chain reaction of waving actions is extremely important to character movement. Changing the speed of the animated movement, along with expressing attitudes, emotions, gestures, and reactions, can all be combined and fitted to your character.

SKETCHING BASICS—A SHORTHAND ART

ANIMATORS MAKE A SERIES OF ROUGH OUTLINE SKETCHES THAT SUGGEST THE MOVEMENT OF A CHARACTER. IT IS LIKE HANDWRITING WORDS WITH NO THOUGHT ABOUT FORMING INDIVIDUAL LETTERS—ONLY ABOUT WHAT YOU'RE SAYING (OR ACTING). TO DRAW A POSE, MAKE SCRIBBLES OF WHAT YOU SEE IN YOUR IMAGINATION; THEN STUDY THE SCRIBBLES FOR SUGGESTIONS. FORGET *DRAWING*—SCRIBBLE!

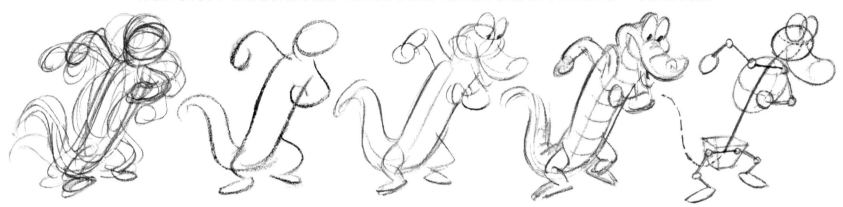

A BEGINNER CAN ONLY BECOME AN ANIMATOR THROUGH MANY HOURS OF SKETCHING. MAKE MANY ATTEMPTS. THE SKETCH IS LIKE A PLAN FOR A BUILDING, SO PICK FROM SEVERAL SKETCH ATTEMPTS.

REVERSE YOUR SKETCH (TURN IT OVER ON A LIGHT BOARD) AND REDRAW. GENTLY ERASE IT WITH A KNEADED ERASER AND REDRAW. SKETCH IT IN COLORED PENCIL AND THEN REDRAW IN BLACK.

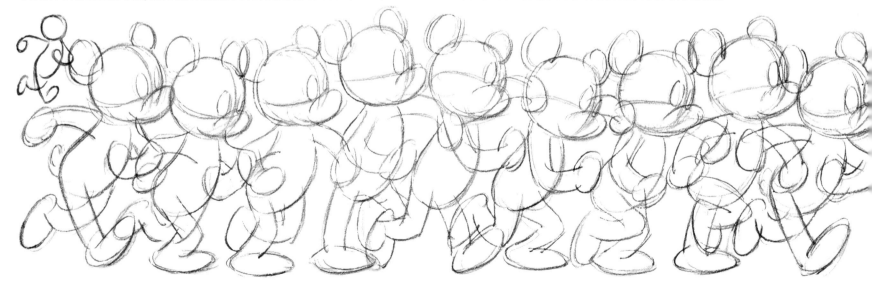

THIS IS AN ANIMATOR'S "ROUGH." A CLEANED-UP, FINISHED DETAIL DRAWING IS MADE FROM THIS. YOU SHOULD KNOW ALL ABOUT THE SKELETON, BUT ANIMATORS DON'T DRAW THE SKELETON FIRST; THEY SKETCH THE OUTLINE.

SCRIBBLES CAN BECOME MULTIPLE SKETCHES. KEEP TRYING TO GET A SUGGESTION OF WHAT YOU WANT. A ROUGH OUTLINE SUGGESTION IS THE FIRST STEP. IT MAY TAKE MANY SCRIBBLE ATTEMPTS. USE YOUR IMAGINATION TO DEVELOP THE DRAWING.

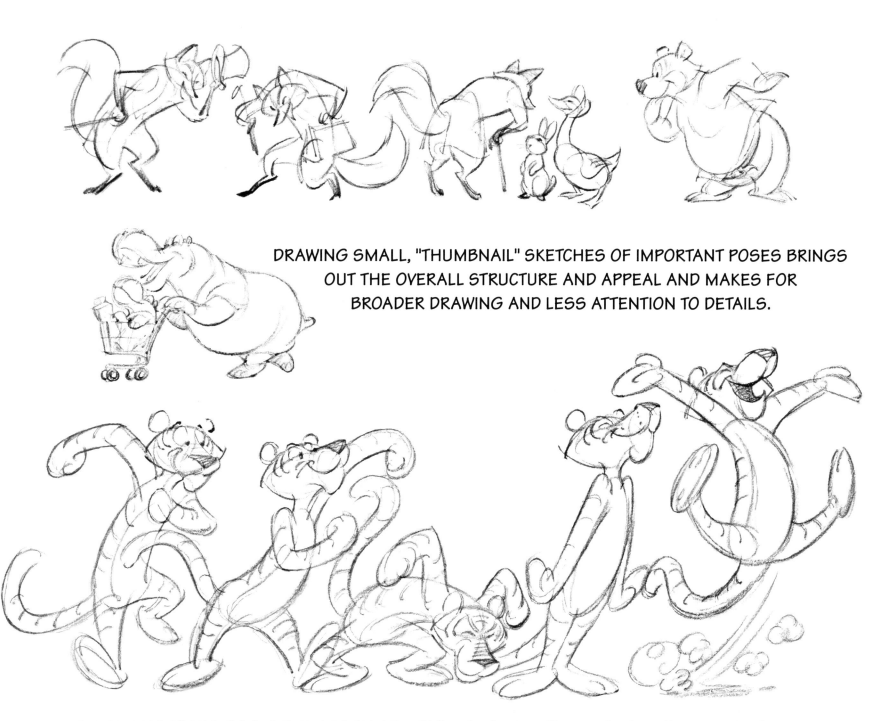

DRAWING SMALL, "THUMBNAIL" SKETCHES OF IMPORTANT POSES BRINGS
OUT THE OVERALL STRUCTURE AND APPEAL AND MAKES FOR
BROADER DRAWING AND LESS ATTENTION TO DETAILS.

THESE KEY POSES OF A TIGER ACTION ARE FROM TRIAL SKETCHES. THEY MAY BE CHANGED
TO FIT THE ACTION AS IT EVOLVES IN ANIMATION.

BALANCE AND TILT IN MOVEMENT

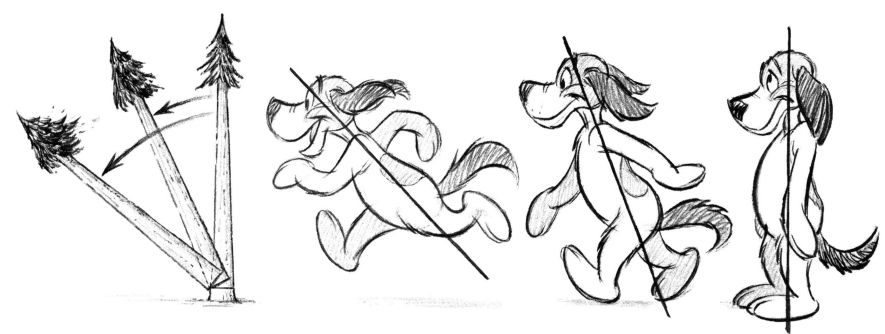

THE "CENTER OF BALANCE" LINE TIPS IN A FORWARD
MOVEMENT IN PROPORTION TO THE SPEED OF THE ACTION.

HOWEVER, CHARACTERS CAN ALSO RUN LEANING BACKWARDS. ALSO
THE BALANCE LINE CAN BE A CURVE IN AN ACTION (IN ANY SLANT)

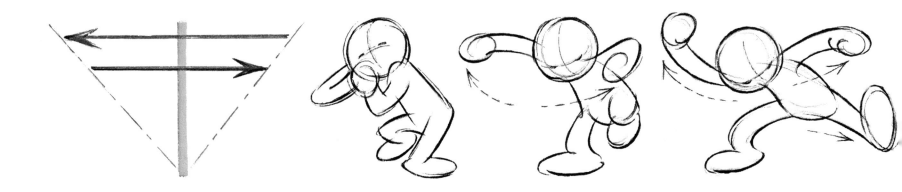

A THRUST IN ANY DIRECTION TRIGGERS A CHAIN REACTION
BALANCE IN THE OPPOSITE DIRECTION IN PROPORTION
TO THE SPEED.

THESE BALANCING REACTIONS DO NOT NEED TO BE
SIMULTANEOUS TO THE THRUST ACTION OR TO EACH OTHER—
THEY MAY OVERLAP.

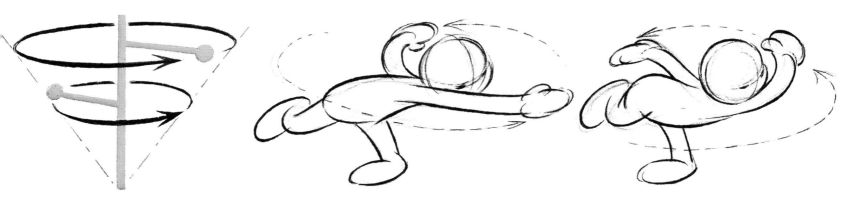

A THRUST IN A CIRCULAR SWING TRIGGERS A CORRESPONDING SWING ON THE OPPOSITE SIDE OF THE CIRCLE MOVEMENT.

THIS CIRCULAR PATH OF ACTION CAN BE HORIZONTAL OR TIPPED TO ANY DIAGONAL ANGLE, OR IT CAN BE A VERTICAL CIRCLE.

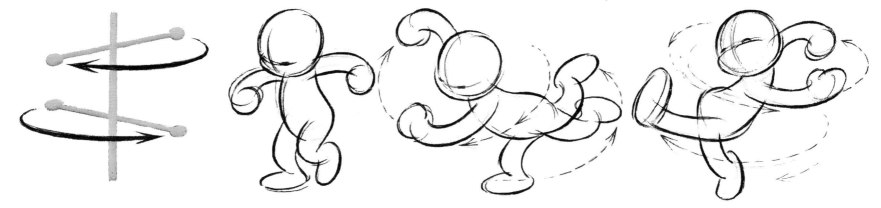

AS THE CHEST TWISTS WITH A THRUST, THE HIPS TWIST IN THE OPPOSITE DIRECTION IN A BALANCE REACTION (OR VICE VERSA).

THESE BALANCING REACTIONS NEED NOT FOLLOW THE THRUST; THEY MAY PRECEDE AND/OR MOVE AFTER THE THRUST OF ACTION.

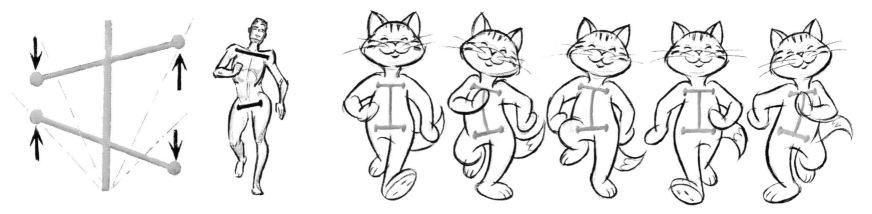

IN A WALK OR A RUN THE HIPS SAG WITH THE LEG LIFTED, WHICH TRIGGERS A CHAIN BALANCE REACTION IN THE TILTS OF THE CHEST, SHOULDERS, AND HEAD. THE ARMS SWING HIGHER ON THE RELAXED SIDE AND LOWER ON THE OTHER SIDE.

THIS ACTION GIVES WEIGHT TO A HEAVY GIANT OR A LARGE ANIMAL WITH A PONDEROUS, CRASHING GAIT. IT IS NOT TYPICAL OF CLOSELY KNIT ATHLETES. THE RESULTING HIP SWAY IS A TYPICAL FEMALE MOVE.

BALANCE AND TILT, CONTINUED...

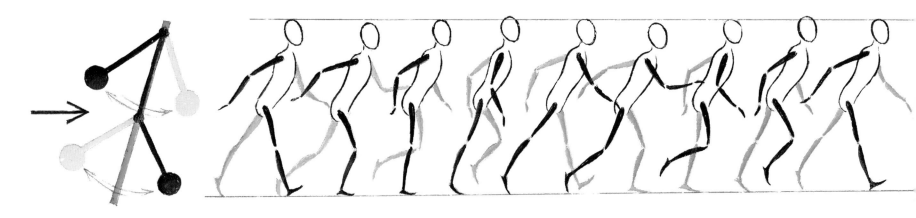

IN A **PENDULUM BALANCE,** THE ARMS SWING AS A REACTION TO THE THRUST OF THE PENDULUM LEG ACTION OF A WALK OR A RUN. THE EXTREME OF THE ARM SWING IS NOT ON THE LEG CONTACT DRAWING BUT ON THE RECOIL. THE LEG MOVES BACK AND STRAIGHTENS IN THE PUSH-EXTREME. AS A BALANCE TO THE LIFTED LEG, THE ARMS MOVE FORWARD IN A LOWER ARC THAN THEIR RETURN.

A **VERTICAL THRUST** UP OR DOWN CAN CREATE A **VERTICAL REACTION.** THIS ACTION IS IMPORTANT IN DIALOGUE MOVES OF THE HEAD AND ARMS AND IN ANTICIPATION ACTION DRAWINGS OF A HUNCH-CONTRACTION INTO A THRUST. WHEN THE LEG LIFTS, THE HEAD AND THE ARMS REACT BY LOWERING. IN A HEAVY DRAFT HORSE ACTION THE HEAD LOWERS AS THE LEG LIFTS IN A PULL.

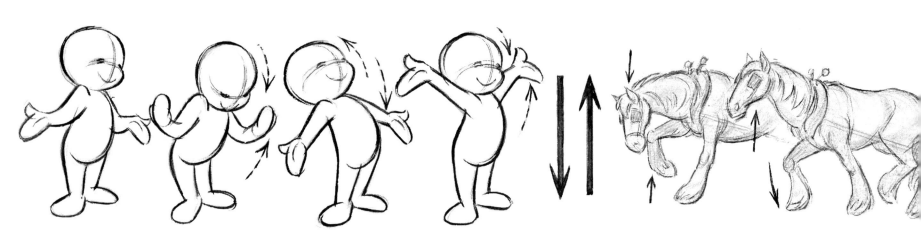

132

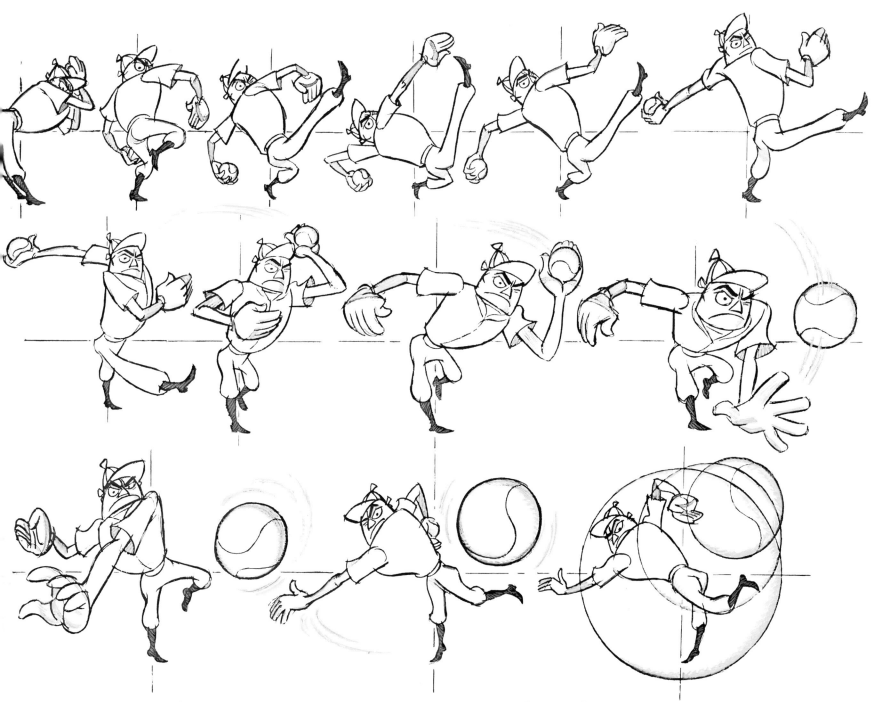

THE BASEBALL PITCHER GOES THROUGH AN ELABORATE
BALANCING ACT AS HE LIFTS HIS FOOT IN A WINDUP
BEFORE A LEG SWING THAT HAS BEEN EXAGGERATED IN
FORESHORTENING. AS HE STARTS THE PITCH, THE ARM IS

DELAYED TO GIVE MORE VIOLENCE TO THE ACTION. SINGLE-
DRAWING DRAFTSMANSHIP IS ABANDONED FOR THE
DRAFTSMANSHIP OF A SERIES WE SEE IN LESS THAN
A SECOND.

133

STRAIGHT-AHEAD AND RHYTHM ANIMATION

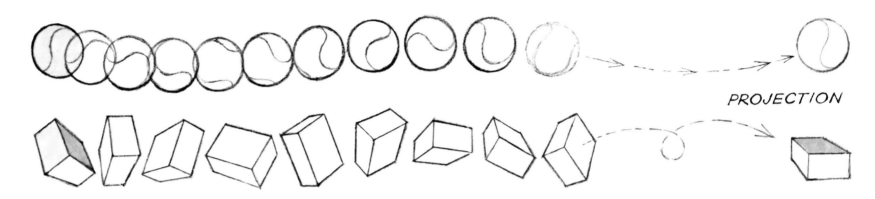

PROJECTION

STRAIGHT-AHEAD ANIMATION (DRAWING EACH MOVE FROM THE BEGINNING IN A GROWTH SEQUENCE) IS USED FOR ACTIONS THAT INVOLVE RHYTHMS IN CHARACTER MOVEMENTS. THERE MAY BE SEVERAL OVERLAPPING SECONDARY ACTIONS MOVING IN A CHARACTER, AND EACH ONE HAS DIFFERENT TIMING AND RHYTHM. THEY ARE STARTED UNEVENLY BY TURNS, TWISTS, AND OTHER BODY ACTIONS. THEY ARE IMPOSSIBLE TO POSE-PLAN, AND MANY ARE DISCOVERED AS YOU ANIMATE STRAIGHT-AHEAD. START WITH A PLAN OF ACTION AND WORK WITH ROUGH SKETCH-SCRIBBLES AND RHYTHM LINES; AIM FOR THE SWEEP OF THE CHARACTER. KEEP A MODEL DRAWING ON A SLIP OF PAPER TO CHECK SIZES AND SCENE PERSPECTIVES.

A METHOD TO ANIMATE—VISUALIZE THE ENTIRE SCENE WITH PROJECTION POSES AT THE MOST IMPORTANT POINTS. THEN USING THESE DRAWINGS AS A GUIDE, MAKE PATHS OF ACTION (IF PRACTICAL) AND ANIMATE STRAIGHT-AHEAD FROM THE START TOWARD THE FIRST POSE. WHEN YOU NEAR THIS POSE, USE IT ONLY AS A GUIDE AND DO NOT WORK INTO IT UNLESS IT FITS THE RHYTHM PROGRESSION OF YOUR ACTION. DON'T HESITATE TO REVISE; DISCOVER IMPROVEMENTS AS YOU PROGRESS. RESEARCH THE SCENE BY ACTING IT OUT IN FRONT OF A MIRROR OR STUDY LIVE-ACTION FILM RESEARCH. MAKE THUMBNAIL SKETCHES; ANIMATE FROM YOUR IMAGINATION; CREATE. ROUGHLY COMPLETE ALL DRAWINGS AND MAKE A FILM PENCIL TEST (FILMING THE PENCIL ROUGHS).

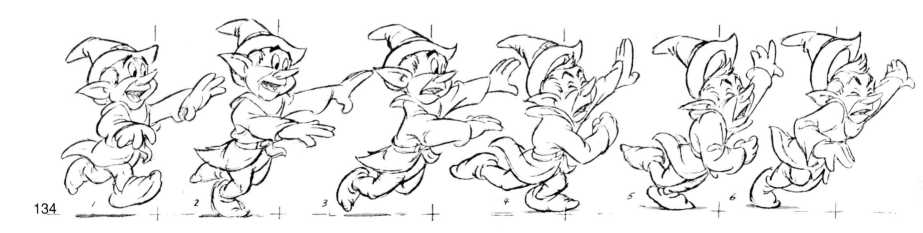

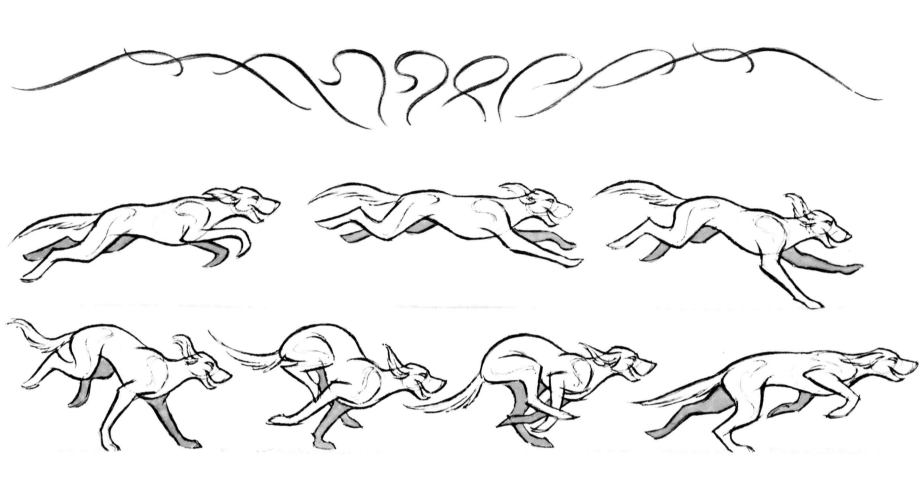

NOTICE HOW THIS SMOOTH-FLOWING "RHYTHM PATTERN" RELATES TO THE ANIMATION CYCLE OF THE DOG ABOVE. THE SMOOTH MOVEMENT OF THE LITTLE CHARACTER BELOW IS BROKEN WHEN HE FALLS.

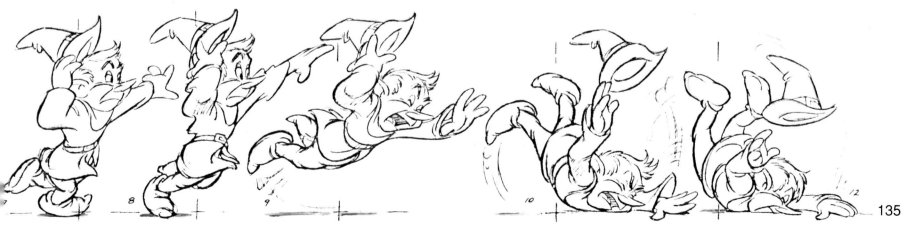

135

ANTICIPATION · ACTION · REACTION

AN ACTION LIKE THE SWING OF A PENDULUM IS A MOVE BETWEEN TWO EXTREME POSITIONS. AN ACTION DRAWING OF THE PENDULUM IN CENTER POSITION HAS LITTLE VISUAL VALUE TO DEPICT THE ACTION. IT IS THE EXTREME POSITIONS OF THE PENDULUM THAT DEPICT THE ACTION—AND MEASURE IT. THE FIRST EXTREME IS ANTICIPATION: GET-SET, WIND UP, PULL BACK, CONTRACTION-CROUCH OR RISE, OR PULL UP (THE LATTER FOR A DOWN MOVE). THE SECOND EXTREME IS THE REACTION-RECOVERY FROM THE MOVE— EITHER A CRASH OR A STRETCH-AND-SETTLE THAT MAY VIBRATE.

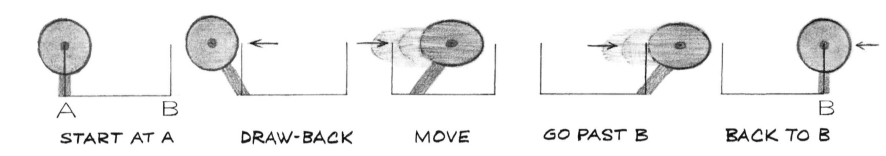

| START AT A | DRAW-BACK | MOVE | GO PAST B | BACK TO B |

THE SLIGHTEST MOVE IN ANY DIRECTION MAY BE REINFORCED WITH A MOVE IN THE OPPOSITE DIRECTION, INTO AN ANTICIPATION BEFORE THE ACT, AND THEN A RECOVERY PROCESS. NOTE: THE ACTUAL CONTACT DRAWING IS OF SUCH LITTLE VALUE THAT IT IS OFTEN BEST TO ELIMINATE IT, AS SHOWN AT RIGHT, ON PAGE 137.

IN THE GOLF SWING WE ELIMINATE THE CENTER DRAWING OF THE CLUB ACTUALLY HITTING THE BALL; IN A FOOTBALL KICK, WE SKIP THE FOOT CONTACTING THE BALL, ETC. THE EFFECT OF THIS TRICK IS A CRISPNESS OF EXECUTION BECAUSE YOU NEVER SEE IT.

IN THE ACTIONS AT RIGHT WE DON'T ACTUALLY SEE THE RABBIT CONTACT THE BULLDOG OR THE WOODCUTTER HIT THE TREE. THIS IS NOT A TRICK; IT'S A TIMING EXAGGERATION.

HOWEVER, A TRICK LIKE THE MAGICIAN'S SLEIGHT OF HAND IS VALUABLE TO THE ANIMATOR. CALLED A "FAKE," IT IS USED IN SITUATIONS LIKE THE DRAWING OF THE WOODCUTTER. HIS AXE FITS THE ACTION SIMPLY, AND THE TRUTH IS A QUICK, CONFUSING TWIST ON THE AXE. WHEN AN ACTION IS CONCEALED FOR A FLASH OR WHEN A QUICK MOVEMENT LOSES THE EYE, CHANGE THE LEGS, HANDS, OR WHATEVER AWKWARD SITUATION YOU ARE IN.

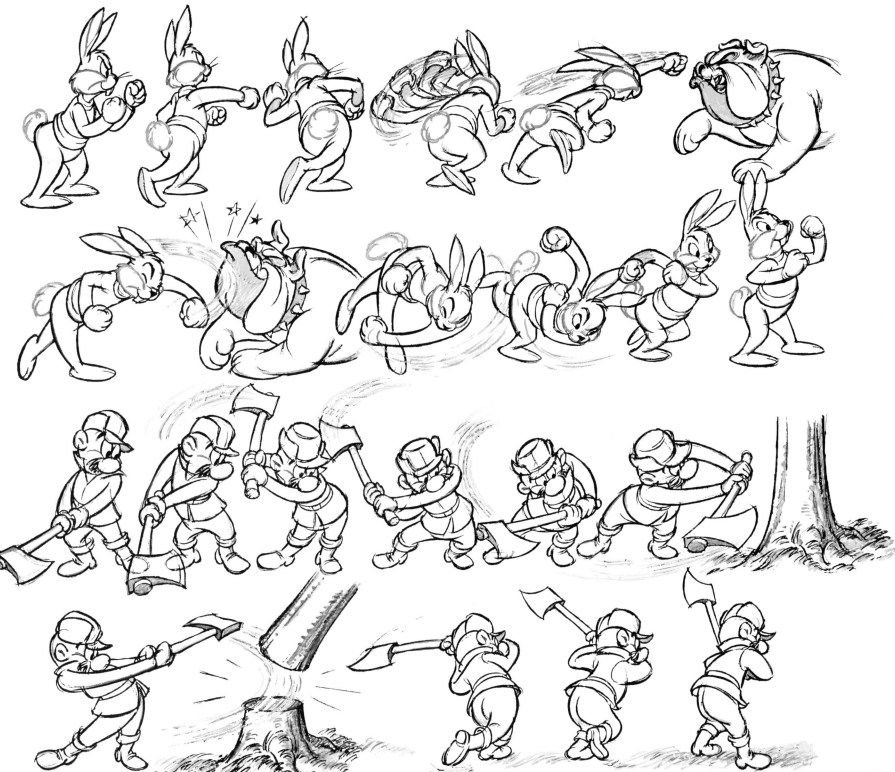

137

STRAIGHT-AHEAD ANIMATION

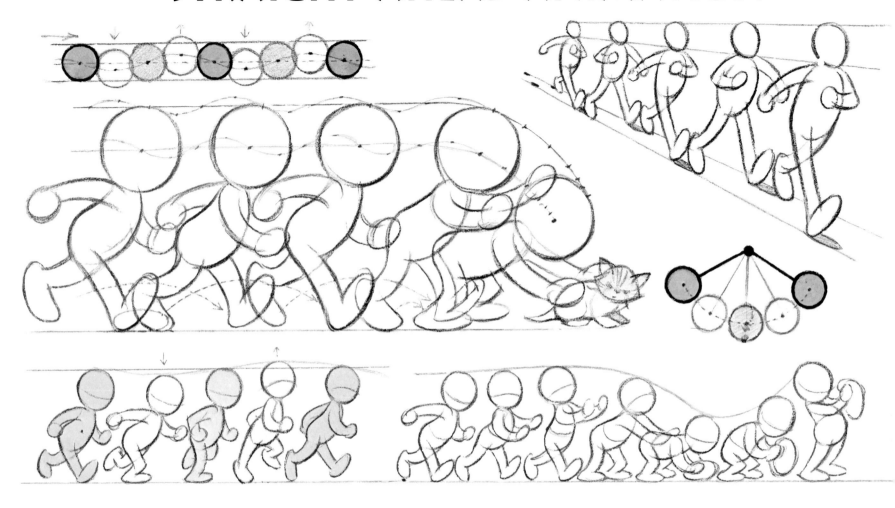

THERE ARE TWO DISTINCT METHODS OF ANIMATING: (1) THE **STRAIGHT-AHEAD** METHOD (SHOWN ABOVE), WHICH SIMPLY INVOLVES DRAWING ONE MOVE AFTER ANOTHER IN AN EVOLVING SEQUENCE OF GROWTH, AND (2) THE **POSE-PLANNING** METHOD, WHICH IS ACCOMPLISHED BY SKETCHING "KEY" OR "EXTREME" POSES (AS SHOWN WITH THE MOUSE ON PAGE 139) AND THEN FILLING IN THE ACTION WITH **IN-BETWEEN** DRAWINGS.

THE CHARACTER ABOVE WALKS FOR THREE STEPS AND THEN REACHES DOWN FOR THE KITTEN; HERE THE FOOT CONTACT EXTREMES ARE PLACED IN A STRAIGHT PATH OF ACTION. THEN THE CHARACTER CHANGES HIS "ACTING"—HE ANTICIPATES THE REACH FOR THE KITTEN BY LIFTING HIS ARMS AND MOVING HIS HEAD BACK. THE HEAD STAYS BACK TO COUNTERBALANCE THE REACHING ARMS; IT THEN FOLLOWS THROUGH IN AN OVERLAPPING ACTION AS THE KITTEN IS LIFTED. THE WALK IS AN OVERLAPPING ACTION. EACH ACTION MUST FIT THE MOOD OF THE STORY; THERE IS A TIME AND A PLACE FOR EACH ANIMATION APPROACH.

POSE-PLANNING DRAMATICS

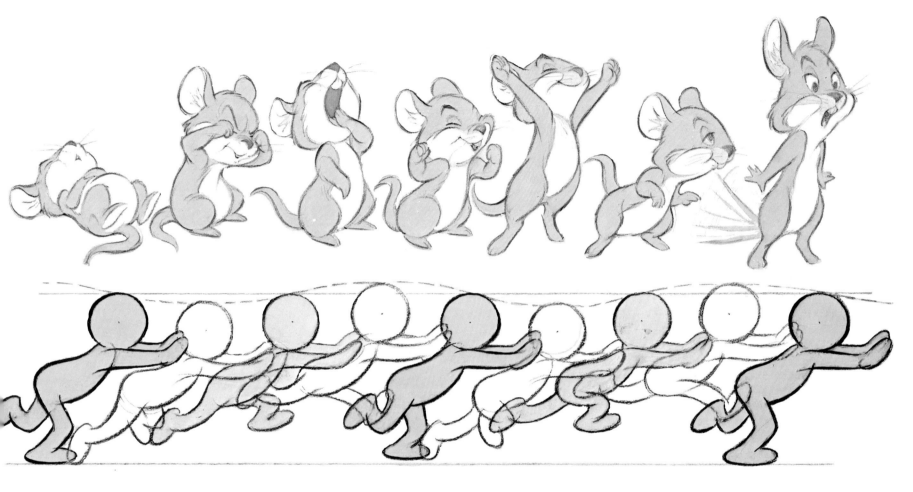

THE IMPORTANCE OF THE EXTREME DRAWING IS BEST ILLUSTRATED USING PENDULUM ACTION (SEE PAGE 136). PLAN WELL-DEFINED ACTIONS (SUCH AS A WALK OR RUN) BY FIRST DRAWING A PATH OF ACTION USING PERSPECTIVE (PAGES 74-75), AND THEN RENDERING THE SAME CYCLE DRAWING IN PROGRESSIVE POSITIONS. THE IN-BETWEEN DRAWINGS ARE PLANNED WITH SPACING CHARTS (WHICH ALSO INDICATE THE "ARC" OF THE ACTION IN CASE OTHER ARTISTS COMPLETE THE SCENE) AND ROUGHED IN BY THE ANIMATOR. THE IN-BETWEENS CAN RADICALLY CHANGE AN ACTION—EITHER IMPROVING OR STUNTING IT.

THE MOUSE IN THE EXAMPLE DEMONSTRATES THE IMPORTANCE OF POSE-PLANNING. THESE TYPES OF SCENES ARE BASED ON THE DRAMA, GESTURE, OR ATTITUDE OF POSES—NOT THE SPECIFIC ACTION. THE KEY POSES MUST BE CAREFULLY THOUGHT OUT BECAUSE THEY ARE USED TO ENHANCE THE ACTION, PRESENTATION OF DRAMA, AND MOOD; THEY REINFORCE THE STORY, SCENE COMPOSITION, AND DRAWING POINTS.

ARCS · CURVES · PATHS OF ACTION

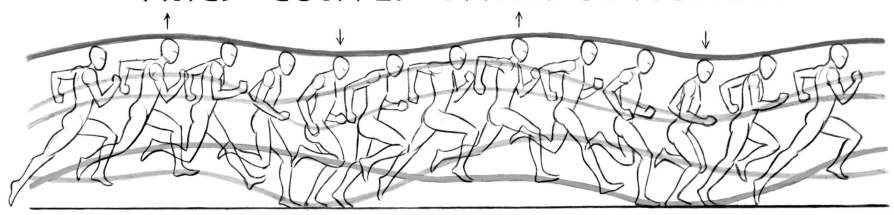

A CHARACTER MOVES IN PATHS OF ACTION THAT EITHER CURVE OR GO STRAIGHT. IF A DRAWING IS PLACED IN AN ACTION THAT DOES NOT FIT THE PATH OR SPACING PLAN, A JITTER, A JERK, OR AN UNREALISTIC ACTION WILL OCCUR. YOU DON'T NEED TO CHART ALL THE PATHS; YOU CAN SEE THEM WHEN YOU FLIP THE DRAWINGS. THE DEGREE OF ARC IN AN IN-BETWEEN CAN EITHER IMPROVE OR STUNT AN ACTION.

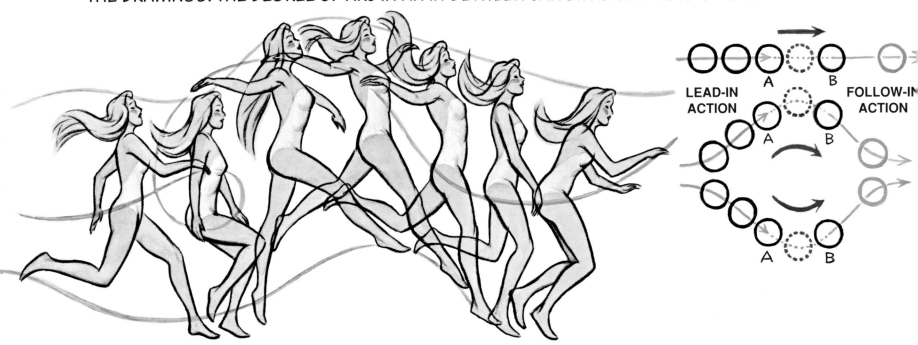

LEAD-IN ACTION

FOLLOW-IN ACTION

EXPERIMENT WITH THE DEGREE OF ARC IN THE IN-BETWEENS. WILL THE GIRL'S ACTION ABOVE BE IMPROVED IF A DRAWING BETWEEN 1 AND 2 DIPS LOWER IN A CROUCH ANTICIPATION THAN THE PATH INDICATES?

WHAT IF A DRAWING BETWEEN THE HIGH 3 AND 4 WERE HIGHER? WHAT IF A DRAWING AFTER 7 WERE LOWER? TRY TO THINK LIKE THIS ... EXPERIMENT ... FLIP THE DRAWINGS TO SEE IF YOU ARE CORRECT!

MULTIPLE ACTION PATHS IN BOUNCE-STRUT

USING THIS DOUBLE BOUNCE-STRUT AS A GUIDE, TRY ANIMATING THE SAME ACTION AND PATHS USING ROWDY RABBIT FROM PAGES 40 AND 41.

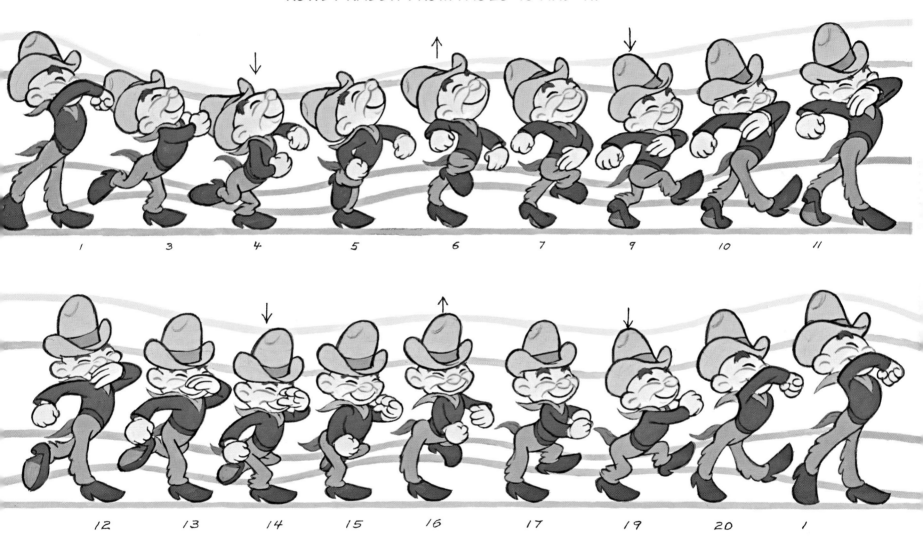

IT IS IMPERATIVE THAT YOU CONSULT THE DRAWINGS GOING INTO A AND OUT OF B. CHECK AT LEAST TWO PRIOR DRAWINGS AND A FOLLOWING EXTREME. THERE ARE TWO THINGS TO NOTICE: (1) WHAT IS THE RIGHT ARC, IF ANY, AND (2) IS THE DRAWING EXACTLY IN BETWEEN, OR IS IT CLOSER TO A OR B ACCORDING TO THE PROGRESSION OF DRAWINGS? THIS IS ARC AND SPACING. EXPERIMENT! YOU WILL LEARN THE TRICK OF TAKING DRAWINGS OFF PEGS, SHIFTING THE EXTREMES SO THE DETAILS COINCIDE, PLACING THE CORNERS OF YOUR IN-BETWEEN PAPER BETWEEN THE TWO SHIFTED EXTREMES, AND MAKING AN IN-BETWEEN ON MUCH EASIER TERMS THAN THE PEGS ALLOW. IT IS BEST TO MAKE A LIGHT MECHANICAL DRAWING—NO MATTER HOW CRUDE—BETWEEN LINES, AND THEN CORRECT THE DRAWING OF THE IN-BETWEEN, FLIPPING ALL THE TIME.

THE WAVE PRINCIPLE

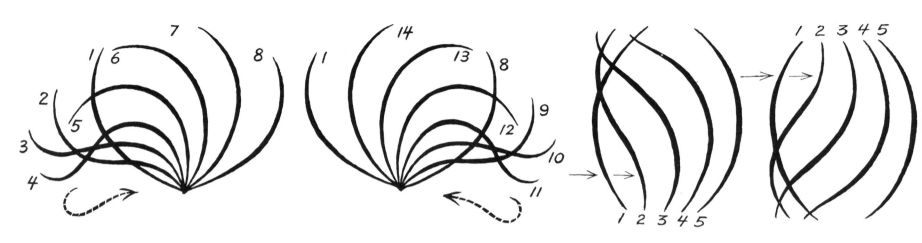

RHYTHM IN ANIMATION ACTION IS BASED ON THE WAVE PRINCIPLE. THE "LINE OF BEAUTY CURVE" (LIKE AN "S") ANIMATES AS A WAVE INTO THE OPPOSITE Z-SHAPE AND BACK. THE WAVE IS PUSHED OR MANIPULATED FROM ONE SIDE TO THE OTHER.

THE FIRST THREE DIAGRAMS ABOVE ARE WAVED FROM THE BASE; THE FOURTH IS WAVED FROM THE TOP. BE SURE TO WAVE RHYTHM IN THE RIGHT DIRECTIONS. IN THE EXAMPLE, THE HORSE WAVES THE COWBOY AROUND LIKE A FLAG.

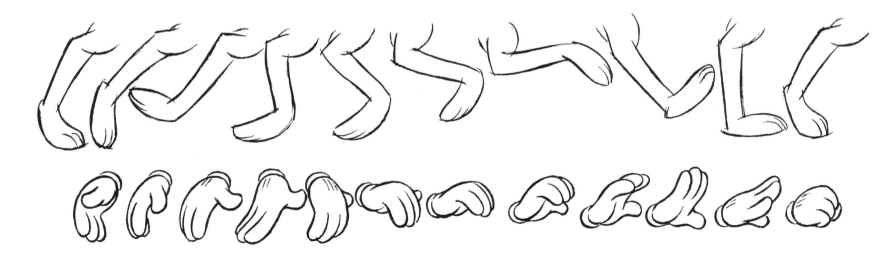

IN ANIMATION WE BUILD FROM THE FIRST DRAWING (AS WITH THE HORSE) AND START A CHAIN REACTION OF RHYTHM LINES WAVING. USE THE SECOND DRAWING AS A GUIDE. THEN WHEN YOU GET THERE, REVISE IT SO IT FITS THE SERIES' WAVE PROGRESSION AND ANATOMY PROGRESSION. THIS PRINCIPLE APPLIES TO ALL ANIMATED CURVES.

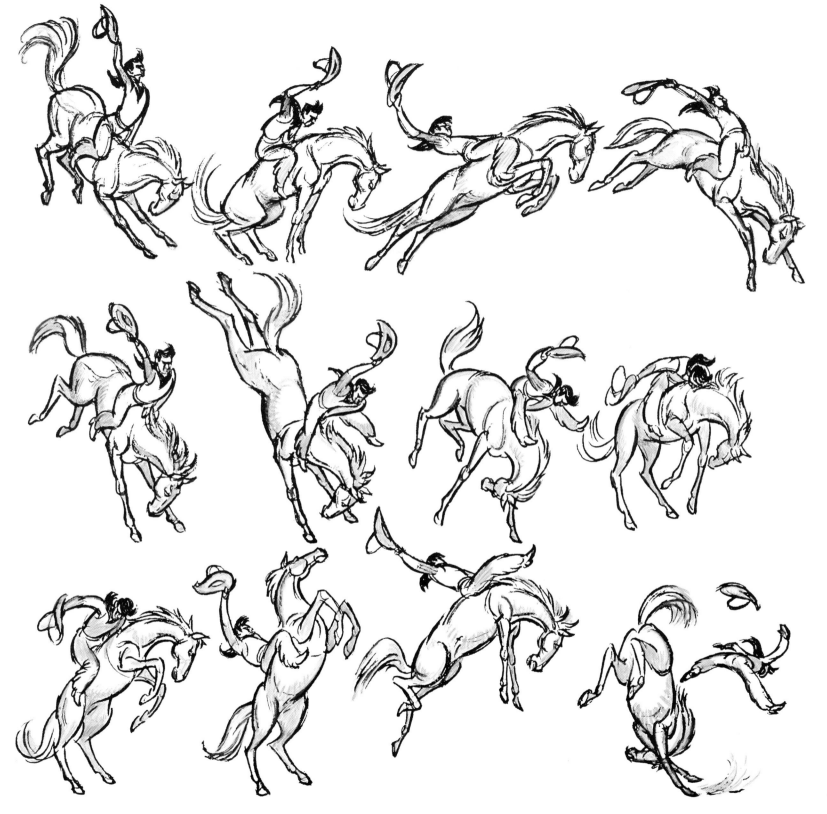

DELAYED SECONDARY ACTION

MAKE OVERLAPPING ACTION WHENEVER YOU CAN. WHEN ANIMATING A CHARACTER FROM ONE POINT TO ANOTHER, DON'T GO THERE WITH ALL PARTS OF THE CHARACTER AT ONCE. INSTEAD, ARRIVE WITH DELAYED SECONDARY ACTIONS, AS ILLUSTRATED ON THIS PAGE.

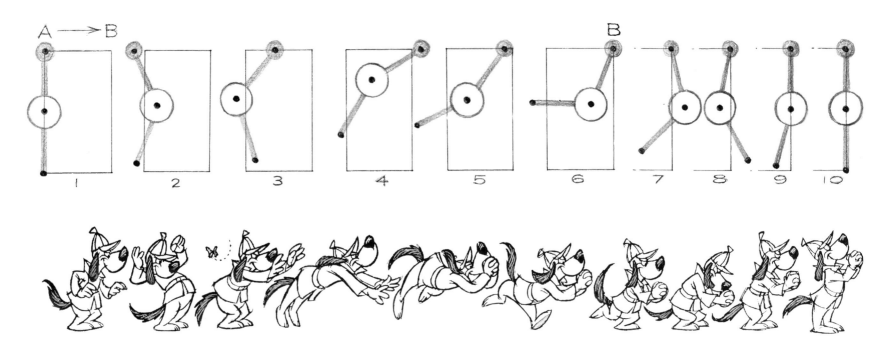

WITH **DELAYED SECONDARY ACTIONS**, ALWAYS GET A GOOD FOLLOW-THROUGH ON LOOSE-MOVING SECONDARY OBJECTS, SUCH AS COATTAILS, HAIR, EARS, AND TAILS. IN THE SQUIRREL ACTION AT RIGHT, ON PAGE 145, THE FEET ARRIVE FIRST; THEN THE BODY RISES. AFTER THIS, THE ARMS MAY ARRIVE, FOLLOWED BY THE TAIL.

THE DOUBLE PENDULUM ACTION ABOVE ILLUSTRATES A PRIMARY ACTION OF THE DARK CIRCLE FROM A TO B, FOLLOWED BY TWO SECONDARY ACTIONS OF THE PENDULUMS. THIS PRINCIPLE IS ALSO APPLIED TO THE ACTION OF THE DOG GRABBING A BUTTERFLY WITH THE PRIMARY ACTION OF HIS ARMS. HIS HIPS AND BODY ARE SIMILAR TO THE TOP PENDULUM, AND HIS FEET AND TAIL ARE SECONDARY TO HIS

HIPS, LIKE THE LOWER PENDULUM DIAGRAMS. THIS PRINCIPLE IS ALSO APPARENT IN HIS HEAD, WHICH SWINGS FROM HIS ARMS, AND THE EARS PENDULUM FROM THE HEAD.

DELAYED SECONDARY ACTIONS ARE EFFECTIVE IN PUTTING LIFE INTO POSES AND HOLDS. A CHAIN OF PARTS CAN ARRIVE LATE AT DIFFERENT TIMES AND IN DIFFERENT TIMINGS TO TAKE THE CURSE OFF ANY HELD DRAWING. THEN VARIOUS PARTS, SUCH AS THE EYES, CAN "TELEGRAPH" THE NEXT MOVE IN SECONDARY ACTIONS THAT PRECEDE IT. THUS, LIMITED ANIMATION FOR TV CAN BECOME VERY CONVINCING. HOWEVER, THIS IS NOT AN ECONOMY ANIMATION FORMULA; IT IS BASED ON LIFE. NOTHING MOVES IN EQUAL COMPARTMENTS OF ALL PARTS IN UNISON.

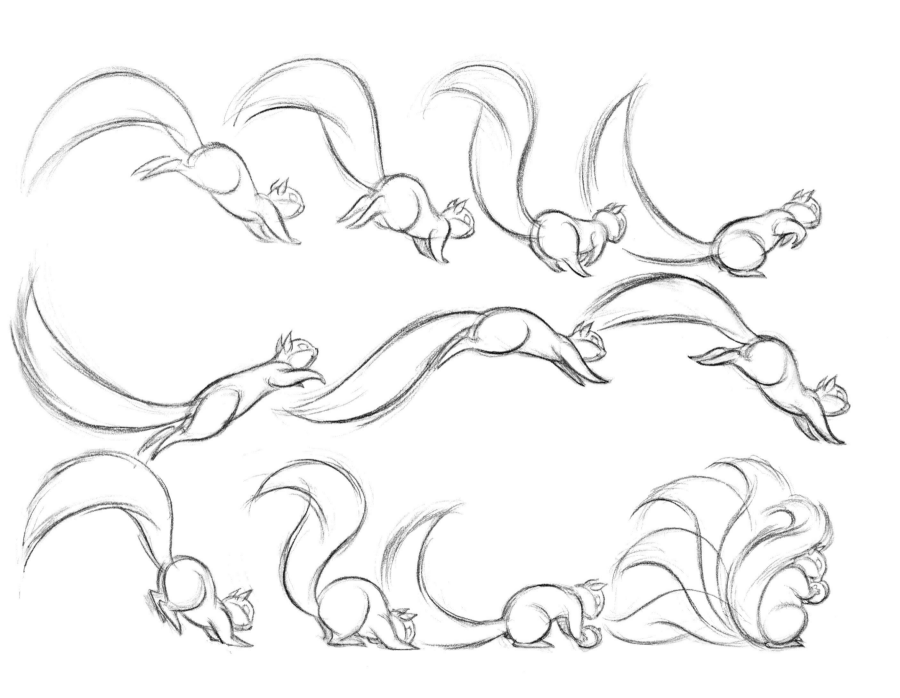

STUDY THE DELAYED ACTION OF THE SQUIRREL'S TAIL.

FAST ACTION · IMPACT · SPEED

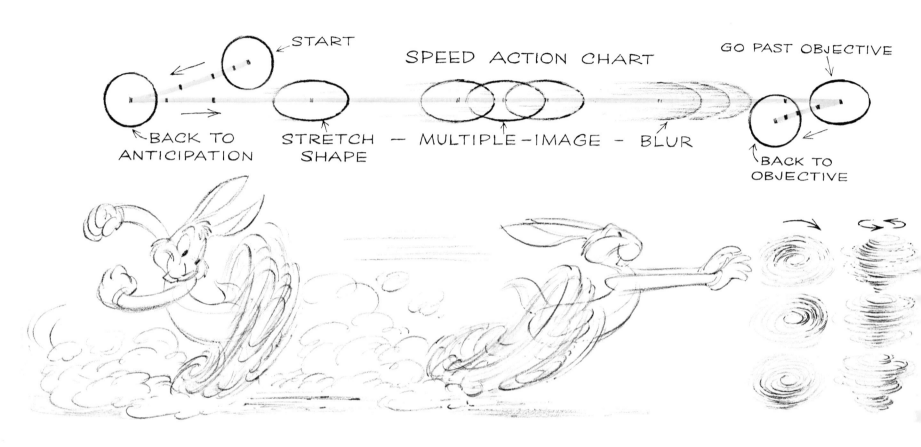

START

SPEED ACTION CHART

GO PAST OBJECTIVE

BACK TO ANTICIPATION

STRETCH SHAPE — MULTIPLE—IMAGE — BLUR

BACK TO OBJECTIVE

IN **FAST ACTION**, AS ABOVE, THE CHARACTER STRETCHES, GOES INTO A BLUR EFFECT, DISAPPEARS FOR A FRAME, AND THEN REAPPEARS AT THE OBJECTIVE. MULTIPLE IMAGES CAN SPEED THE ACTION.

THE ANIMATED BLUR REPLACES LEG ACTION IN A THREE OR FOUR DRAWING TWIRL, AS SHOWN. CHARACTERS EXPLODE FROM ANTICIPATION OUT OF SCENE WITH ANIMATED SPEED LINES, AS SHOWN AT RIGHT.

AS SHOWN IN THE ELF (OPPOSITE PAGE, TOP RIGHT), MULTIPLE IMAGES OF A FAST-MOVING HAND (OR LEG) CARRY THE ILLUSION OF THE MOVEMENT BETTER. THUS, A FAST-MOVING LEG OR ARM PASSING THE BODY IS AN IMAGE ON EACH SIDE.

IMPACT, AS SPEED IS ABRUPTLY HALTED, ENHANCES THE IMPRESSION. AS SHOWN IN THE STORYBOARD AT RIGHT, ON PAGE 147, THE BULL COLLIDES WITH THE TREE ON A FAST-MOVING PAN. NOTICE THAT THE IMPACT KNOCKS THE PAN AND TREE BACKWARD, THEN INTO A FORWARD AND BACK RECOVERY, AND THEN INTO A STOP. ALTERNATELY, THE PAN ACTION CAN BE ENLARGED TO A STAGGER/JITTER ACTION, OR THE BULL CAN GO INTO A STAGGER ACTION AFTER THE IMPACT.

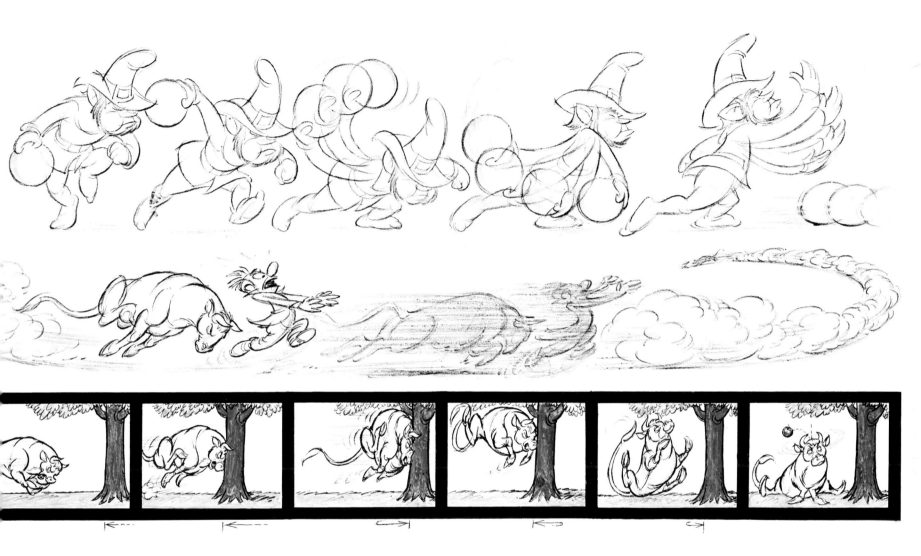

VERTICAL IMPACT— AFTER A FAST FALL, THE IMPACT WITH THE EARTH IS USUALLY HANDLED WITH A VIOLENT, VERTICAL STAGGER/JITTER OF THE BACKGROUND. HOWEVER, CLASSIC IMPACTS IN GREAT CARTOONS HAVE ALSO INCORPORATED ANIMATED REPERCUSSION EFFECTS IN THE BACKGROUND— FOR EXAMPLE, DISTANT ROCKS RISING AND FALLING FROM THE SHOCK WAVES. OTHER GREAT IMPACTS HAVE CREATED ANIMATED CRATERS AND SMOKE.

SPEED EFFECTS—CLOUDS OF DUST AND/OR SMOKE ARE STIRRED UP BY THE SPEED OF THE BULL CHASE. SPEED-LINE BLUR EFFECTS OFTEN FOLLOW, INCLUDING FRAGMENTS OF DOUBLE IMAGES. AS SUCH SPEED GOES THROUGH A QUIET, STILL BACKGROUND, THE GRASS AND TREES ARE SUCKED IN THE DIRECTION OF THE PASSING TORNADO. THESE SPECIAL EFFECTS INVOLVE ANIMATED BACKGROUNDS.

THE CARTOON "TAKE"

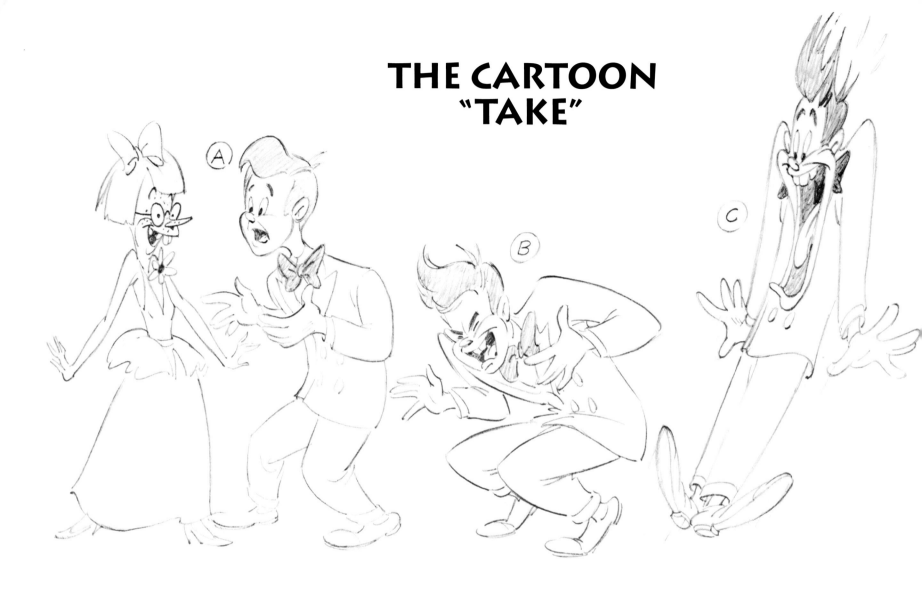

A "TAKE" REGISTERS A CHARACTER'S SUDDEN SURPRISE IN A CARTOON.
THE AVERAGE CARTOON IS FULL OF TAKES. SOME ARE SUBDUED; OTHERS
ARE VIOLENT LIKE THE ONE ON THIS PAGE. THE TAKE IS USUALLY PRECEDED
BY A *GOOD* ANTICIPATION DRAWING, SUCH AS STEP B. THE CHARACTER SEES
HIS DATE FOR THE EVENING IN STEP A, CRINGES INTO ANTICIPATION IN STEP B,
AND THEN FLIES UP INTO A WILD TAKE IN STEP C.

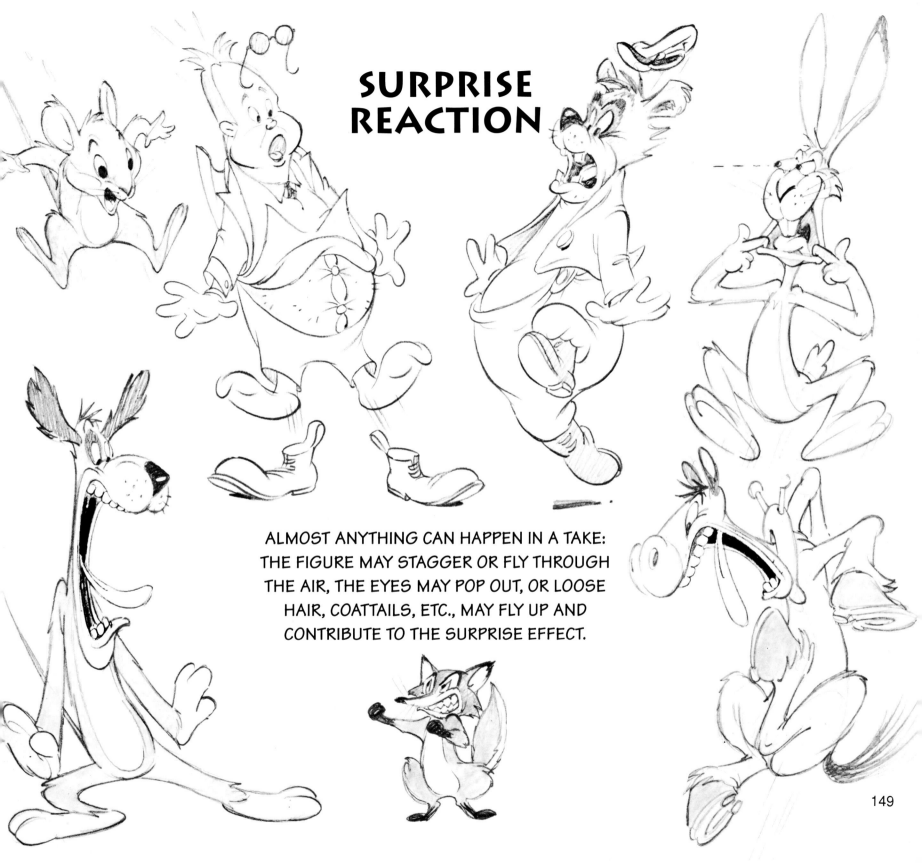

SURPRISE REACTION

ALMOST ANYTHING CAN HAPPEN IN A TAKE:
THE FIGURE MAY STAGGER OR FLY THROUGH
THE AIR, THE EYES MAY POP OUT, OR LOOSE
HAIR, COATTAILS, ETC., MAY FLY UP AND
CONTRIBUTE TO THE SURPRISE EFFECT.

EXPRESSING AN ATTITUDE

GESTURES, MANNERISMS, ATTITUDES OF POSTURE, AND OUTBURSTS ARE A LANGUAGE OF ANIMATION THAT SPEAKS EMOTIONS AND REVEALS CHARACTER THROUGH YOUR DRAWINGS. AS THE ART DEVELOPS, THE COMIC CHARACTERS BEGIN TO "THINK" AND ASSUME PREDICTABLE CHARACTER—MOST OF IT HILARIOUS. HOWEVER, IN LATER DISNEY FEATURES THE ANIMATED ART OFTEN REACHED A HIGH POINT OF MOVING PEOPLE TO TEARS. THE ANIMATOR BECAME A "REAL" ACTOR.

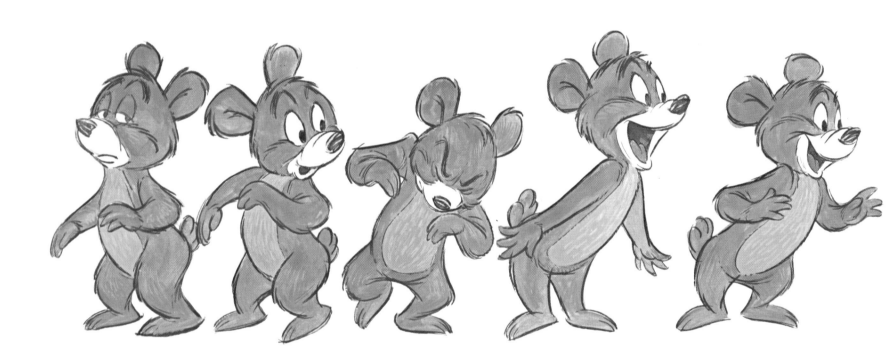

HERE ARE SOME RULES FOR THESE ACTORS: (1) NEVER MOVE OR "FREEZE" WITHOUT MEANING, (2) HOLD A GESTURE AS LONG AS POSSIBLE TO LET IT REGISTER AND SINK IN, AND (3) DON'T OVER-GESTURE. MAKE EVERYTHING WORK FOR YOU: EARS, TAIL, HAIR, LEGS, FEET, CLOTHING, ETC. FOR THE ACTION, MAKE A FEW THUMBNAIL SKETCHES AND A SHORT SCRIPT. FOR EXAMPLE: DOG WITH RED HAT ON PAGE 151 SNEAKS IN AND STOPS IN FORWARD CROUCH; THE BIG EYES LOOK FROM SIDE TO SIDE AND THE BODY BECOMES ERECT; THE HAND FOLLOWS THROUGH SLOWLY TO LIPS (SHOW CONSPIRACY); IT MOVES INTO POSE SLOWLY, AND THEN THE EARS AND TAIL OVERLAP IN POSE.

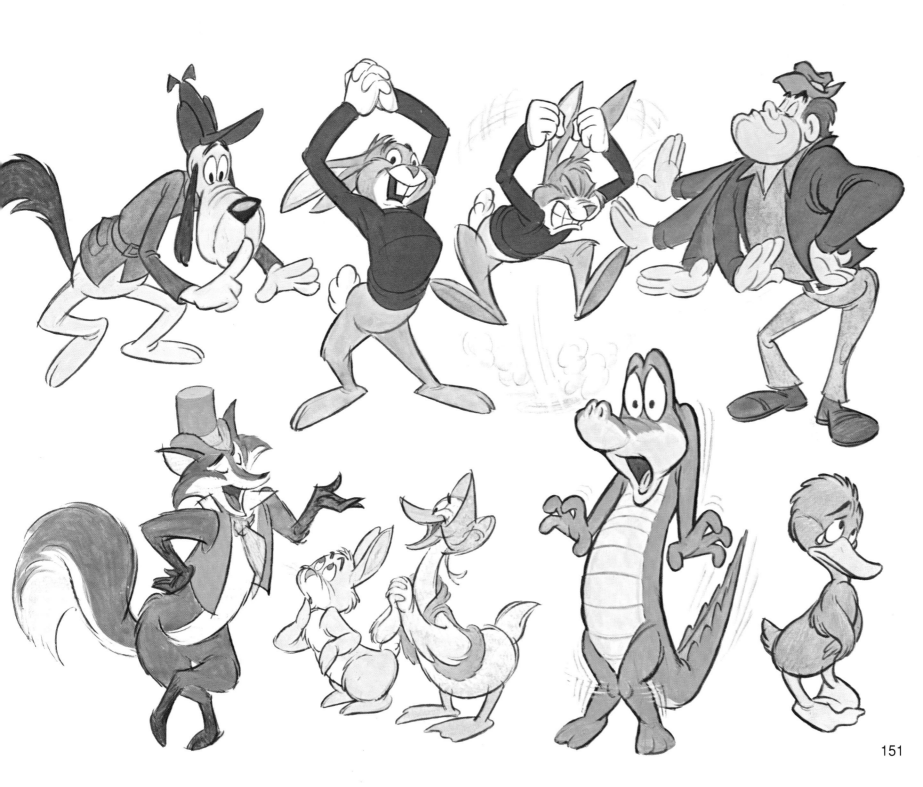

EMOTION · GESTURE · REACTING

START WITH THE EMOTION—GET INSIDE THE CHARACTER AND ACT IT OUT—AND THEN SKETCH THE SWEEP OF THE BODY, ARMS, LEGS, AND HEAD. EXPLORE EVERY TILT AND TURN OF THE HEAD AND THE EXPRESSIVE HANDS.

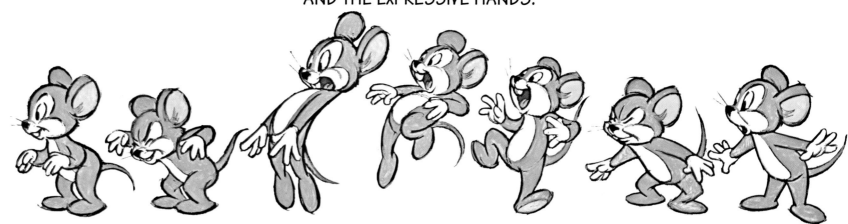

IN THE "TAKE" OF THE MOUSE ABOVE, THE MOUSE SINKS INTO AN ANTICIPATION CROUCH OR CONTRACTION THAT IS ALWAYS BRIEF, AND THEN SPRINGS INTO THE STRETCH EXPANSION (ALSO BRIEF), AND THEN IN A SCRAMBLE REVERTS TO NORMAL-SIZE LOOK. THIS ANIMATION REACTION HAS WIDE USE IN MANY FORMS. IT CAN BE REVERSED WITH THE STRETCH FIRST, THEN CROUCH CONTRACTION, AND THEN INTO LOOK.

ACTIONS HAVE DRAWINGS LIKE BEAR NO. 2 ON PAGE 150 AND SLOW-BURN NO. 2, BELOW, THAT NEED TO BE HELD OR PROLONGED WITH CLOSE ADJACENT DRAWINGS. THE BEAR COULD BLINK, AND NO. 2 OF THE BURN COULD SLOWLY MOVE FURTHER BACK.

ANIMATION IS A CALCULATED SPACING OF CARTOONS THAT CAN BRING GESTURES LIKE THESE TO LIFE. EACH OF THESE GESTURES REQUIRES: (1) RELATED ANIMATION ACTING INTO THE POSE, (2) OVERLAPPING ACTION INTO AND OUT OF THE POSE, AND (3) THE SUBTLE ANIMATION OF THE POSE, OR A "FREEZE" WITH DRAMATIC MEANING. WHEN ANIMATING, NEVER GO TO A PLACE ALL AT ONCE UNLESS THERE'S A REASON (WHICH ISN'T OFTEN). HERE ARE THREE CLASSIC ANIMATION PATTERNS: THE BEAR "DOUBLE-TAKE" INTO POSE (PAGE 150), THE MOUSE "TAKE" INTO POSE (ABOVE), AND ONE VERSION OF THE GREAT "SLOW-BURN" (BELOW).

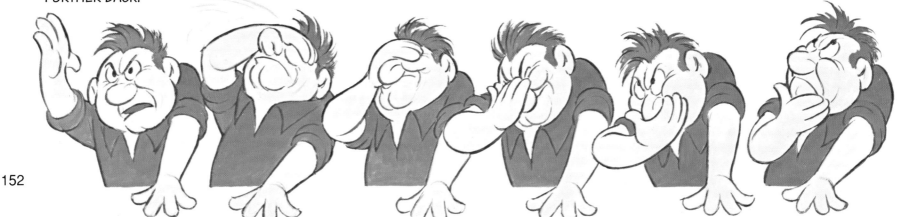

THE BODY LANGUAGE ACTOR

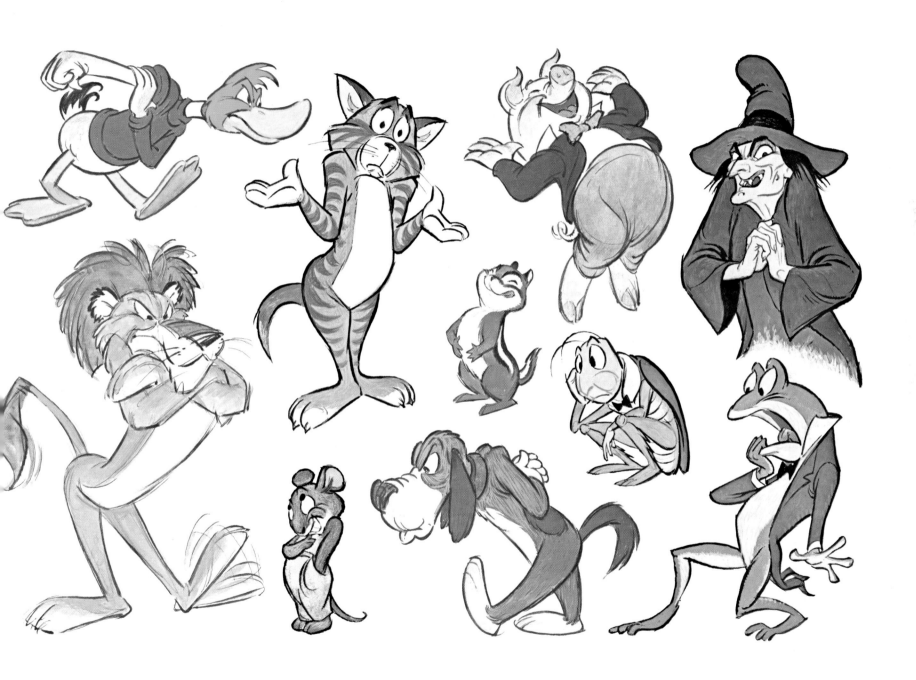

MAKE A COLLECTION OF BODY GESTURE CARTOONS AND PHOTOS.

WEIGHT—RECOIL EFFECTS

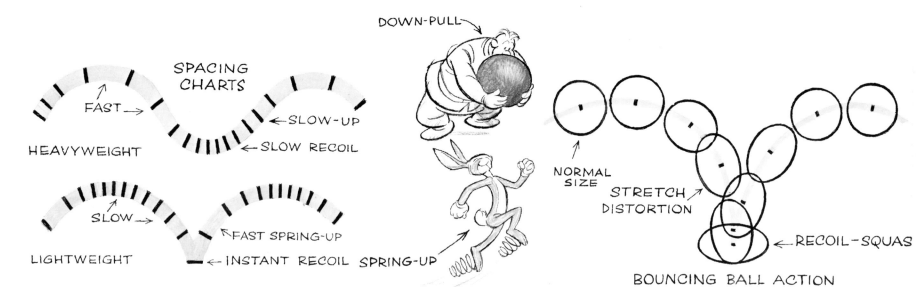

SPACING CHARTS

FAST →

HEAVYWEIGHT

← SLOW-UP

← SLOW RECOIL

SLOW →

LIGHTWEIGHT

FAST SPRING-UP

← INSTANT RECOIL

DOWN-PULL

SPRING-UP

NORMAL SIZE

STRETCH DISTORTION

← RECOIL-SQUASH

BOUNCING BALL ACTION

WEIGHT IS REGISTERED IN ANIMATION BY
1. THE VISUAL STRUGGLE TO MOVE WEIGHT.
2. THE VISUAL EFFECTS OF STOPPING WEIGHT.
3. THE TIMING CAUSED BY IMMOBILITY AND GRAVITY.
4. CHAIN-BALANCE DUE TO TYPES OF SAG.

LIGHT WEIGHT IS REGISTERED BY
1. THE SPRING UP WITH NO RESISTANCE.
2. THE ELIMINATION OF RECOIL PROCESSES.
3. TIMING CAUSED BY MOBILITY AND FLOAT.
4. NO SAG, STRESS, STRAIN, OR SQUASH.

THE **BOUNCING BALL PRINCIPLE** ILLUSTRATES THE BASIC RECOIL-SQUASH-CONTRACTION AND THE STRETCH-ELONGATION THAT ARE PART OF MOST CHARACTER MOVEMENT. THE ELEPHANT AT RIGHT SHOWS OVERLAPPING SQUASH-RECOIL AND STRETCH.

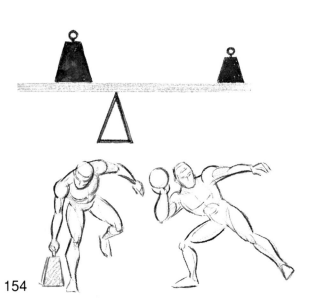

THE **OFF-CENTER BALANCE** IS CAUSED BY ONE-SIDED WEIGHT (LEFT).

THE **CHAIN BALANCE** IS EXAGGERATED IN A FIGURE ACTION CAUSED BY HIGH SAG, SUCH AS WITH HEAVY GIANTS AND ANIMALS (SEE PAGE 131).

STRAIN IS CREATED WHEN MOVING HEAVY BODIES OR WEIGHTS.

STRESS IS CREATED WHEN PULLED AND PUSHED ANATOMY SHOWS WEIGHT (RIGHT).

154

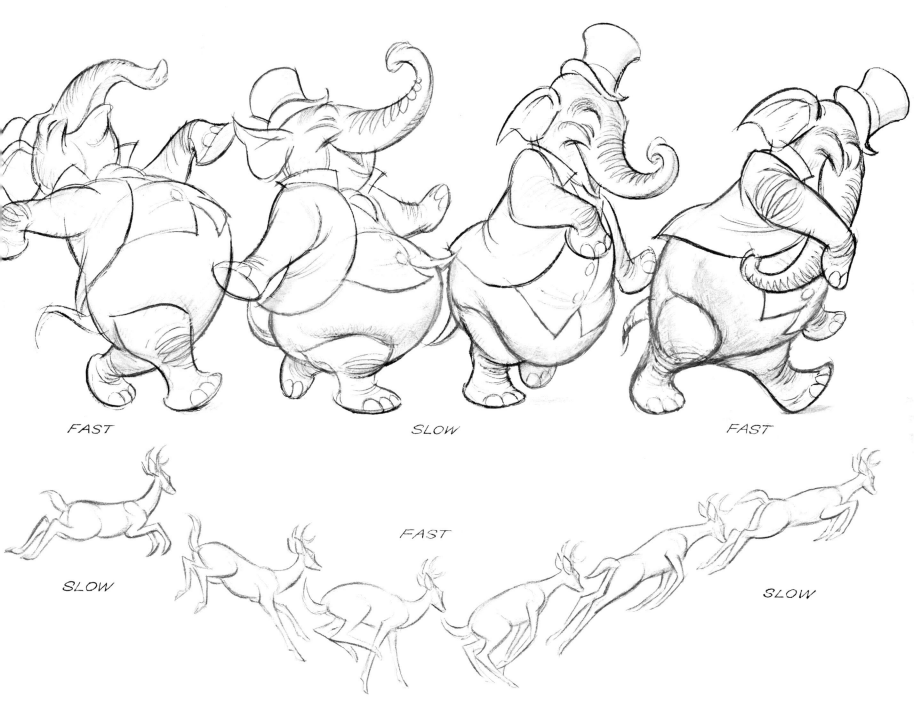

FAST SLOW FAST

SLOW FAST SLOW

THE TIMING OF A CHARACTER ACTION HAS A GREAT DEAL TO DO WITH WEIGHT—OR LACK OF IT. AS
SHOWN, THE RECOIL PROCESS TAKES TIME FOR AN ELEPHANT, WHILE THE DEER HARDLY TOUCHES THE
EARTH, SPRINGS UP, AND FLOATS, UNTOUCHED BY GRAVITY.

OVERLAPPING ACTION · FOLLOW-THROUGH

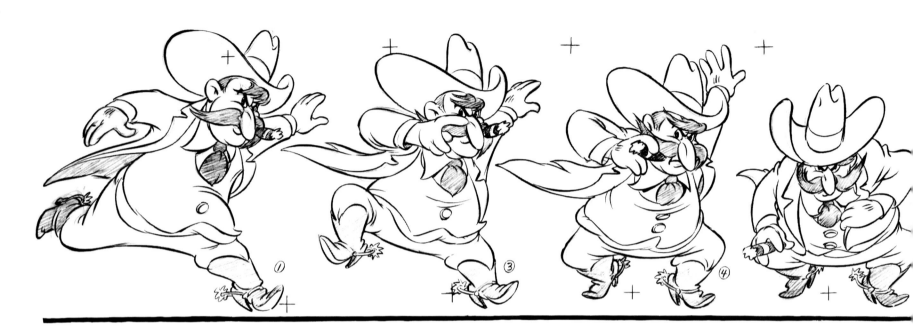

OVERLAPPING ACTION (NOTE: THIS RULE HOLDS TRUE IN THE MAJORITY OF ANIMATION ACTIONS)—WHEN ANIMATING A CHARACTER FROM ONE POINT TO ANOTHER, DON'T GO THERE ALL AT ONCE. THE MAIN ACTION CAN BE PRECEDED AND FOLLOWED BY LESSER ACTIONS THAT RELATE TO, OR ARE THE RESULT OF, THE MAIN ACTION. THESE ARE KNOWN AS "OVERLAPPING ACTIONS" AND THE PROPER USE OF THEM WILL GREATLY IMPROVE THE QUALITY OF YOUR WORK. NOTICE THAT FROM THE ANTICIPATION IN STEP 8, THE COP COMES TO AN EXTREME ACCENT IN STEP 10 AS HE STARTS SAYING, "ALL RIGHT!" THE MAIN ACTION OF THE FIGURE CAUSES A LESSER ACTION—OR REACTION—ON THE COP'S STOMACH. DOWN IN STEP 10, IT RECOILS IN STEPS 13 TO 16, BOUNCES BACK IN STEP 18, AND THEN FINALLY SETTLES BACK UP IN STEP 24. IN OTHER WORDS, A MAIN ACTION BETWEEN STEPS 8 AND 10 HAS CAUSED AN OVERLAPPING LESSER ACTION TO OCCUR FROM STEP 10 ALL THE WAY TO STEP 24.

FOLLOW-THROUGH—ANOTHER RULE OF ANIMATION IS THAT WHEN A FLAG—OR SOMETHING SIMILAR—IS WAVED OR JERKED, THE FLAG WILL FOLLOW A DEFINITE CURVING PATH THAT IS DETERMINED BY THE POSITION OF THE MAST A SPLIT SECOND BEFORE THE MOVEMENT. IN ANIMATION THIS NATURAL LAW IS CALLED THE "RULE OF FOLLOW-THROUGH." STUDY THE ENDS OF THE COAT HERE. PUT THIS TYPE OF FOLLOW-THROUGH ACTION ON ALL FLEXIBLE, LOOSELY-WAVING OBJECTS; IN A STRICT SENSE, ANY OBJECT THAT "GIVES" IN ANIMATION HAS A CERTAIN AMOUNT OF FOLLOW-THROUGH ACTION.

SQUASH AND STRETCH—WHEN A SANDBAG MOVES THROUGH THE AIR, IT WILL STRETCH IN THE DIRECTION OF THE MOVEMENT. THEN WHEN ITS PROGRESS IS ARRESTED, IT WILL "SQUASH" OUT. IF IT WERE ALIVE (ANYTHING CAN HAPPEN IN A CARTOON!), IT WOULD ALSO SQUASH FROM ANTICIPATING THE ACTION IN WHICH IT STRETCHES. NOTICE STEPS 8 AND 10 ABOVE. THE PROPER USE OF SQUASH AND STRETCH WILL STRENGTHEN AN ACTION. IT IS ESSENTIAL IN CREATING A FEELING OF WEIGHT IN CHARACTERS.

THE SQUASH AND STRETCH PRINCIPLE

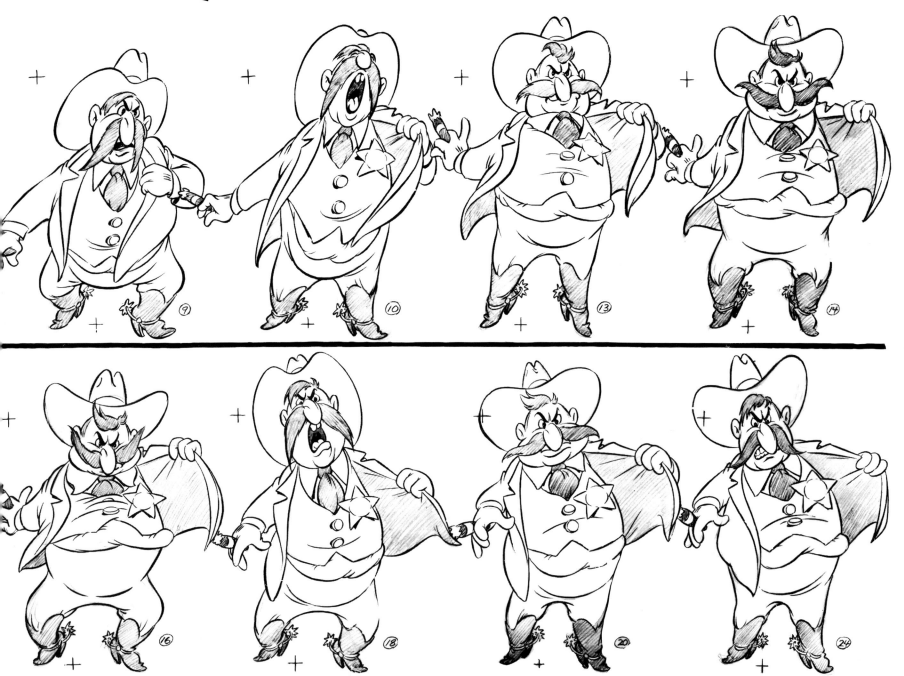

IF YOU TRACE THIS CHARACTER, REMEMBER THAT THE CROSSES ABOVE AND BELOW
EACH DRAWING ARE AT A FIXED POINT ON THE SCREEN, SO THEY SHOULD LINE UP.

DANCING HIPPO

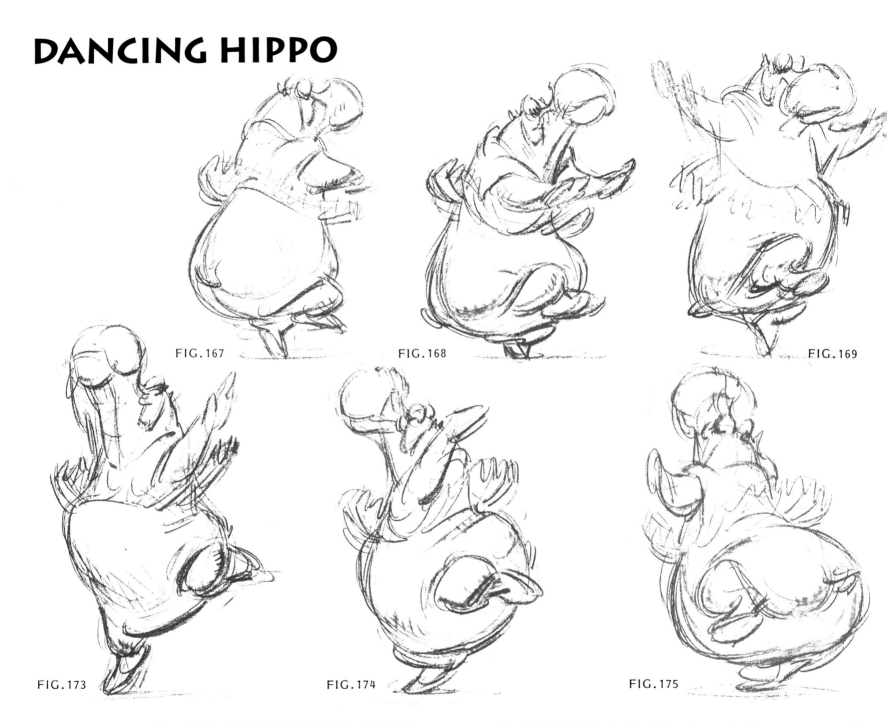

FIG.167

FIG.168

FIG.169

FIG.173

FIG.174

FIG.175

158

DURING HER PERFORMANCE THE HIPPO BALLERINA MAKES A JUMP AND TURN LASTING ONE SECOND, OR TWELVE DRAWINGS OF TWO FRAMES EACH. THE METHOD IS STRAIGHT-AHEAD ANIMATION.

EACH DRAWING EVOLVES FROM SEVERAL OF THE PRECEDING DRAWINGS. THE ANIMATOR FLIPS THE DRAWINGS LIKE A "FLIP BOOK" AND MAY WORK ON SEVERAL AT ONCE.

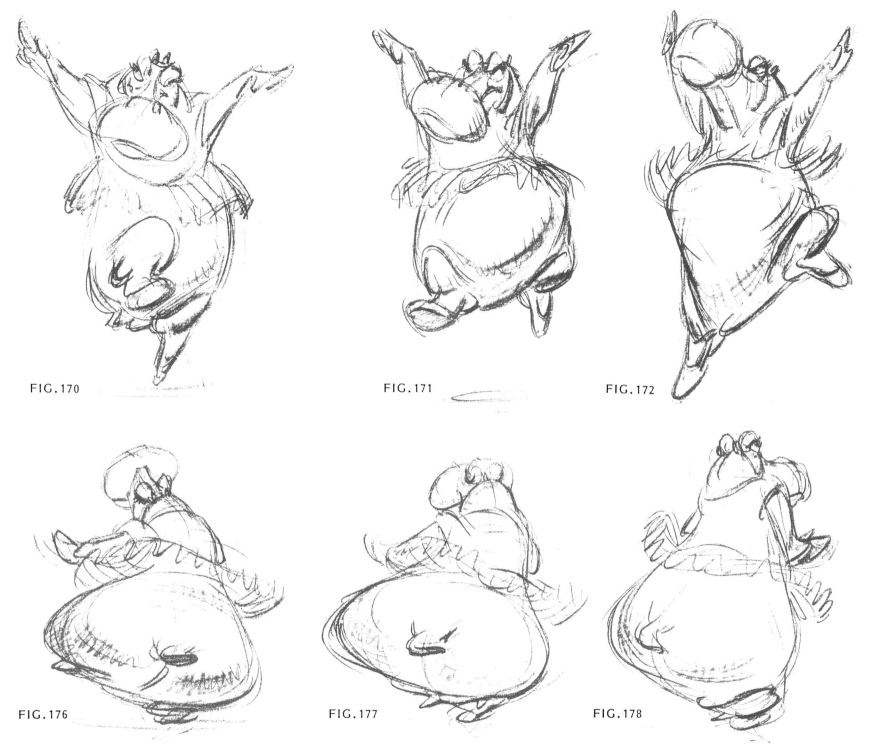

FIG.170

FIG.171

FIG.172

FIG.176

FIG.177

FIG.178

STUDY THE OVERLAPPING ACTIONS OF THE ENORMOUS TUMMY, THE SKIMPY TUTU SKIRT, THE ARMS, THE LEGS, AND THE HEAD, AND THE SQUASH AND STRETCH PRINCIPLE SHOWN AS THE HUGE POSTERIOR-HINDER SIDE OF THE BODY (FANNY)

SQUASHES TO ENORMOUS PROPORTIONS ACCENTUATED BY THE FORCED PERSPECTIVE. THE HIPPO BALLERINA SWINGS HER ARMS UP TO CREATE A MOMENTUM FORCE TO LIFT THE HUGE BODY (SEE JUMP IN SPACING).

159

ALLIGATOR BALLET

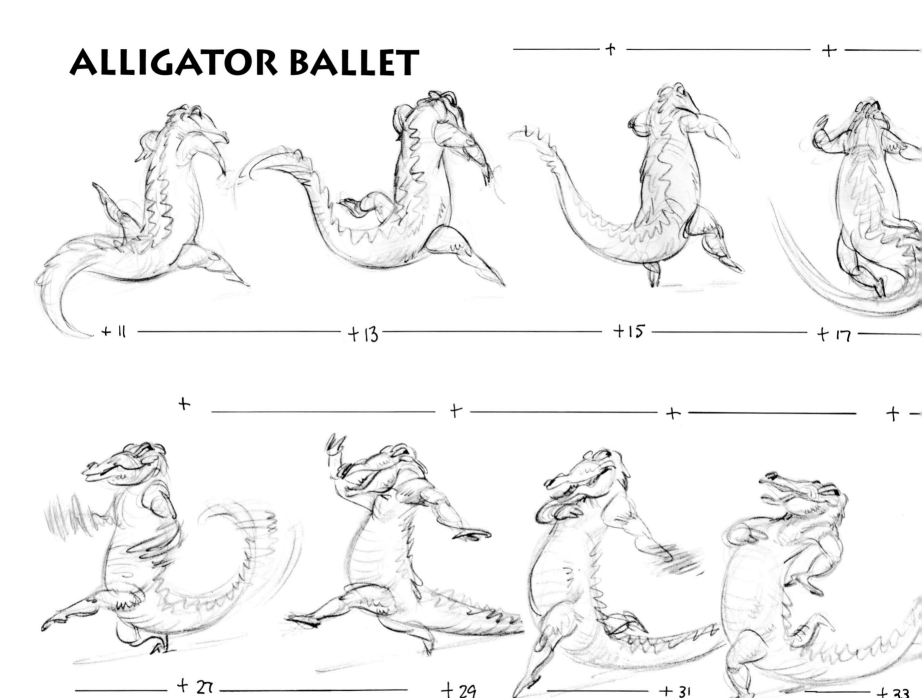

+11 —— +13 —— +15 —— +17

+27 —— +29 —— +31 —— +33

IN THIS TYPE OF ANIMATION, THE ANIMATOR MUST MAKE EVERY DRAWING COUNT BECAUSE EACH ONE IS A SEPARATE IDENTITY—NOT AN IN-BETWEEN. (THE USUAL METHOD OF OUTLINING THE ACTION WITH A FEW EXTREMES AND THEN RELYING ON AN ASSISTANT TO FIT IN THE REMAINING DRAWINGS IS NOT USED.) EACH MOVE OF THE ALLIGATOR HAS A QUALITY ALL ITS OWN AND MUST GROW FROM THE PRECEDING DRAWING.

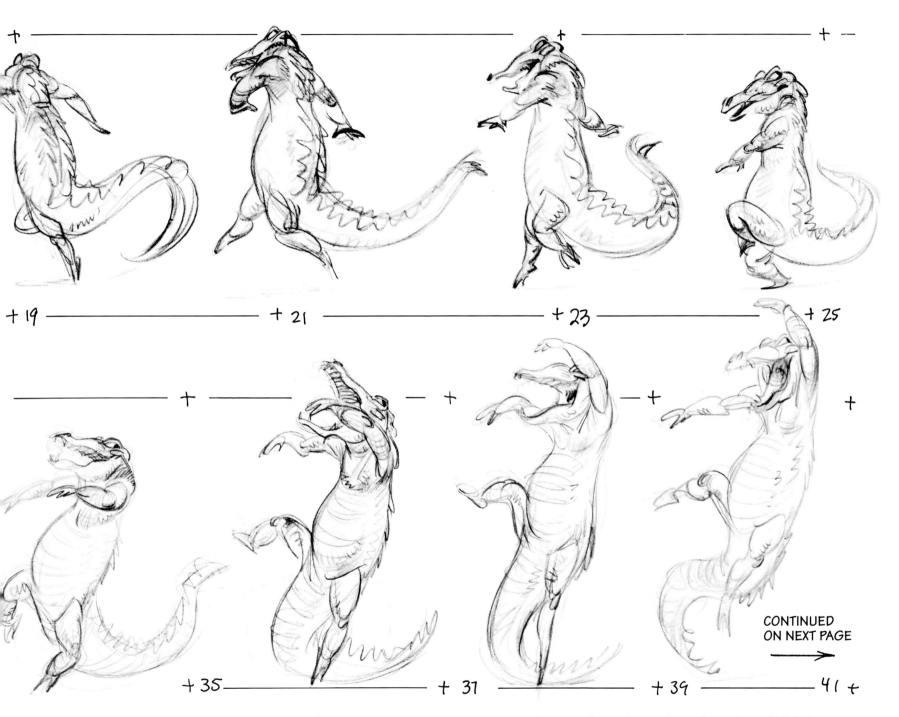

+ 19 ——————— + 21 ——————— + 23 ——————— + 25

+ 35 ——————— + 31 ——————— + 39 ——————— 41 +

CONTINUED
ON NEXT PAGE
→

DURING THIS FLIPPING REFERENCE TO A SERIES OF DRAWINGS, THE ANIMATOR MAY GO BACK AND CHANGE WHOLE ACTIONS IN THE DRAWINGS THAT LEAD UP TO THE DRAWING HE IS CURRENTLY WORKING ON. HE IS ACTUALLY WORKING ON ALL THE DRAWINGS ON THE TOP PEGS AT THE SAME TIME. (BOTTOM PEGS ARE NOT ADAPTABLE TO THIS TYPE OF ANIMATION AS FLIPPING AND DRAWING FROM THE TOP OF MOST DRAWINGS ARE DIFFICULT AND CUMBERSOME.)

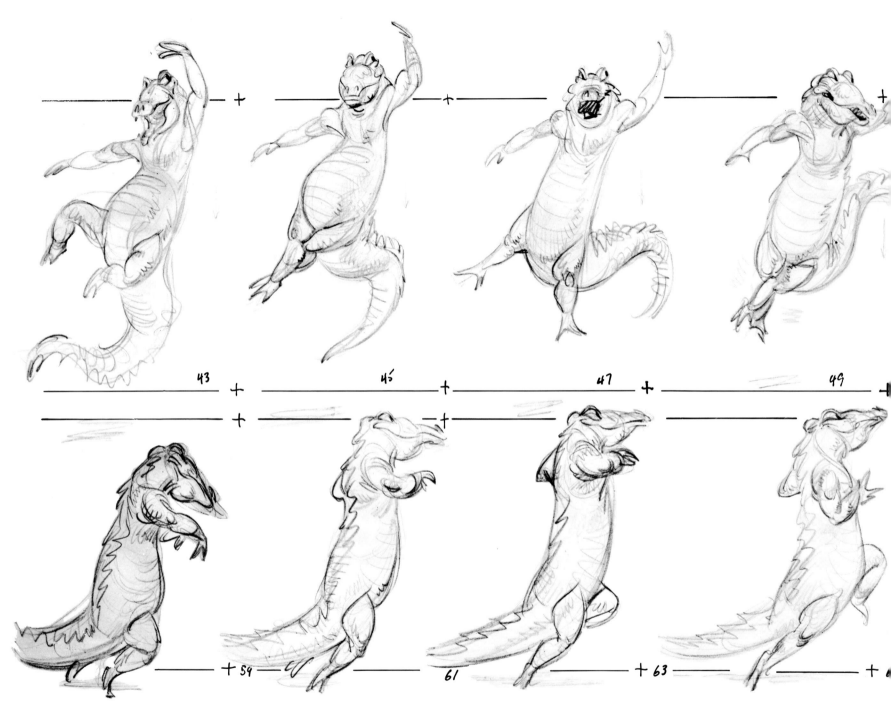

43 45 47 49

59 61 63

WHEN THE ANIMATOR HAS COMPLETED THE SCENE OF THE
ALLIGATOR BALLET ACTION, EACH DRAWING IS PHOTOGRAPHED
TWO TIMES (2s) FOR A ROUGH FILM TEST (TWELVE DRAWINGS
ARE VIEWED IN ONE SECOND ON THE FILM). HE THEN USES A

REVOLVING-PRISM EDITING VIEWER OR A MOVIOLA PROJECTION
MACHINE TO ANALYZE THE ACTION TO DECIDE WHETHER EACH
FRAME FITS OR NOT. HE THEN MAKES ANY NECESSARY
CHANGES. THROUGH THIS PROCESS OF ANIMATING AND FILM

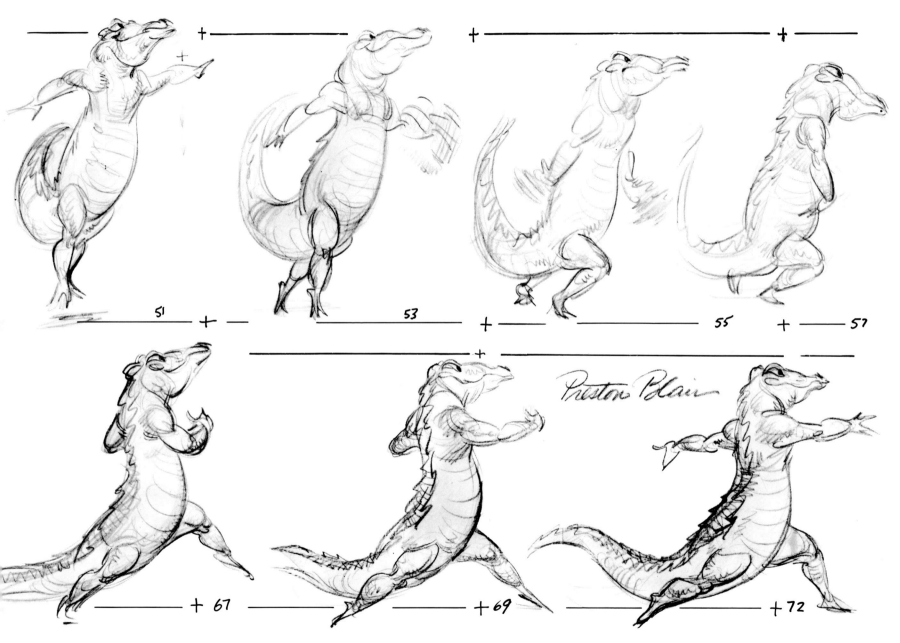

51 53 55 57

67 69 72

Preston Blair

TESTING, THE ANIMATOR LEARNS HOW TO TIME AND SPACE THE DRAWINGS TO ACHIEVE THE PROPER SPEED IN EACH OF THE PRIMARY AND SECONDARY ACTIONS THAT SIMULATE REALITY. HE WILL ALSO LEARN HOW MANY DRAWINGS ARE NEEDED TO REGISTER AND SEE ANTICIPATIONS, POSES, AND REACTIONS. ON FILM, YOU DO NOT SEE JUST ONE OF THESE ALLIGATOR DRAWINGS; YOU SEE THE SEQUENCES. NOTE: THIS PROCESS IS EXPLAINED IN GREATER DETAIL IN CHAPTER 5.

HIPPO AND ALLIGATOR BALLET

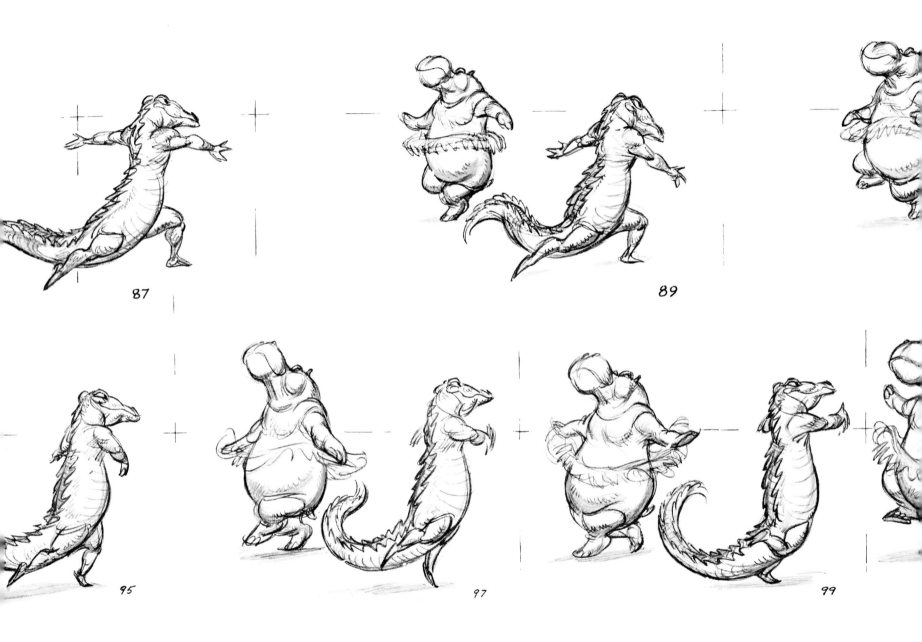

87

89

95

97

99

THE HIPPO IN DISNEY'S MOVIE *FANTASIA* WAS CONCEIVED IN THIS EXPERIMENTAL ANIMATION.

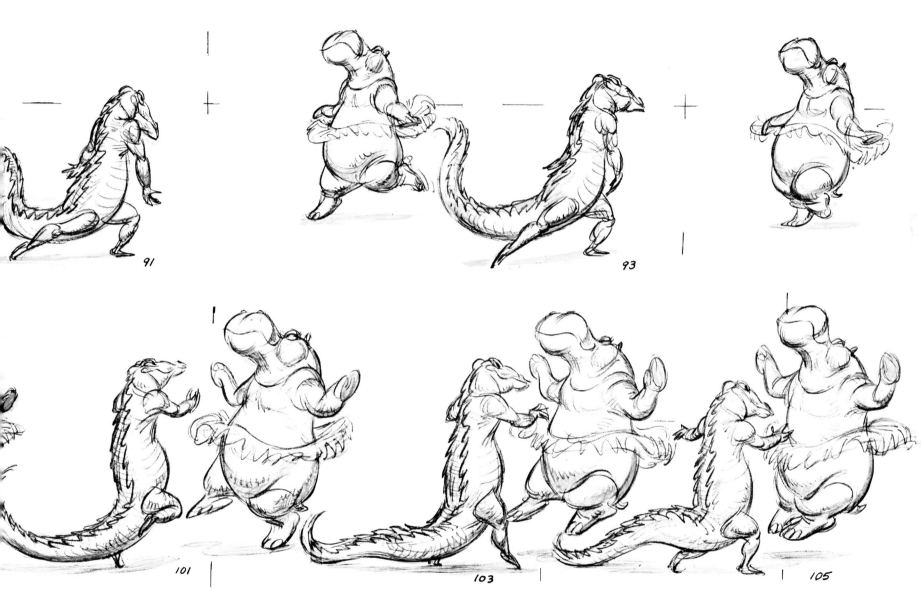

91 93 101 103 105

CONTINUED
ON NEXT PAGE

I MADE THE MODEL SHEETS AND ANIMATED HER IN THE BALLET.

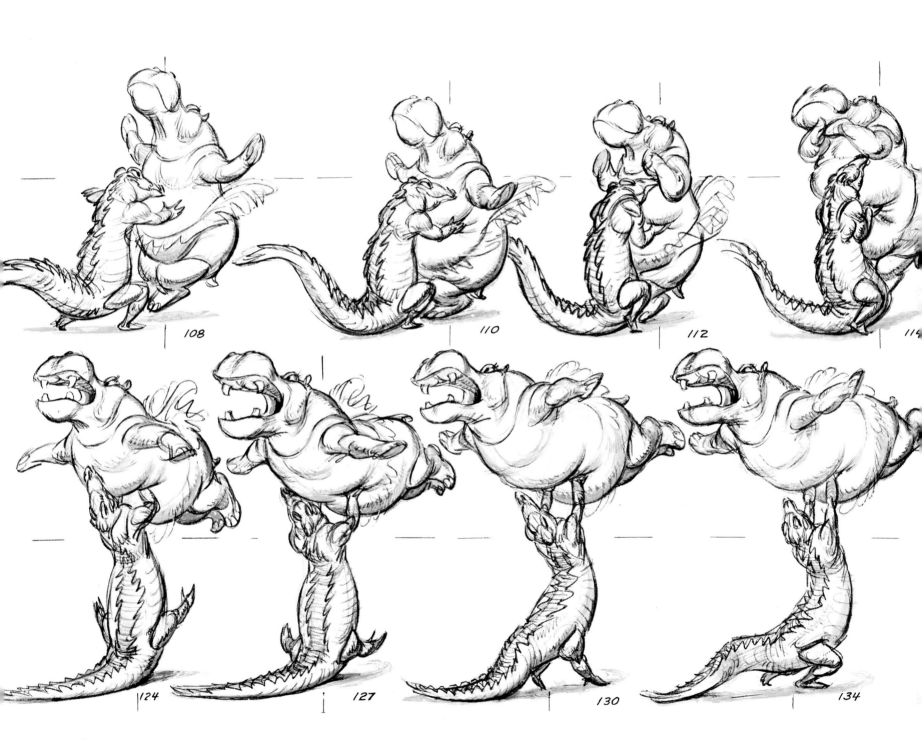

108 110 112 114

124 127 130 134

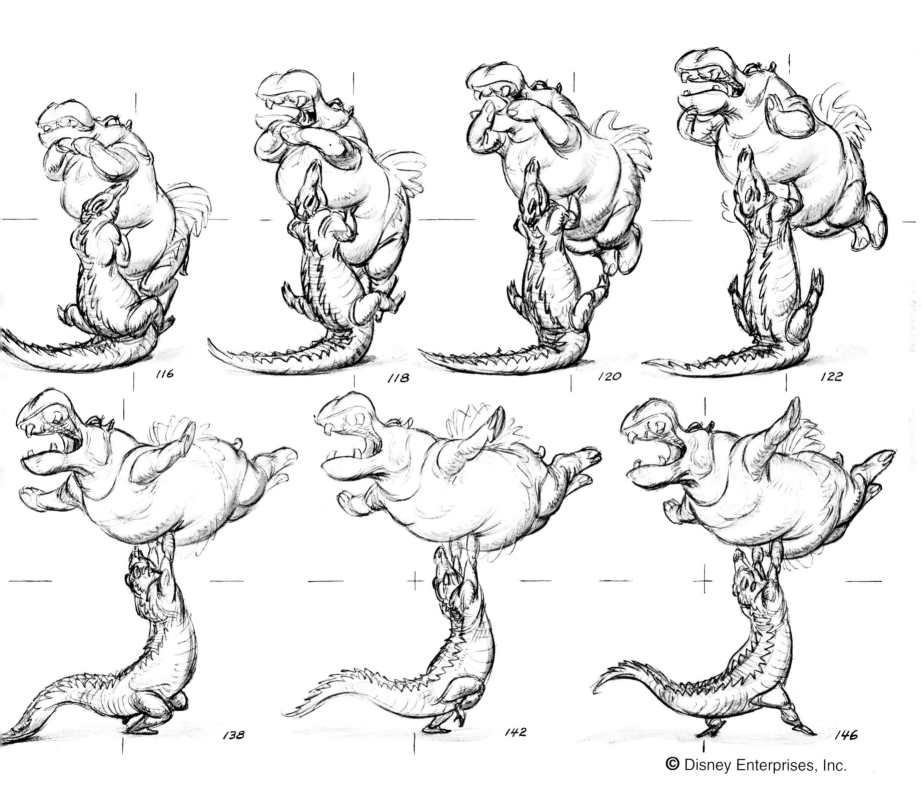

116

118

120

122

138

142

146

WOMEN

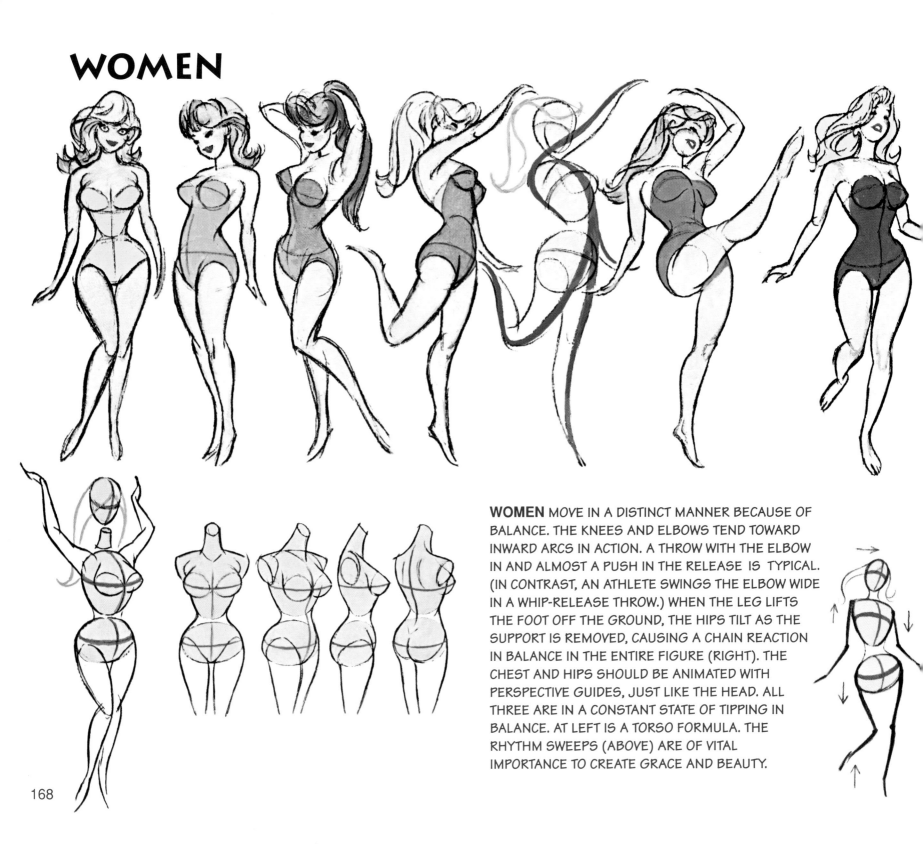

WOMEN MOVE IN A DISTINCT MANNER BECAUSE OF BALANCE. THE KNEES AND ELBOWS TEND TOWARD INWARD ARCS IN ACTION. A THROW WITH THE ELBOW IN AND ALMOST A PUSH IN THE RELEASE IS TYPICAL. (IN CONTRAST, AN ATHLETE SWINGS THE ELBOW WIDE IN A WHIP-RELEASE THROW.) WHEN THE LEG LIFTS THE FOOT OFF THE GROUND, THE HIPS TILT AS THE SUPPORT IS REMOVED, CAUSING A CHAIN REACTION IN BALANCE IN THE ENTIRE FIGURE (RIGHT). THE CHEST AND HIPS SHOULD BE ANIMATED WITH PERSPECTIVE GUIDES, JUST LIKE THE HEAD. ALL THREE ARE IN A CONSTANT STATE OF TIPPING IN BALANCE. AT LEFT IS A TORSO FORMULA. THE RHYTHM SWEEPS (ABOVE) ARE OF VITAL IMPORTANCE TO CREATE GRACE AND BEAUTY.

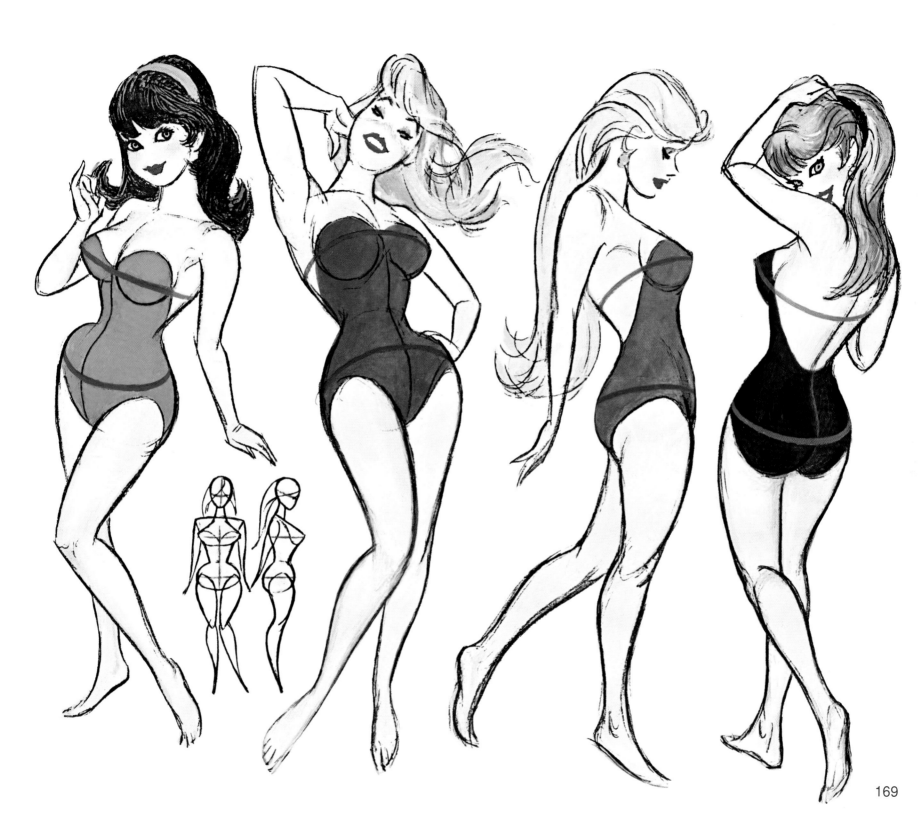

169

BUILDING AN ACTION

THIS DANCING GIRL ACTION IS DEVELOPED LIKE STACK-ING BUILDING BLOCKS—ONE ON TOP OF ANOTHER. THE FIRST DRAWINGS ARE RHYTHM SCRIBBLES. AFTER EACH ONE IS MADE, THE DRAWINGS ARE FLIPPED TO STUDY HOW THE ACTION IS PROGRESSING. WHEN THE SKETCHES ARE ALL ON PEGS (SEE PAGE 218), THE ACTIONS CAN BE REVISED AND RE-REVISED, LIKE CHANGING DOTS IN THE PAGES OF A FLIP BOOK. THIS GIRL'S LEG DID NOT SWING HIGH AND WIDE AT FIRST; I MADE A SERIES OF SCRIBBLES OVER THE FIRST CRUDE SKETCHES TO REVISE THE ACTION. THEN THESE ROUGHS WERE MADE OF WHAT I IMAGINED SEEING IN THESE FORMS.

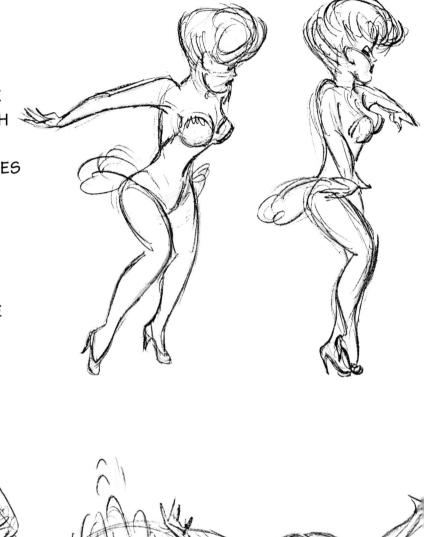

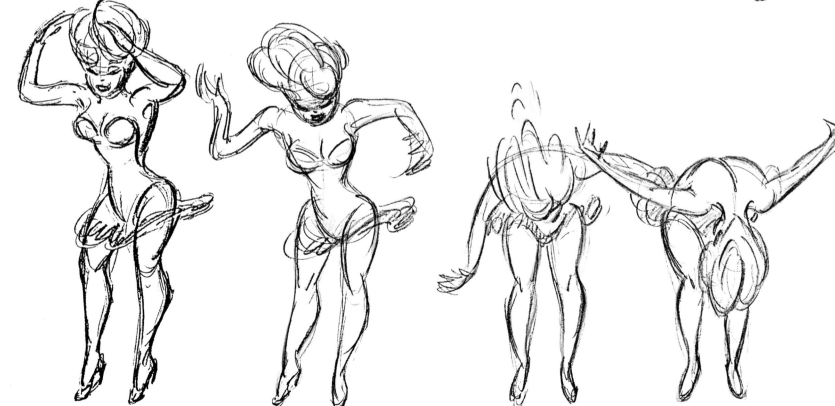

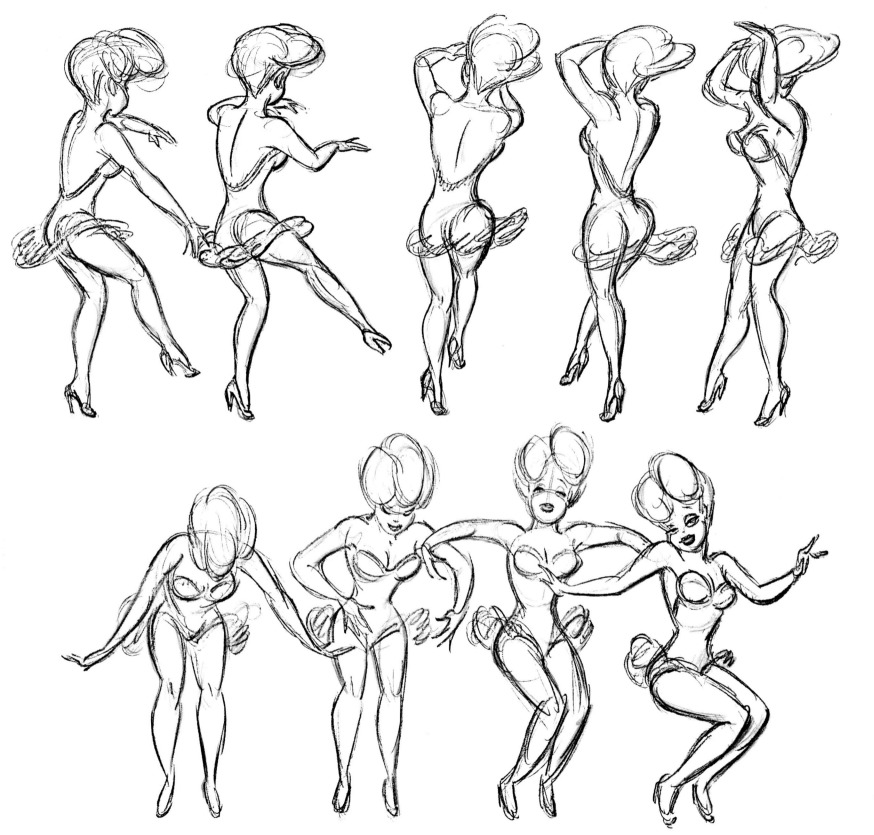

A DANCE KICK

THIS DANCING GIRL RISES FROM A TWIST-POSE (1), STEPS (13) INTO A DANCE-KICK (23 THROUGH 31), THEN INTO A BACK STEP AND SINKING ACTION (49), AND INTO A REVERSAL OF POSE 1 (ON 2s—ON ONLY ODD NUMBERS). THUS, DRAWINGS 1 THROUGH 49 REVERSED ANIMATE THE GIRL IN A KICK TO THE LEFT, AND BACK TO 1 FOR A CYCLE. THIS KICK HAS A DOUBLE TOP STAGGER IN THAT THE ACTION OF THE ENTIRE FIGURE RAISES THE LEG TO 23, SINKS TO 25, AND RAISES AGAIN TO PUSH THE LEG OUT IN A KICK AT 27.

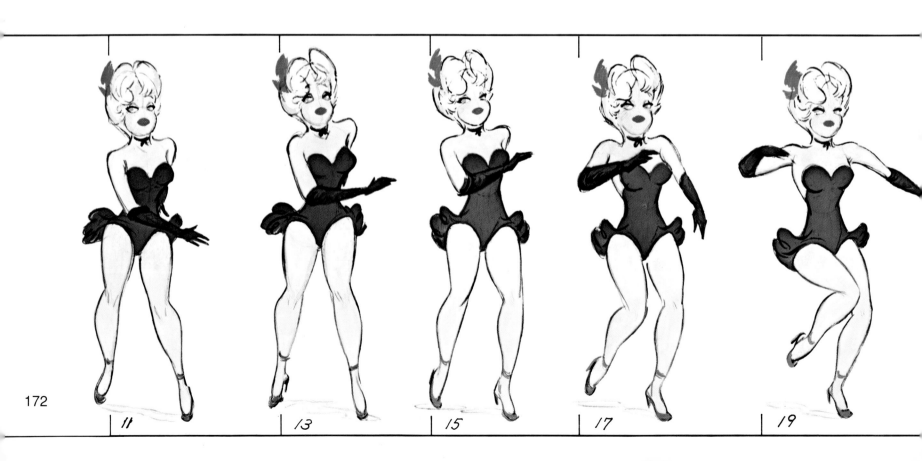

11 13 15 17 19

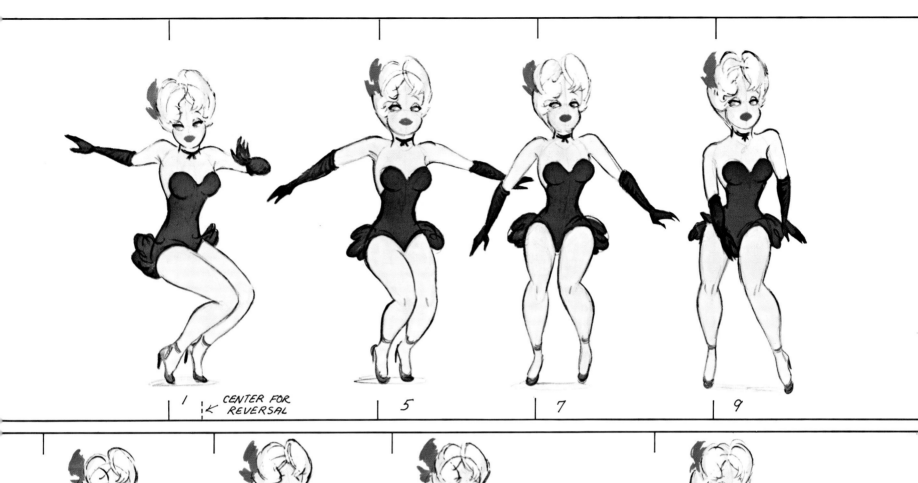

1 CENTER FOR REVERSAL 5 7 9

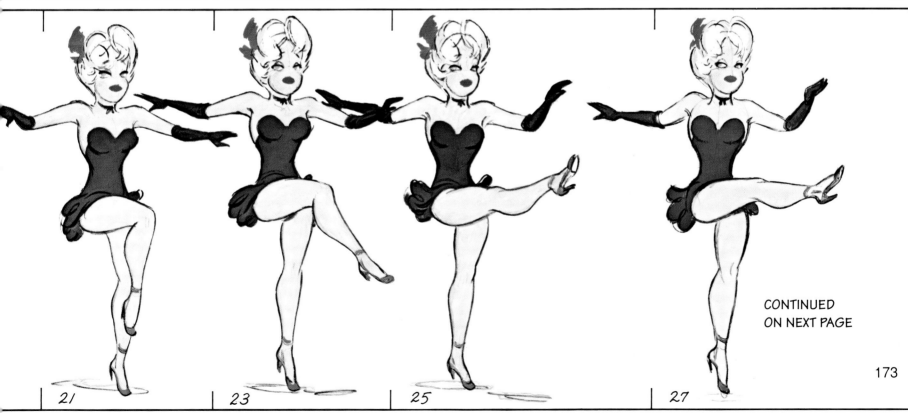

21 23 25 27

CONTINUED
ON NEXT PAGE

173

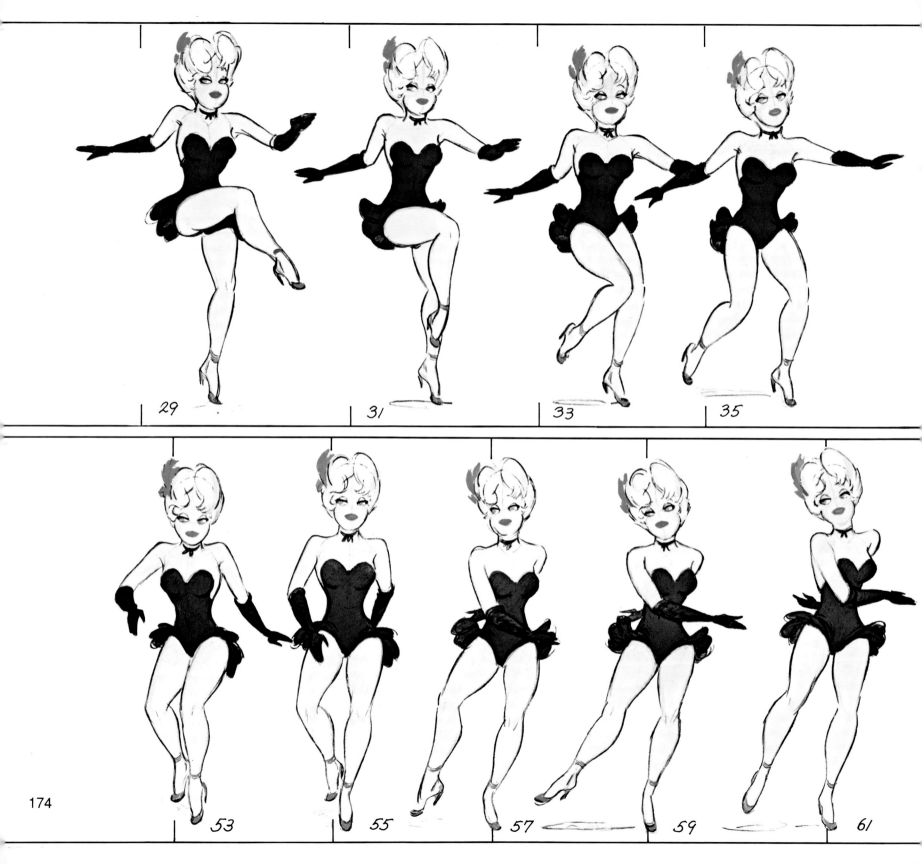

29 31 33 35

174

53 55 57 59 61

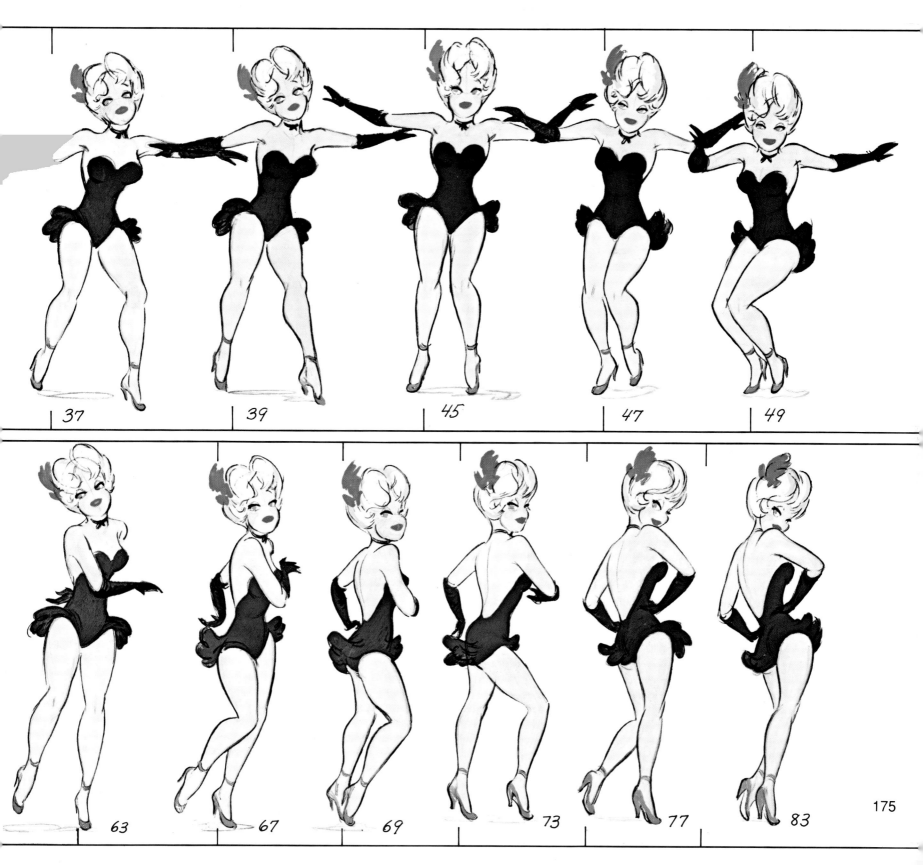

37 39 45 47 49

63 67 69 73 77 83

175

BACK-GROUND CONTROL

CHARACTER METAMORPHOSIS ANIMATION

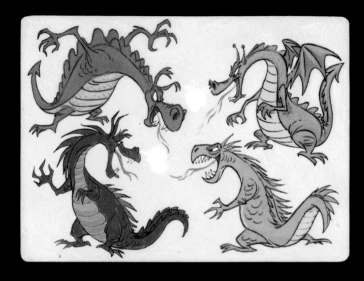
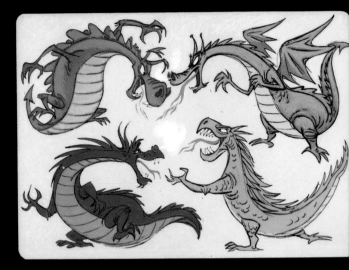
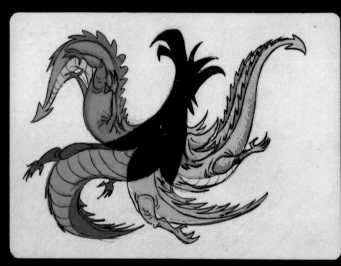
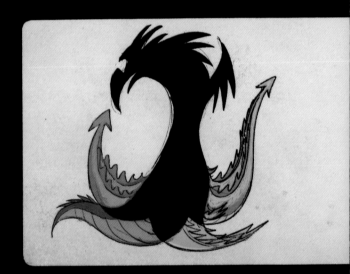
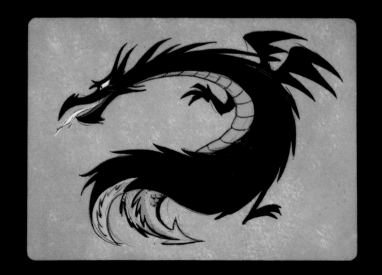
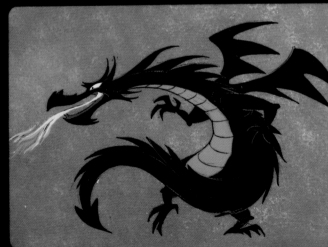

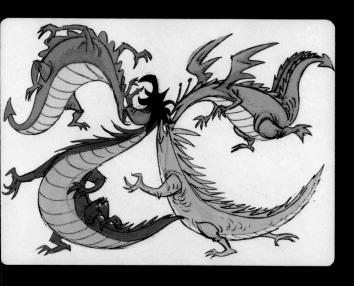

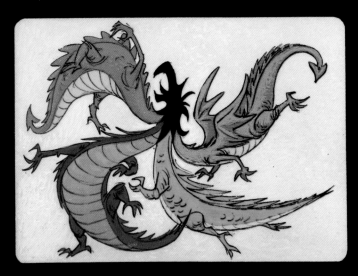

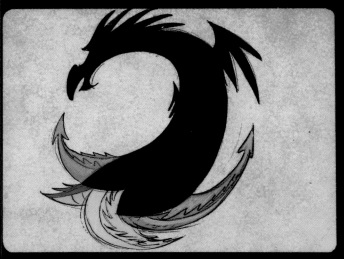

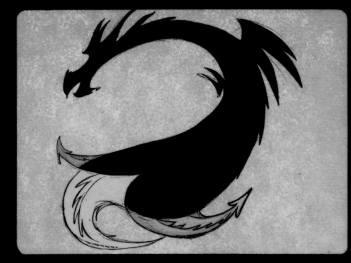

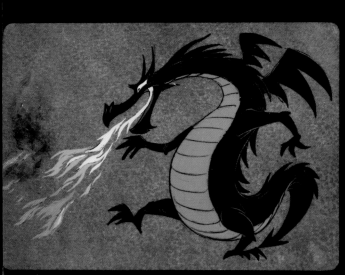

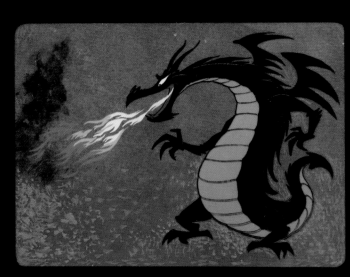

THE DRAMA OF METAMORPHOSIS (OFTEN CALLED "MORPHING") IS A VALUABLE TOOL IN ANIMATION. IN THIS SCENE, METAMORPHOSIS IS USED IN TWO WAYS:

1. A SPECIAL LIGHTING EFFECT KNOWN AS "CROSS-DISSOLVE" IS USED TO CHANGE THE BACKGROUND FROM LIGHT TO DARK.

2. THE FOUR DRAGONS ARE "MORPHED" INTO A SINGLE FIRE-BELCHING DRAGON MONSTER. STUDY THE CHANGES SHOWN IN THIS SEQUENCE. WHEN YOU USE THIS TECHNIQUE, THE ACTION SHOULD FLOW GRADUALLY AND SMOOTHLY.

177

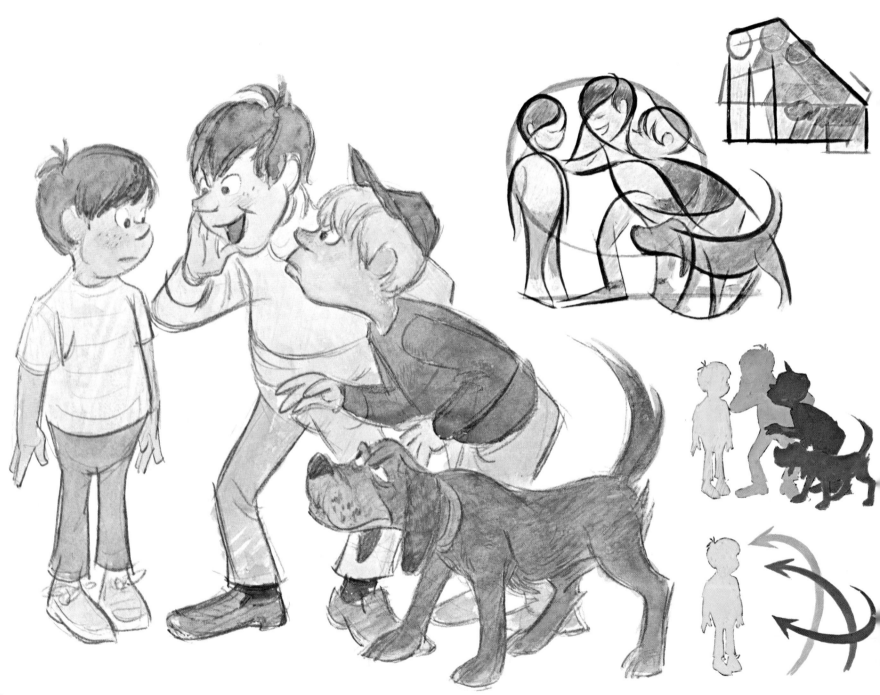

COMPOSITION · STAGING · DRAMA

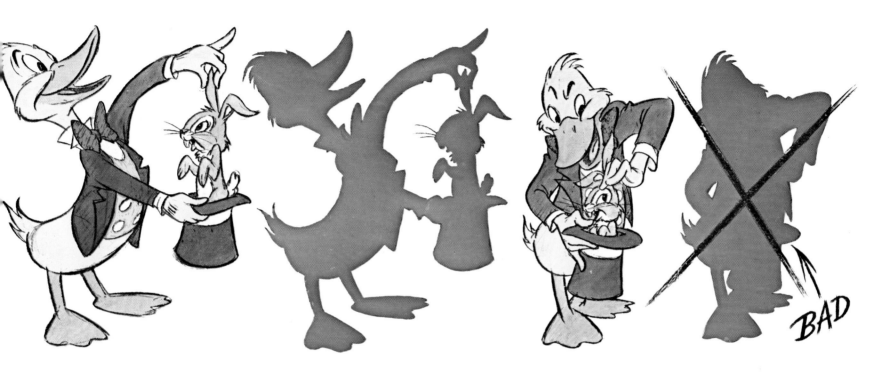

THE **DRAMA** PORTRAYED BY THE COMPOSITION FIRST CATCHES THE EYE, AND THEN DIRECTS THE EYE TO THE **CENTER OF INTEREST** BY VARIOUS DEVICES. AS SHOWN ON PAGE 178, THE CHARACTERS MAY BEND FORWARD AND LOOK AT IT, OR THE ABSTRACT DESIGN MAY POINT AT IT, INTERSECT IT, FRAME IT, CIRCLE IT, OR BEND AROUND IT (JUST AS PARENTHESES DO). THE CHARACTER IS ACCENTED BY COLOR DIFFERENCE, CONTRAST, OR TONE; IT IS CLEAR OF DETRACTING DETAIL (SEE DUCK ABOVE) AND ISOLATED; AND IT MAY ALSO BALANCE THE COMPOSITION IN IMPORTANCE.

COMPOSITIONS CAN BALANCE LIKE A SCALE WITH EQUAL WEIGHTS (AREAS), OR AS A BALANCE OF INTEREST. ANY SMALL, ISOLATED OBJECT OF GREAT IMPORTANCE CAN BALANCE A HUGE OBJECT.

CHARACTERS ARE FIT AND WOVEN TOGETHER IN A GROUP WITH RHYTHM LINES, STRAIGHT LINES THAT ALIGN, AND AREAS THAT FIT IN PATTERNS.

THE ALIGNMENT OF CHARACTER ABSTRACT LINES CREATES CIRCULAR AND CURVED RHYTHM LINES AND THE HORIZONTALS, VERTICALS, AND DIAGONALS.

THE VIEWER'S EYE LEVEL IS IMPORTANT WHEN HE LOOKS AT GRANDEUR OR BIG MONSTERS FROM A WORM'S-EYE VIEW, OR WHEN HE LOOKS DOWN AT SMALL THINGS.

APPRECIATE THE **VALUE OF SILHOUETTES** TO DEFINE AND CLEARLY TELL THE STORY IN TWO DIMENSIONS; EVEN IN GROUPS THEY DEFINE ALL ALONE (AS SHOWN ON PAGE 178).

DIALOGUE

Dialogue, mouth movements, body movements, and facial expressions all work together to portray the correct animation of the character. The examples on pages 138-139 are a great beginning for turning your character into an actor. Although it is interesting when your cartoon character simply walks across the screen, making it speak with the proper mouth movements and adding the gestures that go along with them turn the character into an actor with a distinctive personality. This is when the real excitement of animation begins.

A world of professional knowledge is contained here, including tips on how to keep your character's movements lifelike and real. Mouth movements used in dialogue make the character seem alive, and the dialogue delivery develops the personality of the character. In addition, the information on scientific phonetics is invaluable. Included are diagrams showing mouth positions, along with a thorough explanation of how sounds are made using the throat, tongue, teeth, and lips. Schedule diagrams showing timing and duration of sounds, along with explanations of what sounds are nasal, throat, or explosive, are covered.

Study the charts and the mouth drawings, paying close attention to the studies of the consonant sounds, the vowel sounds, and the diphthong vowel sounds. By studying this entire chapter, you can make your character say anything you wish, while creating the personality you had in mind when you first designed it.

DIALOGUE EXPRESSIONS · POINTERS

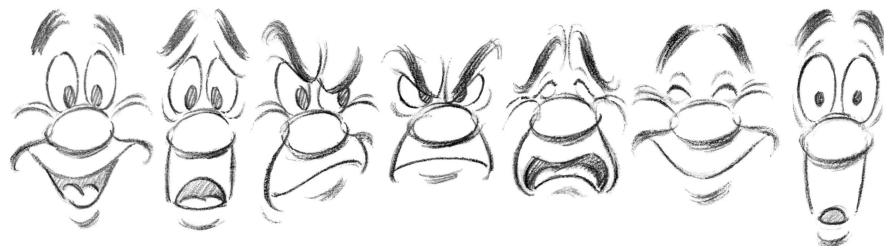

AN ACTOR/ANIMATOR HAS AN ENORMOUS RANGE OF FACIAL EXPRESSIONS. HE OFTEN STUDIES THESE EXPRESSIONS IN A MIRROR SO HE WILL BE BETTER ABLE TO DRAW THEM. EVERY EXPRESSION IS BASED ON FOUR FACTORS: THE EYEBROWS, THE EYES, THE EYELIDS, AND THE MOUTH/CHEEK AREA. ALL AFFECT THE EXPRESSION AND THEY MUST ALL WORK TOGETHER.

MANY EXPRESSIONS ARE NOT SYMMETRICAL, BUT THEY DON'T HAVE TO BE. AN ASYMMETRICAL EXPRESSION CAN CHANGE YOUR ANIMATION TO A NONSYMMETRICAL LOOK WITH DRAMATIC EFFECT.

THE ANIMATION PRINCIPLE OF CONTRACTION TO EXPANSION TO NORMAL OR EXPANSION TO CONTRACTION TO NORMAL IS VERY IMPORTANT IN FACIAL ACTION AND EFFECT. OVERLAPPING ACTION OF THE FOUR FACTORS CAN IMPROVE MANY ACTIONS. FOR EXAMPLE, AN EYE BLINKS (CONTRACTS), OPENS WIDE (EXPANDS), AND THEN GOES INTO NORMAL POSE, FOLLOWED IN AN OVERLAPPING ACTION BY THE EYEBROWS AND THEN THE MOUTH/CHEEK EXPRESSIONS. THE FACE IS A CONTINUOUS OVERLAPPING ACTION OF

CONTRACTION AND EXPANSION. MAKE A CASSETTE RECORDING OF THE DIALOGUE; THEN PLAY AND STUDY IT WHEN ANIMATING. MOUTH AND ACT OUT EACH PHRASE AND SENTENCE MANY TIMES BEFORE DRAWING THE ACT.

IN ADDITION TO THE FACIAL FEATURES, THE TILT ANGLE AT WHICH THE HEAD IS HELD, THE DIRECTION THE CHARACTER IS LOOKING, AND THE MOVEMENT OF THE HEAD IN RELATION TO THE BODY ALL HELP TO CREATE EXPRESSION. THE SIMPLE TILTING OF THE HEAD INTO A POSTURE RELATED TO THE FACIAL EXPRESSION CAN CONVEY A BROADER EMOTIONAL RANGE. FOR EXAMPLE, A HAND PUPPET OPERATES ON A TILT AND BODY TWIST ALONE, WITHOUT THE BENEFIT OF ACCURATE PHONETIC MOUTHING OR ANY FACIAL ACTION WHATSOEVER TO CONVEY EMOTIONS. MANIPULATING A HAND PUPPET IS EXCELLENT DIALOGUE RESEARCH FOR AN ANIMATOR TO LEARN HOW A MERE FIVE-DEGREE CHANGE IN TILT CAN CONVEY A DIFFERENT EMOTION. MANY TILTS OR HEAD TURNS ARE GESTURES IN THE ACTION, SUCH AS A NOD FOR AFFIRMATIVE DIALOGUE, A SHAKE SIDEWAYS FOR NEGATIVITY, OR A CERTAIN JERK TO POINT TOWARD ANOTHER CHARACTER, ETC.

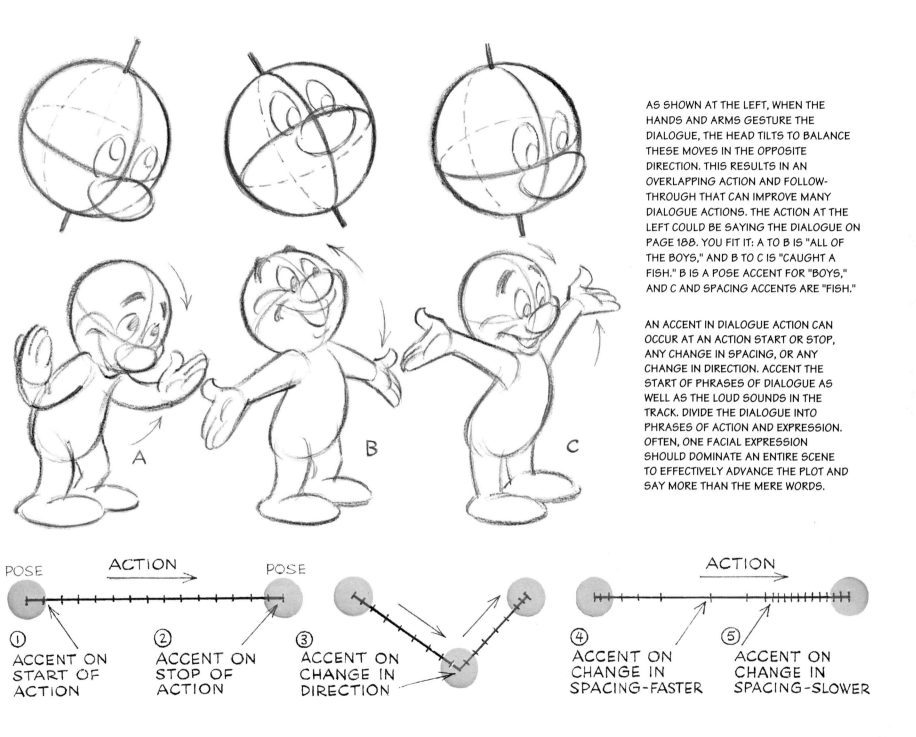

AS SHOWN AT THE LEFT, WHEN THE HANDS AND ARMS GESTURE THE DIALOGUE, THE HEAD TILTS TO BALANCE THESE MOVES IN THE OPPOSITE DIRECTION. THIS RESULTS IN AN OVERLAPPING ACTION AND FOLLOW-THROUGH THAT CAN IMPROVE MANY DIALOGUE ACTIONS. THE ACTION AT THE LEFT COULD BE SAYING THE DIALOGUE ON PAGE 188. YOU FIT IT: A TO B IS "ALL OF THE BOYS," AND B TO C IS "CAUGHT A FISH." B IS A POSE ACCENT FOR "BOYS," AND C AND SPACING ACCENTS ARE "FISH."

AN ACCENT IN DIALOGUE ACTION CAN OCCUR AT AN ACTION START OR STOP, ANY CHANGE IN SPACING, OR ANY CHANGE IN DIRECTION. ACCENT THE START OF PHRASES OF DIALOGUE AS WELL AS THE LOUD SOUNDS IN THE TRACK. DIVIDE THE DIALOGUE INTO PHRASES OF ACTION AND EXPRESSION. OFTEN, ONE FACIAL EXPRESSION SHOULD DOMINATE AN ENTIRE SCENE TO EFFECTIVELY ADVANCE THE PLOT AND SAY MORE THAN THE MERE WORDS.

POSE — ACTION → POSE

① ACCENT ON START OF ACTION

② ACCENT ON STOP OF ACTION

③ ACCENT ON CHANGE IN DIRECTION

ACTION →

④ ACCENT ON CHANGE IN SPACING-FASTER

⑤ ACCENT ON CHANGE IN SPACING-SLOWER

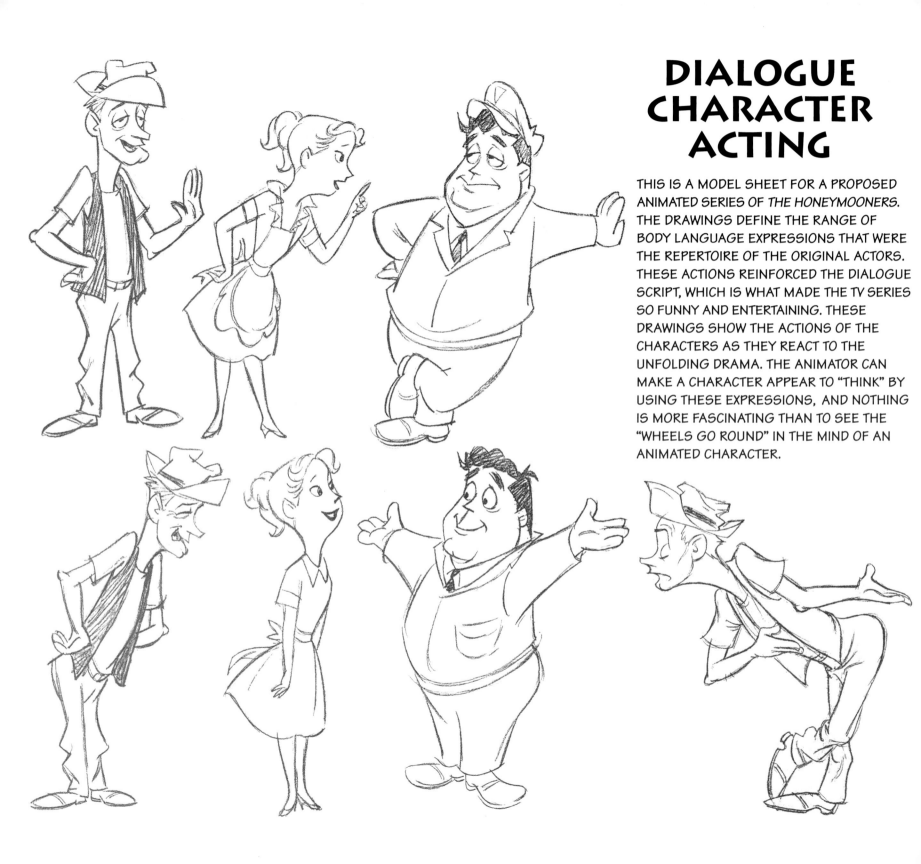

DIALOGUE CHARACTER ACTING

THIS IS A MODEL SHEET FOR A PROPOSED ANIMATED SERIES OF *THE HONEYMOONERS*. THE DRAWINGS DEFINE THE RANGE OF BODY LANGUAGE EXPRESSIONS THAT WERE THE REPERTOIRE OF THE ORIGINAL ACTORS. THESE ACTIONS REINFORCED THE DIALOGUE SCRIPT, WHICH IS WHAT MADE THE TV SERIES SO FUNNY AND ENTERTAINING. THESE DRAWINGS SHOW THE ACTIONS OF THE CHARACTERS AS THEY REACT TO THE UNFOLDING DRAMA. THE ANIMATOR CAN MAKE A CHARACTER APPEAR TO "THINK" BY USING THESE EXPRESSIONS, AND NOTHING IS MORE FASCINATING THAN TO SEE THE "WHEELS *GO ROUND*" IN THE MIND OF AN ANIMATED CHARACTER.

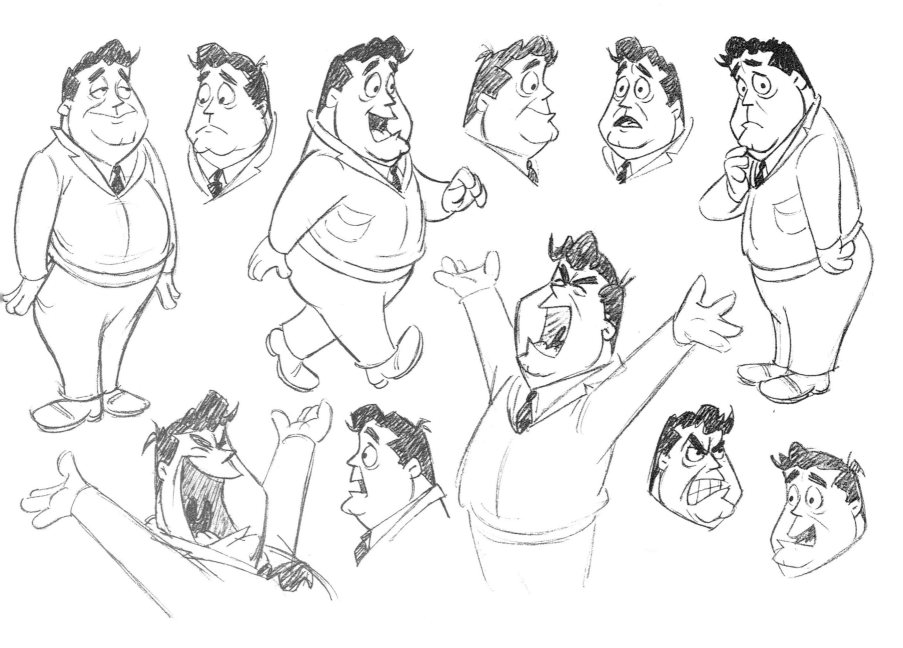

RUNNING A GAMUT OF EMOTIONS, THE ACTING HERE ADVANCES THE PLOT—IN AN UPROAR OF DRAMA. THE HEIGHT OF THE ART IS TO SURPRISE THE VIEWER WITH THE CHARACTER'S EXPRESSIONS ... LEADING FROM ONE CRISIS TO ANOTHER ... ON THE WAY TO THE FINAL CRISIS ... IN THE ANTICS OF PEOPLE WHO ARE DRAWN ... BUT COME TO LIFE WITH THE ART OF THE ACTOR-ANIMATOR. THE ACTING AND EXPRESSIONS OF THE FACE, BODY LANGUAGE, BODY ACTION EXPRESSIONS, AND GESTURES, LINKED TO DIALOGUE, ALL ADD UP TO THE CREATION OF AN ANIMATED PERSONALITY.

DIALOGUE

BELOW ARE THE MAIN MOUTH EXPRESSIONS USED IN DIALOGUE. THE FACE IS AN ELASTIC MASS THAT CAN BE SQUASHED OR STRETCHED TO FIT THE MOUTH EXPRESSIONS. THIS CREATES A GOOD CONTRAST BETWEEN POSITIONS THAT HELPS YOUR ANIMATION. STUDY YOURSELF IN A MIRROR AS YOU SPEAK THE WORDS YOU ARE ANIMATING. PRONOUNCE THE WORDS DISTINCTLY AND THE CORRECT MOUTH POSITIONS WILL BE APPARENT.

THE VOWELS

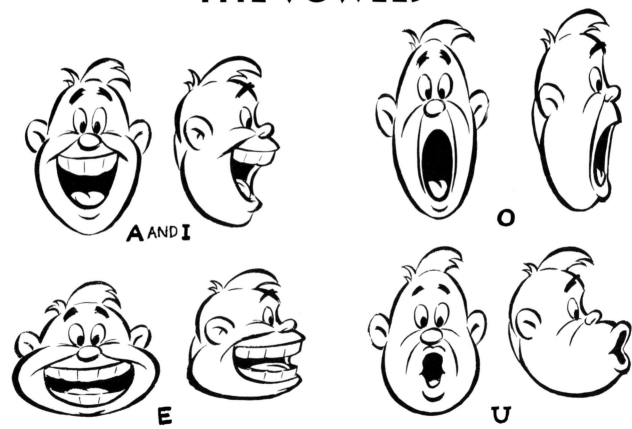

A AND I

O

E

U

WHEN ANIMATING A GROUP OF WORDS, STUDY THE WORDS AS THEY SOUND WHEN THEY ARE SPOKEN QUICKLY. IT IS BEST TO FOLLOW THIS OVERALL MOUTH PATTERN AND REPRESS OR MODIFY INDIVIDUAL SYLLABLES THAT ARE NOT IMPORTANT TO THE WHOLE.

THE CONSONANTS

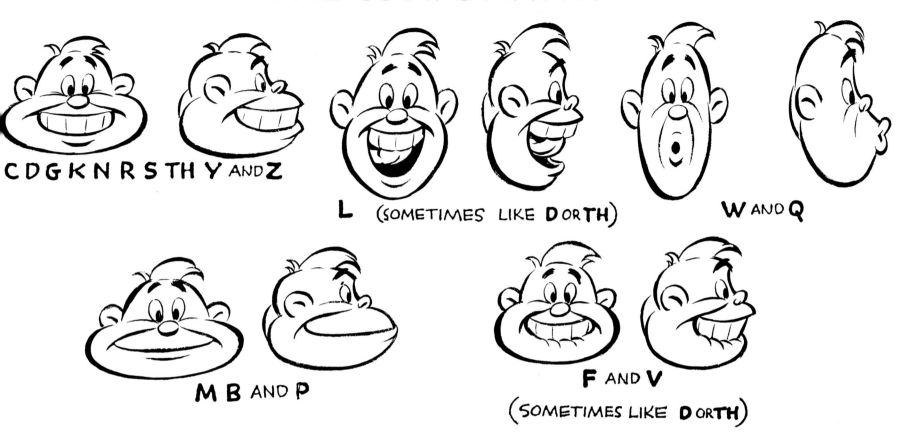

C D G K N R S TH Y AND Z

L (SOMETIMES LIKE D OR TH)

W AND Q

M B AND P

F AND V

(SOMETIMES LIKE D OR TH)

BELOW, TO HELP GET YOU STARTED, I HAVE COMBINED A FEW MOUTH POSITIONS TO MAKE WORDS.

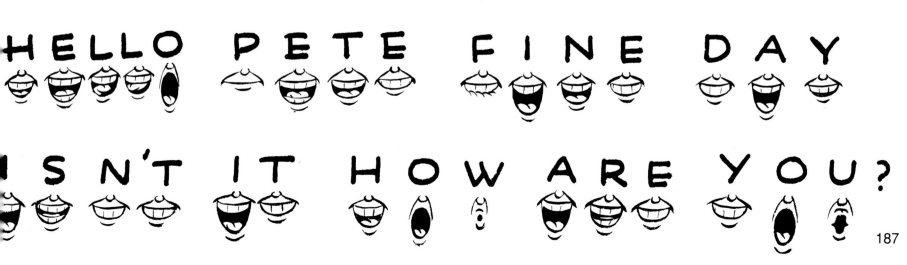

HELLO PETE FINE DAY

ISN'T IT HOW ARE YOU?

MOUTH ACTION · PRONUNCIATION

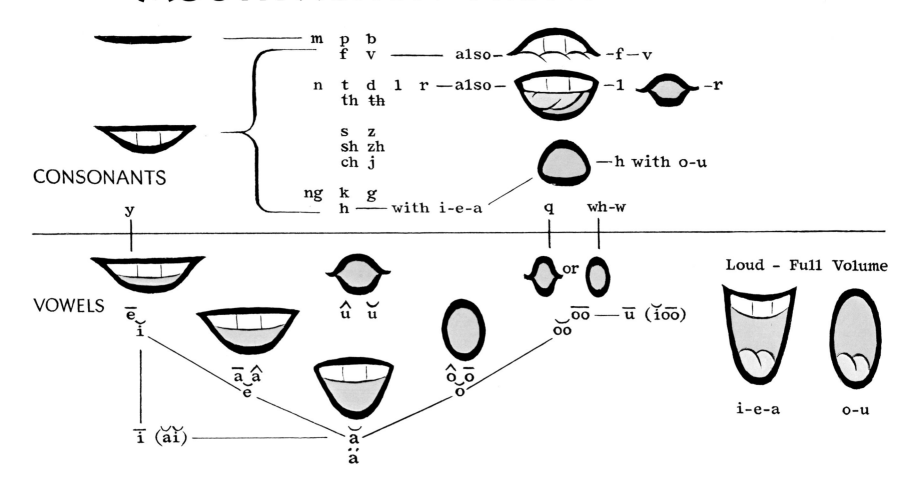

CONSONANTS

m p b
f v — also — -f -v

n t d l r — also — -l — -r
th th

s z
sh zh
ch j

h with o-u

ng k g
h — with i-e-a q wh-w

VOWELS

y

ē
ĭ

ŭ ŭ̆

ā â
ĕ

ī (ai)

ă
ä

ô ō
ŏ

oo
ōō — ū (ĭoo)

Loud - Full Volume

i-e-a o-u

Webster Pronunciation Symbols -

ôl äv the bôiz kôt ă fĭsh

English -

All of the boys caught a fish.

Animated Mouth Arrangement -

th k

ô-1-ä-v-ĕ-b-o-iz-ôăĕif/ĕĭsh

⌐ Inbetween drawing ⌐ Jump in size

THE ANIMATOR CREATES AN ILLUSION OF SPEECH—
OR A BELIEVABLE IMAGE THAT IS BASED ON REALITY.
AN ANIMATOR ANALYZES REAL MOUTH ACTION FROM
PHONETIC SCIENCE, THE PRONUNCIATION GUIDES IN
THE DICTIONARY, AND HIS OWN MOUTH ACTION.

WHEN YOU PRONOUNCE "ALL OF," YOUR MOUTH
SHAPES THE SOUND "OL AV." THE "A" IN "ALL" IS LIKE
THE "O" SOUND IN "BOUGHT" OR "CAUGHT." THE "O" IN
"OF" IS AN ITALIAN "A" SOUND AS IN "FAR" OR
"FATHER." (ENGLISH IS IRREGULAR.)

A FAMOUS EXAMPLE IS THE WORD "FISH." THESE
LANGUAGE SOUNDS COULD BE SPELLED "GH-O-TI"
FROM THE WORDS "ENOU-GH," "W-O-MEN," AND "NA-
TI-ON."

IN THE PHONETIC CHART AT LEFT, THE ITALIAN "A" IS
FORMED AT THE BOTTOM MIDDLE OF THE MOUTH, THE
"I" AT THE TOP FRONT, AND THE "OO" AT THE TOP
BACK. THESE ARE THE VOWEL EXTREMES. THE
CONSONANT "W" IS AN EXTREME "OO," AND THE "Y" IS
A CONTINUATION OF "I." THE CHART IS A PATH TO
FOLLOW.

THE PHONETIC "I" IS REALLY TWO SOUNDS BLENDED:
"A" AND "I." ALSO, "U" IS "I" AND "OO." MOUTH IT. THE
WORD "FEW" ACTUALLY ANALYZES THE SOUND "U"
FOR ANIMATORS.

AMERICANS MOUTH "R" AS "U." A SCOTTISH "R" IS LIKE
"N-T-D."

ACCORDING TO PHONETIC SCIENCE, "M," "N," AND "NG"
ARE NASALS AND SOUND COMES AT THIS MOUTH,
BUT "P" (UNVOICED) AND "B" (VOICED) ARE
EXPLOSIONS OF "M" AND THE SOUND IS AFTER THIS
MOUTH. ALSO, "T" AND "D" ARE EXPLOSIONS OF "N,"
AND "K" AND "G" ARE EXPLOSIONS OF "NG" (A SOUND
WITHOUT A LETTER).

THE DIALOGUE IS ENTERED ON THE EXPOSURE SHEET
BY THE TRACK-READER. THE SOUND AND VOLUME OF
EACH FRAME ARE ALSO INDICATED. THE MOUTHS
SHOWN ON THE EXPOSURE SHEET HERE ARE A GUIDE
FOR YOU; THEY ARE NOT USUALLY DRAWN ON THE
SHEETS.

MOUTHS SHOULD FIT THE CHARACTER AND THE
MOOD. OFTEN, A CHARACTER MUMBLES OUT OF THE
CORNER OF HIS MOUTH AND THE DIALOGUE IS A
SLIGHT VARIATION OF A GESTURE MOUTH.

STUDY YOUR OWN MOUTH ACTION IN A MIRROR;
STUDY THE GENERAL FLOW OF SHAPES THROUGH A
SENTENCE. YOUR MOUTH BLENDS AND
CONSOLIDATES VOWELS AND CONSONANTS IN A
CONTINUOUS MOVEMENT. THE FASTER THE SPEECH,
THE MORE THE WORDS ARE BLENDED UNTIL AN
ENTIRE SENTENCE IS MOUTHED AS JUST ONE WORD.

THERE IS A SPEED LIMIT WITH SPEECH, AND
ANIMATION THAT PASSES THIS LIMIT CHATTERS
UNREALISTICALLY, DESTROYING THE ILLUSION. THIS IS
CAUSED BY TOO MANY JUMPS FROM SIDE TO SIDE IN
THE ABOVE PATH. DON'T MAKE JUMPS TOO CLOSE
TOGETHER OR MAKE TOO MANY TOGETHER IN THE
EXPOSURE TIMING. ALSO, MAKE JUMPS BEFORE
VOWELS WHEN THE MOUTH OPENS.

IMPORTANT VOWELS ARE TREATED LIKE A POSE WITH
PLENTY OF DRAWINGS TO MAKE THEM REGISTER.

MANY MOUTHS IN YOUR ACTION CAN BE INFLUENCED
OR MODIFIED IN SHAPE TO FIT ADJOINING MOUTHS,
RESULTING IN SMOOTHER ACTION. MANY
CHARACTERS CANNOT PRONOUNCE WORDS WITH ALL
THESE POSITIONS ON THE CHART (F-1, FOR EXAMPLE),
AND MANY GESTURES LIMIT MOUTH SHAPES, SO
JUST TRY TO DRAW IN THE DIRECTION OF THE CORRECT
MOUTH (BLEND).

DIALOGUE		DIAL	5	4
—		1	1	
		2		
		3		
	AW	4	2	
		5		
		6	3	
		7		
		8	4	
		9		
	LL	0	5	
		1		
	O	2	6	
		3		
		4	7	
		5		
		6	8	
	F	7		
		8	9	
	TH	9		
		20	10	
		1		
	E	2	11	
		3		
		4	12	
		5		
		6	13	
		7		
	B	8	14	
		9		
		30	15	
		1		
	OY	2	16	
		3		
		4	17	
		5		
		6	18	
		7		
	S	8	19	
		9		
	C	40	20	
		1		
	AW	2	21	
		3		
		4	22	
		5		
		6	23	
		7		
	T	8	24	
		9		
		50	25	
		1		
		2		
		3		

THE HECKLER

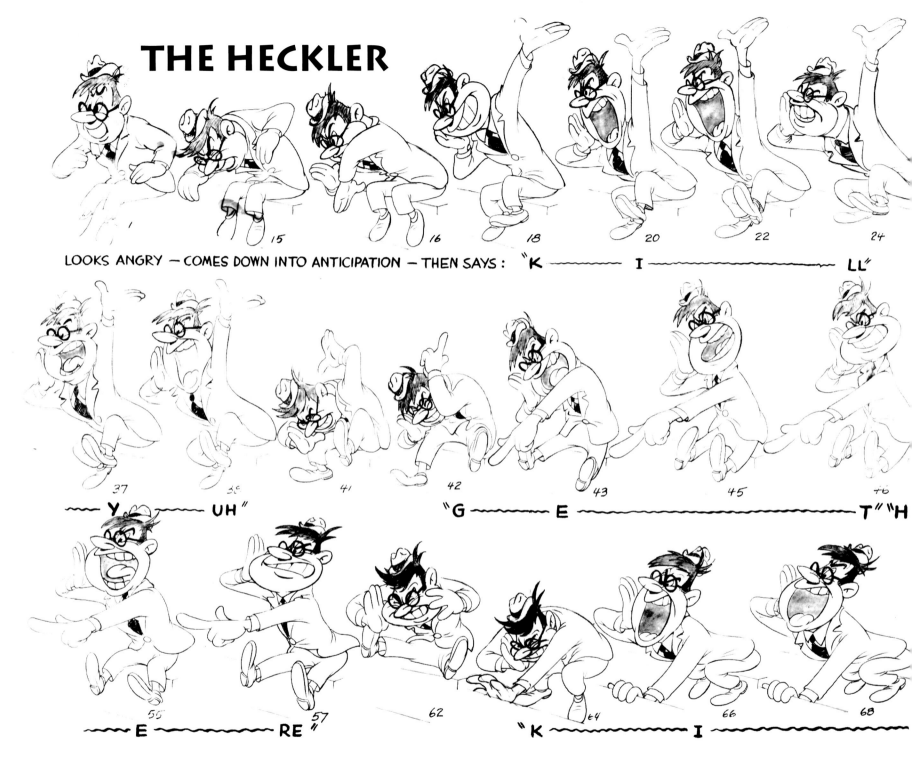

LOOKS ANGRY — COMES DOWN INTO ANTICIPATION — THEN SAYS : "K ——————— I ——————————— LL"

—————— Y ———————— UH" "G ——————— E —————————— T" "H

—— E ———————— RE " "K ———————— I ——————

THE CLEANED UP "KEY" DRAWINGS ABOVE WILL GIVE YOU AN IDEA OF HOW DIALOGUE CAN BE ANIMATED. THE FIRST DRAWING IS A TWELVE-

DRAWING "HOLD" (THE MISSING NUMBERS ARE IN-BETWEEN DRAWINGS PUT IN BY ASSISTANT ARTISTS).

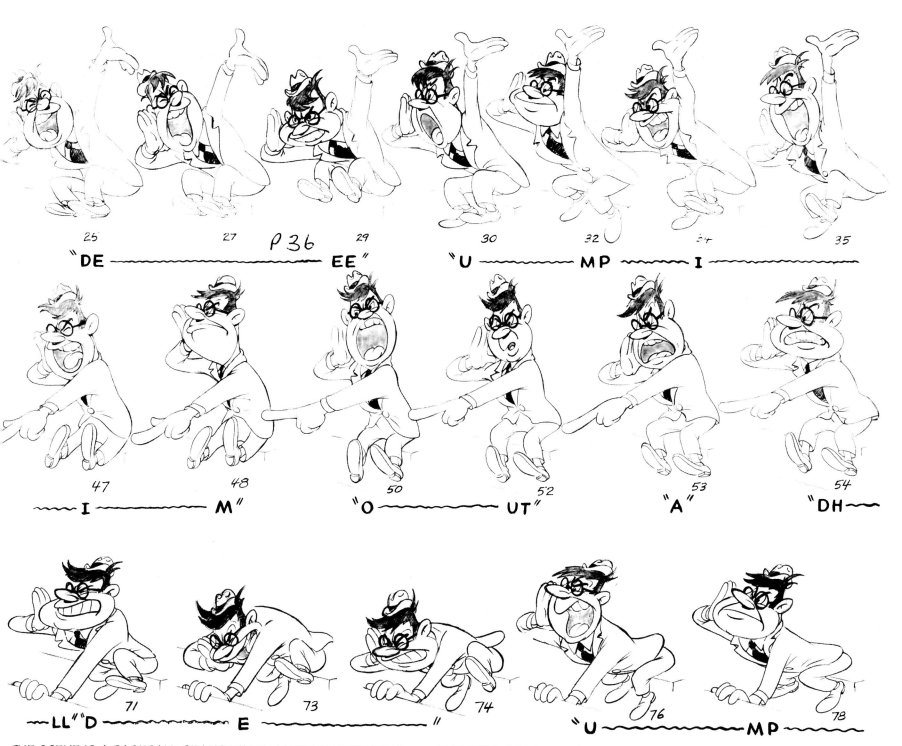

25 27 P 36 29 30 32 34 35

"DE ～～～～～ EE" "U ～～～ MP ～～ I

47 48 50 52 53 54

～～ I ～～ M" "O ～～ UT" "A" "DH ～

71 73 74 76 78

～LL"D ～～～ E ～～～ " "U ～ MP ～

THE SCENE IS A BASEBALL GRANDSTAND, AND THE HECKLER IS YELLING, "KILL DE UMPIRE! —GET 'IM OUT O' DERE! —KILL DE UMPIRE! —KILL DE UMP!" WHEN AN OFFSTAGE SHOT (SEE PAGES 192-193)

SIGNIFIES THE UMPIRE'S EXECUTION (96), THE HECKLER GOES INTO A SURPRISE "TAKE," RISES, REMOVES HIS DERBY, AND SADLY WATCHES THE DEAD OFFICIAL CARRIED OFF AS A TRUMPET PLAYS "TAPS."

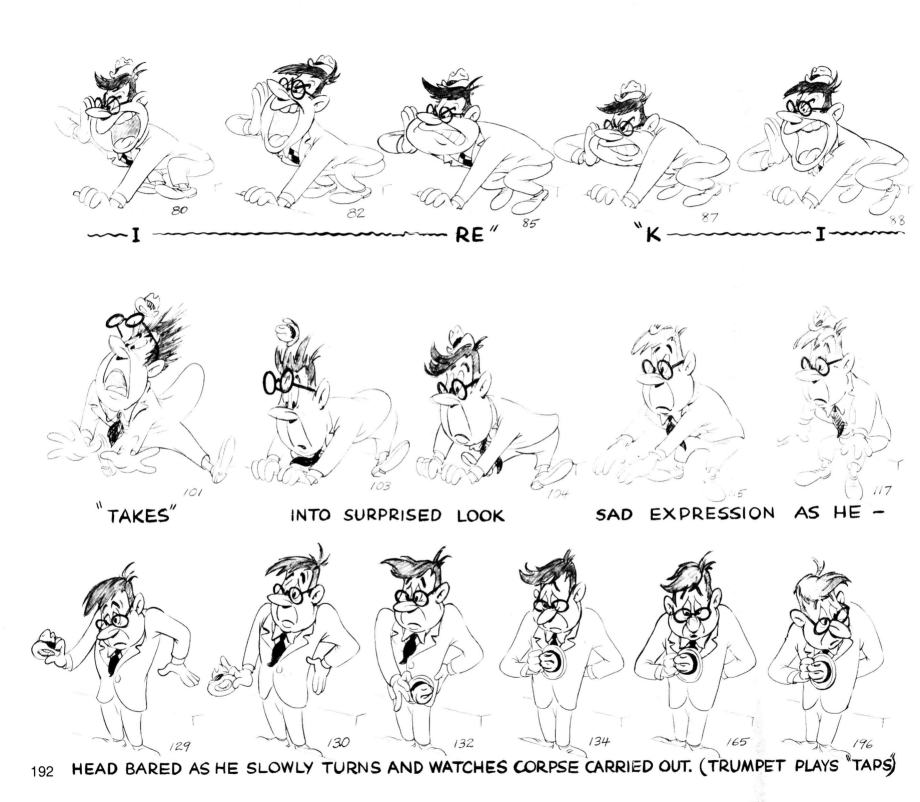

——I —————————————— RE " 85 " K ——————— I

80 82 85 87 88

" TAKES " INTO SURPRISED LOOK SAD EXPRESSION AS HE —

101 103 104 115 117

129 130 132 134 165 196

HEAD BARED AS HE SLOWLY TURNS AND WATCHES CORPSE CARRIED OUT. (TRUMPET PLAYS "TAPS")

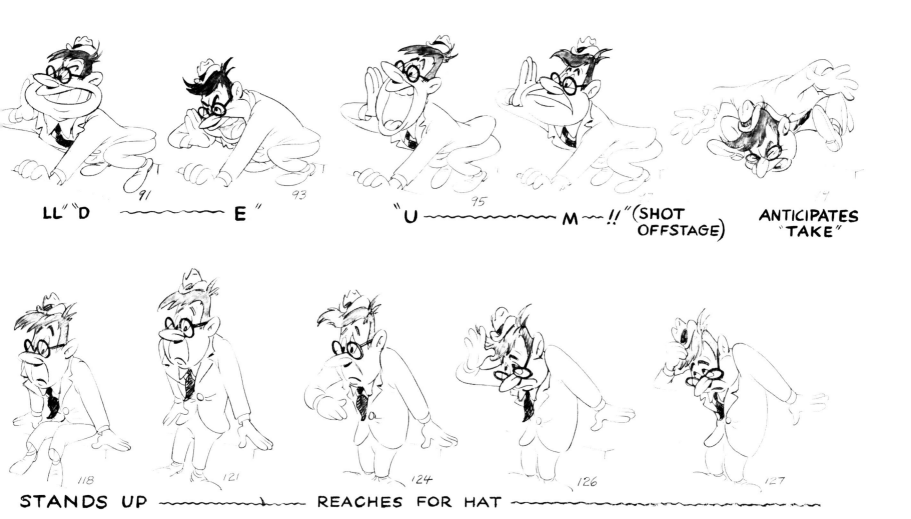

LL" "D ∼∼∼∼∼∼ E " "U ∼∼∼∼∼∼ M ∼ !! "(SHOT OFFSTAGE) ANTICIPATES "TAKE"

STANDS UP ∼∼∼∼∼∼ REACHES FOR HAT ∼∼∼∼∼∼∼∼∼∼∼∼∼∼∼

TO REPEAT: THE MISSING NUMBERS OF THE HECKLER ARE IN-BETWEEN DRAWINGS PUT IN BY ASSISTANT ARTISTS. THE FIRST DRAWING OF THE SCENE ON PAGE 190 IS A TWELVE-DRAWING "HOLD" AS THE SAME DRAWING APPEARS ON TWELVE MOTION PICTURE FRAMES. LOOK OVER THIS ACTION AND STUDY THE ANIMATION PRINCIPLES I HAVE PREVIOUSLY OUTLINED AS SQUASH AND STRETCH ON HEADS, OVERLAPPING ACTION, FOLLOW-THROUGH, THE USE OF THE ANTICIPATION DRAWING, AND THE DIALOGUE VOWELS AND CONSONANTS FROM PAGES 186-189. ALSO NOTICE THE GENERAL PHRASING OF THE DIALOGUE HERE: HOW THE HECKLER ASSUMES A GENERAL POSITION FOR A WHOLE SENTENCE AND THEN CHANGES TO ANOTHER POSITION FOR THE NEXT SENTENCE, INSTEAD OF CHANGING POSITIONS ON EVERY WORD.

STUDY HOW ACTORS GO THROUGH A SERIES OF GESTURES AND ATTITUDES AS THEY ACT THEIR PARTS ON TELEVISION AND HOW THEY RELATE THIS BODY LANGUAGE TO THE WORDS—THE SENTENCES AND PARAGRAPHS OF THE DRAMA. THEN LOOK AT A COMIC BOOK, NEWSPAPER COMIC STRIP, OR ANY DIALOGUE IN PRINT AND ACT OUT THE EXPRESSIONS AND POSE GESTURES YOU WOULD USE TO ANIMATE (BRING TO AN ILLUSION OF REALITY) THE STILL CARTOON DRAWING.

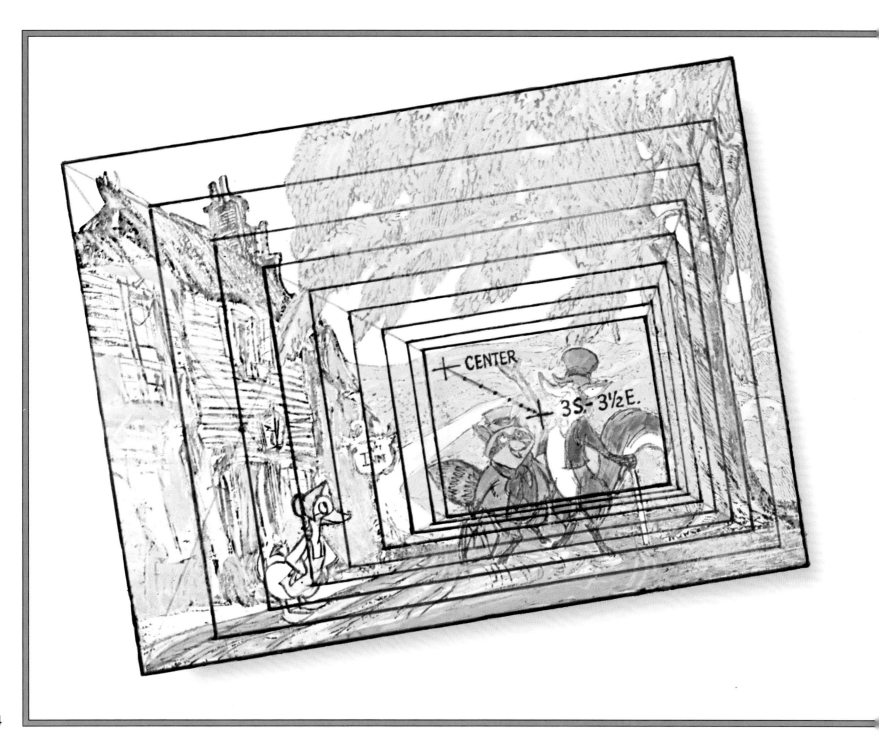

TECHNICAL

This chapter includes clear explanations of many technical topics: tinting and spacing patterns, background layout drawings, the cartoon storyboard, and the synchronization of camera, background, characters, sound, and music.

The storyboard and script are the foundations for the rest of the animation. Methods of synchronizing dialogue with character actions and gestures and camera positions are shown on a single chart that ties them all together into smooth, progressive animation. Cycles of planned animation and limited animation cutouts that can save a great amount of time on certain types of animation are shown on pages 200-203. The use of background pans, overlays, and cels is also explained.

Pointers on how to set up and build your own animation studio and camera compound are shown and discussed on page 218. You can make your studio as elaborate as you wish, but a well-functioning studio can also be constructed economically. Of course, the camera is the most expensive part of the venture, but the camera "truck" is easy to construct. The most critical part of this construction is that all of the angles between the camera and the filming surface (compound top) be accurate so that no distortion occurs.

This chapter contains all of the vital information needed to get you underway in your studio to develop and produce your own animated film cartoons.

TIMING AND SPACING PATTERNS

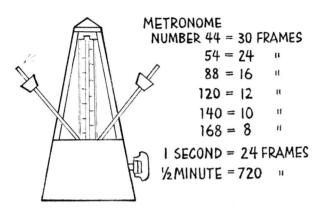

METRONOME

NUMBER 44	= 30 FRAMES
54	= 24 "
88	= 16 "
120	= 12 "
140	= 10 "
168	= 8 "
1 SECOND	= 24 FRAMES
½ MINUTE	= 720 "

The animator is the "actor" of the film cartoon. An actor's timing, which is based on instinct and personality, is the essence of the art. The actor must learn the craft, such as how to walk or move with meaning, to never pause unless there is a reason, and if there is a pause, to pause as long as possible. The actor/animator must learn the value of a "hold": the proper amount of time to linger so it will register with the audience for all it is worth. He must also decide whether to jump into a hold or to cushion into it gradually; when to "freeze" a hold or when to keep up subtle secondary actions to give it a "breath of life"; when to start small actions during the hold that anticipate the following move; when to move the eyes to anticipate coming movement, and, finally, after such anticipation, when to jump out of a pose or when to slowly move out. Such is the craft of the art.

The swings and ticks of a metronome can determine the exact speed of the frames of a walk, a run, or any action you visualize. Set the arm at 8 frames and act out a fast walk or run with your fingers. You may then decide that 12 frames are closer to what you need. Make frame-count marks, as shown above. Then check the clock so thirty 12-frame ticks fit in fifteen seconds.

To check the look of even speeds, place your pencil over a straight 12-field, as in figure 12 at right (simply a line divided evenly by 12). Then move the pencil back and forth, from one end of the 12-field to the other, at a 24-frame tick (metronome set at 54, which equals 24 frames per second). By doing this, you can visually check the look of an even speed. From this test, you will find that it takes one 24-frame tick to move across 12 inches. This means that the movement equals 1/2 inch per frame. If you use two 24-frame ticks to cover 12 inches, then the movement will be 1/4 inch per frame.

The pendulum pattern (figure 1) is evenly spaced. This pattern occurs in leg and arm movements in walks and runs. The unevenly spaced figures (figures 2 and 3) change the action considerably. Figure 2 is slow-out, slow-in, slow-out, etc. Figure 3 is either slow-out, fast-in, slow-out, etc., or reversed to fast-out, slow-in, fast-out, etc.

Figures 4 through 11 are actions of the head or body in walk and run cycles. The recoil drawing is at the base. When time is spent around this, the weight is accentuated and the creature simply cannot seem to get off the ground. When the high drawing is accentuated, the creature is so lightweight that he bounces up, floats, and scarcely touches the ground. Walks with character usually have uneven spacing. Figures 4 and 6 are for heavyweights. A lightweight deer would bounce and float like figures 5 and 7. Figures 8 and 9 are usual in a walk or a run on a pan. Recoil is bottom, rise to the left midway up, high on top, and contact midway down on the right. Any of these four positions can be accentuated in timing to create character. In figures 10 and 11 the head or the body and the head are moving from side to side in the walk or run action on a pan. Reverse the direction on these (or on figures 8 and 9) and you will get a different character.

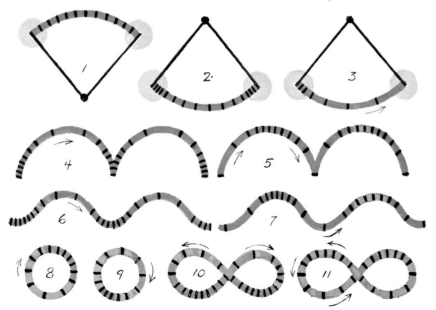

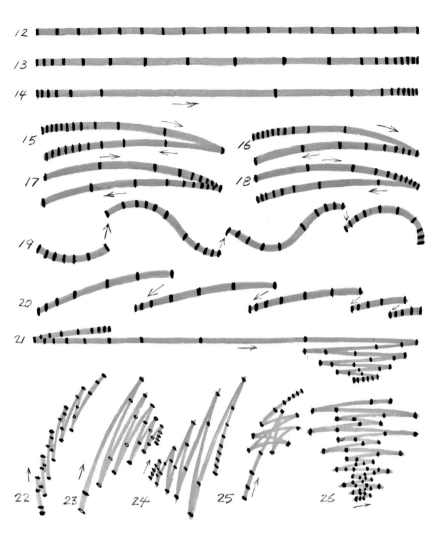

FILMED RESULT OF SPACED MOVES

The filmed result and meaning of a spaced move depend on (1) actual measurement, (2) relation to the field size, and (3) relation to the size of the character. The animator has a specific action to do in a certain time or number of frames. From experience he knows how specific patterns of spacing will work when they measure and path the actions in the character. He often charts a pattern in advance, but these patterns are usually inherent in the animation structure and they evolve intuitively during animation.

A puppet moves as the strings are adjusted. An animated character moves according to spaced-move patterns in the actions. When the animator starts a scene, you can check the looks of even speeds by moving your pencil back and forth across a 12-field as timed by a metronome. You can figure it out: At the 24-frame tick, one move across 12 inches is a speed of 1/2 inch per frame, and it takes two 24-frame ticks to move your pencil across 12 inches at 1/4 inch, etc.

My advice to the beginner is to first try to develop a sense of timing by animating and film testing a large and a small circle in various speeds in the patterns outlined throughout this book. Then study the action of the patterns and learn to adjust the spacing of the animation to create the exact character action for the specific scene. You can then plan the timing so your animation will do whatever you visualize. You will learn to think of animation in a series of motion picture frames and how to register takes, gestures, actions, and poses.

Often, the best way to move is simply in a straight line as in figures 12 to 14. All patterns may be better when evenly spaced in various accents.

Figures 15 to 18 occur in hand and arm movements.

Figure 19 happens constantly in live action. A hand and arm move in an arc, then suddenly jump to a different arc as the result of another body action accent or jerk (such as a kick).

On figure 21, a hand and arm or an entire character comes back in anticipation, moves fast, then violently stagger-stops. Figures 22 to 26 are some of the many stagger actions for takes, stops, collisions, crashes, etc. An evenly spaced series of drawings can be a stagger action: 1-10-2-9-3-8-4-7-5-6, etc.

As shown above, a small move on a small circle has the same relation to the circle as a large move on a large circle. A large move on a large field appears the same on film as a small move on a small field.

ACCENTS · BEATS · SCENE TIMING

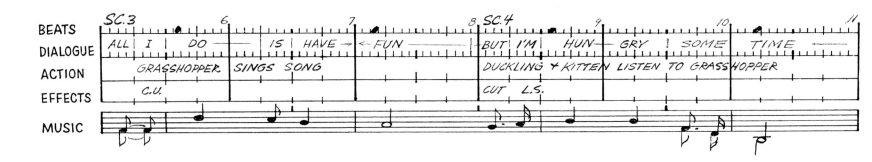

BEATS	SC.3		6		7		8 SC.4		9		10		11
DIALOGUE	ALL	I	DO —	IS	HAVE →	←FUN —	BUT	I'M	HUN—	GRY	SOME	TIME —	
ACTION	GRASSHOPPER	SINGS	SONG				DUCKLING + KITTEN LISTEN TO GRASSHOPPER						
EFFECTS	C.U.						CUT L.S.						
MUSIC													

A **STOPWATCH** starts and stops with the push of the button. The animator must time his acting to plan the number of frames for each action. Some watches have footage scales. A second hand on an electric clock, a metronome, or live-action film research can also be used for scene timing.

The **STORYBOARD** and the **SCRIPT** are the building plans (like a blueprint), and the film is constructed on these foundations. Each scene is described in the script for picture and sound. The scene title describes the characters, the sound, and the type as (1) **CLOSE-UP,** (2) **MEDIUM CLOSE-UP,** (3) **MEDIUM SHOT, (4) MEDIUM-LONG SHOT,** or (5) **LONG SHOT.** The transition from one scene to the next is described as (1) **CUT-TO,** (2) **CROSS-DISSOLVE,** (3) **FADE-OUT,** (4) **FADE-IN,** (5) **TRUCK-BACK-TO,** (6) **TRUCK-DOWN-TO, (7) WIPE, (8) IRIS-OUT, (9) IRIS-IN,** or (10) **ANIMATED METAMORPHOSIS.** Layout drawings based on the storyboard are made of the background and key character positions. Dialogue and music are recorded and a film editor "reader" measures and writes down the exact frame position on the **BAR SHEETS** and **EXPOSURE SHEETS.** The music or **BAR SHEETS** plan the production timing on all the scenes in a film.

The **EXPOSURE SHEETS** plan the animation production timing of an individual scene. Each frame, foot, and scene has a number. Each music beat, action accent, word sound, and timing detail also has a number. For a drawing to appear "in sync" with a sound accent, the drawing should be exposed two or three times before the sound. Some animators allow for this, but most animate to the same frame as the sound, then shift the entire film two or three frames ahead of the sound track during editing. Sound accents can be "hit" by any radical change in picture timing, such as sudden starts or stops, jumps, and action reversals or freezes. Sudden slow spacing or wide spacing in a continuous action can accent a sound. Think in series of frames because you can't see anything else.

Accents on walk and run cycles come at the recoil-bottom or high point drawings. Most action and dialogue can be on 2s. When the action is fast with wide spacing, use 1s to avoid too wide, jumpy spacing. The four cels over the background in cartoon films allow four action levels. Also, parts of a character can move on one level (12A-E, as shown on the production sheet "The Lost Kitten" at the right on the opposite page), while the other parts are held on the next level (12). There shouldn't be any vital actions or important dialogue in the first five or six frames of a scene.

TV bar sheets (as shown above) have one foot (16 frames) per bar. Theatrical music bar sheets vary in bar length to fit the musical mood of the film. Dialogue and music are planned in these bar sheets with a stopwatch. Music is then composed and recorded with dialogue and the scene timing may have to be adjusted to fit. Adjustments and changes are a constant in animated films.

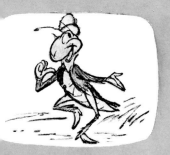

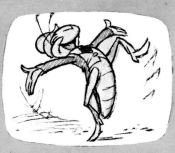

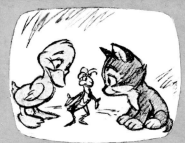

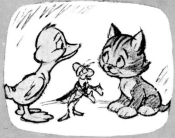

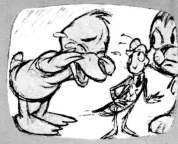

| GRASSHOPPER: "ALL I DO.." | (SINGS)— --IS HAVE FUN. | (SONG)— ..BUT I'M HUNGRY.. | SOME TIME ...LIKE NOW. | DUCKLING: AN' I'M HUNGRY-RIGHT —NOW...TOO! |

PRODUCTION #34 - THE LOST KITTEN

VIDEO	AUDIO
SCENE 3. CLOSE-UP GRASSHOPPER	SONG - MUSIC
Grasshopper sings to off-stage Kitten and Duckling with flourish and spirit.	GRASSHOPPER SINGS: (bouncing)
Jumps for joy.	All I do.... ...is have FUN..
(CUT TO)	
SCENE 4. LONG SHOT - GRASSHOPPER DUCKLING AND KITTEN	SONG - MUSIC
Duckling and Kitten look at Grasshopper who becomes subdued and serious as he laments in song.	GRASSHOPPER SINGS: (the blues)
Kitten and Duckling look sadly at each other.	...But I'm hun-gry.. ..some time..like now.
(TRUCK DOWN TO)	
SCENE 5. MEDIUM SHOT - DUCKLING & GRASSHOPPER AND HEAD OF KITTEN	SAD MUSIC
Duckling sadly gulps, speaks, and then sheds a tear... wipes eye with wing	DUCKLING: (faltering speech) ..An' I'm hungry... right now..gulp..too..
Grasshopper turns to Kitten..shakes his head in agreement with Duckling.	I ran away from... my MEAN step-mother.. ..an' now...(sobs)

PRODUCTION "#34 'LOST KITTEN'" ANIMATOR SCENE 3 SHEET 1

SCENE DESCRIPTION GRASSHOPPER SINGS SONG

ACTION	DIALOGUE	DIAL No.	4	3	2	1	BG	CAMERA INSTRUCTION
GRASSHOPPER RAISES HANDS	Ô	8 1			BLK	1		CAM. AT 7 FIELD CENTER
		2						
	L	3				2		
		4						
		5				3		
	I	6						
		7				4		
		8				5		
		9				6		
INTO	✳ DOO (EW)	9 0				7		
		1				8		
		2						
GESTURE		3				9		
		4						
		5				10		
6		6						
		7				11		
		8						
GESTURE		9			12A	12		
		10 0						
	IS	1			12B			
		2						
		3			12C			
		4						
	HAVE	5			12D			
		6						
		7			12E			
INTO		8						
		9			BLK	13		
JUMP		11 0						
		1				14		
		2						
7	FUN	3				15		
		4						
✳		5				16		
		6						
		7				17		
		8						
		9				18		
		12 0						

CYCLES—PLANNED ANIMATION

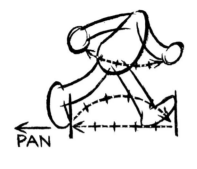

PAN

When the foot is placed on the ground in a pan scene, it moves with the pan moves, as in those indicated on page 201. The "pan" in this case is the movement of the background while the character is walking in the middle of the scene. The background art is moved a precise distance as required by the character action. For example, the background would be moved more slowly for a walk than for a run. Consequently, foot contact on the background and speed of movement must be precisely coordinated by using the methods shown at the left and on the next page. These moves are related to a stationary centerline. The body and all the parts move in paths of action; these are the usual patterns. The action can move in either direction. As in life, cycles have countless variations, and you can exaggerate or subdue any position or move.

Never move a character without meaning. Bring out a gesture, mannerism, or story mood in every cycle. On page 141, two of the cycles below are combined in a double-bounce-strut. Notice the cocky gesture at high points. It is a series of closely related drawings; no time is lost in going to the opposite step gesture. Funny walks can "make" a film.

PLANNED ANIMATION is a system of combining animation methods and planning the reuse of the artwork for many different scenes. It is used to produce the considerable film footage of a television cartoon series. A change of pace results from the use of full animation in critical actions of the story and the use of limited animation in dialogue with bursts of full animation for important gestures. Animation, backgrounds with overlay backgrounds, and camera fields and trucks are planned for use in many combinations. Thus, the production work gets more "mileage." You must plan your film!

CYCLE ANIMATION, as shown on page 201, can be put on long cels that allow twelve inches on each side of the drawing. Such animation can be used in the field center with a moving pan as the background. The same cels placed on moving pegs can move the character through a still background scene. The same cels can also walk into another background, stay centered as the background moves, and then move out when the background stops. On the other three cel levels in the animation scene, other cycle characters can move at a different speed, in any direction.

LIMITED ANIMATION is based on dividing a character into as many as four cel levels and a dialogue system. It is especially adaptable to the type of characters illustrated on page 203. The dialogue system is often more elaborate, as seven heads up and down and seven heads in a sideways move, all around a centered head. Laughs and giggles are often animated by a laughing, evenly spaced, up-and-down series of such heads in a stagger-timing on the exposure sheet. A dialogue head series can be fitted to a body cycle walking on a pan background. A bottom peg camera device moves the pegs up and down to fit the walking action. (Note: body action peg holes are adjusted.) Heads can fit characters in a vehicle on a pan. This entire action bounces on the rough road using the same device attached to the bottom peg bar. Such mechanics are endless.

ANIMATED CUTOUTS can be added to both full and limited animation cels. After the cel is placed on camera, the cutout is placed over or under the cel according to a few dot guides on the cel. For example, an elaborate line engraving of an antique auto is cut out and placed under a cel series that animates the wheel action, dust, smoke, and characters seated in the auto.

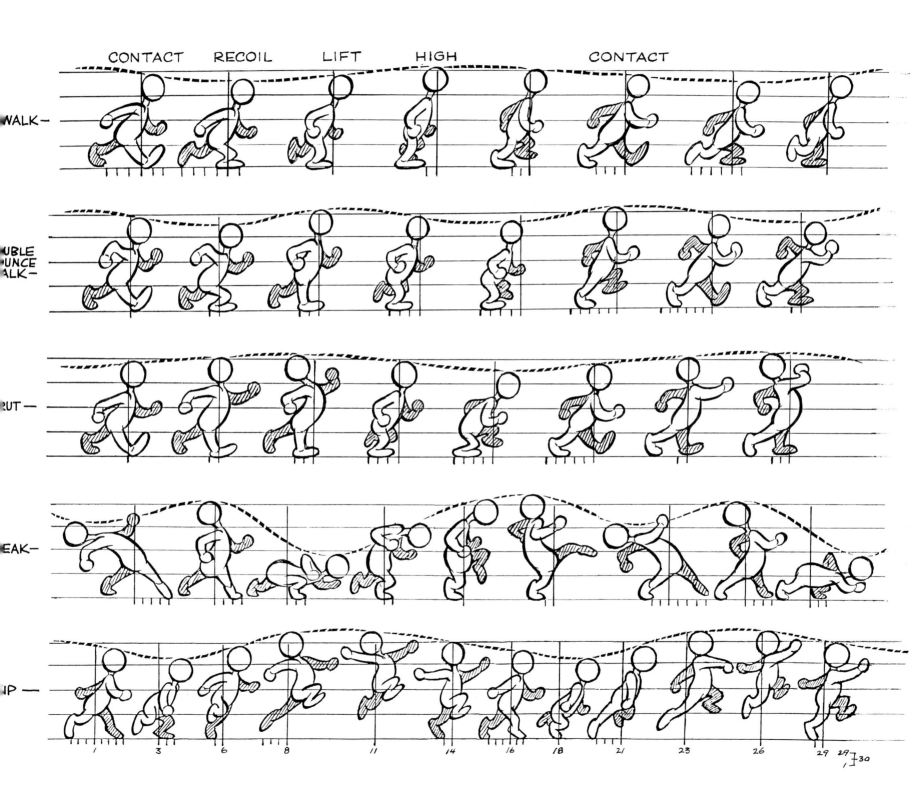

CONTACT RECOIL LIFT HIGH CONTACT

WALK—

DOUBLE BOUNCE WALK—

STRUT—

SNEAK—

LEAP—

1 3 6 8 11 14 16 18 21 23 26 29 29/30

LIMITED ANIMATION · CUTOUTS

Animation cutouts can be very cost effective in producing animated films. Body poses, with different head attitudes, can be used over and over in multiple combinations. For example, different arms can be used on the same body, as can mouths, eyes, and noses on a single cel head without having to redraw the entire body for each movement. All parts of these "animation cutouts" can be stored for recall in another scene or film.

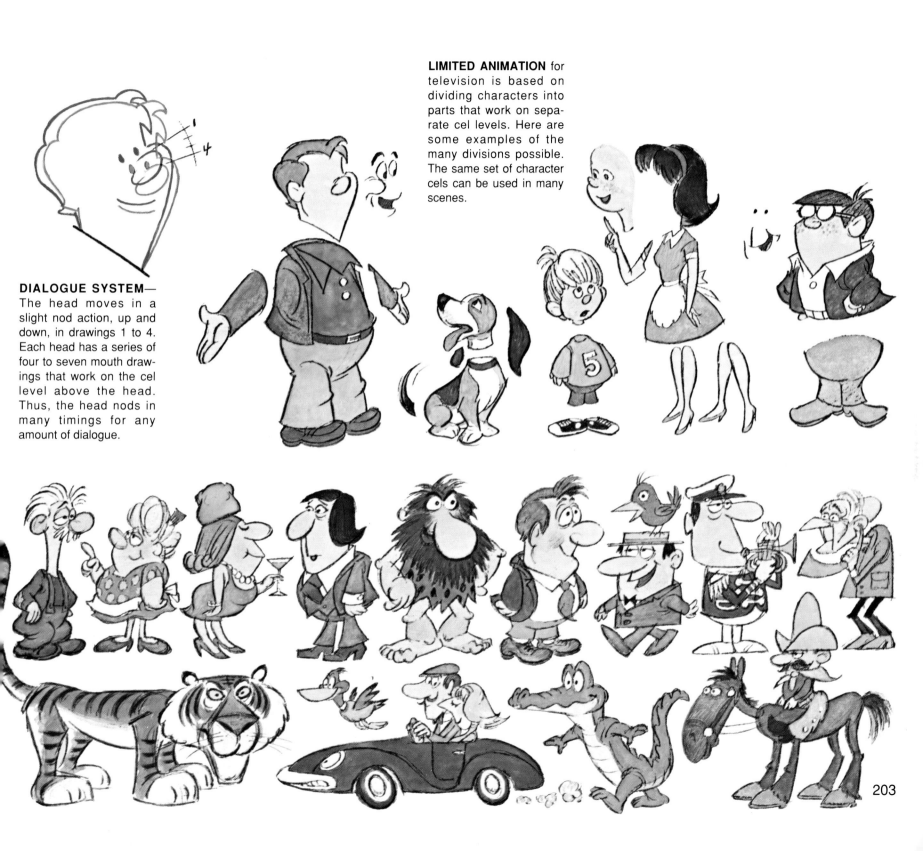

DIALOGUE SYSTEM—
The head moves in a slight nod action, up and down, in drawings 1 to 4. Each head has a series of four to seven mouth drawings that work on the cel level above the head. Thus, the head nods in many timings for any amount of dialogue.

LIMITED ANIMATION for television is based on dividing characters into parts that work on separate cel levels. Here are some examples of the many divisions possible. The same set of character cels can be used in many scenes.

203

MAKING AN ANIMATION CEL

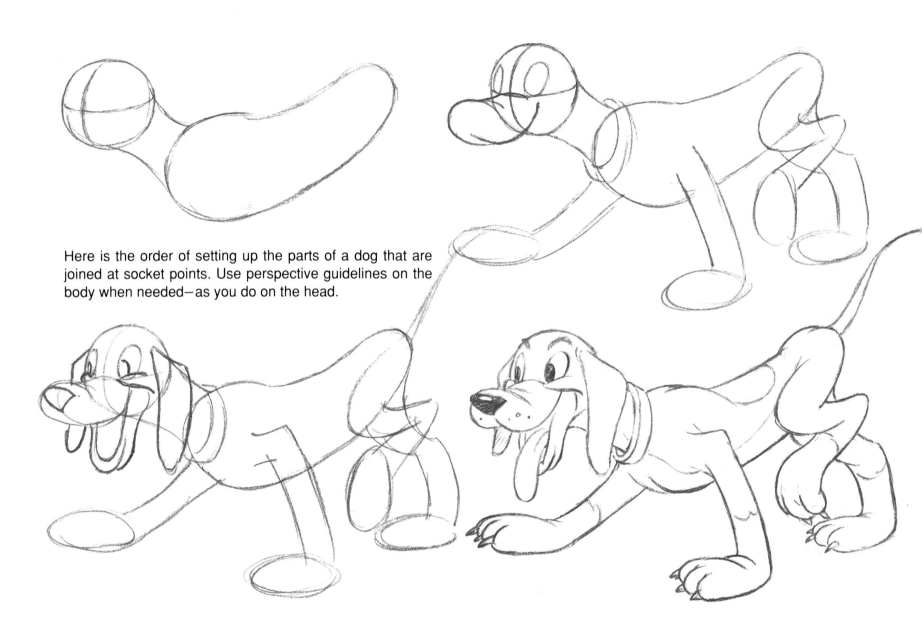

Here is the order of setting up the parts of a dog that are joined at socket points. Use perspective guidelines on the body when needed—as you do on the head.

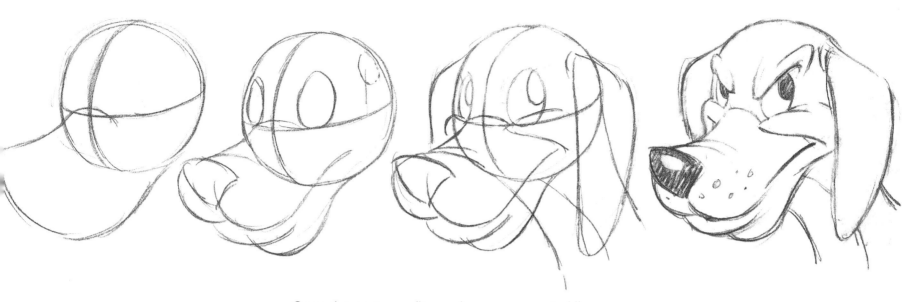

Once the parts are fit on, clean up unwanted lines.

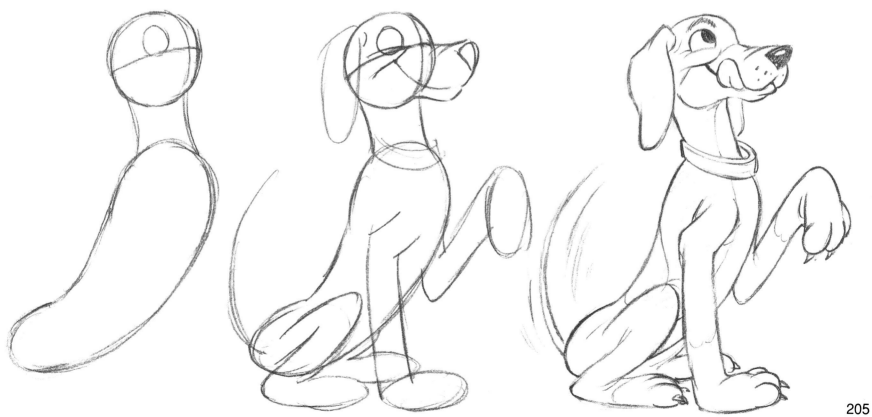

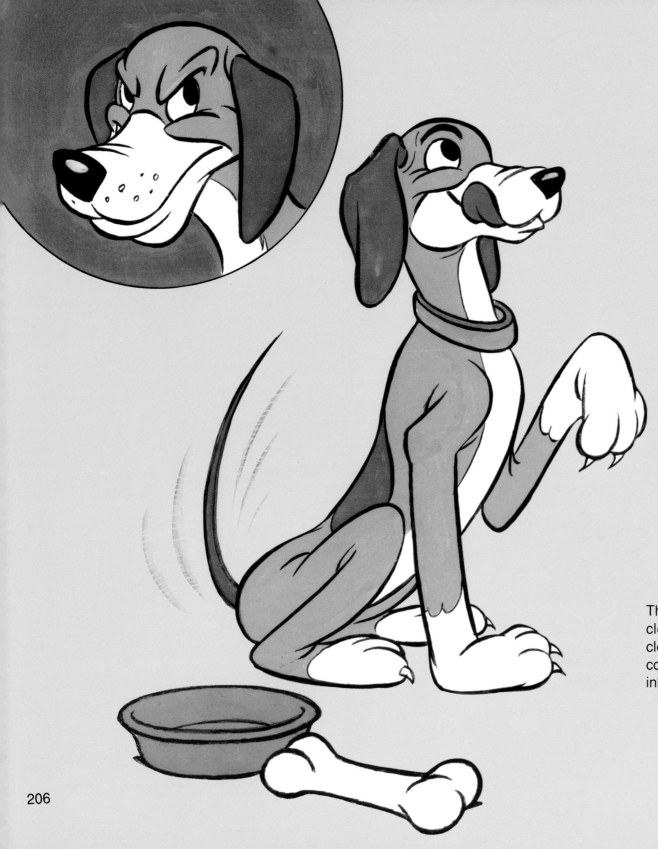

COLORING THE CEL

This is a colored cel made from the cleanup drawing on page 205. The cleanup drawing was enlarged on a copy machine, and then a brush and ink were used to trace it onto the cel.

The cleaned up animation drawing is transferred to a transparent cel (celluloid .005) by tracing with a pen or brush and ink (special ink that adheres to acetate must be used). The drawing can also be photocopied onto the cel. Then the colors are painted on the back of the cel with opaque acrylic paint (acrylics are used because they will adhere to the cel). After the cel is colored, it is placed over the background and photographed with the camera. (This process is explained in more detail on pages 217-219.)

Most cartoon cels are inked with a pen, but the brush can be used to give a heavier, more accented line (the drawings on these two pages were done with a brush). If you are designing an original character, experiment with its coloration by using transparent watercolors on photocopies or enlargements of your cleanup drawings. Color many drawings until you perfect the color scheme, and then make acrylic-colored cels using the watercolor paints as guides. You can make colored backgrounds for the cels using both watercolors and the opaque acrylics (the way studios do). Background texture can be created with a wet sponge and opaque acrylic paint.

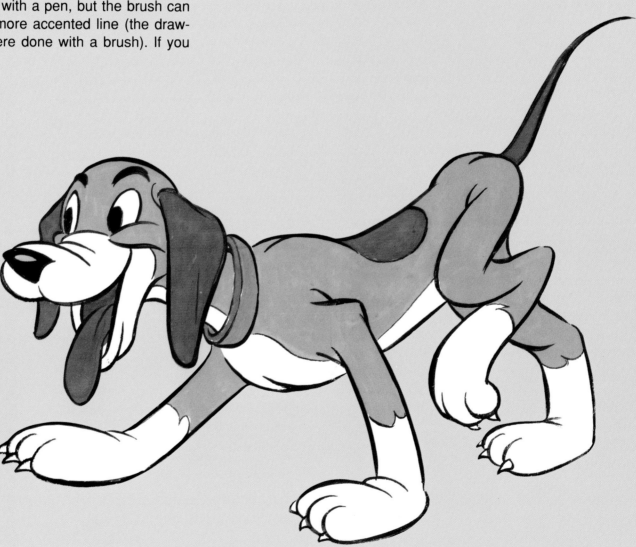

THE CARTOON STORYBOARD

On pages 208-211 is an example of a storyboard that is the basic plan of an animated cartoon film. It resembles a page in the newspaper comics. Artists in a story department develop the story line of the film by attaching these story sketches onto a large blackboard-size board with pushpins. The storymen will replace drawings and re-edit the storyboard constantly as they visualize and originate additions and changes to add humor to the story.

The inanimate object that has come to life (the tree) is another type of cartoon character to add to this book. Here the trees engage in the full verbosity of a violent argument, and the storymen must visualize the continuity. Then, the film director and staff take a hand in the development, followed by the animator who often puts in the vital finishing touches and changes. It is a constant creative process—at least at the important studios—especially on features. The storyman has to know staging and drama; he has to figure out and anticipate what the audience is thinking and then surprise, amuse, or spellbind the viewer. Such is the simple recipe for a blockbuster epic. Story artists also visualize the art style of the film. Storyboards may incorporate an occasional picture done in full-color watercolor or pastel that establishes the color and the background treatment. Drawings may be from 6" x 4-3/8" to 12" x 8-3/4", which are the same proportions as the animation field.

A team of artists usually develops the storyboard after the idea is acted out by the storyman before an audience in a conference of evaluation. This helps the creativity process tremendously. For example, while looking at the storyboard below, a storyman might add picture panels between the first two that visualize an interesting or amusing way that the golden hatchet was obtained by our hero.

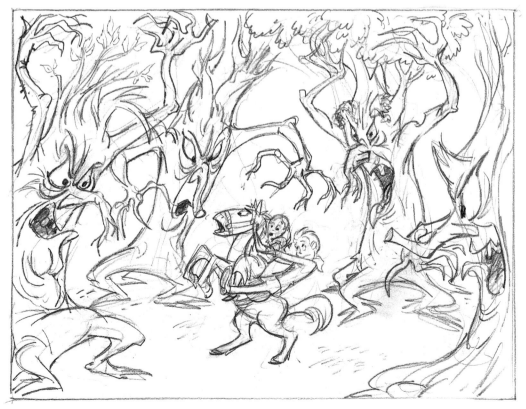

(1) Strange faces appear on the forest trees. The branches become horrible hands and arms.

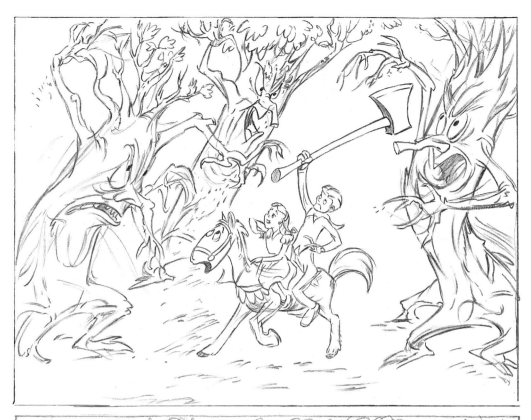

(2) Our heroes on horseback panic, but
suddenly, by magic, a golden hatchet
appears in the grip of one of the heroes.

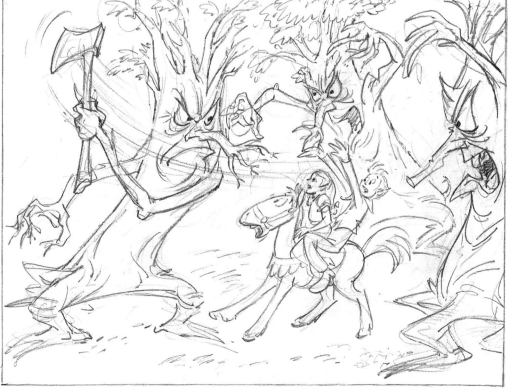

(3) An angry tree grabs the magic
hatchet from our hero's grasp, and
the other trees attack.

209

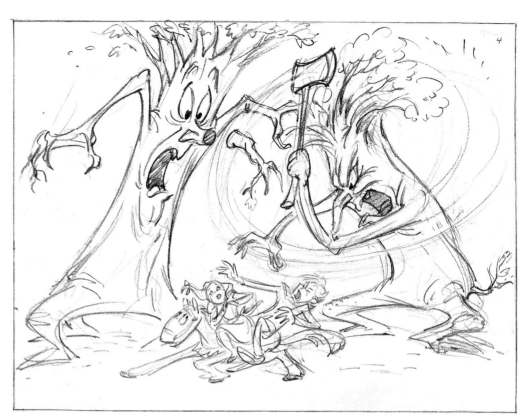

(4) The second tree swings the hatchet at
 our heroes and misses, but the hatchet
 cuts the first tree's nose off.

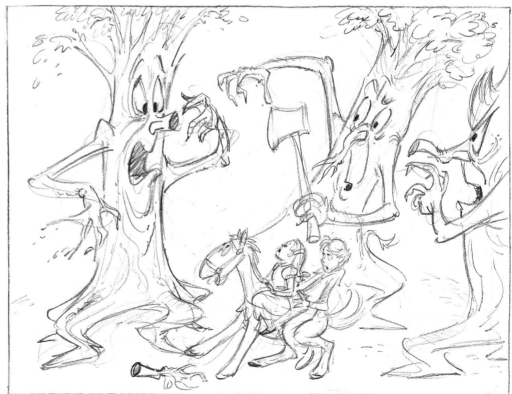

(5) In horror, the angry tree feels and
 looks down at the stub of his nose
 while other trees are shocked.

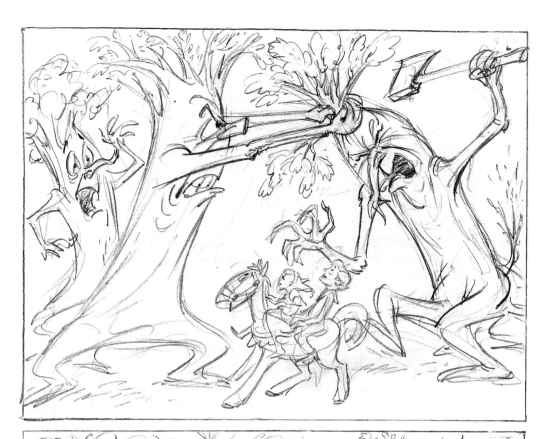

(6) The enraged tree grabs the other tree's hair (branches) by the roots and shakes.

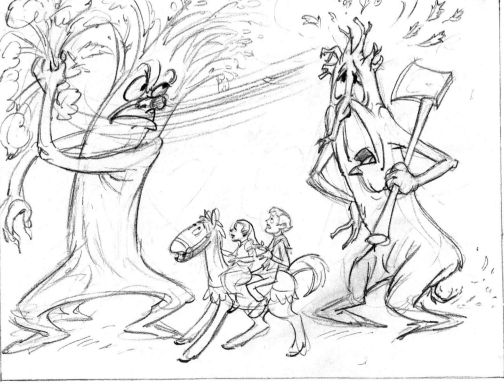

(7) With a vicious yank, the angry tree pulls off the other tree's hair, revealing bald stubble.

BACKGROUND LAYOUT DRAWINGS

Working with the film director, a layout artist draws each scene for the animator. He makes pencil drawings of the background and the key animation positions. These layout drawings establish the relationship between the background and the animation art. In the example here, the drawing of the witch in the distance is separate from the layout drawing of the village.

The animator and film director meet to discuss the scene. First they study the various elements of the scene: the storyboard, sound track, layouts, and exposure sheets. Then they usually review the art that leads into it. Finally, the director explains what he visualizes for the scene and how it fits into the rest of the story and film production. For example, a small village is undergoing an aerial attack from the wicked witch; it is evening, and the villagers have lit some lamps that can be seen in the windows. The blue cast of evening is the dominant color of the scene. Starting as a small dot in the distance, the witch enters the near sky on her broomstick, screaming and cackling hysterically. Lightning flashes as the whole scene jumps to a warm daylight color for a few frames; this is followed by a clap of thunder, which intensifies as the witch winds her way forward, coming down the street from the upper left. Panicked villagers run through the streets, hiding in doorways—here and there people close their shutters. Suddenly, with a fiendish scream, the witch rockets to the foreground for a moment, her head turned away as she navigates the turn and screams at the villagers. Then, twisting down the street toward the upper right, she turns left to fly around the chimney in the center of the scene. The fiendish hag disappears behind the roof at the top of the scene for a moment

and then reappears in the sky on the opposite side. Turning forward, she hurtles up the narrow street canyon, pursuing the stumbling and falling villagers. Next, preceded by a flash of light and a clap of thunder, the witch gyrates to the foreground to scream at the viewer, as pictured in the drawing at far right. Then turning back to the village, she streaks down the street to the right, twisting and turning around the chimneys, rooftops, and streets, finally rocketing into the far sky, becoming a mere moving speck above the distant trees.

Today, it is possible to animate these active villagers and the distant witch on a much larger scale. The scene is first divided into sections; these sections can be combined and reduced to the scale above on photocopied cels. (Modern Disney feature animation demonstrates a computer-assisted process.) To do this type of animation, you need four layers of cel animation—on either a single field or multiple fields (long cels)—which are on either top or bottom pegs, a pan background that can move right or left on top or bottom pegs, and either top or bot-

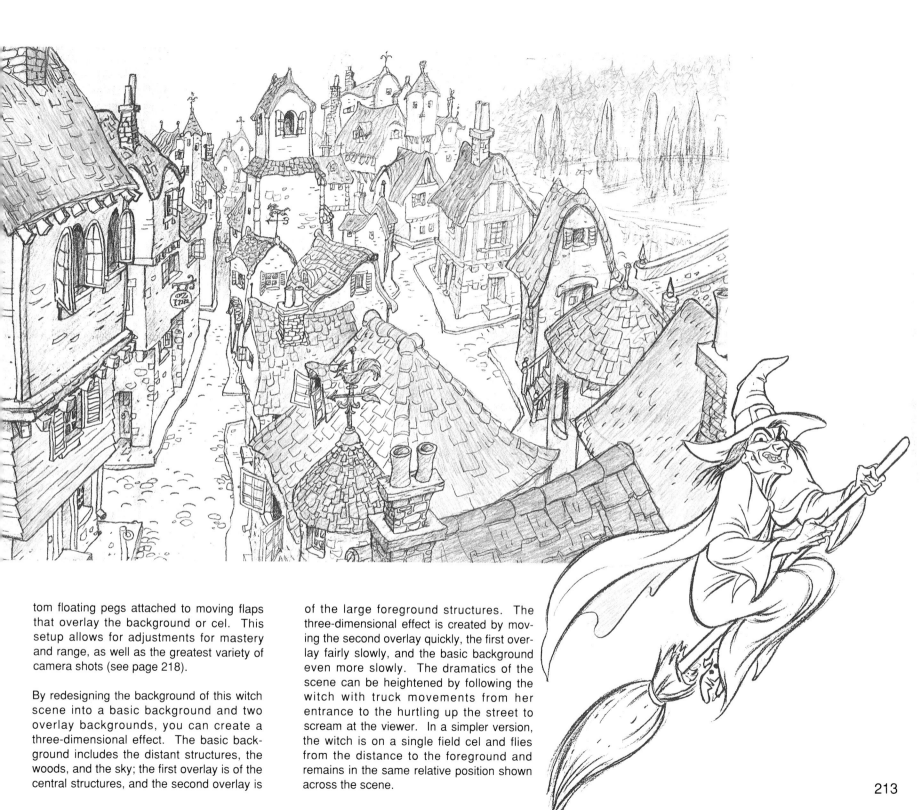

tom floating pegs attached to moving flaps that overlay the background or cel. This setup allows for adjustments for mastery and range, as well as the greatest variety of camera shots (see page 218).

By redesigning the background of this witch scene into a basic background and two overlay backgrounds, you can create a three-dimensional effect. The basic background includes the distant structures, the woods, and the sky; the first overlay is of the central structures, and the second overlay is of the large foreground structures. The three-dimensional effect is created by moving the second overlay quickly, the first overlay fairly slowly, and the basic background even more slowly. The dramatics of the scene can be heightened by following the witch with truck movements from her entrance to the hurtling up the street to scream at the viewer. In a simpler version, the witch is on a single field cel and flies from the distance to the foreground and remains in the same relative position shown across the scene.

213

STILL BACK-GROUNDS · TRUCKS · AND FIELDS

The no. 12 field scene can have four cel levels and a number of overlays. The distant hills could be the background. The foreground and the foreground inn and tree could be two separate overlays. They could separate during a truck-down to give depth.

Cels can be separated vertically to create a natural movement of objects and create a feeling of depth during a camera truck-down toward the cels. (The vertical movement up or down of the camera on the frame is called a "truck.") A truck movement is indicated using the field center location of the chart (pages 215 and 218). The truck move is charted on the chartmap (a portion of which is shown, actual size, on page 215) that can be registered below the camera on the compound, if necessary. To help you better understand trucks and fields, the trucks shown on page 215 are designed to appear on film absolutely even, with no sudden moves or hesitations.

A truck is indicated as per field center location on the chart on page 218, like a map: north, south, east, and west. The truck is charted on a section of the chart (shown actual size, at right, page 215). This truck is down (or up) between a no. 12 field at center (C) and a no. 4 field at a center point that is three fields south of center and 3-1/2 fields east of center (no. 4F., 3S., 3-1/2 E.).

Still the path of a truck can curve or even stagger. The field can tip to any degree or it can turn around. In this scene, the fox could run up the road, up the hill, past the inn, and into the foreground—into the camera or

reversed—followed by a curved truck from a 3-1/2 to 12 field.

Truck moves are usually evenly spaced on the charted path (in red) with a slight slow-in and slow-out. To help you grasp the meaning of trucks and fields, here is a truck that is figured to appear on film absolutely even. Each move reduces the field by the same percentage. The fields look like the framework of a house. Even steps down the road are in the same configuration. Use diagonals, as shown, to locate such positions in perspective work.

Now when you animate in these fields, you can see that the same spaced move in your animation art will be a different length and speed in each separate field. Let's say you have to shift gears for each field. The same pan move is also slower in the large fields and faster in the small fields.

COMPOSITION OF PICTURES

Under the realistic surface of every picture are abstract principles of composition that are the structure and foundation on which the picture is built, the decorative pattern of the picture, and the means of telling a story or expressing a dramatic mood. Thus, composition has a triple function.

The abstract principles are
1. The varied principles of balance.
2. The entrance and the exit of the eye.
3. Circular and rhythmic composition.
4. Angular composition.
5. Units/groups—the figure in landscape.
6. Light, shade, and color.

Artists operate intuitively with composition. Many draw without the power of knowing the composition principles they use; they draw without recourse to inference or reasoning

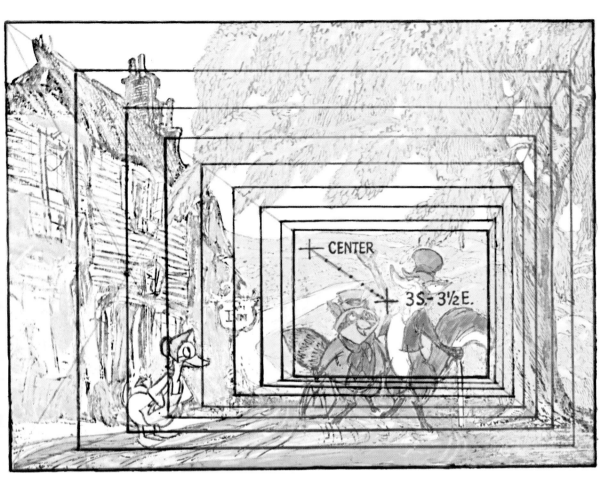

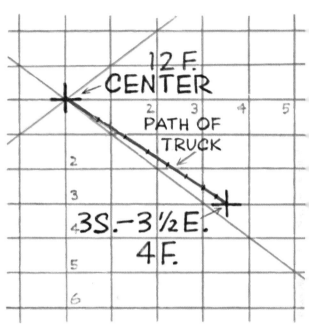

but with a kind of innate or instinctive knowledge of composition. This was the case with Michelangelo, whereas Leonardo da Vinci composed with knowledge.

THE CENTER OF INTEREST

An understanding of composition principles is extremely useful to an animator when he or she moves and poses the actors in the stage set. The animation is the center of interest in the total picture. In all types of art there are abstract elements that support and point to this center. A classic example is Da Vinci's *The Last Supper* with all the diagonals leading the eye to the central figure. In the example here, the abstractions of the fox and the raccoon fit and take advantage of the circular rhythms (red) and the vertical-horizontal-diagonal composition (blue). So watch the perspective in the set as the actor moves (with meaning) and "play all of your cards."

As the camera trucks down and around the no. 12 field scene above, the smaller fields that result have different compositions with different abstract patterns, and the animator designs the animation to fit, keeping the animation as the center of interest.

215

PAN BACKGROUNDS · OVERLAYS · CELS

The bear and the raccoon (seen on page 217) in a walk cycle animate through the scene, moving from right to left. The pan background (top) moves to the right under the bear and raccoon long cels. Above these cels an overlay background of the large tree moves right at twice the speed or spacing of the pan background. Above the tree overlay, a second overlay background moves right at three times the speed of the pan. Thus there are three different background pieces. Each moves at a different speed, giving the scene an illusion of reality, with great depth and distance. For instance, close trees move faster than distant trees. Variations in pan overlay speeds are plotted using actual perspective moves.

Backgrounds can be several fields in length, or a cycle background is planned with three or more fields, such as the first and last fields, painted exactly alike. Thus, the background can be jumped between these fields in a cycle.

Cycles like this bear and raccoon that move through a scene are on long cels that allow a full, clear field (not indicated) on each side of the characters. If a drawing is used in one peg position, it is usually put on a single field cel.

In planned animation for TV, many scenes are made from this artwork. Other pans are shot at smaller fields. Still scenes are made from sections of the background with other overlays and other animation used. The bear and raccoon cycle walk through other backgrounds.

Overlays are cutouts, or the paintings are made directly on the cel with vinyl-acrylic paint. This water-based paint adheres to acetate; it is used for all animation cel production and for the artwork. As shown on page 217, the back of the animation cel is painted with this opaque paint. Originally, the drawings were traced with pen or brush on the front of the cel with acetate inks.

PHOTOCOPY

A state-of-the-art photocopy machine is used to transfer most animation art to cels using fumes instead of heat to fix the image on the cel. Two types of machines are used, and the animator should know what each offers, just as he should know what the animation film camera can do. (1) The original machine with a hand-operated bellows offers both enlargement and reduction; it is used for both cels and backgrounds. (2) This is a 35mm microfilm unit that is fitted with a 35mm projector mechanism. The drawings are photographed on film by an animation camera, and then this film is used to mass-produce cels. Thus, the rotoscope is obsolete. Trucks and all operations of an animation camera can be done by this versatile camera.

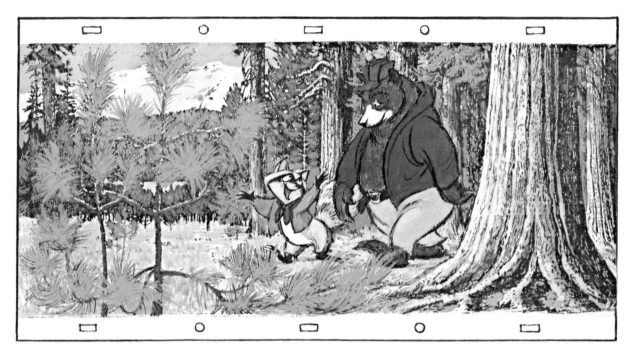

CAMERA AND TECHNICAL

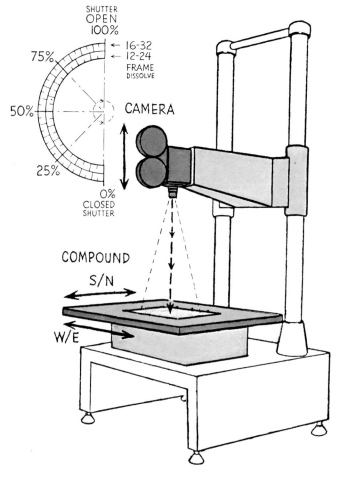

SHUTTER
OPEN
100%

← 16-32
← 12-24
FRAME
DISSOLVE

75%

50%

25%

0%
CLOSED
SHUTTER

CAMERA

COMPOUND

S/N

W/E

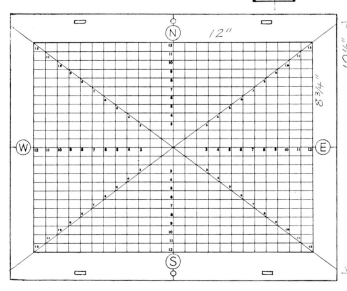

12"

8 3/4"

12" FIELD CHART

The **ANIMATION CAMERA** moves vertically up and down from a fixed center point. The artwork on the **COMPOUND** moves north/south (N/S) and west/east (W/E). A camera "truck" is the vertical movement of the camera and the compound adjustments needed. Compound moves alone are called "camera-moves." The camera trucks from a 3-1/2 to 12 field, according to the chart at the right. Fields are located by center of field like a map: N/S and W/E. This measures compound moves. The **COMPOUND TOP** has top and bottom peg bars that move right or left. These are called "pan moves" for a background and "peg moves" for cel animation artwork.

12 1/2"

9"

GLASS

DRAWING DISC

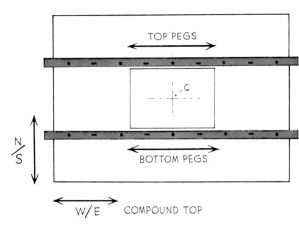

TOP PEGS

C

N/S

BOTTOM PEGS

W/E COMPOUND TOP

Animation is drawn on 10-1/2" x 14" paper and photographed on .005 acetate "cels." These are punched with peg holes for registry. The pegs at the top of the page are widely used for TV shows, commercials, and other production.

Most animators use an aluminum-cast drawing disc that fits and rotates in a circular hole cut in a drawing board or table. The disc shown above has an adjustable moving peg bar that can serve as either top or bottom pegs by rotating the disc. Other discs have only the set pegs or two moving peg bars.

A 60-watt bulb or double fluorescent light is used in a light box under the disc. (Never use a single fluorescent light because it is stroboscopic and bad for the eyes.)

The 12 field (12" x 8-3/4") as charted above is the size and area of normal production. Only fields from a 3-1/2 field to a 12 field are used. The location of the center point of a field on the chart above is specified as either "C" (for center) or the N/S and W/E field distances for "C." On the exposure sheet on page 219, the start 5 field's center point is 1-1/2 fields south of center and 3 fields east of center—like a map.

Cameras truck to an 18, 24, or as high as a 36 field. This is for special or unusual artwork that is rarely animated (it is usually still). Cameras have special equipment for fully animated cel production at an 18 field. Extra peg bars are built into the compound. Many compounds have double top and bottom peg bars to help with 12 field production.

Many compounds rotate 360 degrees (a complete circle). Fields can tip to any angle, twirl around, or shift to a 90-degree vertical that would allow for an up-and-down pan scene. An 8-3/4 field is the largest that will fit sideways for such a pan. Tilted fields are indicated in degrees, just as surveyors indicate angles on a map. This versatile camera can do many things.

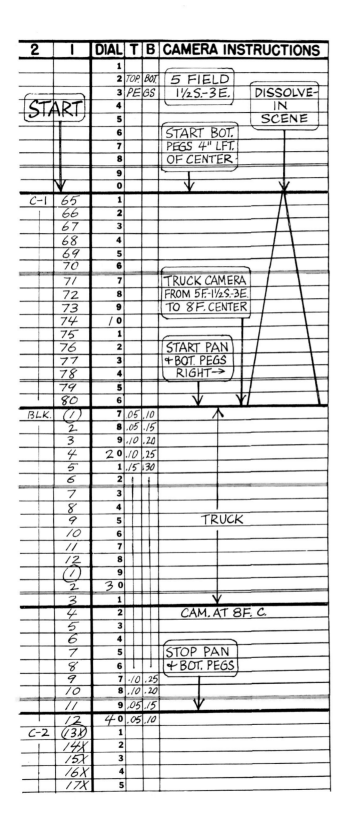

The camera operator shoots the scene based on the exposure sheet form and method shown at the left. The animator draws a heavy line at the start and stop of all camera and peg bar moves. A truck is indicated with a vertical arrow, a camera dissolve-out is a V, and a dissolve-in is an inverted V, as shown. These two V forms are combined in an X form for a fade-in and fade-out dissolve, and they overlap in an XX shape for a cross-dissolve.

Compound peg bar cel or pan moves are given in decimals; however, pan moves are also given with a chart of moves above or below pegs on the edge of the background.

When a held cel is removed, resulting in no cel position in column, a blank cel is placed. There are four cel levels. Sheets are usually for 80 frames or 5 feet (see pages 198-199). A scene is easier to "shoot" if the pan is on the top pegs and the cels are on the bottom pegs. Animation drawn on the "natural" top pegs can easily be put on bottom peg cels.

The camera runs both backward and forward, and it can shoot a scene in either direction. Thus, a scene exposed beginning at the end and moving toward the start enables a piece of artwork or an animated cycle to be "scratched off" or cut off according to planned spacing. When projected forward, the action is growth.

An opaque shadow, cloud, water cycle, rainbow, or ghost animation becomes transparent to a certain degree by making one run of the scene at a 50% (or other) shutter stop, then making a second run without artwork to be transparent at a 50% (or other) shutter stop (the total exposure of both runs must be 100%). Or a character appears to walk through an opaque rainbow, tree, cloud, door, or water cycle by making two 50% runs with the character above and then under these artworks. A "matte" shot uses a black matte over a scene being photographed; thus the area of the matte is unexposed. In another run, a character is exposed in this exact area.

HOW CARTOONS ARE MADE

The simplest form of animation is the "flip" book. To make a simple flip book, draw a dot, a circle, a skeleton, etc., on the edge of a notebook. Then draw the same figure, slightly progressed, on the next page. Do this for fifteen or twenty pages; then flip the edges. An illusion of movement is created. Good animators retain the same spirit of fun and simplicity of the flip book in their work.

In the film studios, the basic flip book idea is enlarged on. First, the animators and their assistants make pencil drawings on paper (10-1/2" x 12-1/2"). This work is then traced in ink on celluloid transparent sheets (cels). Next, opaque colors are painted on. These inked and painted cels are then photographed in sequence on a painted background. This motion picture cartoon film is then projected onto a screen.

HOW TO MAKE AND USE AN ANIMATION BOARD

An animation board will be a great help in your study of animation. Buy some unruled, 10" x 12" loose-leaf notebook paper that is punched with two big holes. Construct pegs of wood or metal on your board (as illustrated) so the paper fits snugly over the pegs. The glass should be the same size as the paper.

When you turn on the light under the board, you will be able to see through several sheets of paper and note how your series of drawings varies in position. Visualize and plan your action; then start with a key drawing or "extreme." The next extreme in your action should be made on another sheet of paper with the lights on so you can work from your preceding position. Follow this procedure until all the extremes of your action have been roughed in; then make the in-between drawings to tie the action together.

If the background does not move to the right or left, the scene is "still." If the background moves, the scene has a "pan" action and is called a "pan scene." During a pan action everything that touches the ground moves with and at the same speed as the pan—for example, feet that touch the ground in a walk or a run.

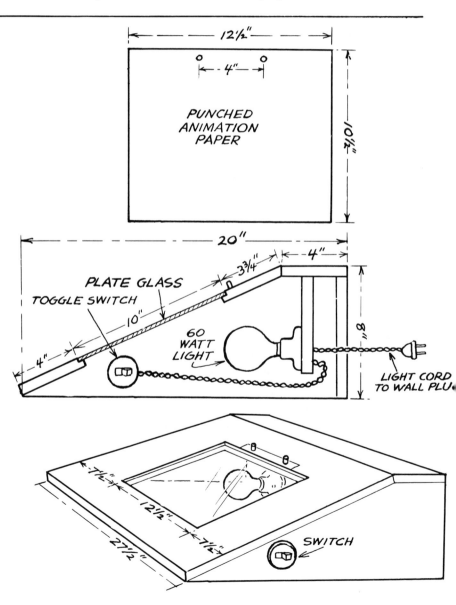

POINTERS ON ANIMATION

1. Work "rough" when laying out your animation. Feel out the basic construction of all the drawings in a scene; add the details later. The drawings on page 204 are roughs. Cleanup drawings (pages 205-207) are made by working over roughs with a new sheet of paper on your animation board (similar to a tracing).

2. It is always a good idea to anticipate an action. When animating a character from one place to another, always go in the opposite direction first, just as a baseball player draws back and cocks his arm before he throws.

3. To help accent a pose on a character, go slightly past the pose when animating into the pose. For example, in a quick point make the finger go out fast and then, just for an instant, pass the position it finally stops at.

4. Create overlapping action whenever you can. When animating a character from one point to another, don't go there with all parts of the character at once—arrive at different times (see pages 128-129 and 134-135).

5. Always get a good follow-through action on loose, moving things such as coattails, hair, long ears, etc. (see pages 156-157).

6. Remember "squash and stretch." Your character is an elastic mass—not rigid like a glass statue. This type of distortion will give "sock" to your work. The recoil is a type of squash drawing; it is essential for a feeling of weight in your characters. Study the bouncing ball action on pages 100-101; also see pages 154-155.

7. Appreciate the value of a good silhouette in your key drawings. A solid silhouette of a drawing should still register the meaning and attitude of the pose (see pages 178-179).

8. Be alert to use exaggerated foreshortening in animation—it is very effective. For example, if a character is swinging a bat around horizontally, when the end of the bat comes out and toward the camera, force the perspective on the bat, making the end very big. When it's on the other side of the character, make the end very small.

9. Make "pose" drawings. First visualize the scene, plan it with "poses," and, finally, animate. Make a few drawings of how you think the character should look at the most important points in the scene. These should be carefully thought out in regard to dramatic presentation, interpretation of mood, character, action, and humor. With these drawings as a guide, start with your first pose and animate your in-between drawings toward the next pose. When you reach the second pose, do not use it as an extreme in your action if it does not fit into the logical progression; instead, make another one that ties in with your animation. Then proceed toward the next pose, and so forth.

10. When possible, make a "path of action" and a "spacing chart" of the action you are animating. For example, if a character is running away from the foreground, off into the distance, and over a hill, make two lines charting the top and bottom of the character in its flight; then mark off the estimated position of each drawing on this track. They will be spaced widely in the foreground and closely in the distance. The procedure of mapping your action will increase accuracy and save time.

11. Remember the timing points, and vary the speeds of action in a scene. A change of pace is usually desirable in animation. Learn the value of a hold: the perfect amount of time to linger on a pose so it will register with the audience for all it's worth. Study the art of going into and out of holds, cushioning into holds, when to freeze a hold deadstill, and when to keep up subtle animation during a hold to give it a "breath of life." These points and others under "timing" are the essence of the art of animation, just as they are with the art of acting, only the animator is the actor of the animated cartoon film. It is the animator's job to portray emotions, which is a highly individual task. That is why animation is an art—an art of expressing one's own personality. Use these pointers to learn how to animate characters that live, have feelings, and show emotion—characters who act convincingly and sway the viewer with suspense, enchantment, and humor. The art of animation has a great potential and future for an animator like you.

HOW TO MAKE A CARTOON FILM

- **PRODUCE AN ANIMATED FILM YOURSELF WITH LITTLE MONEY.**

- **MAKE A WOODEN CAMERA STAND.**

- **GET THE CAMERA ADJUSTED ON THE STAND CORRECTLY.**

- **PUT SOME LIGHTS ON THE SIDES TO LIGHT THE ARTWORK.**

- **HOW TO ELIMINATE THE EXPENSIVE COMPOUND MECHANISM.**

- **ELIMINATE THE EXPENSIVE PLATEN.**

- **YOU DON'T HAVE TO HAVE A COSTLY STOP-MOTION MECHANISM; YOU CAN KEEP TRACK OF THE FRAME COUNT YOURSELF ON THE EXPOSURE SHEET.**

There are several ways to make your own cartoon film without too much money. You can also make a film of your animation drawings without expensive sound tracks. You will need a 16mm or 8mm motion picture camera that is able to shoot one frame at a time and a wooden frame to support the camera as it points down at the animation artwork. The camera will be mounted to the frame in a fixed position, allowing only one field size. The frame is attached to a baseboard, and the animation drawings are placed on a set of pegs attached to the baseboard.

Determine the distance the camera lens needs to be from the artwork to photograph a full animation field (12" x 8-3/4"); then focus the lens to that distance. If necessary, make film tests to be sure the field size and focus are correct. Be sure the camera is not tipped at an angle and attach the camera to the wooden frame. Then tape the pegs to the baseboard.

Floodlights are mounted at an angle on both sides of the camera stand above the artwork. Make film tests to determine the proper aperture. It is best if the lights are strong enough for a small aperture opening, but if the lens needs to be wide open, it will take less light and, thus, less heat.

Instead of taping down the metal peg bar, it is better to use an animation drawing disc (shown on page 218). This drawing disc should have both top and bottom sliding peg bars. This allows you to include moving pan backgrounds with the animation drawings.

The animation drawings are lit by a light box built under the disc. The box should be well-ventilated, and mirrors are used to intensify the light and reduce the bulb wattage and heat. Two layers of animation can be shot over a moving pan background as the camera sees through the papers. (TV animation producers make pencil tests this way.) The elaborate platen frames that hold the artwork down can be duplicated by placing a thick sheet of plate glass over the animation art by hand.

Animation camera stands have a single-frame, stop-motion motor assembly that operates by pushing a button or a foot lever. A film counter is attached to this mechanism to record the number of frames photographed. You can duplicate this process by operating the camera by hand for each frame. Make a check on each frame on the exposure sheet after it is photographed.

- **WHY NOT MAKE A COLOR ANIMATED FILM WHILE YOU'RE AT IT?**

- **A VERY EFFECTIVE SPONGE PAINTING METHOD USED BY THE PROFESSIONALS.**

- **YOU CAN MAKE ANIMATED ILLUSTRATIONS USING THE CUTOUT METHOD; IT TAKES LESS TIME THAN YOU MAY THINK.**

- **HERE IS A REAL PROFESSIONAL SECRET METHOD TO MAKE IN-BETWEENS BETTER AND EASIER.**

- **GET GOING!**

However, before you begin filming, you must prepare the animation artwork. Transfer the animation drawings onto cels (.05mm celluloid sheets), which are available at many art supply stores, with ink or brush and ink. Then paint the backgrounds and color the characters with water-based acrylic paint. Buy one pint each of black, white, red, blue, and yellow acrylic house paint and mix these colors to make the full spectrum of colors, in all shades. Studios use the same type of paint to paint backgrounds in flat opaque areas—similar to poster art. An effective technique is to dip a sponge into the paint and then dab the backgrounds with the sponge, creating a stipple effect. For sharp edges, an area in a cel is cut out and placed over the background to serve as a mask. Different colors stippled in layers can create textures that look like stones, bare earth, trees, clouds, etc.

Animated cutouts can replace the inked and painted cel with art. Your animation drawings can be reproduced on a copy machine to make paper copies. Paint these copies in watercolor with any kind of shading you prefer; then cut them out with scissors or a pen knife. Place a cel over your original animation drawing and use rubber cement or paste to attach the cutout to the cel in exactly the same position as the animation.

To make the in-between drawings that will help you with the animation, place the two drawings that are being in-betweened on the pegs with a blank sheet on top for the in-between. Make a light rough sketch of the in-between in the desired position; then take the in-between and the top animation drawing off the pegs. Place the top animation drawing at any angle position over the bottom drawing to make the two drawings coincide closely. Hold the top drawing down and place the in-between drawing over both animation drawings in the closest in-between position you can adjust. The corners of the in-between drawing will be in an in-between position of the animation drawing corners—allowing for the arc of the in-between. Hold all drawings down at the top (or make a contrivance that will) and make the in-between. It is much easier this way.

My sincere best wishes to you!
— Preston Blair

OTHER BOOKS ABOUT ANIMATING

Every student of the art of animation should read and own these books:

Disney Animation: The Illusion of Life by Frank Thomas and Ollie Johnston, Abbeville Press. An excellent and extensive work on how to animate and how to make Disney-style animated cartoons by two of Disney's greatest animators.

Cartoon Animation–Introduction to a Career by Milton Grey, Lion's Den Publications. Provides a full perspective of the animation business and the art of animating in an intimate style that every student animator should read — and enjoy.

The Human Figure in Motion and *Animals in Motion* by Edward Muybridge, Dover Press. Reprints of antique classics containing photographs of actions made before motion pictures were invented. These books are revered by animators.

American Animation by Michael Barrier, Oxford University Press. An analysis of animation's past achievements written in a manner that will give valuable insight into tomorrow's filmmakers.

Of Mice and Magic by Leonard Maltin, McGraw Hill Book Company. Tells the story of the animated film studios and traces the beginning of the art of animation. Many pictures and a great style.